CUT-PIECES

SOUTH ASIA ACROSS THE DISCIPLINES

SOUTH ASIA ACROSS THE DISCIPLINES

EDITED BY MUZAFFAR ALAM, ROBERT GOLDMAN,
AND GAURI VISWANATHAN

DIPESH CHAKRABARTY, SHELDON POLLOCK, AND SANJAY
SUBRAHMANYAM, FOUNDING EDITORS

Funded by a grant from the Andrew W. Mellon Foundation and jointly pub-
lished by the University of California Press, the University of Chicago Press,
and Columbia University Press

For a list of books in the series, see page 253.

CELLULOID OBSCENITY AND POPULAR CINEMA IN BANGLADESH

LOTTE HOEK

COLUMBIA UNIVERSITY PRESS

NEW YORK

Columbia University Press

Publishers Since 1893

New York Chichester, West Sussex

cup.columbia.edu

Copyright © 2014 Columbia University Press

All rights reserved

Library of Congress Cataloging-in-Publication Data

Hoek, Lotte.

Cut-pieces : celluloid obscenity and popular cinema in Bangladesh / Lotte Hoek.

pages cm

Includes bibliographical references and index.

ISBN 978-0-231-16288-3 (cloth : alk. paper) — ISBN 978-0-231-16289-0 (pbk. : alk. paper) —

ISBN 978-0-231-53515-1 (ebook)

1. Motion pictures in ethnology—Bangladesh. 2. B films—Bangladesh.

3. Bangladesh—Social life and customs. I. Title.

GN635.B33H64 2013

306.4095492—dc23

2013011066

Columbia University Press books are printed on permanent and durable acid-free paper.

This book is printed on paper with recycled content.

Printed in the United States of America

c 10 9 8 7 6 5 4 3 2 1

p 10 9 8 7 6 5 4 3 2 1

Cover design by Jordan Wannemacher

References to websites (URLs) were accurate at the time of writing. Neither the author nor
Columbia University Press is responsible for URLs that may have expired or changed since
the manuscript was prepared.

VOOR PAPA EN MAMA,

EN PAUL

CONTENTS

NOTE ON TRANSLITERATION, TRANSLATION, AND PSEUDONYMS

I HAVE TRANSLITERATED all Bengali words and phrases according to their Bengali pronunciation for ease of reading as well as to maintain in written form some of the distinctive Dhakaiya Bangla that is so central to the soundscape of popular cinema.

The following should be noted:

I have transliterated the inherent vowel sound, *shoro o* and *okar* all as 'o'.

I have transliterated both *hroshsho i* and *dirgho i* as 'i'.

I have transliterated *talobbo sho, murdhonno sho*, and *donto sho* all as 'sh'.

I have transliterated *ko* as 'k' rather than as 'q'.

For aspirated consonants I have added an 'h', except for the unaspirated *cho* and the aspirated *chho*.

For example:

I transliterate the Bengali word for *obscenity* as *oshlilota*, not *ashleelata*.

I transliterate the Bengali word for *veil* as *borka*, not *burqua*.

In quotes and titles from other authors I have retained their original transliteration. I have written well-established terms according to common spelling in English (for example *purdah, sari, jatra*, etc.) and names according to convention. Where English words appear in Bengali text, I have transliterated them according to their English spelling.

All translations are my own.

The title *Mintu the Murderer* is a pseudonym, as are the names of all members of its crew, cast, and exhibitors. Where named in printed text, such as newspaper articles, I have substituted the names with their pseudonyms within square brackets. The titles of other action films and the names of their crew members mentioned in relation to cut-piece practices, such as *Cruelty*, are also pseudonyms. I have rendered Bengali film titles in italics

and their English translations within quotation marks, except when the original title or pseudonym is in English, such as *Mintu the Murderer*. Some films have different Bengali and English titles, such as the film *Suryo dighol bari*, which carries the English title "The Ominous House." I have not translated these titles. The names of filmmakers, films, and artists who have not played any role in *Mintu the Murderer* and are not centrally involved in the production of cut-pieces or named in obscenity accusations have been retained in their original.

ACKNOWLEDGMENTS

MANY PEOPLE have been part of this project over the years. They have made it a better book and a much more enjoyable process. The research project on which it is based was made possible by The Netherlands Organization for Scientific Research (NWO) and was part of the NWO Pionier research project "Modern Mass Media, Religion and the Imagination of Communities. Different Postcolonial Trajectories in West Africa, India, Brazil and the Caribbean," directed by Birgit Meyer. It has been a privilege and pleasure to work with Birgit Meyer, and I am grateful for her dedicated supervision and continued support of my work. I thank Willem van Schendel for his supervision of my doctoral project, and I have been inspired by his commitment to the study of Bangladesh.

A special debt of gratitude must be expressed to those who shared their days in film with me: Shahdat Hossain Liton, Md. Abdul Kayum, Md. Nazrul Islam, Edin, Siddique, Imdadul Hoq Khokon, Rezaul Karim, Sharif Hussain Chowdhury, Md. Abdul Rohim, Jamaluddin Chisti, Md. Habibula, Md. Ajgar Ali, Al Mamun, Torun Chowdhury Borua, Jewel, Delowar Hossain Chunnu and the fighters, including Mohammad Habib Hazrat, Mohammad Farhad, Abdul Kader Mithu, Gulzar Khan, Md. Akhtar Akon; Md. Josimuddin, Ali Akram Subho, Riaz, Purnima, Abdullah Zahir Babu, Oyon, Md. Alamgir, Mohammad Shahid Hasan Misha, Mohammad Shajabot Ali Sheikh, Hero, Aziz Reza, Mujibur Rahman Babul, Masud Azad, Zahirul Islam, Babul Sharif, Momtazur Rahman Akbar, Polly Malek, Sharif Uddin Khan Dipu, Shameem Khan, Shakib Khan, Shahara, and the late Manna. I am especially indebted to the kindness of Fatema Akhtar Rita, Suborna Kri Shapla, and Aklima. I thank the Bangladesh Film Development Corporation, the Bangladesh Film Censor Board, the Bangladesh Film Archive,

and Mohammad Jahangir Hossain for their kind support of my research. Monira Morshed Munni, Morshedul Islam, and Zakir Hossain Raju set me on my way, for which I am grateful.

In Dhaka I have been especially privileged to enjoy the kindness, friendship, and hospitality of Sameera Huque, Wahidur Rahman Khandkar Czhoton, Naeem Huque, Mr. and Mrs. Huque, Mr. and Mrs. Alam, Manzur Alam, and Reza Alam. I would also like to thank Yusuf Ali (Noton), Tanvir Ahmed, and Bishawjit Das for showing me Dhaka in the most wondrous light.

My project and sanity have greatly benefited from conversations with, interventions by, and encouragements from dear friends and colleagues: Ze de Abreu, Irfan Ahmad, Kamran Asdar Ali, Richard Baxstrom, Laura Bear, Adi Bharadwaj, Eveline Buchheim, Jacob Copeman, Alex Edmonds, Ajay Gandhi, Peter Geschiere, Parvis Ghassem-Fachandi, Francio Guadeloupe, Thomas Blom Hansen, Stephen Hughes, Bodhisattva Kar, Toby Kelly, Mathangi Krishnamurthy, Maaike Kwakkel, Brian Larkin, Ferd Leliveld, Nayanika Mathur, Martijn Oosterbaan, Christopher Pinney, Mattijs van de Port, Rafael Sanchez, Atreyee Sen, Olga Sooudi, Jonathan Spencer, Rachel Spronk, Sharika Thiranagama, Oskar Verkaaik, and Marleen de Witte. I am very grateful to Jennifer Crewe and Kathryn Schell at Columbia University Press, my copyeditor Joe Abott, as well as to Lalitha Gopalan and one anonymous reviewer for their generous, detailed, and helpful comments.

None of this would have been possible without the love, care, and support of my parents and brother. To Papa, Mama, and Jesse I am indebted for the love of words and all the pleasure in the world.

Paul James Gomes is on every page of this book. His love and care have sustained me in this project. I thank him for everything but especially for taking me to see *Beder Meye Josna* that day.

Parts of chapter 6 have appeared as the article "Unstable Celluloid: Film Projection and the Cinema Audience in Bangladesh," *BioScope: South Asian Screen Studies* 1(1) (2010): 49–66.

CUT-PIECES

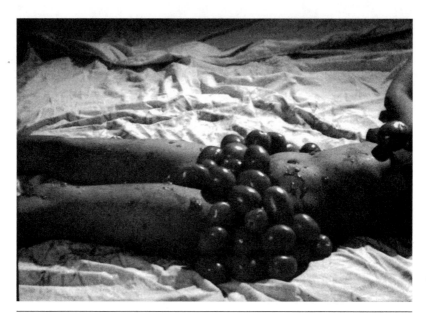

FIGURE I.1 FRAME FROM THE COLLECTION OF PAUL JAMES GOMES.

INTRODUCTION

BEFORE *MINTU THE MURDERER*

IN 2005 a Bangladeshi action film I call *Mintu the Murderer* was written, shot, censored, and released.[1] As the movie traveled through small towns in remote districts of the country, a hot rumor spread: the action film contained pornographic scenes featuring Bangladeshi actresses. The film became enveloped by speculations about its "obscenity." Ticket sales soared across towns in the districts of Rongpur, Khulna, Jessore, and Sylhet. Before long, police officers and journalists were on its trail, hungry for the illegal scenes. By the end of 2005 the film was taken out of circulation and banned by the Bangladesh Film Censor Board for containing "obscene" and "vulgar" scenes. This book is an ethnography of that film.

Of course, the rumors were true. It was entirely possible to watch an action film in a cinema hall skirting a small town in Bangladesh, enjoying the familiar curve of the narrative, the inescapable *dishoom-dishoom* of the soundtrack, the slapstick asides, and then experience a sudden rupture. A hush would fall over the largely male audience as the action narrative was abruptly suspended and an apparently unrelated pornographic scene would appear onscreen. Disappearing as suddenly as it had appeared, such a brief intrusion of genitals or exposed breasts was not a fluke. These were "cut-pieces," short strips of locally made uncertified celluloid containing sexual or violent imagery that appeared and disappeared abruptly from the reels of Bangladeshi action films.

The first time I saw a cut-piece, I was in a packed single-screen cinema hall in Sylhet. A boisterous crowd was reduced to pin-drop silence when a three-minute close-up of cunnilingus suddenly appeared between the fast-paced action scenes. As the impact of the scene wore off and the spectators exploded in voluble cheers, I too reeled from its force. When its

immediate visceral impact waned, questions emerged. What were these rogue clips doing to my understanding of the cinema? What was I to make of this "unstable celluloid," reels falling into pieces upon screening? In this book I make sense of these cut-pieces, their production, consumption, and "obscenity" by giving an account of *Mintu the Murderer*—tracking the film's crew, actors, censors, audiences, and, most of all, its elusive cut-pieces.

· · ·

Shahadat Ali Shiplu was the king of the cut-piece. The newspapers left no doubt about his sordid activities. His name appeared in outraged and excited newspaper reports suggesting that "in today's cinema, [Shahadat Ali Shiplu] competes with [other film directors], and their rivalry consists in who can bring the most nudity to the screen" and "because he has shown great expertise in making cut-piece filled films, [Shiplu] has more films in hand than any other film director" (*Manobjomin* 2005a). That Shiplu was a prolific film director at the time he was shooting *Mintu the Murderer* is hard to deny. In 2005 one hundred feature films were released in Bangladesh. Six of these were directed by Shahadat Ali Shiplu. All six fell foul of the Censor Board and were found to contain uncertified and "obscene" materials. Shiplu really was the king of the cut-piece.

Shiplu ruled as first among equals. Of the one hundred Bangladeshi films released in 2005, fifty-six ran into trouble with the Bangladesh Film Censor Board for being "obscene" or containing illegal imagery. This could be bits of film that had been preemptively cut out by editors before submitting the film for censoring, only to be spliced back in the moment the film was cleared for release. Or it could be bits of unrelated celluloid, made locally or abroad, that featured sexually explicit imagery that was spliced into a film by projectionists in local cinema halls. It could also be sexually suggestive or explicit scenes that were not submitted to the Censor Board but deemed so profitable by producers or exhibitors that they were only put into the film reels at a few screenings, generating rumors of fabulous pornography that only a handful of lucky cinemagoers would get to see. All of these are examples of cut-pieces. The term *cut-piece* derives from the practice of cutting scenes or images out of a film's reels before submitting it to the Censor Board. In 2005 the cut-pieces were such an integral part of the film industry that film reporters considered the Bangladesh Film Development Corporation (FDC) to be awash in porn while local wits suggested it should be renamed the "Blue" Film Development Corporation.

To understand the cut-piece phenomenon, I spent a lot of time with Shahadat Ali Shiplu. In early 2005 Shiplu started to work on his new film *Mintu the Murderer*, which was released in November of that year. I spent the whole year following this film, from its first scriptwriting sessions until its arrival in village cinema halls far from the capital city, Dhaka. This film is my case study, which I undertook in my attempt to understand the cut-piece, celluloid obscenity, and popular cinema in Bangladesh. Thinking through the cut-pieces of *Mintu the Murderer*, I make two central arguments in this book. The first relates to the nature of "obscenity" and its expression through the material properties of celluloid; the second deals with the contemporary media landscape in Bangladesh and South Asia and the forms of its popular cinema.

Cut-piece films and the practices, institutions, and spaces around them are generally considered *oshlil* (obscene) in Bangladesh. The noun *oshlilota* indicates social distinction and sexual mores within a single term, combining the English terms *vulgarity and obscenity.* In this book I take the "obscene" to mean the representation of sexuality in ways that are considered socially and morally unacceptable (OED). The category of the "obscene," like *oshlilota*, is thus imminently social, bespeaking social distinctions and hegemonies.[2] But there is a contradiction at the heart of obscenity: to ascertain what is obscene, a socially inappropriate and "coarse" representation of sexuality must be brought to public attention so that it can be disavowed, an act reminiscent of Foucault's debunking of the repressive hypothesis (1990, 1991). Obscene forms are therefore always public forms marked by an oscillation between being in and out of view. Examples of obscene texts and images that rely precisely upon their temporary or limited public visibility for their full effect include, among many others, the erotic frescoes in Pompeii, the infamous painting *L'origine du monde* (see Nochlin 1986), and the rendering of erotic passages in Latin so as to be only accessed by those with knowledge of that dead language. The obscene is thus marked by a play of veiling while revealing. Its power to incite desire and controversy is dependent on its partial or temporary availability.

And this ephemerality is what the cut-piece performs exceedingly well. The most peculiar feature of the cut-piece is its capacity to appear and disappear rapidly. Because of the pliable quality of celluloid, a few feet of the stuff is easily cut out of a film reel with scissors before its submission to the Censor Board, or taken out of seized films as they travel between a remote cinema hall and the Censor Board in Dhaka, or made to

appear suddenly onscreen, taped quickly into the reels of a feature film. It is this oscillation between presence and absence, appearance and disappearance, veiling and revealing that is central to the obscenity of the cut-piece.[3]

As a cultural form that allows degraded material to oscillate between public presence and absence, cut-pieces form a focal point for public anxieties and fantasies in Bangladesh. The cut-pieces display these anxieties as a consumable spectacle. This means that while on the one hand the actual existence of the cut-piece is taken as an indication of the disintegration of the Bangladesh polity (ineffective legal system, corrupt leaders, wanton powerbrokers, dissipating family values, and faltering public norms but also the disintegration of filmmaking traditions, overwhelmed by uneducated filmmakers and thuggish producers), on the other hand, cut-pieces produce fantasies about this social disintegration as a titillating spectacle or *noir* vision through an obsessive focus on sex, often laced with violence (such as scenes of consumerist paradise bathed in endlessly sexual opportunity, public fantasies about the casting couch, or dystopian images of the rape of college girls by corrupt politicians or property developers). Through its oscillation, the cut-piece becomes a focal point for social controversy, as well as a means by which the fantasies and anxieties that plague society can become visualized. It brings controversy into the public eye without becoming contained (it disappears too rapidly for effective policing of its existence or its visual content) while at the same time heightening its impact through that very elusive status. The cut-piece is part of and comments on the public fantasies and collective myths within contemporary Bangladesh.

The argument I don't make in this book is that the controversies over the obscene cut-pieces in Bangladesh are a product of a particularly Islamic morality. Scholars working in other parts of the Muslim world have demonstrated the significant differences between the relation between Islamic religious discourses and the cinema in, for example, Nigeria, Iran, Indonesia, and Egypt (Adamu, Adamu, and Jibril 2004; Armbrust 2002; Heeren 2007; Naficy 1995). Moreover, accusations of obscenity in very similar tones and registers can be heard throughout South Asia (Hewamanne 2006; Liechty 2001; Padmanabhan 1998; Qureshi 2010) and beyond (Allison 1996; Mat 2006; Tait 2005). A cultural analysis that posits a "knowable" Islam as the deep cause of the crisis of obscenity in Bangladesh misses the obvious continuities connecting Bangladesh's current crisis of celluloid obscenity with similar historical and contemporary

moral panics elsewhere. In contemporary Bangladesh, cut-pieces are considered *oshlil* rather than *haram* (forbidden, in Islam). They are disrespectable and coarse, a problem foremost of taste, class, and sophistication.

How did the cut-piece appear in Bangladeshi cinema? The cut-piece sells movies in the context of the competitive contemporary media landscape of South Asia that includes satellite television, Hong Kong films, DVDs, "Bollywood," and telefilms. A form of exploitation cinema, cut-piece films are rapidly made features with low production values and small budgets that have arisen in the context of increased competition and consolidation of other forms of media, exploiting some opprobrious element to sell (see Schaefer 1999). Within this changed landscape, the FDC in Dhaka continues to operate as a public enterprise under the wings of the Ministry of Information. The continued ban on screening foreign cinema dating from the 1965 India-Pakistan war means that the cinema halls in Bangladesh screen mainly 35mm films made at the FDC, the de facto Bangladesh film industry. Although once the cherished heart of respectable middle-class cultural pursuits, the playground of the *bhodrolok* (gentlefolk), today the FDC is associated with the *oshikkhito* (uneducated) and *mofussil* (rural hinterland); it is considered gauche, unsophisticated, and vulgar. The transformation of the Bangladesh film industry indexed by the cut-piece is part of other social and political changes in Bangladesh that I discuss below.

While the contours of the cut-piece phenomenon in Bangladesh may be particular to the FDC, I argue that the condition of its emergence and the contexts of its production and consumption aren't. The media landscape in which directors such as Shiplu find themselves stretches across South Asia, where illicit pornography circulates in unpredictable directions on digital and analogue carriers, where Bollywood has become an unavoidable part of satellite packages, and where rural single-screen cinema halls continue to cater to many film aficionados. These developments raise the question of how to understand the cut-piece films and their modes of production and consumption within the rapidly expanding scholarly field addressing the cinemas of South Asia. I suggest not only that the study of South Asian cinema stands to gain from the ethnographic details culled from production and consumption contexts but also that the field is overwhelmingly tilted toward the analyses of high quality films with well-recognized actors and directors. Not only does this leave the stuntmen, projectionists, sweepers, censor board investigators, and other everyday laborers of film culture in the dusty and easily forgotten corners of film

scholarship; it also fails to take seriously the enormous production, circulation, and consumption of box-office flops, stray reels, and doctored C-circuit prints that are an integral part of this film culture, even when derided and neglected.

MEDIA ANTHROPOLOGY AND THE STUDY OF SOUTH ASIAN CINEMAS

How might the cut-piece be studied? More absence than presence, its visibility always temporary, the cut-piece is a slippery object of investigation. I used an ethnographic approach to follow the cut-pieces in and out of visibility, deploying the tenacity and duration of immersive fieldwork to track the cut-pieces in the face of scenes appearing and disappearing from scripts and reels, crews withdrawing into outdoor locations, editing rooms locked and bolted, and shots cut from reels destined for the Censor Board. I carried out ethnographic fieldwork in Bangladesh between October 2004 and December 2005. I worked alongside the crew of *Mintu the Murderer* from the first scriptwriting sessions in February 2005 to the film's screening in village cinema halls in November and December of that year. Investigating the processes of mediation and media artifacts in everyday life and their participation in the fashioning of worlds and selves, media anthropology provides empirically grounded theoretical perspectives on the media (Askew and Wilks 2002; Ginsburg, Abu-Lughod, and Larkin 2002; Spitulnik 1993). Anthropology also indulges the study of the counterintuitive, marginal, or elliptical. It is from this position that I approach cut-pieces.

Media are often the means by which anthropologists get at something else. For example, television is studied to understand nation-building (Abu-Lughod 2005), gender identity (Mankekar 1999), or cultures of education (Painter 1994); audiocassettes for political mobilization (Sreberny-Mohammadi 1994) and pious publics (Hirschkind 2006); the Internet for parenting (Madianou and Miller 2011); or loudspeakers for the production of devotional spaces (Lee 2003). Focusing on what mediation accomplishes in other domains, the media themselves remain largely a secondary concern to the study of, for example, nationalism, religion, or social movements. This neglect is due in part to the fact that anthropologists are at ease studying and theorizing the complex social contexts of media consumption. Simultaneously, some anthropologists have been reluctant or thwarted in their efforts to take up contexts of media production, such as

when Abu-Lughod frankly states in her book on television in Egypt that she "did not have the time, qualifications, or inclination to do an ethnography of television production, to demystify the production process" (2005:24) or when Powdermaker (1950) and Ortner (2010) struggled with access to Hollywood.

But if media anthropology aims toward "integrating the study of mass media into our analyses of the 'total social fact' of modern life" (Spitulnik 1993:293), it requires a considered account of these mass media in their own right, investigating their technologies without resorting to technological determinism, examining their contexts with sufficient ethnographic interest, and investigating the complexity of their processes of mediation. That is, "what the media *are* needs to be interrogated and not presumed" (Larkin 2008:3, my emphasis), and "one cannot in principle or in advance know how some media technology, power, text, political economy, communication circuit, or cultural industry determines what people do with media" (Hughes 2011:310). When media anthropology remains conceptually open to the nature of the media, it can inquire how "images and objects [are] densely compressed performances unfolding in unpredictable ways and characterized by . . . disjunctions" (Pinney 2005:269) or how media "are productive of new forms of cultural life" (Axel 2005). At this conceptual starting point the media, their images, structures, and labors, are not subservient to a social or cultural world that is already fully formed, an ethnographic given, but these media provide a site for the production of such new worlds and selves, productive of "the very schematism of perceptibility" (Kittler 1999:xli).

An anthropology of media that proceeds from the theoretical starting point that what the media are and accomplish cannot be read from either their technologies or the societies and cultures in which they are embedded requires a satisfyingly thick description of the media. While contexts of reception have received such immersive ethnographic attention (Dickey 1993; Gillespie 1995; Radway 1995), similar interest for such diverse aspects of production contexts as video narrators (Krings 2009) or dressmakers (Wilkinson-Weber 2010) is now emerging. But how exactly different parts of such a media environment fit together remains in the realm of assumptions rather than empirical investigation. Anthropology's heritage of comprehensive fieldwork sits uneasily with such a fragmented approach. Here, therefore, I do not ask how bits and pieces of fully formed mass media burst into local worlds or how a single segment of media objects comes into being. Instead, I take a holistic methodological

approach, tracing the entire life cycle of a single film, "following the thing" that is *Mintu the Murderer* (Marcus 1998). *Mintu the Murderer* is my anthropological fieldwork site, a dispersed location (Gupta and Ferguson 1992) that brings together people, institutions, labor, desires, and imaginations. While I therefore seem to reduce my insights about cinema and obscenity to a single case study, I am with Geertz in maintaining that "anthropologists don't study villages. . . . They study *in* villages" (1973:22). *Mintu the Murderer* is the field site from which I study the properties of cinema and the complexity of obscenity.

While ethnographic approaches to the cinema have demonstrated, for example, how film has "crept into the intimate texture of rural experience" (Pandian 2008:124) or how cinema offers a mode of world-making (Varzi 2006), the questions about the nature of cinema—its forms, modes of address, or aesthetics—remain largely the concern of film studies. An ethnographic approach to the cinema can, however, contribute to our understanding of cinema, taking the deceptively simple methodological premise of "looking at how someone . . . makes a movie" (Worth 1981:191) to contribute to debates within cinema studies regarding the gaze, narrative, genre conventions, or censorship, and take "us from the site of the screen into the body of practices and life stories that make screen cultures possible" (Vasudevan 2010a:140).

Around the site of the screen in South Asia exists a complex set of practices, institutions, and materials that have received increasing scholarly attention (Ganti 2012; Gazdar 1997; Gopalan 2002; Hughes 2000; Khan and Ahmad 2010; Mehta 2011; Mazumdar 2007; Mukherjee 2011; Raju 2000; Shah 1981; Vasudevan 2000, 2010b). I position this study of the Bangladeshi cut-piece within the body of literature on South Asian cinemas both to understand the cut-piece phenomenon in Bangladesh and to contribute to the debates within South Asian film studies. Methodological nationalism does not aid the study of South Asian cinema, in which the linguistic or regional boundaries have historically been porous (Hughes 2010) and in which the practices, technologies, and lives of the cinema are complexly distributed (Vasudevan 2010a). Contemporary Bangladeshi cinema participates in the shared historical roots, institutional beginnings, aesthetic vocabularies, technological preferences, and competitive forces of South Asia, however modified by local structures, limitations, and desires.

The examination of Bangladeshi cinema from within this body of literature speaks to the recent attempts to broaden the scope of South Asian

cinema studies (Dickey and Dudrah 2010). Many authors are motivated by the desire to dislodge the academic hegemony of the Hindi film by proffering details from other languages or states, such as the Bengali (Gooptu 2011), Tamil (Velayutham 2008), and Bhojpuri (Ghosh 2010, 2012; Tripathy 2007) cinemas. While this is an important move in expanding the field, it misrecognizes the similarities between these fields of film culture and occludes other forms of heterogeneity. Expanding horizontally across the different regions and states of South Asia suggests that the diversity of South Asian cinema lies within different languages and local histories of production and consumption. What such an approach misses is the significant *vertical* heterogeneity of this field, across hierarchies of value and quality. The significant differences are not necessarily distributed only horizontally across geographic space and language; they may also expand vertically, across hierarchies of production value and practices of consumption.

The complex field of cultural production and the theoretically challenging domain of cinematic practices that mark the vertical quality axis of film cultures are often hidden under the blanket term *popular cinema*. This includes those bits of cinema in South Asia and its artifacts that have emerged as respectable objects of study (Mazumdar 2003), alongside the "gentrification of Hindi cinema" (Ganti 2012:4) and even its "Bollywood-ization" (Rajadhyaksha 2003). But the cinema in South Asia knows many temporalities and forms, of which the gentrified Bollywood is but one (Mahadevan 2010; Vasudevan 2010a). The challenge is for scholarship not to be similarly "gentrified" or "bollywoodized," resisting denuding it of the more degraded texts and illicit practices that mark the field of study, and cracking open the category of "popular" cinema to reveal the diversity within.

One of the areas of cinema scholarship that may be opened up is the study of cinematic pornography. From "blue" and "English" films to morning shows and cut-piece-style inserts, the cinema halls in South Asia are a site for the projection of sexually explicit imagery. "Porn studies" (Williams 2004) has been much concerned with understanding the emergence of new styles, aesthetics, production processes, and consumption as pornography appears in new digital formats such as video and ubiquitous arenas such as the Internet. Hard-core celluloid pornography continues to be consumed in public in cinema halls in South Asia. But while eroticism, soft-core pornography, and their controversies have drawn some scholarly attention (Dwyer 2000a; Mokkil Maruthur 2011; Singh 2008;

Srivastava 2007; Swaminathan 2004; Thomas 1996), the aesthetics, projection, and viewing of hard-core pornography in South Asian cinema halls remains unstudied. Its imagery and narratives may be fruitfully studied to investigate the visual production of pleasure or sexual difference, and ethnographic engagements with the processes of production, circulation, and consumption of such material can contribute to our understanding of how actresses negotiate their availability to the gaze of the camera, the ways in which cinema halls produce knowledge about sex and sexual difference in particular affective ways, and how censor board members delimit what counts as "sexual" imagery.

One might ask whether the cut-piece is not a peculiarly local, idiosyncratic, cinematic form, hardly illuminating beyond the confines of rural Bangladeshi cinema halls. However, the phenomenon of the cut-piece is less particular than it may seem. The possibility of "unstable celluloid," the splicing of "other" footage into the main body of a film, is referenced in other work. Brian Larkin mentions similar practices in his account of Nigerian cinema (2004), and Paul Willemen notes that European pornographic cinema in the 1970s would "consist of 'carrier films' . . . along with a menu of possible inserts varying in degrees of 'explicitness'" (2004:24). Within South Asia S. V. Srinivas (2003), Liang (2011), Rai (2010), Srivastava (2007), and Ganti (2009) refer to cut-piece film practices in India, and Hulsing (2004) describes seeing short sequences of locally made porn spliced into films in the cinema halls of Peshawar. The cut-piece is not a strictly Bangladeshi phenomenon.

The real relevance of the occurrences of cut-piece-style practices is that they highlight how cinema generates processes and practices much in excess of its "ideal" forms. In his account of the "B circuit" of film distribution in Andhra Pradesh, S. V. Srinivas suggests that "a range of practices of clearly questionable legality are in evidence here including the distribution of uncensored films, the splicing of sexually explicit sequences in censored films, the circulation of 'condemned prints' (damaged prints that are unworthy of exhibition), the distribution of films long after the rights have lapsed, etc." (Srinivas 2003:55–56). Srinivas adds that "even the economically established A-circuit is not free from such intervention" (2003:49). Nonetheless, the insertion of uncertified scenes or circulation of badly damaged prints enters the burgeoning literature on South Asian cinemas only on rare occasions. Its implications for the field remain undertheorized. This is partly related to the fact that film studies asks different questions than media anthropology does and has

its eyes often fixed on *the* screen rather than a multiplicity of empirical screens and all the extraordinarily less than ideal practices around them.

There is also the less easily countenanced tendency across disciplines to steer away from an engagement with low-investment movies or "B circuits," rural cinema halls, and illegal practices (for exceptions see Gopal 2011; Gopalan 2002; Khan and Ahmad 2010; Singh 2008; Srinivas 2003; Vitali 2009). There is an overwhelming focus on films with high production values, especially so-called Bollywood films, middle-class audiences, and the ideal film text (Derné and Jadwin 2000; L. Srinivas 2002; Uberoi 2001; Virdi 2003), even in studies where authors state that "85% of commercial films in India flop" (Mehta 2011:16) or that during the course of their study "the proportion of films made by individuals from the A-list has never been more than a third of the total films produced and distributed" (Ganti 2012:27). Such peculiarly lopsided case selections in studies of cinema and film culture push from view the prevalence of flop films featuring B actors, failing equipment in studios and theaters, plagiarizing scriptwriters, or frayed third-run movies spliced beyond recognition running in dilapidated tin-roofed rural cinema halls. It is these segments of film culture that I study as they become the focus of moral panics and the vociferous accusation of obscenity.

OBSCENITY IN BENGAL

Studies of obscenity in South Asia have shown how the formulation of the notion of obscenity along lines of class, gender, and race was set into motion by the processes of social transformation produced by imperial rule and colonial modernity (Ghosh 2006; Gupta 2001). In the course of the nineteenth century, alongside the development of a middle class in colonial Bengal, the meaning of *oshlilota* (obscenity) shifted from indicating lack of respectability and prosperity to including new notions of indecency (Banerjee 1987).[4] Banerjee shows how reform movements within colonial bourgeois society led exuberant sexuality, passionate religiosity, and popular humor to be rejected as *oshlil* (Banerjee 1987) and gave rise to new domains of public cultural production considered obscene (Gupta 2001; Mamoon 2001).

The private domains of the family, the body, and language were important zones of contest in the reform movements in colonial Bengal, where a newly emancipated nation was imagined in opposition to British colonial portrayals of Indian society (Chatterjee 1993; Collingham 2001). Although the main thrust of these reforms was the outcome of

competition between men within the colony, "the politics of colonial masculinity also licensed a new public role for women, albeit only within the confines of a reconfigured imperial patriarchy" (Sinha 1995:54). This new public role ensured increased scrutiny of female bodily comportment, dress, and mobility and constituted "a serious attempt to think through what an 'appropriate reformed female' subjectivity, coded as bhadromohila [gentle lady], should be, and how that should be projected as a visual-moral sign" (Bannerjee 1995:75). The modern gentle lady was expected to venture outward attired in new forms of dress specifically produced to maintain her grace and respectability in public (see Souza 2004).

The concerns with *purdah* and propriety were shared among elite women of Bengal from different communities in this period of reform (Sarkar 2008). Sonia Nishat Amin has shown similar debates among Muslim *bhodro* women and suggests "there was considerable reciprocity between Calcutta and the mofussil towns" (Amin 1995:392). Among the nascent Muslim middle class in Bengal in the beginning of the twentieth century "the dismantling of seclusion was accompanied by repeated cautioning which urged women not to lose their sense of 'shame' or 'modesty.' Male-female segregation was transformed from a central spatial division of society to an 'inner' feeling; a 'bodily' feeling which was quintessentially feminine. A re-defined sense of shame redrew boundaries around sexual propriety and sexual conduct considered appropriate for a woman belonging to the respectable class" (Ahmed 1999:116–17). Female comportment as a sign of propriety and civility came into being at the interface between colonial modernity, class distinction, notions of civility, *bhodrota*, religious ideals, and reform in all communities and the attempts toward negotiating the position of women.

Contemporary notions of propriety in Bangladesh continue to draw on this complex heritage. In her discussion of Islamic novels in Bangladesh, Maimuna Huq suggests that "instead of relying on Islam for legitimising a particular social value . . . contemporary Islamic novelists draw on the authority of popular notions of 'cultural decency'" (Huq 1999:155). These notions are made up of overlapping categories of Islamic values and "popular Bengali cultural ideology" (Huq 1999:155). Willem van Schendel describes the Bengali "moral universe" at length: "Islamic, upper-caste Hindu and Victorian English norms of propriety have combined to prescribe a strict dressing code among Bengali. . . . The invisibility of the female body is an important marker of status and propriety among most Bengali, and a woman showing too much of her body is easily reputed to be loose or mad.

In the Bengali moral universe, public nudity can only be a sign of loose morals, extreme poverty, insanity or primitivity" (2002a:359).

The notion of propriety in contemporary Bangladesh is amalgamated from Islamic, Victorian, and Bengali notions, and the main object of this cultural ideology is the comportment of the female body. The inappropriate display of the female body, therefore, not only indicts "loose" or "mad" women but indexes the fraying of the moral fabric of society itself. It becomes the barometer by which to assess the state of society.

The controversy over the obscene cut-pieces indicates the anxieties about changing social relations, cultural forms, and media landscapes. It is not in any simple way an effect of the Islamic traditions of Bangladesh. Studies about the cinema in Muslim-majority societies often postulate at the outset a necessary ambivalence in the relationship between Islam and cinema, especially in the representation of women (Dönmez-Colin 2004; Mir-Hossaeini 2007; Moore 2005). These ambivalences would explain why cut-piece films are denounced as obscene in Muslim-majority societies such as Bangladesh. While religion can provide one of the vocabularies to discuss issues of morality and public decency, in Bangladesh the cut-piece films are generally described as *oshlil*, vulgar, and obscene, an affront to decency. Further, as Joya Chatterji has argued, Islam in Bengal cannot be understood with reference to "a particular understanding of 'Islam' as a pure, transcendent idea, the 'essentials' of which are indisputable" (Chatterji 1996:16). In contemporary Bangladesh the nature of its supposed "Islamisation" (Banu 1992; Lintner 2002; Shehabuddin 2008) has therefore to be understood from within the distinct history of Bangladesh's independence and the subsequent construction of Islam in the public realm. Especially for the middle class in contemporary Bangladesh, the history of the breakup of Pakistan has been used to gloss ardent forms of Islamic religiosity as fundamentally other to the middle-class self. Manosh Chowdhury argues that the othering of fundamentalism (*moulobad*) functions as "technologies of comforting a middle class self—of reducing the sense of social insecurity into a discrete category that has been 'alien,' and as a matter of fact 'other' to the construction of [a] 'cultured self'" (Chowdhury 2006:3). In contemporary Bangladesh, obscenity thus occupies an equivalent position to fundamentalism, not its natural opposite. Both come to act as registers against which a cultured and respectable middle-class self is articulated. The heaving chests of the action heroine and the inevitable beard of the "fundamentalist" both index threats to the social order and cultural sophistication.

THE CUT-PIECE: FETISH, VISIBILITY
AND THE PERVERTED OTHER

When deployed within the context of Bangladeshi cinema, the notion of obscenity produces the idea of a "golden age" of film, destroyed by the entry of the uneducated, the perverted, and the greedy. In public discourse obscene (*oshlil*) filmmakers are set off against "healthy" (*shushthodhara*) directors and films. The adjective *shushthodhara* creates a league of wholesome films and makers (Mamun 2005) who hold up a healthy society threatened by those who pervert it. The social antagonisms that underlie the transformation of society and the film industry (such as the nature of the 1971 independence, class competition, urban-rural antagonisms, and gendered conflicts over labor discussed below) are disavowed through the postulation of obscenity as the disrupting, perverse factor in society and in the film industry. The cut-pieces are a crucial peg in this fantasy scenario. They continually bring to the fore this legion of perverted Others, both within their material existence (cut-pieces as objects made by obscene filmmakers, dodging censorship) and within their imagery (of corrupt politicians and lecherous college girls). The cut-piece fascinates with an image of the Other, thwarting the rightful pleasures of a wholesome society.[5] In this, cut-pieces are one of a number of fetish images that dominate Bangladeshi public life, from the continuous speculation about the murders of political figures (Mohaiemen 2006), the specter of the raped woman (Mookherjee 2008), or the figure of the tribal (Bal 2007).

Moral panics perpetually invoke, up to the point of the lurid, such images of the fantastic Other (Cohen 1980; Critcher 2003; Hall et al. 1979). They generate a desire to see, to look into the supposed "heart of darkness" of the Other. Like the array of texts produced in eighteenth-century Europe that pretended to unveil and penetrate the true life of the Islamic world that Alain Grosrichard argues should be read as an attempt to address the anxieties about European culture and society at that time (1998), social antagonisms and anxieties are waylaid by fantasy formations circulating in public culture. The pornographic is one of the registers in which this operation takes place, directing the gaze onto the sexuality of inscrutable others (Hunt 1993; Pease 2000:7).

Such a view is never uninterrupted but moves between looking and averting the eyes. Linda Williams discerns a persistent "dialectic between revelation and concealment that operates at any given moment in the history of moving-image sex" (2008:7). Writing about the struggle of Indian art historians with erotic temple sculpture and sensual paintings Tapati

Guha-Thakurta describes how such imagery was "dismissed by the first Western experts in the field as debased or grossly indecent [and] they long inhabited a nether zone of voyeurism and disavowal, where scholars both looked and looked away" (2004:255). Netherworlds of bashful scholars that glimpse and avert their gaze, who see but refrain from making visible, and who desire to look but must close their eyes, illustrate the way obscenity works (see also Arondekar 2009). The nether zone of voyeurism and disavowal and the dialectic between revelation and concealment suggest the oscillation between the visible and the invisible that I take to be crucial to obscenity.

Erotic sculpture and painting could come into full view at the moment when imagery that appealed to the senses was transformed into objects of contemplation (Guha-Thakurta 2004; see also Pinney 2004). Similarly, in modernist literature the pornographic is "aestheticized through a contextualisation that works to objectify and distance its appeal to the senses" (Pease 2000:35). In this case "the representation of the sexual is legitimated through *the assertion of form* which holds off the collapse into the pornographic" (Pease 2000:36; emphasis added). Public representation of sexuality stops being obscene, therefore, when its appeal to the senses is assuaged through aesthetic conventions and harnessed to projects of uplift, such as art, health, or education. It would be inaccurate to say that pornographic descriptions in such contexts no longer address the senses. Rather, it is "*the assertion of form*" that provides the parameters within which one is stirred. As a prominent member of the Bangladesh Film Censor Board told me on more than one occasion, the display of Kate Winslet's breasts in the film *Titanic* was not obscene because the film was "artistically made."

Rather than content, it is formal and contextual qualities that make the obscene image. This is, of course, fetishism proper: the value of a thing is not intrinsic to it but is determined by the social relations that produce, and are hidden in, its particular form. Žižek argues that in the analyses of fetishism by Marx and Freud "the 'secret' to be unveiled through analysis is not the content hidden by the form (the form of commodities, the form of dreams) but, on the contrary, *the 'secret' of this form itself*" (1989:11, emphasis in original). The fetish hides the alienation of the social relations that have given rise to it by allowing an affective response to its *form* by its beholders, encouraging them to identify their desires with the fetish. The obscene qualities of the cut-pieces are their detachable celluloid form, their capacity to move and their aesthetic conventions.[6] Neither belonging to the narrative of the film nor being completely separate from it, neither integrally part of the film reels shown nor completely detached from

them, the cut-pieces are "matter out of place" (Douglas 2002:50). This disconcerting form of the cut-piece ensures its disrepute and allows for its power to arouse. Sanjay Srivastava has noted a similar effect in what he calls "footpath pornography" in India. He asks of the blurry and cheaply printed images: "Is it possible to rethink the relationship between the image and the audience in this context such that the felicity of the image depends not at all upon the idea of visuality? . . . It is in this very 'poor quality-ness' that its appeal lies" (Srivastava 2007:182). The ragged edges of footpath porn and the oscillating presence and absence of cut-pieces of low production value produce desire and interest exactly through their fraying imagery and disappearing celluloid. Once in the form of a cut-piece, even Kate Winslet's breasts could become obscene.

Cut-pieces emerge in the manner of an asyndeton, a style of expression in which conjunctions are left out. Rather than suture narratives and clauses, the asyndeton "cuts out; it undoes continuity and undercuts plausibility" (de Certeau 1988:101). The extemporaneous nature of the asyndeton can be discerned in the experimental and impromptu quality of the cut-piece. It illustrates Christopher Pinney's insight that "images are not simply, always, a reflection of something happening elsewhere. They are part of an aesthetic, figural domain that can constitute history, and they exist in a temporality that is not necessarily co-terminous with the more conventional political temporalities" (2004:8). Images operate in the interstice between the reality of the world and our experience of it (Buck-Morss 2004:10), "an experimental zone where new possibilities and new identities are forged" (Pinney 2005:265). Even "cultural artefacts that have been dismissed as ephemeral trash can be historically constitutive" (Ramaswamy 2010:xv). As material objects and imagery, appearing in disjointed and ad hoc manners, the cut-pieces produce an account of their own.

The account provided by the cut-piece is tentatively offered, quickly withdrawn. It makes it a peculiar subset of the media, a particular mode of mediation. Following Samuel Weber, I define a *medium* as a technology of reproduction that makes an absent object present as representation (1996). The absent object can be anything; it may be well defined and already clearly imagined, or it may be ideas and identities in suspension. As a process of mediation, the cut-pieces draw "structures of feeling" (Williams 1977:132–33) into temporary tangibility; they are emerging "aesthetic formations" (Meyer 2009:6) made momentarily present. Flitting in and out of view, they are partial utterances, gestures to other worlds and selves. They speak in ellipses, and in the idiom of sex, about collective fantasies, anxieties, hopes, and possible futures.

"ACROSS THE FRINGE": POLITICAL AESTHETICS AND CINEMA IN BANGLADESH

In the 1977 film "Across the Fringe" (*Shimana periye*, Alamgir Kabir) the actors Joyshree Kabir and Bulbul Ahmed are stranded on a desert island after a cyclone. Joyshree's character is a wealthy and educated urban woman at the beginning of a successful acting career on the Dhaka stage. Bulbul plays a poor boatman working the rivers surrounding the woman's family estate. During their long separation from the outside world they

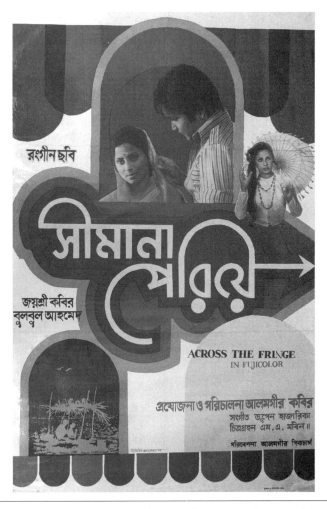

FIGURE I.2 Poster for *Shimana periye* ("Across the Fringe," Alamgir Kabir, 1977).
PHOTO BY PAUL JAMES GOMES.

make a life together, living off the bounty of the island. While Bulbul's character educates Joyshree about agriculture, Joyshree's spare time is spent on teaching Bulbul how to speak "properly" and to recite poetry by Rabindranath Tagore. Toward the end of the movie they rejoin society as a capable wife, cleansed of Western fads and landed patriarchal demands, and an upright husband, transformed through the newly acquired cultural knowledge of middle-class Bengaliness. "Across the Fringe" can be read as Alamgir Kabir's programmatic social and aesthetic project for Bangladeshi cinema and society. Central in this project is an aesthetic transformation signaled by the appropriate poetic resources.

Cinema is one of the means by which forms and aesthetic conventions are crafted for the cultural project that is the nation (Anderson 1990; Chatterjee 2002; Virdi 2003). Not long after the 1947 inauguration of Pakistan as a homeland for Indian Muslims, a movement began for the cultural specificity of the east wing of the Pakistani union. The homogenizing cultural policies initiated by the Pakistani political elite "alienated the Bengali intelligentsia, the professionals, the students—in other words, the newly mobilized groups in the east wing" (Jahan 2001:38). While this "vernacular elite's" political and economic interests grounded the political opposition and the movement for regional autonomy, "its mass appeal and group coherence was supplied by the language movement" (Jahan 2001:43). Against the vision of a united Muslim homeland, this vernacular elite invoked a cultural nation that was not un-Islamic but whose main affective response relied on references to the Bengali language and its culture. In its revolutionary and avowedly forward-looking forms, the project of the vernacular elite and its intellectual and student vanguards was a quintessentially modernist aesthetic project. After independence the aesthetic project hurtled to the heart of the nation because it was "in cultural terms that the nation had figured its identity" (Samaddar 2002:112).

The aesthetic project of the vernacular elite had found its cinematic form in the film "The Face and the Mask" (*Mukh-o-Mukhosh*, Abdul Jabbar Khan, 1956). Arriving in the wake of the language movement, put together by Dhaka-based theater activists, and supposedly inspired by the suggestion by a local film distributor that "even East Bengal's weather was unsuitable for film-making" (Kabir 1979:22), it became the ideal starting point for a nationalist imagination (Hayat 1987:42–55). In 1958 the East Pakistan Film Development Corporation (EPFDC), or "Dacca Studio," opened (Hayat 1987:58). The fledgling institution attracted cultural activists and artists

(Kabir 1979): "As the first [EP]FDC floor was being built [Nazir Ahmed, the corporation's first operative director] decided to make it available only for those who had some filmic background from Calcutta in whatever capacity. . . . As a result the nucleus of East Bengal's film industry, the [EP]FDC, was soon filled with people of Calcutta 'background' whose calibres ranged from that of [the famed film director] Fateh Lohani to errand boys" (Kabir 1979:25).

Besides personnel, Calcutta remained an important source of notions of cultured "Bengaliness" and film ideas. The cinema emerged as an artistic endeavor and a tool for the production of a national modernity for the Bengali middle class in East Pakistan (Raju 2002). No wonder the East Pakistani Bengali cinema initially struggled to find its audience as it competed with Hindi, Urdu, and West-Bengali films (Qader 1993:404). But then the 1965 India-Pakistan war closed Pakistan's cinema halls for foreign films. In combination with growing Bengali nationalist sentiments and the discovery of the profitable formula of folk films (Hayat 1987; Kabir 1969), it gave East Pakistani Bengali films a boost, and production took off.

While "Bangladesh is much more than a 'bourgeois project,' the outcome of middle-class movements" (Van Schendel 2002b:75), in terms of the emerging national aesthetic, much energy was expended on confining a broad spectrum of cultural possibilities exactly to this bourgeois project. Political aesthetic forms emerging from the 1952 language movement and the Liberation War have become hegemonic in the sense that this "particular content assumes, in a certain context, the function of an absent fullness" (Laclau 2006:145). The affective qualities of these forms are derived from the fine arts, nationalized folklore, and literature (Chakrabarty 1999:31; Samaddar 2002). Van Schendel calls this the "vernacular cultural model, a mix of the refinement embodied in the colonial gentlefolk (bhodrolok) and popular Bengali ways" (2009:152). The aesthetics of this model function as effective political signifiers and have come to be inscribed as sophisticated, civil, educated, urbane, and progressive and are associated with the bhodrolok of independent Bangladesh.

The term bhodrolok, while extensively discussed in terms of the emergence of a Hindu elite in colonial Bengal (Bhattacharya 2005; McGuire 1983; Mukherjee 1970), has been debated less in terms of its use and referents in independent Pakistan and Bangladesh. It can be traced to the emergence of a Bengali Muslim middle class in colonial Bengal (Ahmed 1999; Amin 1995; Gupta 2009; Sarkar 2008). Van Schendel (2009:152), Jahan (2001), and Kabeer (1991) note that after 1947, East Pakistan's bhodrolok

emerges when a Bengali "vernacular elite" (Jahan 2001:29) "chose . . . to emphasize the common bhadrolok ('respectable classes') values and aspirations which informed the middle-class way of life for Bengalis" (Kabeer 1991:40). Sophisticated, steeped in the arts and Bengali folklore, this *bhodrolok* cultural formation emerged in the context of political conflict among elites in East Pakistan and became hegemonic in independent Bangladesh. More than an objective description of one's social standing, it indicates a horizon of social and cultural aspiration and provides a register through which to articulate or recognize one's cultural worth.

"The Face and the Mask" and "Across the Fringe" enclose two decades during which cinema functioned to install sanitized cultural forms and *bhodro* (respectable) styles at the heart of the national project. The displacement of the ideal respectable family and folkloristic notions of rural Bengal from the film screens parallels the progressively problematic position of these ideals at the center of cultural-political life. Within a few years of Bangladesh's independence, the vision that had inspired it gave way to disillusionment as the Awami League government failed to bring stability to the country (Maniruzzaman 2003; Ziring 1994). More than two decades of military rule followed. The return to parliamentary democracy in 1990 inaugurated an ongoing political standoff between the two major parties, the Awami League and the BNP (Bangladesh Nationalist Party). The action films that have emerged since the early 1980s participate in this changed social and political terrain. A film such as *Mintu the Murderer*, with its vote rigging, slumlords, and eloping college students, is both a product and particular cinematic account of these transformations. Four of these changes are particularly relevant to understand the emergence of the obscene action film in Bangladesh.

First, the nationalization of major Bangladeshi industries and the generous rural subsidies instituted by the Awami League regime were reversed. The private sector, export production, foreign-aid income, and agricultural privatization were promoted (Feldman 2002:229n15), with the 1982 New Industrial Policy (NIP) carrying the World Bank trademarks of structural adjustment (Siddiqi 2000:L-12). These pushed many members of middling peasant households into a newly forming urban industrial working class (Feldman 2002) and allowed an industrial elite to emerge (Kochanek 2002). It transformed and rapidly expanded the major cities, especially Dhaka and Chittagong. Burgeoning slums accompanied heavy investment in real estate speculation and construction (Kochanek 2002:154). The bougainvillea-clad walls enclosing the gardens of East

Pakistan's regional capital gave way to walls of high-rises separated by slums in the new capital of Bangladesh.

Second, the economic policies had a major impact on the position of women. A significant segment of foreign aid was earmarked for the mobilization of women for work and awareness. Additionally, the rapid growth of the apparel industry manufacturing garments for export relied largely on female workers, integrating them as flexible and cheap labor into the global economy (Kabeer 2000; Siddiqi 2000). A considerable part of the new Bangladeshi working class consisted of female labor derived from struggling rural households (Feldman 1993:222, 1991), now markedly present in the public spaces of Bangladeshi cities. For middle-class and elite families female education rapidly increased, and "as middle class patriarchies reluctantly bowed to the exigencies of inflation-induced income erosion" (Abdullah 2002:138), they, too, became a visible presence in many places of work. The increased prominence of women in public life and places of work has led to male discontent over male unemployment and the loss of control over female labor (Feldman 2002; Riaz 2005; Siddiqi 2000).This has also encouraged a disgruntled part of the rural establishment to stage its battle for scarce resources through the politics of *fatwas* and Islamicization drives (Feldman 2002:220; Rashiduzzaman 1994; Shehabuddin 1999).

Third, the vision of a peaceful and just society that animated the liberation struggle gave way to an increasing sense of a beleaguered public realm. The confrontational politics of preindependence East Bengal and East Pakistan did not dissipate once Bangladesh was formed. Economic and political unrest, including general strikes, violent student politics, and public disobedience in the face of violent state repression, have remained fixtures of Bangladesh's political life (Maniruzzaman 2003:156). Afsan Chowdhury notes that "the period from 1982 to 1990 is considered the grand era of political resistance in the young country that is Bangladesh. During this period the culture of street agitation, fuelled by young rebels, was polished to a shine" (2007). Democratization has not led to a fundamental transformation of the culture of the political elite or the streets. A blinding focus on party politics significantly weakened the independence of the judiciary, as well as the effective functioning of the parliament, and has complicated access to state services by citizens. Meanwhile, unresolved ideological conflicts and struggles over resources have generated extraparliamentary political struggle and violence, especially in the countryside. Against the utopian vision of a free Bangladesh

a general perception of lawlessness emerged, enhanced by extrajudicial killings, police inefficiency, and spectacular crimes.

Fourth, the political and social transformations in Bangladesh have encouraged "new voices . . . seeking participation in a democratic political system" (Jahan 2002:30). Such new voices and ideological positions have come with new political forms. Energizing new communities and commitments, the emergent political aesthetic in Bangladesh includes images of women at prayer (Feldman 2002:231), lifestyle suggestions made in Islamic novels (Huq 1999), images from the popular resistance movement in Phulbari (Chowdhury 2012), and the iconizing of public figures like Nur Hossain (Van Schendel 2009:198) but also the less clearly articulated forms of Djuice youth events or the mass mourning of film stars (Ahmed 2008). Lewis discerns the expansion of a new middle class, which is "often far less wedded to the secular Bengali nationalist tradition" and whose "values signalled a rejection of the refined Kolkata *bhadralok* tradition" (2011:16). These emerging political registers carry different affective resonances from more established political forms.

The waning of the *bhodro* aesthetic project in the 1980s and 1990s is regretted in the contemporary lament over cinematic obscenity. In an editorial for the daily *New Age*, Syed Badrul Ahsan, the cinema commentator for that newspaper, summarizes this attitude succinctly (2005): "There once was a rather large canvas where Bangladesh's movie industry shone in the interplay of light and shadow. Indeed, when you reflect on the state of the nation's film industry, you essentially hark back to a past the glory of which appears to have eluded the present. It is the era of black and white, one that is past, which keeps us in thrall. Ask any movie buff. And the chances are that he will tell you that movies made in the 1960s and till the mid-1970s were perhaps the best that this nation has had to offer."

But these times are no more: "It is going to be a long haul for Bangladesh's film industry if it means to claim a spot for itself in the global environment. . . . All you are then in need of is a coming together of enlightened, culture-oriented, politically conscious men and women in the film industry. These will be the people who will counter the sordid activities of those who have always believed that a bearing of cleavages, a demonstration of ugly sexuality and an employment of stereotyped dialogues are the engine that makes a movie run" (ibid.).

In a nutshell this is the problem with contemporary Bangladeshi cinema as identified by self-acclaimed "film buffs" and journalists of the

upmarket dailies. While Ahsan's punch line is a rejection of "vile" individuals with sexual perversions, what comes through most forcefully is the regret that "enlightened, culture-oriented, politically conscious" people are no longer at the helm of the industry. Moral disdain, claims of obscenity, and notions of incivility form a well-established discursive framework in Bengal through which to address political, economic, and social changes and conflicts. Such registers were in use during colonial

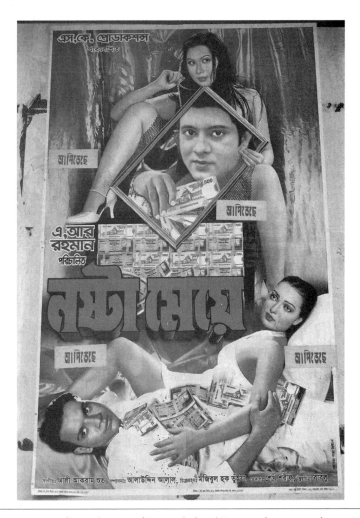

FIGURE I.3 Poster for *Noshta meye* ("Despoiled Girl," A. R. Rahman, 2005).

PHOTO BY PAUL JAMES GOMES.

times (Ghosh 2000) and continue to provide the vocabulary to address contemporary conflicts (Kochanek 2000; Mohaiemen 2006:302). While expressed in terms of obscenity, at the heart of the scandal of contemporary cinema lies the disappearance of the urban intelligentsia from the film industry. The loss that marks Ahsan's writing should be read in the context of a larger melancholic state that grips the Bangladeshi upper middle class in the face of a loss of control over the political project, what Nayanika Mookherjee succinctly terms the "pathos-ridden interrogation of the political trajectory of Bangladesh" (2007:283). Ahsan laments the inevitable failure of translating the program of "Across the Fringe" to the entire nation. In its place has arrived "Despoiled Girl." How did this come to pass?

THE BANGLADESH FILM INDUSTRY AND THE *MOFUSSIL*

In his seminal book *Bangladesher chalachitra shipla* (The cinema of Bangladesh), Mirza Tarequl Qader identifies the 1983 introduction of the capacity tax on cinema halls as the true watershed for Bangladeshi cinema (1993:414). He shows in painstaking detail how the introduction of the capacity tax ensured a rise in profits for film exhibitors since taxation was delinked from the sale of individual tickets. Instead, it became a flat rate depending on a cinema hall's capacity and location, with additional taxation on amenities such as air-conditioning (1993:412). This encouraged a boom in the building of cinema halls (often with few taxable amenities), and 350 new cinema halls were built in the five years between 1983 and 1988, doubling the number of theaters. Compared to 50 percent taxation in urban areas, rural cinema halls paid only 5 percent tax and "due to its profitability, film distribution spread to the *mofussil*" (Qader 1993:414). When selling more tickets did not incur higher tax, "some hall owners used innovative measures to attract the audience" (1993:404), including what Qader describes as "half-pornography" and erotic advertisements. In the same period import duties on television sets were relaxed (Wahid 2007:76), making TV accessible to more people. VHS and later DVDs, VCDs, and satellite television channels (many of which carried foreign content) constituted growing competition for the celluloid industry, which remained protected through bans on foreign cinema in the theaters. Those who could afford to watch films in their homes, especially middle-class women, progressively disappeared from the cinema halls. Instead, a largely rural, overwhelmingly male, and mostly working-class

audience came to watch films in cinema halls. The presence of this audience in the many unembellished rural cinema halls, watching FDC produced films often containing erotic imagery, forms a major component of the rejection of the cinema as obscene and its aesthetics as uncivil.

Alongside the changes in cinema halls in the 1980s, the films screened there were also subject to significant transformation.[7] Markedly declining production values accompanied the emergence of action films as a prominent genre in the FDC studios, coinciding with the consolidation of the genre elsewhere in South Asia (Vasudevan 2004a). In the context of new forms of competition from global media flows, but with continuing state protection of the cinema halls, many film producers in Dhaka have avoided investing in high production values, original stories, or big stars. Instead, they have made cheap films produced with tight production schedules, low production values, stock footage, minimal editing, and simple camera work. For extra selling power cut-pieces may be added to such films. This makes the Bangladeshi cut-piece film a sibling of American exploitation films. Quickly made features requiring little investment, relying completely on the "exploitation" of certain controversial topics and imagery to sell, exploitation films "center on some form of forbidden spectacle that serves as their organizing sensibility—at the expense of others" (Schaefer 1999:5). Just as classical exploitation cinema in the United States was fostered by the consolidation of Hollywood, similarly, the cut-piece films in Bangladesh have arisen in the context of what Ashish Rajadhyaksha identifies as the emergence of "the Bollywood culture industry" (2003:29). The auxiliary industries of "Bollywood," from websites to soft drink advertisements, reach deeply into Bangladesh. Here Bollywood finds an audience in private homes and tea stalls, while Indian films remain banned from the Bangladeshi cinema halls. Bangladeshi romance movies are rarely able to compete with the Bollywood movies screened on satellite TV and available on compact discs. Every year only a handful of big-budget Bangladeshi romance films are made, and only a few of them make a profit. For most producers cheap action films with the promise of cut-pieces have become the only sound investment.

Simultaneous with this shift to action film, art or parallel cinema (known in Bangladesh as "short" film) has come into its own, at a significant remove from the FDC studio establishment. This development began in the late 1970s, when courses in filmmaking were first offered in Bangladesh, including Alamgir Kabir's film appreciation courses at the Bangladesh Film Archive (Mahmud 1991). Kabir's desire for a "pure"

cinema for Bangladesh was inspired by the great Bengali filmmakers, Italian neorealism, and the French New Wave. His legacy has continued to inspire a modernist and realist style in Bangladeshi art cinema. Film appreciation courses encouraged new ways of seeing, antithetical to the vision presented in popular films. Alamgir Kabir referred to popular cinema as "camera-theatre" and explained its appeal in terms of the translation of village theater forms to the cinema (Kabir 1979:70).[8] His courses actively weaned students away from such modes of viewing and seeing. In the mid-1980s the first generation of film appreciation course filmmakers took up 16mm film (occasioning the term *short film*) to make their features (Rahman 1999). As in the French New Wave, this cheaper and versatile format not only enabled young filmmakers to shoot on celluloid with small crews and without major investment but also allowed them to work independently of the FDC. Working at the FDC required large crews, significant investment, and direct engagement with the state bureaucracy. Few cinema halls would run 16mm film, however, so the consumption of these films moved away from the cinema halls. Art films inherited a concern with realism, were delinked from the state bureaucracy of the FDC, rarely screened at cinema halls, and became associated with cultural institutions, including the Goethe Institute. The subsequent availability of video cameras has exacerbated these trends. Continuing state assistance to the FDC did not encourage a popular cinema to arise that uses video formats, as it has done elsewhere (Krings 2005; Meyer 2004), even though (digital) video is omnipresent in documentary genres, advertising, and telefilms in Bangladesh. Here, government policy significantly influences the media landscape, and "cheap" new technologies are not necessarily so cheap as to reach these marginalized groups (pace Ginsburg 1993; and Shohat 1997).

Popular cinema has remained located in the FDC production context, and its melodramas and action films are screened in the expanding *mofussil* cinema halls. The FDC has come to house filmmakers marginalized from newly emerging spaces of artistic expression, leisure, and funding such as cineplexes, private galleries, television stations, and advertisement companies that focus on digital film formats in production and exhibition. Media formats thus progressively map onto class and aesthetic values, so that television and telefilm have become *bhodro* pursuits while celluloid and VCDs have become associated with the *mofussil*, where its audiences, theaters and VCD parlors are located.

More than a location, the *mofussil* is also a frame of reference, in the metaphoric sense of "provinciality," by which the films and the politics of its addressees have come to be understood. To borrow a term from the streets of Dhaka, the backward, uneducated, and gauche forms of the cinema are *mofo*. An abbreviation of *mofussil*, the term *mofo* is used by young Dhakaites to describe their peers from countryside towns. The term *mofussil* describes rural hinterlands and is in Bangladesh associated with backwardness, incivility (*oshobhota*), and a lack of education (*oshik-khito*), an unsettling provinciality (see Cohen 2007). The *mofo* is loosely related to *bhodro* as a separate but related register through which aesthetic forms, discursive positions, aspirations, and practices can be made meaningful in terms of existing hierarchies of value. The term *mofo* is a contemporary expression rehearsing older forms of objection against rural East Bengali forms, including the idea of the "Bangal" (Chakrabarty 1996a). Contemporary *mofussil* forms, such as action films, are the most recent installment of a longer history of the vibrancy of the mofussil hinterland to the making of cosmopolitan cultures in Bengal (Ali 2010; Van Schendel 2009). In the "*mofussil* metropolis" that is Dhaka, those associated with the mofussil and gauche outside of urban sophistication have come to claim and inhabit formerly bourgeois or *bhodro* categories of urban and aesthetic competence (Hoek 2012). This includes the film industry, where in 2005 the filmmaker Shahadat Ali Shiplu made *Mintu the Murderer*.

MINTU THE MURDERER: A FILM IN SIX CHAPTERS

The first time I met Shahadat Ali Shiplu he sat on a low stool surrounded by plastic roses. Small beads of sweat adorned his forehead. Black and white lino on the studio floor suggested a long-lost time of marble splendor in rural Bengal. Shiplu leaned in toward the large fan cooling his star cast. A calm and withdrawn man, he explained the next scene in brief sentences. Meanwhile, the crew repositioned the heavy lights that heated up the small set. Shiplu arranged the sari of the doe-eyed actress as she lay on the bed. Taking up his position beside the camera, Shiplu looked upward briefly and closed his eyes. He was a pious man of set ways, and short prayers preceded many of his actions. As he opened his eyes, he called: "Take!" The cameras rolled and the Vaseline in the actress's eyes promptly produced the tears she now shed.

After my first meeting with Shiplu, I tried to keep up with his hectic filmmaking schedule. I started my ethnographic fieldwork alongside him and his crew when they started work on a new film in early 2005. This film became *Mintu the Murderer*. My fieldwork was organized around the development of *Mintu the Murderer*, so my principal locale was the Bangladesh Film Development Corporation in Dhaka, supplemented with research at the other cinematic institutions that *Mintu the Murderer* passed through, including the Bangladesh Film Censor Board. On the occasion of Eid-ul-Fitr 2005 the film was released. I followed some of its twenty copies around the country for the short six weeks the film was in circulation, before it was seized from the cinema halls and banned in December 2005.

The study of the cut-piece required at times creative use of the anthropologist's methodological tool kit. In his ethnography of the public secret Michael Taussig has noted how "the public secret parodies and subverts our most cherished tools and categories of thought recruited for the pursuit of truth and unmasking of appearance. Observer melts into the observed in confusing ways, subject and object keep changing place in unpredictable rhythms" (1999:104). This switching and fusing befell me as I, too, was sucked into the logic of the cut-piece. I realized that at times looking away was the most effective way of seeing. Initially, this participant nonobservation was frustrating yet tantalizing. It took me a while to realize that this inability to ever fully see *Mintu the Murderer* was exactly the mechanism that made the elusive cut-pieces so magnetic and that I was not the only one trying to see. My vision could never be complete; I would always be taunted by the promise of new horizons of revelation. This was the power of the cut-piece and is integral to the pleasure of cinema.

Through these taunts of hidden visions I realized that in the highly sexualized and patriarchal environment of the FDC, cinema halls, and shooting spots, sight was predicated on relations and friendships informed by gender, age, race, class, and religion. My whiteness, my middle-class background, and my status as a student forcefully allowed me access but occluded my vision as well. Especially the producer of *Mintu the Murderer* perceived me as a threat: never mind anthropology; what if I was, in fact, a journalist? His money was on the line, and he was not going to take the risk. Consequently, I was not in control of my research. As Linda Williams suggests of "screening sex": "this story is never a matter of a teleological progression toward a final, clear view

of 'it,' as if it preexisted and only needed to be laid bare" (2008:2). Like many others within the industry, I was never really out of the game of trying to see, of revealing and exposing, of being tempted to see, of finding temporary satisfaction in seeing and in sharing the moments of insight with those who also tried to view. The cinema ultimately is a mechanism for visibility. As long as the industry remains within my field of vision, I will be interpellated by it. This book cannot but reproduce some of those mechanisms. In many ways it is a work of academic exploitation. I, too, promise to lift the veil from other people's secrets, exposing them in certain places, withholding them in others. This is the dirty work of anthropology.

Each of the following chapters addresses chronologically a stage of the production and consumption of *Mintu the Murderer* and discusses the theoretical concerns brought out by the oscillation of visibility in that element of the film's life. The book is divided into two major sections: film production (scriptwriting, shooting, and acting; chapters 1, 2, and 3) and film consumption (defining and protecting the public, public discussion, audiences; chapters 4, 5, and 6).

Chapter 1 documents the scriptwriting process for the film that was then tentatively called "Top Secret." Drafted in a single afternoon and rewritten through many interventions, the script included the basic elements of the action genre. The negotiations and discussion over the development of the script were less focused on producing a cohesive and singular narrative, however, than on the production of a textual medium from which other things might emerge, such as illegal and unwritten sequences or affective dispositions within an imagined audience. The script was full of opacities that allowed it to become a cut-piece film. Chapter 2 asks how this script was translated into visuals and describes the cinematography of *Mintu the Murderer*'s cameraman Zainul. Describing the use of technology characteristic of FDC filmmaking, and its institutional and social frameworks, I argue that FDC films have a distinct audiovisual form that is rejected as vulgar. In chapter 3 I continue to investigate activities on the set by focusing on the actresses of *Mintu the Murderer*. It is through their bodies that the obscene is brought into view. In this chapter I use my ethnography to show how the actresses tapped into different regimes of visibility to position themselves within the filmmaking process. I suggest this is a form of *purdah*, the management of their visibility, presenting themselves for the gaze of others in formatted ways to-be-seen.

In chapter 4 I move from the internal workings of the industry to *Mintu the Murderer*'s encounter with the public, presenting an ethnography of the editing and censoring of the film. Positing that censorship and editing are mutual modes of montage, I suggest that the cutting in which the Censor Board indulged did not amount to a repression of obscene scenes or cut-pieces. Rather, preemptively cut from the reels, such material was moved by editors and censors between different realms of visibility, moving it away from the official spaces of censorship but not out of public view. In this way censorship regulations produced a mobile film form. Chapter 5 maps the public debate surrounding the film and its cast and crew. Through an analysis of the print media that engaged with *Mintu the Murderer*, I will show how the affective qualities of the notion of obscenity contaminated radically different forms of publications. Echoing across this field of print, each articulation necessarily invoked and reproduced other discussions of obscenity, drowning the crew and cast of *Mintu the Murderer* in its associations. Chapter 6 follows the film as it was finally released in the cinema halls outside of Dhaka during Eid 2005. I look at the film's projection and the actual audiences that *Mintu the Murderer* encountered as it made its way around the country. This chapter shows how the film consisted of "unstable celluloid," as the reels changed with inserts and excisions made while the film screened, producing different assemblages of the same film. Undermining ideas about the stability of film form, I show how the collective viewing of sexually explicit imagery can destabilize the operation of genre. As the film shifted its shape in the course of circulation and exhibition, the responses garnered from the audience were also transformed. Finally, my conclusion summarizes the cinematic forms and pleasures derived from the cut-piece and asks in what other sites the operation of the cut-piece may be encountered.

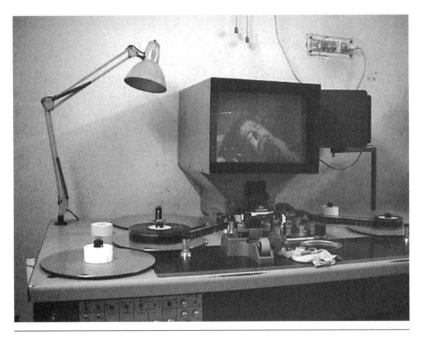

FIGURE 1.1

{1} WRITING GAPS

THE SCRIPT OF *MINTU THE MURDERER*

ONE MORNING in February 2005, I anxiously waited for a man whom I had never met. I had been asked to find the Abul Hotel, a rundown little place in Malibagh, next to a vacant lot where timber had formerly been sold. As I arrived, I gave the ubiquitous "missed call," letting the receiving mobile phone ring only once before hanging up. He now knew that I had arrived. Although I wouldn't recognize him, he would most definitely spot the single white woman lingering on the footpath. I looked around to decipher which man among the crowd walked toward me most purposefully. I tried to push aside the nagging misgiving that whispered I should not be in a neighborhood I didn't know, all on my own, awaiting a man I had never met, who would take me to meet a film director and scriptwriter known for their licentious productions. I wondered how wise I had been to laugh away the concerns of my self-appointed guardians, who had warned that my "state of mind" would suffer from being around such men. Before I could contemplate whether this had been a cautious euphemism, I heard my name. A short man of about thirty-five with a peculiar lisp introduced himself to me as Nazmul Islam, assistant director. Unmindful of the traffic, he traversed the busy intersection. He took me along a narrow alley. Squashed between a wholesaler in rice and a dying company, the alley led to the entrances of three apartment buildings dating from the 1980s. The last one belonged to scriptwriter Shahed Rony.

Climbing three flights of stairs, each decorated with an intricate pattern of intersecting stars, we arrived on a landing from which we could hear the sound of men's voices. Beyond the threshold with all the abandoned sandals, an animated discussion was taking place. As we entered, the small

room fell silent. At the far end of the room sat film director Shahadat Ali Shiplu, cross-legged on the plush red sofa. He motioned me to sit down next to him. After introducing me to the men gathered in the small room, he explained to them that I would stay with them for the coming months, to see how films are made in Bangladesh. He introduced me to Shahed Rony, the scriptwriter; Mohamadul Hasan Litu, the producer of the film; and Mohammad Nazmul Islam, the assistant director I had already met. The others in the room were there only for the social occasion. Rony, Litu, Nazmul, and Shiplu had come to work. Today they would think about the first lineup for Shiplu's new film. The lineup would consist of seventy to eighty scenes, each minimally described, and this would provide the backbone of the script that would be written over the next ten days.

This chapter explores scriptwriting practices for action cinema in the Bangladesh film industry. Here I describe how *Mintu the Murderer* came into existence as a script and introduce its key crew members: Shiplu, Rony, Nazmul, and Litu. Providing an account of the script's "entextual- ization," or "the process of rendering a given instance of discourse as a text, detachable from its local context" (Silverstein and Urban 1996:21), I will argue that the negotiations over the development of the script were less concerned with providing a cohesive and singular narrative than with creating a textual medium from which other things might emerge, including illegal and unwritten sequences, as well as affective disposi- tions within an imagined audience. This script was developed through quoting other texts, as "text is created when instance[s] of discourse . . . are made available for repetition or recreation in other contexts (Bar- ber 2007:22). I will show that scriptwriters "read" already existing texts or fragments of discourse (from other films and newspaper accounts to urban myths and collective fantasies) according to their potential for fulfilling three sets of conventions (genre, structure, and affective narra- tive strategies) that structure action scripts in predictable ways. But this script was not a finite object, as it was continually subjected to rewriting and functioned primarily because of its gaps and opacities rather than its concrete formation. This lack of stability expressed itself in the conflict between the scriptwriter and the film's producer. While the scriptwriter concerned himself with the story, the denotational text, the producer was mainly concerned with what was *not* on the page, the opacities and gaps that the script produced, that which would subsequently allow the inser- tion of other, unscripted scenes, images, and stories: hidden cut-pieces or accounts of the "true" nature of the city that could not be directly stated.

BRAINSTORM: JUICE AND GENRE

"The opening shot will be of a guy in half-pant!" announced Rony, the scriptwriter. In quick strokes he set out a story of a villain in shorts who rose from contract killer to district commissioner. The story involved rape, corruption, slaughter, pregnancy, and suicide. Rony talked fast, the story lines coming one after the other. The action would protect college girls against the killer and his henchmen. There would be conspiracy. In a climactic fight sequence the two parties would meet head-on. "The political party idea is good," interrupted Shiplu, "but the rest needs to be changed." Undeterred, Rony started again. He narrated a new story of two heroes fighting parallel battles. "I don't like it," said Litu, the producer of the film. "We've had that sort of story before." Rony sighed and went out for a break. It was hot inside; there had been no electricity all morning, and the small dark room with the heavy sofas was clammy.

When Rony returned, the brainstorming resumed. All of the men threw around film titles to find story lines or characters that could be used anew. They mentioned Bangladeshi films; Indian films in Hindi, Tamil, and Telugu; Hollywood films; and a few martial arts films from Hong Kong. Rony's most recent releases were praised and compared to other Bangladeshi films. *Bombay* (Mani Ratnam, 1995, India), *Kansas City* (Robert Altman, 1996, United States), *Bap Betar Lorai* ("Father Son Struggle," F. I. Manik, 2004, Bangladesh), and *Sleeping with the Enemy* (Joseph Ruben, 1991, United States) were mentioned in a continuous flow of possible plots and locations. Rony asked whether they had seen a film called *Blackmail* (Anil Devgan, 2005, India), with Indian film star Ajay Devgan in the lead. In it Devgan's children are kidnapped, and toward the end someone questions his love for his own children. "And then he gave this impassioned speech, with tears in his eyes," Rony exclaimed, "Sentiment!" Spurred on, Nazmul asked whether they had seen that film with Manna and Moushumi, two of the most famous Bangladesh film stars. "They killed the hero's wife," Nazmul exclaimed, "and she was nine months pregnant!" He shook his head in amazement.

When the electricity went off again, most of the hangers-on took leave of Rony and left me with the core team of Shiplu, Litu, Rony, and Nazmul. In the quiet generated by the load-shedding, I asked Shiplu to explain the process of scriptwriting to me. Although the brainstorming process was rapid and seemed largely associative to me, it was structured according to a clear logic. This logic combined three sets of conventions: generic requirement, well-established structural frameworks, and a clear sense

of what would appeal to the audience. Shiplu outlined these three sets of conventions for me. He first explained that there are four basic types of film in Bangladesh: social films, romantic films, action films, and folk films. These genre categories describe conventions of filmmaking, as well as audience expectations and their understanding of certain films, the "patterns/forms/styles/structures which transcend individual films, and which supervise both their construction by the film maker, and the reading by an audience" (Neale 2000:12). According to Shiplu, any film made in the country could be classified into these four categories. "I make romantic action movies," said Shiplu, "movies that focus on a love affair with an action plot." Romantic action and its sibling "social action" (which focuses on the violent resolution of a social conflict) were the two most prominent genres in 2005. Every genre came with a certain type of script, and Rony and Shiplu's sorting through story lines was founded on an understanding of these genres and the requirements of a romantic action film. They incorporated or rejected story lines or possible characters for the new film according to the genre conventions of the type of film they were making.

The basic requirements for a romantic action film were elaborated along a structured framework of scenes and sequences that formed the second convention for mainstream films made in Bangladesh. "A story will be divided into six song sequences, ten to twelve fight sequences, a few comedy scenes, and the rest drama," said Shiplu. This structure is conventional for all Bangladeshi popular cinema, transcending the genre divisions. The prevalence of these elements in popular cinema across South Asia has occasioned the term *masala film*, likening the blend of conventional ingredients to the blend of spices in a dish (Gopalan 2003:367). While such blending may suggest a dissolution of genres, Shiplu's framework for classifying films makes clear that despite these overlapping structural principles, the films were still clearly identified by filmmakers as separate genres.

Transcending the generic and structural requirements, there was an additional magic Shiplu hoped to add to the film. "A hit movie will combine three things," said Shiplu, "juice, sentiment, and the question of rich and poor." A successful romantic action movie would have to incorporate these three elements, and it is these that give mainstream Bangladeshi cinema, especially the exploitation genres, its identity and recognizability. First, juice, or *rosh*, was the term applied to a range of scenes that were sexually suggestive and exposed the female body in

varying degrees to the public gaze. This was the most distinctive element of romantic action movies and considered their most important commercial asset. Films and scenes were called "commercial" when they featured sexually explicit or suggestive imagery, mostly contained in cut-pieces. Romantic and social action movies sold on the basis of the rumor of the presence of such scenes, filled with "juice." The second element, sentiment, referred to melodrama, such as the murder of the pregnant woman in Nazmul's example. Sentiment was generally produced through an expulsion from an idealized village into the harsh environment of the city. This was given additional force by the third necessary ingredient of the hit film: the juxtaposition of rich and poor. This form of social antagonism structured the narratives of romantic action cinema. "Although Allah has made us all and we all have the same blood," explained Shiplu, "in this country there are two classes that do not mix: the rich and the poor." The plots of action films were thus also a class exposé, outlining the immoral and corrupted lives of the wealthy and powerful and the injustices they inflicted on the poor. The elements of sex, sentiment, and social antagonism would emerge from the structural framework of scenes and sequence.

The quotidian use of the Bengali word *rosh* to indicate commercially viable and sexually suggestive and explicit scenes makes it easy to miss the etymological roots of this word in the Sanskrit word *rāsā* (I drop the diacritics from this point on), meaning, among other things, juice. *Rasa*, of course, is the central principle of the aesthetic theory set out in the ancient Sanskrit *Natyasastra*, the treatise on performance arts in ancient India (Schwartz 2004). The link becomes evident when we look at the actual use of the term *rosh* by these filmmakers. They applied the term *rosh* to particular scenes that generated a desirable response in the audience and explicitly linked this to the body as a site of dramatic expression and perception. This coincides roughly with a commonsensical understanding of *rasa* as the principal aesthetic goal in the performing arts.

To link the contemporary usage of the idea of *rosh* by Bangladeshi filmmakers to theories of *rasa* potentially creates more trouble than it's worth. Does linking the contemporary production of *rosh*-filled films to these aesthetic treatises place contemporary Bangladesh scriptwriters of dubious artistic training into a timeless space of ancient Hindu scripture or problematically posit them at the heart of a set of debates waged by the finest of Indian aesthetes? This would only be the case if aesthetic

practices and national borders are reified beyond the recognition of the inevitable blurring between low and high art, new and old borders, devotional and secular practices, the past and the spaces of modernity. The recurrence of the term *rosh* among these filmmakers is also less surprising if it is considered that "the sensibility of the text [*Natyasastra*] . . . has been spread throughout the subcontinent by oral transmission and by example in intense and personal context" (Schwartz 2004:4). The roots of South Asian cinema in other performance genres (Hansen 2001), the continuities in personnel in theater and the Bengali film industries (Kabir 1979; Mukherjee 2007), and the reliance on *guru-shishyo* styles of learning the artistic trades in the Bangladesh film industry through apprenticeships (see chapters 2 and 4) could all be used to explain the ease with which a notion of *rosh* finds its way into the scriptwriting discussions for a Bangladeshi action flick.

As these filmmakers refer to these scenes and their effects as *rosh* with such ease and frequency, I take this at face value and suggest that the evaluation of scenes on the basis of their potential for *rosh* can be understood as an aesthetic evaluation that draws, in whatever idiosyncratic ways, on a wider tradition of understanding performance genres in South Asia and foregrounds a concern with audience response. While such an application of the concept of *rasa* to cheaply produced action films and pornography might seem slightly odd, perhaps even anathema, for an anthropologist it is empirical practice, including linguistic practice, which should be paramount in the analysis of particular social practices or cultural forms. If they call it *rosh*, I take this seriously.

The desire for *rosh* and sentiment in Shiplu's new script draws attention to the evocative mode of filmmaking in which he was engaged. Shiplu's recipe for a hit film combined a three-pronged attack on the experiencing body: tearful sentimentality, sexual titillation, and throbbing indignation. Interested mostly in an emotive and visceral response from his audience, Shiplu's films belonged to what Linda Williams has called "body genres," film genres that appeal to the body of film viewers, such as melodrama, horror, and pornography (Williams 1991). Genres such as pornography are self-evidently addressed to the body, and their success is dependent on a capacity to move the body. More recent explorations of the nature of the aesthetic have similarly probed the combined visceral and mental appeal of particular aesthetic forms (Dudrah and Rai 2005; Marks 2000; Pinney 2001; Sobchack 2004). In these accounts a visceral link between the sensorium of the spectator and the aesthetic object is posited in a

way that any reflection on pornography makes immediately self-evident. Except in studies by specialists such as Williams (2004), however, porn has not been a part of the recent enthusiasm for the discussion of the bodily involvement in aesthetics. Where it has been discussed, it has been seen as working so remorselessly on the body that its address is postulated as to the senses only, bypassing the intellect, mind, or consciousness. What the notion of *rosh* as *rasa* brings into focus is that it is not the body that overtakes the mind; rather, in *rasa* the boundaries between body and mind or spirit disintegrate (Schwartz 2004:9), and performance is "an experience at once physical, emotional and cognitive" (Schwartz 2004:50). Pornography in its various forms, distinctive across time and place, variously efficacious, becomes more meaningful when considered as a complex performance genre that aims for an arousal that cannot but be a combination of the physical and mental, firmly placed within a particular aesthetic tradition, rather than an unstructured display of genitals and the simply carnal response of the viewing body.

To write the script for the new action film, Rony combined the mercurial qualities of sex, sentiment, and social antagonism into narrative strands appropriate to the genre film he was making and stretched these across the established structure of six songs, ten fights, and some comedy. To find the story lines and characters that would conform to their generic and aesthetic needs, the team delved into an archive of other narratives available to them, evaluating them by imaginatively looking through the eyes of their imagined audience.

THROUGH THE EYES OF THE SPECTATOR: READING PRACTICES IN SCRIPTWRITING

Shahed Rony was confident about his work as a scriptwriter. He told me on a number of occasions that he would never want for work. "I know what other people want, and I can give it to them," he said during a conversation we had near the FDC, his face a satisfied smile, "because I am educated." Rony studied physics at Dhaka University, leaving with a master's title, but he never worked as a physicist. His father had been a film director of some success, and Rony grew up in Dhaka around cinema. "When my father suddenly died in 1997, I took up scriptwriting full time." In the Malibagh flat where Rony lived with his young family and widowed mother, the cabinets were decorated with his father's national awards and trophies. Speaking to me in a mix of English and Bengali, Rony was an exception in the team.

Unlike the others, Rony had grown up in Dhaka, spoke English, and was educated in reputed schools and the country's most prestigious university. He set himself off from his audience, his colleagues, and the producers and directors who called daily at his Malibagh residence. "I own a laptop, you see," he explained. "Others have to take weeks, writing out the dialogues by hand."[1] He continuously reminded me that he was a member of the middle class. "I could write 'class' films or films for the channels," Rony suggested about his capacity to write for art filmmakers and telefilms. "It is just a matter of time." He wrote scripts for action flicks because it was quick money. "I can line up an action film in two, three days," he said; "if I have ten days, it will be a healthy film." To him the distinction between the two sorts of film was a matter of time investment, nothing else.

During the early sittings for the script, it was usually Rony who would interrupt his work to explain to me why certain story lines would be useful to retain in the plot. His explanations indicated that the scriptwriting practice was structured by an explicit conception of the audience for whom the film was being made. The expectations and desires of a public "out there" were continuously invoked to suggest certain plot twists or characterizations. To outline this "textually inscribed spectator" (Hansen 1991:6), Rony said, "the poor in Bangladesh want relief; they want something unreal; they want their dreams on the screen. These people don't have any entertainment. At home they only have a thin, nagging wife, who doesn't even have a sari. In the cinema halls they see sexy, round women in beautiful clothes. These days the condition of the cinema halls is very bad, very uncomfortable. But still people come. The people that come are lower-class men, and they really enjoy rape scenes; so all commercial films should have a rape scene in them."

Rony's caricature of this mass of deprived and brutal working-class men spoke more eloquently of his own self-perception as an educated, middle-class professional than of the empirical conditions of the cinema halls in Bangladesh (see chapter 6). However, this image of such an uncivil cinemagoer flickers across the region (Kaur and Mazzarella 2009; Srinivas 2000) and has been intimately linked to the development of film criticism across South Asia (Vasudevan 2000), becoming a widely shared and ready-to-hand trope by which the forms of popular cinema are regularly "explained." And it is this perception that structured Rony's scriptwriting, the spectator that he wrote into his plots. As Ravi Vasudevan has shown for Indian cinema in the 1950s, a widespread assumption within the film industry was that "the plebeian spectators would delight in spectacle and

visceral impact, uncluttered by ideas and social content" (1995:311). This assumption was shared by Rony.

Tejaswini Ganti has shown for Hindi cinema that in the process of remaking films, filmmakers "elaborate differences between themselves and their audiences" (Ganti 2002:297). Rony repeatedly distanced himself in this manner. He underlined this difference through an imagined lack on the part of the mass of uncivil spectators. Rony's narratives were inevitably set among the wealthy, and his scripts were littered with references to big houses, chauffeur-driven cars, garden parties, and fancy parts of town. Imagining a poor and deprived audience for his films, Rony produced elaborate images of wealth that were equally fictional.

Although Rony set himself off from his colleagues and audiences resolutely, his use of foreign film narratives disrupted some of the differentiations he made. Ganti's Indian filmmakers "describe audiences in India as unable to empathize with Hollywood films because of their alien themes and alien morality; the assumption running through such description is that they, the filmmakers, have no such problems" (Ganti 2002:297). Rony's practice of translating foreign cinema to Bangladesh shows an entirely different dynamic. Rather than considering foreign films different in themes or morality, Rony read many foreign films in terms of their "Bangladeshi" characteristics: sex, sentiment, and social antagonism. One afternoon he asked me whether I had seen *Jamon Jamon* (Bigas Luna, Spain, 1992). Although I had seen the film not long ago, he outlined the story to me in a completely unrecognizable way. Bigas Luna's dark take on Spanish national identity and caricatured masculinity was recounted by Rony as a great story of a feud between families and impossible romance. Focusing on the relation between the families and the passionate lovemaking scenes, Rony described the film in terms of sentiment and juice, the affective qualities any popular Bangladeshi film should contain. Thus plots and characters from foreign films were effortlessly translated. "Basically it is a story that we've had many times in Bangladesh," he concluded, "but then without the pigs."

Scriptwriting, for Rony, was based on a particular reading practice, informed by a solid understanding of popular Bangladeshi cinema and its requirements. Teasing out the right story lines and characters, he and Shiplu discussed films they had seen and evaluated them according to their generic and aesthetic needs: first, the genre; second, the structural framework; and third, the qualities of *rosh*, sentiment, and social antagonism. On the face of it this process looked like advanced plagiarism.

"Did any of you see *Gangs of New York*?" asked Rony. He set out the plot in a few sentences. "We've had that story so many times," said Shiplu. Rony tried again. The one constant was Jishu's character, the villain in shorts who becomes a powerful politician. I asked Rony how he got the idea for this character. "A Telugu film called *Bharat bandh*," he replied; "it centered on this killer who becomes a national leader." I asked where he saw that film and whether he understood Telugu. "You can watch films online, and people bring them from Malaysia," he responded. "There are a lot of Telugu boys working in Bangladesh, and they translate for us," he added. Narratives came into being within dense intertextual networks. Such practices have been particularly important to action films (Morris 2004; Srinivas 2003). Constantine Verevis suggests that all film remaking "can be regarded as a specific (institutionalized) aspect of a broader and more open-ended intertextuality" (2005:95). Bangladeshi commercial cinema comes into existence within such dense webs of discursive practices, which consist not only of other Bangladeshi films but also of folk traditions, drama, and literature, as well as foreign cinema and television. From these dense flows of images Rony picked those elements that suited the conventions of his romantic action cinema. The resulting film narratives spoke not of a peculiarly isolated Bangladeshi universe. It vocalized the specific juncture in the global economic system that the filmmakers were part of, expressed in terms of the availability of narratives, as well as the presence of translating laborers (Appadurai 1997). It was at this junction that the first lineup of eighty minimally described scenes for Shiplu's new film came into being.

When asked, Rony drew clear lines differentiating himself from the imagined audience. But in the process of writing the script, his reading of story lines and characters showed both identification and disidentification. His evaluation of films was marked by the very expectations he imputed to the audience. The generic requirements he sketched as fulfilling the needs of the spectator were also those with which he judged films. The way in which a film was read by Rony for its scriptwriting potential was as much dependent on the filmmaking traditions with which he was intimately familiar as it was on the qualities and content inherent in the film in question. Rather than a derivative art, lacking in vision or artistry, Rony's scriptwriting skill consisted in effectively reading existing stories and narratives to distil from them instances suitable to the structures of Bangladeshi cinema, reading these through the eyes of an imagined audience.

JUICY SCENES AND BIG PROFIT

After the first day of brainstorming, I returned to Rony's house at nine the next morning. While the city had come to a standstill that night to remember the martyrs of the language movement, students who were shot fifty-seven years ago on this night to defend Bengali against Urdu as the only state language of Pakistan, Rony had spent the night watching Hindi movies to find further inspiration for the new film. When I came in, he was lying on a couch writing down sequence 19. The sequences were rapidly flowing from his pen. Rony was on a tight deadline. He had to present the full lineup to the film's producers in the afternoon. Although Shiplu and Nazmul sat by to direct and help Rony, they spent most of their time regaling me with outrageous stories. "You know that Arab women wear nothing under their *borka*?!" Nazmul told me with a lascivious smile. Turning to the scriptwriter, he said: "Rony *bhai*, we should have a *borka-wali* [woman dressed in a *borka*] in the film!" Rony continued writing unperturbed, rarely paying much attention to Shiplu's assistant.

Mohammad Nazmul Islam was one of Shiplu's junior assistants and an old school friend. They had grown up in Demra together and had been classmates. Nazmul wasn't quite sure of his own age, but he guessed it was a little less than Shiplu's thirty-five. Unmarried and the youngest of three siblings, he lived with his married brother in Demra. Curious about his older friend's work and passionate about drama and film, he would sometimes come to the set to see Shiplu at work. He was unemployed until Shiplu accepted his request to become an assistant film director in 2002. Three years later, he had seen all there was to see in Bangladeshi cinema and was getting frustrated with the endless cycle of scripts, sets, edits, and screenings. But Shiplu relied on him to take care of all loose ends that the others were too senior to bother with; thus, it was Nazmul who mostly got stuck with looking after me during the production of *Mintu the Murderer*.

"I also direct plays, you know," Nazmul would often remind me. "Once I get a good script and producer together, I will be a film director myself." Nazmul hoped his assistant directorship to Shiplu would allow his artistic career to progress until he was able to make his own films. He aspired to make "good" films and was deeply involved in amateur dramatics. Good films and stage plays were part of the *bhodro* horizon of cultural aspiration that Nazmul worked toward while assisting Shiplu in the cheap and

partly illegal action films they produced in volumes. As I have shown else-where in more detail (Hoek 2012), these were not contradictory pursuits for Nazmul but coexisted as a series of arts practices to which he was dedicated. The invocation of "good" cinema was also indicative of the dominance of certain vocabularies to address the cinema made available through art film movements and film appreciation classes and the juxtapo-sition of *shongshkriti* (culture) with its inverse *oposhongshkriti* (degenerate culture and the perversion of taste). Four years after I met Nazmul, he did make good on this promise when he directed the very successful romantic film *Bolbo kotha bashor ghore* ("I'll Say It in the Wedding Bed," 2009) under a pseudonym. But despite his initial success, he was unable to establish himself as an independent director and continued to assist others.

At one o'clock in the afternoon Rony had finished the first lineup, con-sisting of eighty sequences. After a heavy lunch of *biryani* eaten out of the oily cardboard boxes in which it had been delivered, Shiplu, Rony, Nazmul, and I set off. We all packed into a banged-up black Maruti taxi and slowly made our way through the jams to the narrow street in which most film producers had their offices. The large Rajmoni cinema hall tow-ered over and enclosed the constricted street through which rickshaws found their way from Old Dhaka into the newer parts of town. Opposite the cinema hall was Litu's office.

The building had eleven floors, each of which housed a number of film production companies. Producers, assistants, actors, and extras climbed the narrow stairs at the heart of the structure, some carrying film tins, others teacups. We joined them in the steep climb up the narrow stairs. The walls of the stairwell were covered with film posters, and hoard-ings were stacked against the walls. As I made my way up the stairs, the brightly colored posters had a dizzying impact on me.

Litu's office was on the sixth floor. Like all other offices in the build-ing, it was decorated with large posters and cutouts from recently made films. Litu's office consisted of two small rooms, the front room serving as an anteroom, furnished with only one desk and a bench. Stacks of movie posters covered the floor. Behind this room was the inner office. Three desks were crammed into the small space, the prominent front desk pre-sided over by Litu. We sat down on the narrow benches along the wall and waited for the producers behind the desks to start the proceedings.

Litu instructed Rony to read out the lineup to the assembled crew of producers, Shiplu's assistant directors, the chief cameraman, and a sec-ond scriptwriter on Litu's staff. "It is called *Top Secret*," Rony said before

he read out the sequence descriptions one after the other. "Scene One," he read from his notes: "Kader kills a man running down the street with a flag and claims he is a political party worker. Two, the party president Islam Saheb warns the political party members . . . " He continued and had read out the first ten sequences before he was interrupted. "It's much too political," said a senior assistant director. "The Censor Board will never allow it! They will cut the first three sequences immediately." Rony tried to defend his story. "Of course they won't," he suggested. "The government wants to see that those who are calling the general strike [*hortal*] are really criminals! This way it shows that calling a strike is really illegitimate." The assistant director was not to be convinced. "I want a new lineup tomorrow morning," Litu said.

Ideas about censorship continuously informed the development of the script. Many plot twists were abandoned under pressure by Litu. Rony and Shiplu had initially agreed that Salman Khan's entry should be at a graveyard near a slum. Rony had written a scene with great sentimental potential that would speak to people's quotidian experience of violence and disempowerment, as well as the idealized relationship between mother and son. "You can't show the demolishing of a graveyard!" cried Litu. "It's against the law to break down a graveyard!" Litu objected vehemently to this sequence and asked Rony to abandon it. Litu's ideas about censorship complicated Rony's work, because his scripts were largely written around controversial political issues such as corruption. Social antagonisms (among classes, sexes, ages, and communities) structured Rony's scripts, but he always had to navigate his paymasters and their ideas about the public, consisting of censors, journalists, and film audiences. Rony tried to negotiate with the other members of the team while each of them relied on their experience with censorship regulations and the public to imagine what would and what would not be allowed, what was feasible and what was not.

Rony continued reading the sequences as he had lined them up. The assistant director was appeased by the development of the story. "I thought it would be too political," he said, "but the structure is sort of okay." Litu wasn't so easily won over, however. "I want Jenny in the slum as well," he told Rony, "not just Sumit." Jenny was the female action actress Shiplu had cast. She was famous for her appearances in cut-pieces and item numbers. "But that would destroy the story," defended Rony. "Jenny is the only commercially interesting actress in this film," said Litu decisively; "she will be in the slum." "But what will her entry and character be then?" asked Rony,

defeated, "a *jatra* [theater] dancer?" Now Shiplu cut in. "You've already had so many *jatra* dancers in your script," he said, "I don't want any more." Rony looked at his notes and suggested a fight in the slum between Jenny and her taxi driver. "The taxi driver will pull her scarf from her chest," suggested Rony. "That will be her entry." In Bangladeshi cinema sexual harassment was a common device used to place a female character in a position of exposure. The scarf, symbolically protecting the female body from the male gaze, was often pulled off in elaborate scenes. This would establish Jenny's character as a focus for sexual desire. Litu liked that better but still wasn't convinced. Shiplu suggested a gangster entry for Jenny. "Her entry will be in full gangster getup," said Shiplu. Litu responded enthusiastically: "That will have juice!" "She will enter in a sari and then rip it off," Rony suggested, enthused, "and underneath will be a full gangster outfit!" This satisfied Litu. Jenny's character became a female gangster. "Make it commercial," Litu said, "shamelessly!" He added that he was the one investing the money here.

During the scriptwriting process, and generally during the development of the film, Litu, as producer, was concerned primarily with bringing sufficient "commerce" to the film. Shorthand for sexually licentious sequences and double entendre in songs, commerce was Litu's specialty. He officially invested six million taka (60 *lakh*, just over US\$95,000) in *Mintu the Murderer*.[2] The actual investment was probably 20 *lakh* less. Counted against predicted profits, the difference would be untaxed and unregulated. A romantic action film was a good investment for producers such as Litu. Action movies were cheap and required little investment in star actors. Commerce in the form of cut-pieces would draw a sufficient number of viewers to the cinema halls and guarantee handsome returns on the small investment. It is thus hardly surprising that the story was not Litu's main concern. His investment was in possible cut-pieces.

To accommodate the cut-pieces, Litu would urge Rony to write in sequences such as Jenny's. These scenes functioned like "hooks" (Bordwell, Staiger, and Thompson 1988:33), the point at which "the audiovisual texture links a specific causal element [at] the end of one scene to that at the start of the next" (Bordwell 2008). These elements aid transition. The commercial scenes were hooks that allowed a transition into a cut-piece that might become part of the film. When Litu asked for "shamelessly commercial" scenes, he was asking Rony to make sure there were sufficient hooks in the script onto which extra scenes could later be hung.

In Rony's final written script, "shamelessly commercial" sequences, such as Jenny's disrobing, would be followed by a short sentence such as "move to romance," "bed scene," or "song." Otherwise unscripted, these opaque little sentences were the point at which the transition could take place from a commercial sequence to a cut-piece. The cut-pieces Litu had in mind for this film would not be submitted to the Censor Board (see chapter 4). During the writing of the script, therefore, the legal limitations were minded only in relation to the main body of the film. Any extra scenes were already imagined outside of the legal framework of the Censor Board. The little sentences were the textual foreshadowing of the illegal cut-pieces. This also means that the hooks in the script were generally not followed by the scene they seemed to lead into. Explaining how transitions help us to understand the narrative pattern in mainstream cinema, Bordwell suggests that "we're supposed to register those patterns, consciously or not, and they prompt us to react in particular ways" (2008). But, like the cut-pieces themselves, the hook was neither quite there (not described except as "bed-scene") nor entirely absent, figuring only as this brief sentence. The hooks in the script, therefore, did not lead anywhere, not allowing the narrative to progress and suggesting an appropriate audience response, but rather created a kind of narrative abyss, in which the expectation isn't fulfilled. This creates a desire for a resolution on the part of a viewer, to make good on the hook, but also effectively avoids censorship of the script. The script, therefore, was not only a concrete text, setting out a denotational story, but also a textual medium from which unscripted scenes could emerge later in the process.

Litu embodied all the changes the Bangladeshi cinema industry has gone through in the last two decades. Mohamedul Hasan Litu produced his first film in 1992. The film was a joint production, and Litu invested money he had raised among his family members. The money came from the profit his family had made from the cinema hall they ran near the city of Khulna, in the south of Bangladesh. After the death of his father Litu's mother and brother had invested in a cinema hall there. At about twenty years old Litu had collected money from his siblings to start producing films. In 1992 he came to Dhaka to make *Ajkal* ("These Days"). Its director and hero both rose to fame in the early 1990s and *Ajkal* became a success. Litu had been producing films with two partners ever since. His company, Freedom Chhayachhobi, was named after the family cinema hall. Like most producers in the industry, Litu was an entrepreneur and cinema his means of investment. His concern was always with the

production of sexually explicit material, which was cheap to make and guaranteed a good profit. While Shiplu has been reprimanded repeatedly for the production of cut-pieces by his professional organization, the Directors Association, Litu had never gotten into trouble with his Producers' Association. The Directors Association was concerned with cinema as a cultural form and spearheaded the campaign against obscenity; the Producers' Association was concerned with cinema as a form of investment. Keeping production times tight, the budget limited, and the number of cut-pieces high was Litu's way to ensure a high profit on his 40 *lakh* taka (US$63,500) investment.

After two hours of discussion, the meeting was over. Rony, Shiplu, and Nazmul left Litu's office to resume their work. Rony complained that the lineup was good the way he had presented it. "Litu is 200 percent destroying the story!" Shiplu calmed him down by telling him that this was the way things were. The relationship between Shiplu and Litu was mutually dependent yet fraught with conflict. As a film director Shiplu was often frustrated with the interventions of Litu but rarely vocalized them. Ultimately, Litu paid all their salaries. Litu's previous collaboration with Shiplu had led to the most controversial, and biggest earning, of all of Shiplu's films yet, entitled *Famous Eight* (2004). But when Shiplu got into trouble with the Censor Board for obscene and uncertified material in that film, Litu had gone scot-free. Shiplu would often rant that the problem with Bangladeshi cinema was the producers, who would demand and fabricate obscene sequences and cut-pieces on the basis of expected profits rather than knowledge of filmmaking. This was frustrating to almost all of the crew. But even if they were annoyed more than once by Litu's demands, they could never show this. He was considered a mean and poorly educated man, but he controlled the purse strings and therefore had to be appeased. Thus, Rony and Shiplu set off to add more *rosh*, more sentiment, and less political controversy to their fledgling script.

URBAN MYTHS

Over the next week, the last week of February 2005, Rony rewrote the story for Shiplu's film. Together, Rony and Shiplu tried to fulfill all of Litu's demands while maintaining their own sense of what the story should look like. After two days Rony started writing the dialogue. Within another few days the script was ready. It was no longer called "Top Secret." The new film was to be called "Killer Mintu," later *Mintu the Murderer*, and centered

on a contract killer who becomes a district commissioner. As Rony wrote the dialogue exchanges, Shiplu discussed them with Litu and rewrote them by hand himself. When stuck for inspiration, he would tap into the imagination of assistant directors, helped by Litu's other scriptwriters. Litu would adapt entire sequences by handing them over to other script-writers, more adept at producing commercial sequences. Even before Rony completed the dialogue, the film script had already been rewrit-ten many times by various hands. The script was a collaborative product, and no single author was in charge of its development. The process was composite and polyvalent, *Mintu the Murderer*'s stories multilayered and multidirectional.

In the full shooting script that eventually came into being, the first scene of *Mintu the Murderer* was set on a Dhaka street. The notes under the heading "Scene 1" read:

Road—Day
Cars are moving along the roads of Dhaka city. The camera charges
 onto one car amongst them. A police car guards the car from
 behind. Inside the car a gentleman with a calm face is sitting.
 This is minister Kuddus.

Rony had written a dialogue that would take place inside the car, between Kuddus and another minister. The latter asked whether it had been wise of Kuddus to complain against a third minister. It was his duty, replied Kuddus. At that moment the car brakes. In the direction notes Rony wrote of a man in shorts, with a pipe gun, trying to kill Kuddus. This would be Mintu's entry. In the final version of the film the politician sticks his head out of the window to ask what's going on. Mintu announces his links to the corrupt minister. He then swings a blade and decapitates the politi-cian in one fell swoop. Scooping up the head and placing it into a bag, Mintu walks off along the tarmac road leading into the city. The image freezes and technomusic comes on. The opening titles and credits role.

This short scene sets the tone for the rest of the film. True to its genre, this action film is set in a turbulent city. The story of *Mintu the Murderer* narrates the corruptions, violence, and pleasures of Dhaka. As described in my introduction, the action film arose in Bangladesh in the mid-1980s, amid a highly confrontational political culture. Ravi Vasudevan has argued for the city of Bombay in the same period, and under some com-parable social transformations, that in such a context "a cinema of urban

anxiety has ample sources to develop its scenarios from the life world of the city and the nation" (Vasudevan 2004a:223–24). *Mintu the Murderer* was such a film of urban anxiety. The ideas that were produced during its brainstorming sessions were all focused on corruption in the city.

This emphasis on the city in action film is in sharp contrast to art film. While Bangladeshi action cinema presents the city as the inevitable destination of all village dwellers, in short film and self-acclaimed healthy films the city is a far less common backdrop. The vision of the Bengali village is produced by the urban vestige of the media, now largely represented by makers of short films, telefilms, and healthy films.[3] Film scripts for Bangladeshi action movies, instead, tell stories of tentative urban belonging, set firmly in the city. This coincides remarkably with the overwhelmingly rural backgrounds of those on the crew of *Mintu the Murderer*. Almost all those who worked on *Mintu the Murderer*, from artists to producers, from directors to technicians, were born and raised outside of the major urban centers, specifically Dhaka.

It is from the lifeworlds of a city changed by rapid urbanization, liberalization, and class transformation that the stories of contemporary action cinema emerged in scripts like Rony's. Urban myths, social fears, and public dangers, from drugs and arms caches to food adulteration and kidnapping, fueled the imagination of Rony and Shiplu as they sought and found the appropriate plot, characters, and locales for their new film. Project developers demolishing slums to put up apartment blocks, vigilante groups running protection rackets, political corruption, and rape occurring in police custody were all mentioned as possible plot elements. But Rony also relied heavily on current affairs, urban myths, gossip, and newspaper reports to produce a script of urban turmoil and the city's secret life. In this way the script came to recount a specific view of Dhaka. Like the Bombay cinema described by Vasudevan, "much of the power of the popular cinema is exactly in . . . setting up scenarios of the city, its violent landscapes and subaltern experience. . . . This breaching of the vistas of the developmental dream of nationalism is effected by outlining new senses of frustration and violence" (2010b:318).

The script for *Mintu the Murderer* eventually came to dramatize an instance of vote rigging, through which hit-man Mintu becomes a district commissioner. Mintu's main opponent was conceived as a slum-based gangster in a long-standing rivalry with a corrupt minister over liquor smuggling. These characters were written for the main villain, Jishu Jadughor, and the action hero Sumit Hossain. Rather than a fantastical

account ripped from another gangster flick, the story resonated with the turbulent politics of postcolonial Bangladesh (Van Schendel 2009).

"In my films you'll see the tip of it," said Rony. "I can hardly show all that goes on. But it is only in films that you can see a little of what is really happening. The newspapers won't tell you anything." Operating within registers of censorship and political sensitivities, Rony's accounts of the "true" nature of the city could not be directly stated but emerged nonetheless through the emotional and effective resonance of his stories. The urban anxiety driving his scripts provided a means to address the inequalities and dangers of the violent, at times lawless, often fragile, social existence that the rampant growth of Dhaka has produced. His scripts resemble the narratives of the Nollywood films discussed by Brian Larkin (2008), which he argues are driven by "an aesthetics of outrage, a narrative based on continual shocks that transgress religious and social norms and are designated to provoke and affront the audience" (184). The importance of such an aesthetic is not merely that it can create profitable films but that it "makes public stark, ethical conflicts at the heart of society at a time when the moral basis of society is in transition" (185). In Larkin's account this aesthetic works through the stimulation of the body, in a way comparable to Rony's scripts, and its commentary resonates at a visceral level. Thus, what is known by all but cannot be articulated generally, in Taussig's words (1999), comes to be expressed at a bodily level instead. It is at this visceral level that an account of contemporary urban sociality is articulated.

The film scripts written by Rony narrativized the lifeworlds of those like Litu, Shiplu, and Nazmul, who dwelled on the verge of the expanding city, or in rapidly constructed tower blocks, those recently arrived, aiming up and outward, caught up in the inequalities, injustices, and possibilities of contemporary Bangladesh. As Mazumdar has argued for Bombay, "popular Bombay cinema is a legitimate and powerful archive that provides us access to a range of urban subjectivities" (2007:xviii). Where art film and TV dramas relentlessly focused on the trials of peasant life in apparently timeless Bengali villages or indulged in the glossy, car-driven lives of young people in fancy neighborhoods, popular action cinema narrated other lives and worlds. Where "the technical media offered the possibility of functioning as a producer of the images or experiences through which a collective might come to recognize itself and its own material conditions of existence" (Lastra 2000:6), Rony's scripts, and action films in general, produced a powerful set of images of contemporary Bangladesh

unavailable elsewhere. Rony did this through a set of narrative techniques and modes of address that are bodily resonant, relying on sex, sentiment, and social antagonism to drive the message home. As Larkin suggests, based on Bakhtin and Mbembe, "the grotesque is not just a system of signs, a collection of images, but a cultural analytic whereby the order of society is made manifest and can be viewed" (Larkin 2008:184). Thus, the scripts for popular Bangladeshi action films provide an important means by which contemporary society and its operations of power can be seen and understood. Scripts like Rony's present accounts of contemporary life in novel but articulate idioms of urban cinema.

But these idioms are not necessarily legible to all. This included film critics and other *buddhijibi* (intellectuals) in Dhaka. Discussing three action films released in 2004, a year before *Mintu the Murderer*, film scholars Gitiara Nasreen and Fahmidul Haq argue in their book *Bangladesher chalochchitra shilpo: Sangkote janosangskriti* (The film industry of Bangladesh: Popular culture in crisis) (2008) that "these films probably don't have a written script, [and] there's no continuity to the narrative, no evidence of skill in direction" (107). They add that "even though we found the name of the scriptwriter in the credits of each selected movie, we don't think there are any well organised scripts for these films" (2008:108). Second-guessing the credits of a film is a creative practice of film scholarship but, given the structures of film production in Bangladesh, rather counterproductive. No film in Bangladesh can be released without a censor certificate, and to apply for censoring, one of the documents that must be provided by the film producers is the script for that film. Similarly, scripts are integral to the daily shooting (chapter 2) and editing (chapter 4) practices of commercial filmmaking at the FDC. Rony's eighty-scene lineup was closely calibrated to achieve the desired length of the film, which in turn was tied in with the package deals film producers could buy from the FDC (the so-called P-film), as well as the rising costs for censoring films over a certain amount of footage (see chapter 4). The chance of a popular FDC-made film not to have a script is negligible.

It is easy to presume that the assumption (based on an evaluation of the film language in terms of "lack of continuity" or "skill") that there is no script for popular action films shows a real lack of engagement with the film industry and its practices. Besides an evident distance from the everyday practice of the industry, however, the incredulous response of Nasreen and Haq reveals a more general class conflict at the heart of the distinction between "obscene" popular art "in crisis" and "healthy"

or "art" cinema. The tropes, narratives, and structures of Bangladeshi action films as written by Rony present powerful accounts of contemporary society. These accounts have what John Niles calls the "cosmoplastic power" by which new ways of seeing the world are expressed and aid "the consolidation of new mentalities" (Niles 1999:88) to shape the way in which the world might be experienced. But they do so in largely unpalatable, because visceral, forms and with great opacities at the heart of the script produced through censorship regimes. And this imagery clashes with other narratives, images, and tropes by which the collective might want to recognize itself and thus become illegible to some.

SENTIMENT

Like Rony, film director Shahadat Ali Shiplu was born into the film industry. His father owned a cinema hall in Demra, into which the edges of Dhaka city now encroach. After passing his secondary school exams, at age sixteen, he started helping his father manage the hall. As Shiplu recounted, "I had to take the contract films on. From when I was twelve years old I watched a lot of films, Bangla, Hindi, English, lots. I would go with my uncle to pick up the posters and photosets, and I thought that I could do it better, more beautifully. Deep inside I thought that, but I didn't tell anyone. Later on when I was sent to Bogra to take care of a cinema hall there, I lost a lot of money in six months."

Shiplu's uncle suggested he go back to school. After a spell at a graduation college in Dhaka, where he left without a degree, Shiplu decided to try his hand at filmmaking. He approached film directors and producers. Eventually he was introduced to filmmaker Abu Johir. "When he heard that my father had a cinema hall, he was speechless. 'If your father owns a cinema hall, then why will you work in film?' I said that I needed a vocation, that I needed to work, and that I wanted to work in cinema. He said that working in cinema is very hard and asked if I could work hard. I said that at this young age, I had already worked so hard and that cinema couldn't be much harder."

In 1989, when Shiplu was about nineteen years old, Abu Johir took him on as assistant director. After learning the trade, Shiplu directed his first film in 1999. His first hit film came two years later, "Heavy Attack" (*Kothin hamla*, 2001). He became known for making romantic action movies that especially drew audiences outside of the big cities, where his name became associated with hard action and sexually explicit sequences. Both

the Bangladesh Film Censor Board and the Film Directors Association reprimanded him repeatedly for making vulgar films. The Bangladesh Film Censor Board withdrew the certificates granted to his films on a number of occasions, and court cases had been lodged against him that were still not resolved in 2005. But his reputation had also made him one of the most productive filmmakers in the industry, as film producers sought him out to make films full of "juice" that would not want for audiences.

Shiplu was not particularly comfortable with this reputation, which embarrassed him. He would explain to me that his family was a religious one, and he disliked being associated with his own work. But his reputation had become the source of his income. Besides making six action films in 2005, Shiplu also worked on a folk film, financially backed by young producers who were willing to take a chance on Shiplu. This project was the film *Bilashi* (Shahadat Ali Shiplu, 2005), a rural fairy tale or folk story about a prince and a pauper girl who fall in love. With clear references to two of the most popular films in Bangladeshi film history, *Rupban* (Salahuddin, 1965) and "Gipsy Girl Josna" (*Beder meye Josna*, T. H. Bakul, 1989, with Iliyas Kanchon, Probir Mitra, and Anju Ghosh in the lead roles and not to be confused with its 1991 remake for the West Bengal market),[4] and its recent reincarnation in another successful folk film, "Beautiful Khairun" (*Khairun shundori*, 2004), Shiplu had high hopes for *Bilashi*. He hoped that the success of *Bilashi* would establish him as a maker of healthy films and allow him to move away from making vulgar films. *Bilashi* was written and directed with his own team, so Shiplu's hopes in 2005 were vested in this folk film rather than on yet another action film to be made for a producer who had an interest only in low investment and high profits. Like Nazmul, Shiplu aspired to make "good" films. Eventually, however, *Bilashi* failed miserably at the box office, and Shiplu continued to make action films for producers such as Litu.

Shiplu was not alone in his aspirations to move into more "healthy" forms of filmmaking, such as folk or romance films. Shiplu had cast the young and fair actor Salman Khan as the romantic hero. Casting for action movies was generally done long before the script or story were conceived because the actors were the most important asset of a film and most difficult to retain. With the idea of Salman as valiant protector of his parents' graves thrown out under pressure by Litu, Salman's character and entry proved a stumbling block. "He won't do a gangster role," Shiplu had reminded Rony; "he'll refuse anything but being the hero." In trying to find a heroic entry for Salman, controversy broke out among the team

over the question of Salman's social ties. If his parents were dead, then to whom did he belong? A romantic hero without social bearings was an impossibility. If there were no social relations into which he was embedded, how could there be sentiment? As Ganti has noted, "Adding emotions to a film involves placing a character in a web of social relations of which kin are the most significant and common in Hindi films" (Ganti 2002:291). In action films the city would rip up these relations, producing the desired sentiment. Rony was asked to rewrite Salman's character to embed him properly into the social relations within the script.

The resolution of the problems with the lack of social ties for Salman's character illustrates the way in which the city has come to be imagined in Bangladeshi action cinema. Rony resolved the problem by making brothers of romantic actor Salman Khan and action actor Sumit Hossain. In the script Rony suggested a lengthy flashback halfway through the film, which shows the two brothers as small children. Salman is an infant in his mother's arms and Sumit a young boy of about nine. They have just arrived in Dhaka from the village. They left because of the sudden death of the children's father in the city. The mother takes her sons to the city to find her husband's brother, who will now need to take care of them. Arriving in the city, they are caught in a rainstorm. They are asked to step inside the house of a man who says he knew their father. Once inside, the mother is promptly raped. The young Sumit kills the rapist and then runs off into the dark city to grow up to become one of the city's most feared mafia dons. Salman, however, stays with his mother and grows up to be a handsome college student. The rape propels the whole story and allows Sumit's mafia character to become embroiled in a feud with a number of corrupt politicians, the very minister who hires the contract killer Mintu. The kinship relations in *Mintu the Murderer* are strained through exposure to the city, and thus produced the required sentiment.

This flashback resolved the problem of Salman's character. It establishes the kinship relations and the lack of paternal figure in the lives of the protagonists, as well as the village as the ideal prelapsarian location from which they are expelled.[5] Their expulsion into the city sets in motion the story of the contradictory pleasures and fears of modernity and the city. Salman's character becomes embroiled with Mintu, and he joins his brother as they take up arms and vigilantism. Although reminiscent of the common trope in South Asian cinema (Booth 1995), the dichotomy of the good and bad brother is not carried through to the end. Instead, their moral positioning reflects the ambivalent nature of the city. Neither

brother remains steadfast in his encounter with the all-devouring city. The new arrivals to the city are immediately confronted with its decay and leap headlong into it. Unfazed by the depravity of the city, the two brothers adapt rapidly. Eventually both end up in jail. This has been a standard narrative device in almost all of Shiplu's films.

The battle to maintain one's standing and moral uprightness, once engaged in the dirty business of urban life, plagued not only the film's hero but also crew members such as Nazmul, Shiplu, and Salman, who were all central in the production of popular action films yet continually distanced themselves from the implications of this work. When discussing the background and journey to the city with crew members, many stressed to me their *modhyobitto* (middle-class) rural backgrounds. This connoted simultaneously their social standing, moral uprightness, and cultural capital but also their nimble capacity to make it in the city, using contacts and wits to gain employment and make a living. Here *mofussil* backgrounds were imbricated with *bhodro* horizons of aspiration and accomplishment. It was about such a city of complex transformation that scripts for films like *Mintu the Murderer* spoke eloquently and resonantly.

CONCLUSION

Rony finished the script within ten days. He relied on existing plots and adapted them to suit the requirements for a romantic action film. The generic romantic action story line of a love affair driving an action plot, stretched over the requisite six songs, ten fights, some comedy, and plenty of drama, was enlivened by the specialist addition of sex, sentiment, and social antagonism. Reading other snippets of discourse for these attributes and their expected effects on the imagined audience, Rony's script came to speak of the city as a place of danger and opportunity, revealing the contradictory fortunes of living in the metropolis. His stories of the city, made up of urban myths, everyday experiences, and tabloid speculations, produced a resonant account of the new urban Bangladesh, unarticulated elsewhere and often illegible for it.

During the ten days he worked on the script for *Mintu the Murderer*, Rony was also working for other producers. The time he invested in Shiplu's script was minimal. It suited the requirements of Litu, for whom the film was an investment above anything else. He was concerned mainly with the production of commercially viable sequences, specifically cut-pieces. Shiplu's new script was therefore filled with hooks, moments where the

narrative could easily transition into unscripted scenes of a sexual nature. The script, then, was full of opacities, difficult to read accounts of the city, and omitted scenes of sex and pleasure. Designed to appeal to the body on both counts, the script already set up *Mintu the Murderer* as a film to be rejected and delighted in as vulgar and obscene. In the next chapter I will describe how this script was translated into images during the shooting of *Mintu the Murderer*. Scripted and unscripted scenes were to come alive in front of the lenses of Shiplu's trusted cameraman, Zainul bhai.

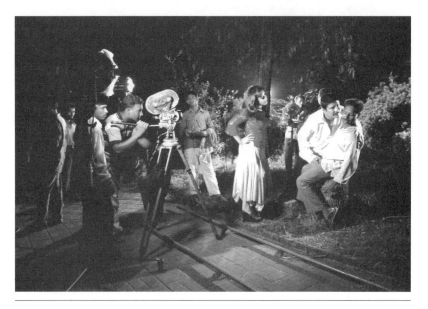

FIGURE 2.1 PHOTO BY PAUL JAMES GOMES.

{2} A HANDHELD CAMERA TWISTED RAPIDLY

THE TECHNOLOGY OF *MINTU THE MURDERER*

HE LAY on his back in the middle of the street. A crowd of villagers had gathered along the thoroughfare of the small settlement in the rural hinterland of Dhaka and watched him lying there. Underneath him a blanket shielded him from the worst dust and rocks. Two lorries came thundering past, narrowly missing his outstretched body. A blue jeep approached, carrying a number of men brandishing hockey sticks and large blades. As the jeep neared, the man arched his back and lifted the heavy equipment in his hands. His head to the floor and his eye to the viewfinder, he waited for the jeep to reach him. The moment it passed, he rapidly twisted the heavy camera in his hands at a forty-five-degree angle as he lifted his torso off the ground. "Got it!" he called and passed the camera to the assistant waiting beside him. *Mintu the Murderer*'s cameraman, Mohamed Abdul Zainul, had set the film at twenty frames per second and added a special effect with his acrobatics. "The jeep needs to go like *shaaaattt!*" he explained onomatopoeically, describing what the effect of his camerawork would be onscreen. "It will be the effect of fast motion."

Susan Buck-Morss has noted that in film studies "the techniques of filmmaking tend to get less attention than cinema's narrative and textual qualities" (Buck-Morss 2004:6), while Shuddhabrata Sengupta asks, "Who wants to talk about work, labour, production, machines, technology, power and knowledge when we can do a little detour into the semiotics of the navel twitch in a song sequence?"(Sengupta 2005:137). In this chapter, and the next two, I focus on the labor and technologies of *Mintu the Murderer*. Addressing women's labor in chapter 3, and editing in chapter 4, in this chapter I will discuss how the distinctive aesthetic of popular cinema in Bangladesh comes about within the realm of technological

expertise, equipment, labor conditions, production regimes, institutional regulations, and social relations of the Bangladesh Film Development Corporation, the national film studio where all popular cinema is made. This distinctive aesthetic is regularly cast as coarse and unsophisticated, vulgar and *mofo*, compared to short film, telefilm, and advertising. *Mintu the Murderer* acquired such an aesthetic and came to look as it did through the deployment of technologies in ways that were particular to its place of production. To understand why the jeep carrying Mintu's henchmen entered the screen seemingly suspended sideways in the air, it is therefore important to ask why Zainul twisted the handheld 2C camera rapidly at a forty-five-degree angle rather than only semiotically untangle the meaning of such a suspended lorry.

In this chapter I will describe how Zainul used the camera to shoot *Mintu the Murderer* and why he made some of the decisions he did. By describing his cinematographic work on the sets, I will explain the aesthetic conventions of Bangladeshi action cinema. I will first provide a detailed description of a single shot from *Mintu the Murderer* and analyze the way filmmaking technology (the hardware consisting of lights, lenses, and the like) is used here. I then will analyze this shot through Zainul's own explanation of his filmmaking techniques. Second, I will outline the institutional arena in which Zainul worked. Describing the way the Bangladesh FDC functioned as an institution shows how its organizational structure contributed to film form. Third, I will demonstrate how the social networks at the FDC shape filmmaking. The social hierarchies at the corporation were expressed largely through the idiom of obscenity. I will show how this resulted in different regimes of visibility within the FDC. Combined, the technological, institutional, and social aspects of filmmaking at the Bangladesh Film Development Corporation produce an aesthetic that is recognizable across genres of popular Bangladeshi cinema. Following Zainul as he navigated these arenas to shoot *Mintu the Murderer*, it will become clear how the technology and institutional environment of the FDC created a distinct aesthetic that could become rejected as vulgar.

TECHNOLOGY IN WONDERLAND: CINEMATOGRAPHY AND AESTHETICS

Zainul had arrived early. Together with the rest of the crew and the equipment, he had taken the bus from the FDC grounds in the morning. The group went to Wonderland, a fraying amusement park in the fancy part of

town. Here the first morning of shooting for *Mintu the Murderer* would take place. Zainul had instructed his assistants to set up the camera while the lighting crew hooked up extension cords to a generator. After this they waited in the shade. The gentle morning light had long passed them by and the eleven o'clock sun baked the fading paint of the park's benches. The production boys passed around tea and snacks. Zainul sat on a plastic stool beside the camera. It stood on a wooden tripod, blind to the scene before it. Zainul sipped his tea. The technicians waited. Behind them the large Ferris wheel stood motionless.

Activity burst onto the set when film director Shiplu arrived with his artists. They had been in makeup for the last hour. A young girl in a sleeveless *shalwar kameez* traipsed up toward the camera. The girl touched the metal casing that held the film and brought her hand to her chest. She then lifted the same hand to her mouth and kissed it. She repeated the gesture, expressing respect for the machinery that captured her image. "You'll make me beautiful, won't you, Zainul *bhai*," the girl pleaded with the cameraman beside the tripod. She flashed the heavy fake eyelashes surrounding her perfectly shaped eyes. Zainul smiled at her and assured her of his skill in translating her natural beauty to the star image she would acquire onscreen. He, too, relied on the camera to bring out the natural beauty of the starlet to the satisfaction of the producer, his paymaster. When he had set the camera on its tripod earlier in the morning, he had expressed his respects to the equipment with hand gestures similar to those of the young actress. As chief cameraman his livelihood depended on this tool. He therefore always paid his respect to the camera on the first day of shooting for a new film. Today the camera would be opened for *Mintu the Murderer*, and Zainul wanted to ensure a propitious fortnight of shooting.[1]

It was twelve days after director Shahadat Ali Shiplu had first sat down with scriptwriter Rony to brainstorm for the *Mintu the Murderer* script. On the first day of shooting they would shoot sequence 17, in which the romantic heroine meets the husband picked for her by her brother and falls in love with the romantic hero accidentally passing by. Senior assistant director Faruk, acting as script supervisor, carried these pages of the script on a clipboard. Much of the printed dialogue written by Rony had been crossed out, and several sections had new lines written in by hand. With a ballpoint pen he drew lines through some of the dialogue, dividing the sequence into shots. Decoupage, or the cutting up of the script into shots, was done on the set, minutes before the shots were taken.

The opening shot would establish the scene. The heroine was sitting with her friends and sister-in-law at a table in Wonderland, burgers and soft drinks in front of them, speculating about the looks of the husband-to-be. The first shot would take in the scene and show a dialogue between the heroine and her friend. The rest of the sequence was divided largely to coincide with a shot/reverse shot structure, following the dialogue taking place between the heroine and her companions.

Shiplu told Zainul that the first shot would be of the heroine and her friends around the table. The director gathered the actresses and positioned them in a half circle. He fiddled with their clothes, read out their dialogue, and explained what the scene was about. The actors did not know the story of the movie they were acting in and were briefed on the set per scene. Only the senior members of the crew, such as Zainul and the assistant directors, had been briefed about the entire film beforehand. The young heroine, Shavana, was wearing a yellow *shalwar kameez* refashioned by the production house's tailor. He had lopped off the sleeves of the prêt-a-porter georgette *kameez* and lowered its neckline. The waist and back were taken in to fit tightly around her petite figure. The canary yellow scarf formed a narrow band along her neck and disappeared over her shoulders. Beside her sat the more seasoned actress Shadnaz in her own brightly colored sari with matching ruffled blouse. Like Shavana, her eyes were heavily made up and shone out from a face that was pancaked a shade of yellowish white. Along her nose a broad white band had been painted, to make it seem long and straight. To Shadnaz's side were two junior artists, or extras. They were not made up and wore their own shalwar kameezes. Shiplu rearranged the scarf of one of the extras to resemble Shavana's. As Shiplu turned away, the girl slowly pulled the scarf back down to cover her chest rather than just her neck.

While Shiplu arranged the actresses, Zainul instructed his assistants and the light men. He gestured to demonstrate the position in which the camera should be set up. The heavy wooden tripod was lugged about ten feet from the table. He asked the assistant in charge of the lens case for the zoom lens and instructed another to measure the distance to the scene to set the aperture. To both sides of the table Zainul positioned solar lights, placing a light man with a card between the glare of the lights and the camera. His chief assistant carried the light meter and read its measurement in the bright sun. Zainul calculated the aperture to a slight overexposure. Then he leaned in toward the viewfinder and checked the frame. He would pan toward the women until they were all in the frame.

There he would remain until the dialogue exchanges were spoken. "Have a look Shiplu *bhai*," called Zainul to the director. "Coming, *ustad*," replied Shiplu as he finished instructing the women. Shiplu stepped up toward the camera and checked the framing of the actresses that Zainul had envisaged. "I'll pan from the pond to the table," explained Zainul. Looking through the viewfinder, Shiplu moved the camera along the angle described by Zainul and agreed to his suggestions.

"Uncle, we're ready," called Shiplu to the producer Litu, who had placed his short rotund body on a bright red plastic stool in the shade of a tree. Next to him the hero, Salman, sat in a foldout chair, his long denim-clad legs stretched before him. His young assistant struggled to hold a large umbrella over the actor's head. Litu hollered at his assistants and motioned the young starlet Shavana to come join him. As the actress strolled toward him, the production boys brought out large paper boxes filled with sweets. Every *mohorot*, the first shot of a new film and the first cut of a final negative print, was celebrated with sweets. Litu held out a *gulab jamon* for the beautiful Shavana. Careful not to smudge her lipstick, Shavana bit into the tip of the proffered sweet. The producers, director, and the main artists present fed each other sweets. The still photographer memorialized the event with a number of group pictures. The crew ate their sweets while they worked. As the producer reclined in the shade, sweets in hand, Shiplu set out to direct the first shot.

"Shavana, ready?" asked Shiplu as the heroine took her seat at the table. Shiplu had taken his place beside the camera. On the other side Faruk stood with the dialogues in his hands. Next to him junior assistant director Nazmul held a notebook under his arm and used chalk to write the scene, shot, and take on a clapboard that had "Killer Mintu" painted on it in flowery red lettering. "*Ustad*, ready?" asked Shiplu of Zainul. "Yes, take, take," replied Zainul, anxious to get under way. It was twelve thirty, and most of the morning shift had disappeared. In the burning afternoon sun Shiplu looked up, closed his eyes, and, as he opened them again, called for the take. Zainul ran the film and swiveled the camera from left to right. As it came to a standstill, assistant director Faruk started to holler out the dialogue. He read from the pages of the script held by his clipboard. "I don't understand why a good student like you would spoil her studies by getting married," he yelled in flat tones. While he spoke, one of the extras repeated him verbatim. "I don't have any choice, dear," Faruk screamed. Shavana repeated the words with elaborate facial expressions. She spoke softly and was barely audible. As she spoke, Zainul used the zoom lens to slowly frame the group

of women ever more tightly. By the end of Shavana's two sentences, he held the frame in place. When Shadnaz's lines came, she repeated Faruk in a clear voice. Shavana's final line finished the shot. "Cut!" called Shiplu, "Ok!" Nazmul presented the clapboard to the camera and Zainul took a shot of it before moving the camera. In his notebook Nazmul jotted down that the first take of the first shot for scene 17 was okay. They moved on to the next, three weeks' worth of shots still to go.

I have given this lengthy description of a single shot for *Mintu the Murderer* as a basis from which to explain how the technical aspects of the shoot produce a distinct aesthetic for action cinema. There are some common features to popular Bangladeshi cinema. The most important of these are overexposure in most scenes, predominantly bluish hues in the coloring of certain sequences, sudden transitions, shallow depths of field, a strong frontal focus on the actors in a frame, minimal mise-en-scène, sudden twists and jerks of the camera, melodramatic acting styles, out-of-synch dialogue, and many stock sounds. I will account for this aesthetic by relating each element of the first shot of scene 17 to Zainul's perspective on cinematography. Between takes he would often sit with me, explaining the craft and illustrating what he had just done for *Mintu the Murderer*. It was Zainul and his team of assistants who guided me through the filmmaking process, explaining the technical but also the personal sides of filmmaking at the FDC. With tea and *paan*, during lunch or late at night, after a long day of shooting, they would patiently explain to me what had happened on set, who said what, and why things worked the way they did.

SEQUENCE 17 DISSECTED

"In our country there are mostly 2C cameras," said Zainul about the Arriflex 2C camera he was using for *Mintu the Murderer*. The camera had been rented from the FDC's Camera Society. It dated from the 1960s and was the cheapest of the cameras available. Zainul would prefer to work with one of the better cameras at the corporation: "Who doesn't want to work with nice things?" The FDC owned three 4C cameras, Arriflex 435s. "There is only one 4C camera right now," said Zainul. "Two are broken." The state of disrepair of the 4Cs was partly due to their lack of use. While the cheaper 2C cameras were in continuous use, few production parties were willing to spend the money needed to rent the 4Cs. "And," added Zainul, "with this party, I won't be able to use it. To use this camera you will have to

apply five or six months in advance. If I wanted the [4C] camera then, I would get it. But these parties, they'll gather the money four to five days before shooting, and then a party will get formed. So we can't take the 4C." The low-budget productions were made quickly; therefore, the easily available 2C cameras were typically used.

Because the 2C camera had a noisy engine, all films produced within the FDC were shot entirely without sound. No sound recordings were made during the twelve days in which *Mintu the Murderer* was shot. Instead, dialogue, background sound, and music were all produced and mixed in the corporation's sound studios (for an account of the dubbing process at the FDC and its gendered implications see Hoek 2009). In his discussion of the development of sound recording in American cinema, John Belton notes how in sound mixing "the sound track loses its wholeness: it is separated into dialogue, sound effects, and music tracks that are recorded at different times" (Belton 2004:393). At the FDC no direct connection, or indexicality, remained between the moment of shooting and the sound that was put under the imagery. All sound was produced in the studio, and not even a guide track was recorded on set. Often the actors did not dub their own dialogue. Instead, dubbing artists were used to supply their voice in a process called automated dialogue replacement (ADR). Thus, "the building of the sound-track, using the image rather than the pro-filmic event as a guide, now becomes a final stage in the realization of the image" (ibid.). A soundtrack so radically separated from the set and completely built according to the image distinguished the FDC-produced film from short film and telefilm, which both used on-set recording to build their soundtracks. The radically separated soundtrack of action films is immediately recognizable for its stock sounds (cars braking, footsteps, the iconic "dishooms"), the impossibility of perfect lip-synching, and the limited number of dubbing artists who fill in most speaking parts in any film. This practice created a unified sound aesthetic that is found in most mainstream Bangladeshi cinema—big-budget romances, "healthy" films about the Liberation War, and action films alike. The delegation of sound to postproduction was a fast and efficient use of the available technology. It allowed short shooting times and was therefore cost-effective. Keeping an entire crew and stars on a set would be much more expensive and much more unpredictable than renting the FDC sound theaters and its skilled staff.

The noisy 2C camera and the lack of sound recording on the set also affected acting practices. On the *Mintu* set, dialogue was hollered at actors in flat tones by the assistant directors during shooting. The actors didn't

have to make any sounds, only to move their lips. They lacked knowledge of the film's exact plot, and method acting was impossible. Dramatic representations of particular moods, such as tearful reunions, aggressive threats, or sensuous indulgence, were dramatically enacted through broad gestures and elaborate facial expressions without much sound. Such acting practices were especially common for character actors. These actors performed iconic types representing generic elements, and they did so in personally crafted routines recognizable across different films. Many of these actors blended their characters and persona. The character actor and comedian Kabilla, for example, held on to his own name onscreen and off, wore his own clothes, and commenced his routine when entering the FDC complex, not just when "take" was called. In *Mintu the Murderer* character actors were cast to perform their already established routines in their own subplots, largely independent of the main story. The lack of on-set sound recording and the independence of acting from the plot result in the acting styles so criticized by both Kabir (1979) and Ray (1993) in popular Bengali cinema.

With the 2C camera Zainul used an array of lenses. "In our country we have 9.8, fish eye, 16, 14, 18, 24, 25, 32, 35, 40, 50, 75, and 85," enumerated Zainul. In his description of his cinematographic practice, he would always speak in the plural. In this way he referred to the filmmaking practices of those working within the FDC, which in his account stood for filmmaking practice in Bangladesh generally. His description of cinematography took place within the imagined boundary of the nation and was actively set off from other national film industries, most notably those of India and America.

I asked Zainul which of these many lenses he used most. "The 40 lens, this is your 'master lens,'" explained Zainul. "The 40 lens captures your figure just as it is; this lens won't give you any change [in perspective]. Of all the lenses, we use this one most." A 40mm lens is a normal lens when using 35mm film in cinematography (Wilson 1983:108). For the first shot of sequence 17 Zainul had used a zoom lens with a focal length of 24mm to 120mm. He had started the shot at 24mm, giving the widest possible view, and then slowly expanded the focal length to zoom in on the actresses. Later on he explained the use of the fixed 24mm lens: "The 24 lens is a little wide. When we're outside, we need this depth to get all the subjects in focus. When we need the background as well as the artist, then we'll use a 24 lens. So we'll have a focus on the artists, and the background, too, will be clear because of the wider depth of field."

The next shot of sequence 17 was a close-up of Shadnaz and Shavana talking to each other. There Zainul used the "natural" 40mm lens. In the subsequent close-up of Shavana as she watches the hero stroll past, Zainul used an 85mm lens. "For actresses like Shavana, Jonna, Jenny, I use a 75 or 85 lens. This is to make their faces bigger." I asked him why they had to be made bigger. "They have smaller faces, [so] using a 75 or 85 lens will make them rounder, bigger, and more smooth. It will look more beautiful on the screen. It will be made better than it is." On the lanky romantic hero of *Mintu the Murderer* Zainul would use a similar lens to fill out his face. For the action hero, played by the shorter and stouter Sumit Hossain, Zainul would use a 35mm or a 40mm lens. The actor's bigger face would be expanded only a little. "Where it is broken and scarred, it will become smooth," said Zainul. "He will look better."

For Zainul the choice of lens depended on the actors in front of it. The purpose of the lenses and framing was to maintain a clear and unambiguous focus on the dramatic action unfolding between characters. The frames cut tightly around the faces or bodies of the protagonists, and the lenses brought out their faces as much as possible. When shooting actors and drama, the bulk of shots for action films, Zainul preferred lenses with long focal lengths, creating shallow depths of field, and he tightly framed the actors without any real background to speak of. Deep focus was generally uncommon in popular Bangladeshi cinema, although shorter lenses were available. In *Mintu the Murderer* Zainul made use of shorter focal length lenses only in confined spaces. While such short focal lenses can be used to create a wide canvas with a deep focus, Zainul used it when he was confined to the backseat of a car. Being extremely close to the heroine in the front seat, he used a very short focal length to capture her entire face, ending up with an almost spherical image.

The effects of Zainul's shallow depths of field were further enhanced by decoupage and mise-en-scène. The on-set decoupage followed a strict shot/reverse shot format, giving each character his or her own shot accompanying the delivery of spoken lines and allowing assistant directors to cut the sequences into shots without intervention by the film's director. Shiplu explained this practice according to cinematographic conventions in Bangladesh. "In the West you have different sorts of shots and sets with lots of detail," he said, comparing the filmmaking traditions. "Here in Bangladesh the background is much lighter." According to scriptwriter Rony this technique has to do with the focus on the artist: "We prefer a shot with the actress in the middle

and the sides of the shot almost empty." The depth of field in such shots was extremely shallow, highlighting the presence of the star, while the takes were short, following the dialogue. This practice is far removed from Bazin's idea of depth and composition, in which "whole scenes are covered in one take, the camera remaining motionless" (Bazin 2004:48) and "the effect and meaning are not the product of a juxtaposition of images, but are inherent in the visual images themselves" (Braudy and Cohen 2004:2). Zainul's ubiquitous use of the longer lenses, his tight framing, and the lighting of his stage design created many comparatively shallow frames that focused solely on the subjects placed before the lens and their immediate actions.

In his book *The Ideology of the Hindi Film* (1998), M. Madhava Prasad notes how "in the case of the Indian popular cinema, we encounter a situation that seems to correspond to the non-realist model that Bazin criticizes" (23). Instead of a realism that asks the spectator to interpret a wide canvas with an elaborate mise-en-scène, Prasad sees a frontal aesthetics in popular Hindi films. "In the frontal spectacle, the performer is the bearer of a message from the symbolic, and the performance a vehicle for its transmission to the spectator" (20). He continues: "the performance as a whole . . . is an apparatus for the devolution of a message/meaning that pre-exists any performative instance" (71–72). This preexistence of the message devolved through such a frontal aesthetic relates to the preordained moral categories through which the melodrama of popular Indian cinema unfolds (ibid.; see also Thomas 1996). In the frontal aesthetic with shallow depths of field produced by Zainul, meaning is transferred to the spectator from a central point, taking the spectator by the arm and leaving no ambiguities about the moral position of a character and the appropriate reading of the film.

The pan inserted at the beginning of sequence 17 by Zainul might seem to counteract the shallowness of the frame. However, more than establishing a sense of the location in which the protagonists find themselves (in which the fraying Wonderland background purveys a sense of lower-middle-class aspirations expressed through associations with leisure time and branded soft drinks), the pan fulfilled a technological function related directly to montage. Zainul always built transitions into his shots. "I will always first think where the previous sequence was cut. That is what it depends on. Where did I 'rip' the sequence preceding? From where I start with a sequence depends on that." In Eisensteinian fashion Zainul made filmic meaning through the juxtaposition of shots. The importation of

questions of montage into his shoot was related to editing practices at the FDC. "Dissolve?!!" laughed Shiplu, when I asked him about the lack of dissolves or fades in *Mintu the Murderer* later on. "No one uses dissolves!" He asked all present in the cramped editing room to tell him if they knew what a fade was. No one could answer him. As I explain in chapter 4, montage for *Mintu the Murderer* only made use of cuts. To soften the at times abrupt changes between scenes, Zainul would try to ease into a new sequence by inserting pans or opening a new shot with reference to the one preceding it. Although most of these transitions would eventually be cut out in the editing process, Zainul's cinematography nevertheless carried the traces of such transition building. Rather than a gesture toward composition-in-depth, such pans sutured scenes that would otherwise be abruptly spliced together in the editing rooms.

Zainul made do with a zoom lens and a trolley (always using this English word to refer to the dolly) to create all the effects in his films. The zoom he used at the end of the pan would bring the protagonists closer and would give the shot more movement. In action films he often juxtaposed the zoom with the trolley shot. To take close-ups of villains he would take low angles and rapidly approach the villain from the front with a long focal length lens. The villain's eyes would be enlarged both by the lens and the expressive acting typical of the character actors. In the sound studio an ominous "*eeeeeehhh!*" would be added to such a zoom. "These are odd effects," explained Zainul, "to interest the audience." The rapid twisting of the camera created a similar effect. "The audience will be curious: '*eh shala*, what's happened?!' They'll say that sort of thing." Zainul's hands-on camera work thus created a range of dramatic visual effects. In the absence of special effects departments and expensive montage techniques, Zainul used imaginative cinematography to produce special visual effects.

The effects of the framing and lenses were strengthened in sequence 17 by Zainul's lighting practices. He had set up two solar lights beside the actresses, aimed at reducing the shadows on their faces underneath the midday sun. At the same time, the cross lights cancelled out any formation of shadow on their faces whatsoever, literally smoothing them out. I asked him to explain this way of lighting the scene:

> *Zainul:* If there are three artists, I will have one light from the back, I will put one light on the right, a cross-light, and on the left another cross-light and in the middle I will have a "wash."

Lotte: A wash?

Zainul: A wash is an even light. It diminishes the shadows from the
side. . . . Since I am doing this with cross-lights, I'll have a cut light.
Cut light means a cross light. From the cross light on the side I will
get your eyes, with the cross light here I will get his eyes, but from
here [the front] there is no light, so I will give a gentle wash light
from here [i.e., from the position of the camera, facing the artists].

When I asked him why he did this, he replied that there is no theory
of lighting: "It is the personal theory of a particular cameraman, what
he likes."

Zainul did hold express opinions about what lighting he liked. "As a
cameraman, I want the actress to look better than she is, her skin better
than what it is. People want artists to be more than what they are. This
is necessary for a heroine or a hero, isn't it?" The abundant use of light
to rid the faces of the actresses of any shadows achieved this aim. Rather
than bouncing light off white surfaces, all lights would be aimed directly
at the subjects in front of the camera, creating a harsh image without
shadows. To Zainul, however, such brightly lit faces achieved the aim of
embellishing the hero and heroine. "I could use a solar with paper," said
Zainul about using a paper filter with the wash light, "if I put the paper,
what happens is that the wash will be *smoooooth*." Zainul emphasized the
lone English word. "We use butter-paper, because there is nothing else."
This makeshift gel achieved the smoothness that was the aim of his lens
and light choice. Smoothness described the effect of large and luminous
faces directly addressing the spectator.

Zainul's lighting practices conformed to other regularities in FDC films.
For *Mintu the Murderer* Zainul used two babies (1 kilowatt lights), twelve
"solars" (2 kilowatt lights), one panja (meaning five or hand, a five-kilowatt
light), and a daylight. The first four lights are tungsten lights, with high
color temperatures, creating yellow and reddish colors. The daylight was
created using HMI (Hydrargyrum Medium-arc Iodide) light, which has
a low color temperature, producing light close to daylight. Ideally, one
would not mix this HMI light with the tungsten lights without using CTO
(Color Temperature Orange) filters or gels, to make the HMI light orange.
Similarly, one would use different stock for outdoor and indoor shoot-
ing, T-type balanced for tungsten light and D-type balanced for daylight.
However, D-type film was unavailable in Bangladesh. Zainul combined the
T-type with his own handmade orange filters. His assistants would hold

these in front of the expensive Carl Zeiss lenses while Zainul filmed, turning the blue daylight orange. Often, however, during long shooting days, they would mix day and tungsten light without using a filter, because there wasn't enough time, and not enough lights had been rented by a production party. The blue hues that appeared in some sequences in FDC-produced films were due to the use of T-type film with daylight without filters. Zainul worked according to his own rules and within the limits set by the budget and technological environment. The peculiar colors of the reels were exacerbated by the conditions in the FDC lab, where, cameramen complained, the solutions were old and off. Idiosyncratic light effects could be found in the films shot by all cameramen working at the Bangladesh Film Development Corporation. Part necessity, part innovation, these techniques further endowed the popular film with its own recognizable aesthetic.

There were further technical limitations with which Zainul had to contend. He liked to recount how he had explained the secrets behind his light-filled frames to the late superstar actor Manna:

> Manna *shaheb* asked me: "Zainul, why do you use so much light? What is the reason for that? You are a cameraman so you must have a reason, your own theory. Why do you do this?" Then I told Manna *shaheb*, "Yes, I have my own theory. The theory is that if I watch my own films in Dhaka, it looks bright, too much light. Your [i.e., Manna's] movies are clear in the Dhaka halls. But if you watch them in the *mofussil* halls, done by your cameraman, then you'll see that they [the audience] can't see. [They'll say] 'Eh! There's no light! No light!' And if my movies go to the *mofussil*, then you'll think it is as clear as the movies in Dhaka." Today our market is a *mofussil* market. So I will think about them when I light. But listen, this is not any sort of international theory. This is what I apply, from my own experience. With the environment here, the photography is adapted to that environment. That's why I overexpose.

The projection equipment in small-town cinema halls, which make up the bulk of Bangladesh's film theaters, is often old and not fully functional. Zainul knew the industry's main addressee was the audience in these cinema halls and adapted his photography to their conditions. The overexposure of popular film is a result of the imagined imperfect media environment of *mofussil* towns. The *mofussil* spectator was already inscribed into the aesthetic of the film.

The brightness of the frames produced by Zainul was finally also a negative choice. He described the use of the wash light as a weakness: "It is a weakness because of the speed at which we work. If I want to light an actress with cut-lights [i.e., with indirect light and the creation of shadows], it would take me a very long time and many lights. . . . How many sequences do I do in one day? I do four or five sequences, six sequences. In that case I would be able to do only one sequence in a whole day. Then a film would not be ready in ten or twelve days, it would take a whole month."

The speed at which *Mintu the Murderer* was shot did not allow for the visual delicacies Zainul might have envisaged. Time limitations combined with the use of lights, lenses, decoupage, film stock, camera setups, and exposure to produce a particular film aesthetic. This consisted of overexposure, lack of shadows, tight framing, frontal approach to subjects, limited depth of field, blue hues, stock sounds, limited range of voices (often out of synch), no natural sound, and melodramatic acting. This aesthetic was partly the result of technological conditions within the FDC and in the cinema halls but also constituted a positive choice on the part of the filmmakers and producers.

POPULAR TO PUBLIC: HOW INSTITUTIONAL REGULATION IMPACTS FILMMAKING

Bangladeshi popular cinema didn't always look like *Mintu the Murderer*. Zainul entered the film industry in another era, when film production in Bangladesh had been organized in a different manner. The private studio in which Zainul first learned his craft barely resembled the current FDC regime in which he worked. The institutional environment within which film production takes place decisively shapes the way technologies are deployed and the visual form film takes. In this section I describe how Zainul came to work at the Bangladesh Film Development Corporation and show how the institutional regime there impacts filmmaking.

Zainul's career in cinema started when he left home in a spat with his mother. He had grown up in Chittagong, where his father worked with the railways. Zainul was fascinated by football and film and as a schoolboy used his pocket money to buy a secondhand Pentax. When one day his mother scolded him for spending more time taking photographs and playing football than studying, he ran off to Dhaka to find a job. It was 1984 and Zainul was twenty-four years old. He turned to his father's friend

M. A. Awal for a job. Awal was the owner of Popular Studio, a private film studio in Pagla, Narayangunj, almost sixteen miles south of Dhaka. It was here that Zainul's career as a cameraman began.

Popular Studio was the country's first private film studio, set up in 1965. When Awal took over Popular Studio in 1977, he turned it into a private company and expanded its facilities (Qader 1993:359). At that time production houses used private studios for shooting. Private investors, such as Awal, invested in cameras and lighting equipment, technicians, floors, sets, and elaborately manicured natural environments. Qader's description of Popular includes a detailed list of the types of flowers and trees that the company maintained, as well as a description of its large field, waterfront, and pond (1993:359). Qader's elaborate description of both the equipment and the scenery of each of the four private studios shows how scenic shooting spots and dreamlike backgrounds were the main commodity sold by these studios. With the steady increase in film production, the additional facilities that the private studios provided to the fledgling FDC in the 1960s were indispensable.

Both the mid-1960s and the mid-1980s saw a dramatic increase in film production and a transformation of audiences and main genres. It was at this second phase of growth in the industry that Zainul turned to his father's friend for a job. Awal offered Zainul a position as assistant cameraman, and he gladly took it. As Zainul explained: "When I went to watch a film, as a child, even then I would think that the cameraman was the most important person. He would take such beautiful pictures, how beautifully it was being lit. If I could do such work! . . . I wasn't interested in directing. I wanted technical work, which has life! I wanted to work from the heart." This passionate technical work Zainul learned as an assistant at Popular Studio. The private company had a complete technical staff on its payroll. According to Qader, in the early 1990s this cost Popular Studio 20 million taka per year in salaries (1993:359). The studio employed technicians such as cameramen, lighting crews, and carpenters. Zainul worked in this arrangement for ten years. During this time he learned the craft from the chief cameraman. "I would ask him, 'Ustad, with what lens have you taken this close up?' or 'What lighting did you use?' When I was with my ustad, I tried to understand what he was doing. Afterwards, I worked from his theory." Zainul continued to address his teacher as ustad, a term of respect used for those who have mastered artistic skill or technical craft. On the set of Mintu the Murderer Zainul was always addressed as ustad.

Zainul learned by watching and emulating his *ustad* at Popular Studio. Through his apprenticeship, he learned to control the lights and the aperture, to make filters, and to transform the actors into stars. The internalization of shooting practices through the apprenticeship structures formed his aesthetic decisions. "We who work in film, we haven't studied anywhere," he said. "It is all experience. You can learn, but the work hasn't been taught anywhere. . . . You work from your own memory: what comes when and what you like." In lieu of filmmaking institutions, filmmaking skills were and continue to be passed along through apprenticeships. Such a *guru-shishyo* framework is an important means of imparting proficiency in the performative arts across South Asia (see Schwartz 2004:5). On a number of occasions I heard established art filmmakers, young cinephiles, or documentary filmmakers blame the "bad" camera work or editing in popular cinema on a lack of formal education. This notion feeds directly into ideas about the vulgar, coarse, and unskilled nature of this cinema.

By the late 1990s, this apprenticeship structure had become contained entirely within the FDC. Few of the private studios that had been set up in the 1960s and 1970s survived the 1990s. When M. A. Awal died in 1994, Popular Studio was sold and never revived. The time of the private studios had passed; of those in existence in the 1960s and 1970s, only Bari studio, in Testuri Bazaar, survived into the twenty-first century. This studio had changed with the times, having invested in a video camera and video editing technologies, as well as color lab facilities. Unlike the other studios, its investments had not been in mango trees or lily ponds but new technologies (Qader 1993:360). It had rid itself of the financial burden of hiring creative staff and instead merely rented out its facilities. Working conditions for those in the film industry had changed, and most now depended on individual producers to hire them on particular projects, rather than being on permanent contracts with a particular studio.

As the FDC expanded to include more floors and more facilities, and private studios shut down, the FDC came to be the only place for making popular films in Bangladesh. Access to the large gated compound in the center of Dhaka was based on membership of the cinema associations or employment with the corporation. Its large entrance was covered in sparkling white tiles and decorated with the portrait of the father of the nation, Sheikh Mujibur Rahman. Outside, crowds would gather daily to spot stars going in and out. Those who managed to enter as friends or family members of a spot boy or a technician would wander the lanes of

the facility in wonder. The lanes led to floors and were skirted by lawns and small gardens. On some fields piles of used positive celluloid would lie abandoned. On any given day in 2005 at least two parties would be shooting, and many more would be locked up in the editing rooms and dubbing theaters. The Mercedes of the stars would drive right up to the studio floors. Key grips and gaffers could be seen balancing high above the ground, adjusting the spotlights atop a set piece. Extras waiting for a day's labor were gathered in a small room near the front gate, waiting for an assistant director to pick them to linger in a background. Along the lanes entire crews sat down on the floor to eat rice and fish. Amid all this journalists and producers milled, their eyes open for scandal and new talent. In the center of the compound was the Directors Association, where well-established directors sat and drank cups of tea. There was no need to ever leave the compound; everything and everyone necessary for making films in Bangladesh was at the FDC.

In 2005 the Bangladesh Film Development Corporation compound housed all the facilities necessary for making feature films: nine studio floors, each with attached and air-conditioned makeup rooms; eleven editing rooms; twenty-two "empty" rooms for cutting celluloid; a lab; three dubbing theaters; one rerecording theater; one background theater; an auditorium; and a mosque. Most cinema associations, such as the Directors Association and the Artists Society, had their offices on the premises. The management of the FDC was housed in a three-story building over the laboratory. A canteen and kitchen, volleyball field, and a number of collective eating spaces made up the rest of the FDC's facilities. A digital sound lab was under construction. The company imported raw stock and sold this to producers with an added 10 percent service charge.

Film producers were encouraged to work through the FDC structure, renting the corporation's facilities. Most films, like *Mintu the Murderer*, made use of this arrangement. *Mintu the Murderer* was a P-type film, according to which "the producer has to deposit an amount of BDT 430,000 [approx. US$6,825] as the security money. By virtue of this agreement, the producer receives the entire service from the shooting phase to the censor print development in credit in the provision that the developed negative of the film will be mortgaged to the corporation" (Bangladesh Film Development Corporation, Undated a). This provision made it highly desirable to work through the FDC structure because one could start without having even most of the investment ready. The system was also open to some abuse, however, because producers could easily shoot

more than one film under a single name and deposit, as Litu did during the making of *Mintu the Murderer*. As a public enterprise, the FDC needed to make a profit, and highly productive film producers and directors such as Litu and Shiplu were its most steady source of income. The shift to action films within the FDC has to be linked to the FDC's financial reliance on prolific producers and directors, like those of action films.

In 2005 the FDC was a public enterprise that functioned for profit but was also part of the government bureaucracy. It was set up with government money to support filmmaking in East Pakistan in 1958 (Hayat 1987:58; Qader 1993:324). Although now self-governing as a corporation, the FDC fell directly under the authority of the Ministry of Information. Its governing body was chaired by the secretary of the Ministry of Information and included highly placed bureaucrats of the Ministry of Trade, the Ministry of Foreign Affairs, and the Ministry of Cultural Affairs. The managing director of the FDC was appointed by the Ministry of Information and had a fixed three-year term. The FDC had 383 employees in 2005, spread over administrative, technical, and production-related divisions. These employees, such as the light technicians, sound technicians, "floor-in-charges," and all office employees, were commonly known as *shorkari* (government) staff. They were paid monthly incomes and built up a pension. The management, however, did not consider the term "*shorkari* staff" appropriate, as they preferred to see the FDC as a profit-based corporation rather than a government institution. Most of the FDC staff, however, considered themselves in the government's employment and explained their "service" as such.

Only through membership in the professional associations of cameramen at the FDC could Zainul be hired by film producers and work at the corporation. The Camera Society managed and maintained all the camera equipment owned by the FDC and registered and supervised all cameramen and camera assistants. Film producers that made their films within the FDC structure and took film stock and facilities on loan were required to work with freelance craftspeople who were members of the national professional associations. A variety of professional associations operated within the FDC, ranging from the Production Managers Association and Directors Association to the "Bhai Bhai Film Fighters Circle." In effect the professional associations were the gatekeepers to much of the employment in the Bangladesh film industry. Those in charge of the professional associations were the link between the management of the FDC and the

freelance creative labor that made use of its facilities for an investing producer. Their elections were accompanied by heavy electioneering and much suspense. Only those who made art films and telefilms, and were not reliant on FDC facilities, could work outside of this framework.

The division of labor at the FDC had definite aesthetic effects. On the one hand, freelance workers were organized through professional associations that functioned relatively independently of each other; on the other hand, permanently employed FDC staff operated key equipment such as the mixing tables and lights. *Shorkari* staff occupied their stations daily and for a number of films simultaneously. Similarly, the fighting troupes, character actors, and choreography teams traveled from set to set to perform their stunts and craft for the different parties that had hired them. Film production at the FDC, therefore, often involved the recombination of already existing skills, formats, and technologies. Prasad has termed a complex of similar processes in the Hindi film industry a "heterogeneous form of manufacture." He argues that in the Hindi film industry the "different component elements have not been subsumed under the dominance of a cinema committed to narrative coherence" (1998:45). Prasad is mainly concerned with the fact that many of the component parts of the filmmaking process have a tradition outside of the industry, such as the influence of Urdu poetry on dialogue writing. In the Bangladeshi industry a heterogeneous form of manufacture expressed itself in the relative autonomy of the different artistic practices within the FDC, such as scriptwriting, set building, sound mixing, fight directing, or comedy acting. These separate practices provided formatted parts that combined to produce *Mintu the Murderer* rather than being made subservient to the narrative of the film.

A good example of the artistic autonomy of the component parts of FDC films is the way in which sets are built. Two days before shooting for *Mintu the Murderer* commenced in Wonderland, assistant director Nazmul met Shah Yugantor, the "set and floor in charge" at the FDC. Shiplu had asked Nazmul to make sure that the sets for the first days of shooting would be ready on time. It was Yugantor's job to instruct the set builders about the kinds of sets and props that were needed. Yugantor was *shorkari* staff. He had been a carpenter before finding employment at the FDC thirty-seven years earlier. Born in Chandpur in 1953, he was educated until the age of sixteen and then started his work as a carpenter. He found a job at the FDC through a connection. By 2005, at

fifty-two years old, he had risen to manage all the carpenters at the FDC and was due for retirement.

"Basically we need a slum," Nazmul had said to Yugantor, "with a lower family house in it." He had used the English words "lower family" to describe the sort of set he needed. I asked him what this meant. "Like any house in a slum," Nazmul clarified. I asked Yugantor whether they would make a design or outline for such a room. "There's no need," said Yugantor; "we know exactly what a lower, middle or high family house looks like." Every set could be organized under basic categories like "godown," "hospital," or "bar." There was no need to further elaborate on the set required. "And a dance set," added Nazmul, "for the second day of shooting." Yugantor noted it down. He assured Nazmul it would be no problem; he would set them up on the day of shooting. I asked Yugantor whether this was not a little tight, to build a whole set. "These are not very difficult sets," replied Yugantor. "These sets we can build in a few hours." And that concluded Nazmul's meeting with Yugantor. The sets for *Mintu the Murderer* came about through a recombination of existing elements, as set pieces and props were reused, walls repainted, and sofas rearranged to create new sets. Yugantor's team built standardized sets for most films in production at the FDC, irrespective of the intricacies of a particular plot.

The distinctive aesthetic of popular Bangladeshi cinema is not only the result of a cameraman's individual inclinations, such as Zainul's preference for wash lights and overexposure. The institutional framework provided by the FDC has a strong influence on the way its movies look. Production parties making action films have become an important source of income for the FDC. It is to them that the corporation sells or rents most of its material for filmmaking (T-type stock, daylights, flatbed editing tables, and Rock and Roll machines). These come packaged into sets of cinematic services staffed by permanent employees who work according to their time-controlled shifts. Filmmaking in the FDC allows film directors little leeway to steer these different departments according to the narrative requirements of a particular film. Instead, directors such as Shiplu rely on this well-oiled filmmaking machine to make many films in a very short time span. The result is a distinctive aesthetic that can be recognized in almost all films made at the FDC. It is this aesthetic that has elicited accusations of vulgarity, referring to "unimaginative," "coarse," and "unsophisticated" use of the filmmaking technologies available.

THE SOCIAL LIFE OF THE SET

"It is all about the relations you maintain," Zainul said. "It's about your behavior, your activities, and your work." The way Zainul shot the many action sequences that passed before his lenses was not only dependent on the state of the Arriflexes in the Camera Society's possession but also on the social life of the sets on which he deployed the 2C. The social world of the FDC animated the institutional framework of filmmaking, and it was into this social world that the technologies of filmmaking were embedded. In the final two sections of this chapter I will outline this social world and its impact on filmmaking, first by describing the personal relations on set through a detailed account of the shooting of sequence 68 of *Mintu the Murderer* and, second, by showing how hierarchical relations between filmmakers were mediated by the professional associations.

"I can say that, by the grace of Allah, I have always maintained good relations with everyone here," said Zainul. "That's why I have work." Zainul was acutely aware that since the demise of Popular Studio, he was fully dependent on producers to hire him from among the many cameramen available at the FDC. He had a wife and three young children and had to pay for the house he rented on the edge of the city, over an hours' bus ride from the FDC. There was no security beyond the work he could get right now; thus, he worked long days, all days. He worked two shifts a day, from eight in the morning to eleven at night. He would lament the lack of time he had with his children, especially when he went outdoors. Often he and his assistants would spend whole weeks in a row at outdoor shooting spots. The high tide for action films kept Zainul busy, as he was mostly hired to shoot action movies. Prolific action directors like Shiplu hired Zainul often. At the time of shooting *Mintu the Murderer* he had a number of bookings lined up to fill the next months. He would receive about 50,000 taka (almost US$800) for each film he completed, which he did every fortnight. He paid 20,000 taka (approx. US$320) of this to his assistants, who split the amount among themselves. Although the production parties rarely paid the sum in full and on time, Zainul did manage to make a living following his passion for the technical work of the cameraman.

It was the third day of shooting for sequence 68 of *Mintu the Murderer*, March 15, 2005. This sequence was the climactic fight scene in which the mafia don Badsha, played by Sumit Hossain, takes out Mintu, played by Jishu Jadughor. The ten-minute sequence mainly involved scenes of

fighting and bombs exploding. Over five days the entire sequence was shot under a big tree where tables and chairs suggested a wedding party.

That morning none of the actors had appeared from the makeup rooms as yet. Zainul sat on a plastic stool and called out for a *paan*. One of the most crucial tasks of the assistant in charge of the lens box was to make sure that nestled among the Zeiss lenses were a number of *paans*, ready for consumption. Chewing on the bitter leaves was Zainul's means to work tirelessly through the long days. It was mid-March, and the sun burned down on the camera assistants, the fighters, and light men assembled at the set. The assistant directors made their rounds from the makeup rooms to the room where the extras waited for jobs and then on to the lab, where the first reels were being processed.

In a corner of the set one member of the fighting troupe sat on his haunches and performed the delicate task of filling condoms with Rooh Afza. The sweet red syrup favored by children had a remarkable likeness to blood. Full condoms were taped to small wooden planks. "Condoms are thin and because they are slippery, they conduct electricity well," the fighter explained. "We attach the wires to the condoms, and when we turn on the electricity, the condoms will explode." Worn under a torn shirt, the exploding condoms are hidden, but the Rooh Afza bursts forth from a hole in the shirt, giving the impression of blood gushing from a bullet wound. The fighters would have wires running through their trousers and across their chest to deliver electric current to the condom. Many condoms were needed for the elaborate fight scenes of sequence 68, and thanks to the HIV/AIDS campaigns set up by development organizations, the fighters could fill up many condoms at a very low cost.

It was after eleven when the stars of the film appeared on the set. Salman's little assistant struggled with a foldout chair. As Salman sat down, the boy angled the umbrella over the actor's painted face to ward off the sun. The sassy assistant to actress Jenny positioned a similar chair beside Salman's and yelled at the action heroine to come and sit down. Jenny bunched up her orange sari and flopped down in the chair. "Tea, isn't there tea?!" hollered Jenny, before her assistant took over her cry. A skinny production boy in fashionably patterned jeans and a *tabij* tied around his arm, brought three cups of hot sweet tea. Salman waved him away. "Lota, tea!" ordered Jenny, as she gestured me to sit on the stool beside her. I took the cup rejected by Salman. The hierarchies on the set were clearly structured, and the order in which food was consumed was carefully maintained by the production boys, themselves at the bottom of

the pile, always eating last. First to eat were the stars, director, and producer. Their lunches were served in the air-conditioned makeup rooms. The rest of the crew and cast ate on the set floor and outside, along the FDC lanes. The same food was served to everyone, however, and the same cups and plates circulated among everyone present on the set. In these hierarchies Zainul's position was among that of the senior crew. Only the director, producer, and the stars outranked him. At times he would eat with the director and stars in the makeup rooms, but more often he could be found outside, sitting beside the tripod, chatting with the lighting crew and the extras. His pleasant personality secured good relations with all, not only the producers. Zainul's genial temperament would, however, be severely tested during the hectic shooting day ahead.

Before taking the first shot of the day, Zainul was instructed by the special effects director, Munna. As the leader of the fighting troupe hired by the producer of *Mintu the Murderer*, Imdad Hasan Munna directed all action sequences. Shiplu would observe Munna direct his fighters as they acted out elaborate battles. There were a number of fighting troupes at the FDC, each led by an established film fighter. Most of these men prided themselves on their martial arts skills and had made their careers in the 1980s, when a sudden craze for martial arts blew over from the United States and Hong Kong. Munna explained to Zainul there would be an explosion first and then a gunfight. Shiplu sat back and let Munna direct the fight sequence. During each film Zainul worked with a fight director and a dance director. They would autonomously enact their craft. Shiplu often left Zainul alone with Munna or any of the dance directors involved in *Mintu the Murderer*. Zainul was explicit about the impact this had on his shooting practice. "When I am working with the film director, I will work according to his sense of style," he said. "But when I am working with the fight director, I will adapt to his vision." Each director represented a different element that made up the entire film, and each had his own style, to which Zainul adapted his camera work.

"They'll run in from here," explained Munna, as he held his thumbs and index fingers at right angles to indicate the frame he envisaged, "raise their guns, and shoot. Next shot, Mintu's henchmen on that side are hit in the chest and fall down." Zainul nodded and started to set up the camera. He instructed his assistants to use the trolley. The fighters worked fast and efficiently. Three of them took off their shirts and had the filled condoms strapped to their chests. Electric wires were pushed through the back of their trousers, and linked up to a switchboard out of frame.

The villains had similar wires pushed through their shirtsleeves, linking up to the fake guns they were holding. "Lights up!" cried Zainul. As Munna called "Action," a metal rod out of frame was pushed to the switchboard, briefly completing the electric circuit of the wires in the villains' sleeves, setting the guns off with a bang and lots of smoke. "Cut it!" The shot was okay and the next one set up. Because the fight scenes consisted of very short takes, Munna and Zainul worked in close synch at a high speed, making their way through the standardized fights. The camera was repositioned and with the call for action, the electric circuit was closed again and the current passed to the condoms, making them explode. The Rooh Afza pushed through the ripped shirts and the fighters dropped down in an elaborate posture of violent death.

While Zainul and Munna worked their way through the many battles of sequences 68, visitors and spectators came by the set for a chat or a peek, some people in search of work, others in search of friends. Among the visitors that day were two men who did not go by unnoticed. Salman had just slung the heroine, Shavana, over his shoulders, and Zainul knelt, the 2C handheld to his face, taking a low angle to capture the dramatic rescue of the heroine. The two visitors made their way to a bit of shade, where a number of plastic chairs were quickly vacated for them. "Please sit down, sir," said Sumit Hossain, the action hero who had rapidly crossed the set to offer the gentlemen a seat. One of them was Chasi Nuzrul Islam, chairman of the Directors' Society, member of the Censor Board, famed "healthy" filmmaker, and decorated war hero. He opened the button of his navy blue jacket, an anchor on the breast pocket, and sat down on the plastic chair. He cleaned his gold-rimmed glasses before putting them back on his nose. Beside him the famous romantic actor Ferdous lifted his red *sherwani* away from the dusty floor as he sat down. Sumit Hossain pulled up a stool and sat beside Ferdous. The actor playing Mintu, Jishu Jadughor, joined them. He sat down on the side of Chasi the chairman. As his shot finished, Salman rushed over to join them, too, pulling up a further stool. Shiplu, meanwhile, left the shooting to Zainul and Munna, who both continued undisturbed. Unlike his star cast, Shiplu retreated to where the producer, Litu, stood. They spoke in low tones and remained at the far end of the set. Neither of them greeted the powerful guests. The young actress Shavana sat down on the makeshift dais, wearing her elaborate wedding *shari*. Jenny and Kabilla continued to talk together but turned off the stereo. I continued to watch Zainul and Munna as they plied on.

The visit of Chasi Nuzrul Islam and Ferdous to the set was short, but its impact lasted throughout the afternoon. One of Zainul's assistants recounted his vision of what erupted a little after the gentlemen left. "It happened when Chasi Nuzrul Islam was here," the assistant said, explaining the explosive tempers to me. The gossip on the set was that action hero Sumit had tried to impress Chasi Nuzrul Islam and that renowned villain Jishu had undercut him by saying that no film in Bangladesh could be made without him. According to Zainul's assistant, Sumit had felt denigrated in front of the film director. Sumit had responded by trying to regain some face by outdoing Jishu on the set. After the visitors had left, Sumit had rebelliously taken over the direction of the scene.

"This angle, *ustad*," Sumit Hossain said to Zainul, when they resumed shooting after Chasi Nuzrul Islam and Ferdous had left. Sumit closely instructed Zainul about the angle he should take for the next shot. "Take it from below," he repeated; "then you will get the most action." Zainul replied vaguely and redirected his irritation to a light man with a cutter, who stood on the wrong side of the light. Sumit Hossain had only recently taken a tumble from the more profitable category of romantic hero to being an action hero. He was getting older and no longer acted opposite the most celebrated romantic heroines. During the shooting for *Mintu the Murderer*, Sumit would act out his part with great drama and always at the top of his voice. Unlike the romantic hero Salman, who played Sumit's younger brother and whose star was rising, Sumit Hossain always tried to underscore his knowledge of character acting. This expressed itself in his reciting his lines at full voice, instructing Zainul about the most appropriate angles for his shots, and intervening in the plot where he thought fit. The latter proclivity ensured a full-on conflict during the shooting of sequence 68.

"He has to do it; otherwise it doesn't make sense!" Sumit Hossain tried to convince Adom, the assistant director who was holding the script. "Make him lick the spit off my shoes!" Adom disagreed with Sumit. "Your character is a mafia don who has turned good," Adom reasoned with him; "you can't be vengeful and cruel." Sumit's character, Badsha, had been made to lick spit off the shoes of Mintu, played by Jishu. Now, in the final battle between Mintu and Badsha, Sumit wanted this scene to repeat itself inversely, to indicate Mintu's final defeat by Badsha. "The audience would love it," tried Sumit. "They want to see Mintu defeated. And then I will kill him with my sword." In the script Mintu was captured by Badsha in sequence 68 and handed over to the authorities. This would indicate

Badsha's reform and his law-abiding righteousness. "You can't kill him!" Now Adom was getting angry. He was a high-strung man who took his responsibilities seriously and did not take kindly to commandeering. "This is completely ridiculous," said Jishu Jadughor dismissively. This was all Sumit needed out of Jishu. "You don't know anything about film," said Sumit threateningly. Before long the two men were in an all-out fight over the most appropriate ending for *Mintu the Murderer*. Shiplu ran over to calm the tempers. As director of the film his call was final, but Shiplu knew he was dependent on the stars to complete the film at all. Ever the diplomat, Shiplu calmed the two combatants. He called Adom over and sat with him to change the script. Sumit would get his way, and Badsha would make Mintu lick his shoes before killing him with a large blade. As *Mintu the Murderer* was being shot, actors, assistant directors, and fight directors all had a hand in changing the script according to their insight and conditions on the set. Because the story was not the guiding force in the filmmaking process, steering the uses of technology, acting, or editing, the story could easily be altered. The story of *Mintu the Murderer* remained continually flexible.

Zainul had let the storm pass him by and sat in the shade with a *paan*, awaiting the final verdict. He didn't care one way or the other how *Mintu the Murderer* would end, as long as the shooting wasn't delayed endlessly. "Action, Action," Adom yelled as he finished rewriting the sequence. Relishing his victory, Sumit instructed Zainul closely about how to shoot his final killing of Mintu, asking him to sit on the floor and take plenty of low angles. Zainul complied largely with Sumit's demands, wanting only to finish the sequence.

THE MOVEMENT AGAINST OBSCENITY
AND REGIMES OF VISIBILITY

The conflict between Sumit and Jishu was more than a clash of star egos. It was related to hierarchies among people at the FDC. Their conflict had been precipitated by the visit of Chasi Nuzrul Islam. With his entrance the fault lines among the film personnel became immediately clear. Chasi Nuzrul Islam was a powerful individual in the FDC. His position of power came from a number of things: his long-standing involvement in the industry; his overlapping membership in influential positions of major cinema institutions, especially the Censor Board; his making of one of the first films on 1971; and his substantial patronage network. Through his

positions he could make important decisions about the day-to-day affairs at the FDC, including whether to have certain directors banned or producers and actors blacklisted. He kept a close eye on what happened on the FDC premises and would often be found sitting in the Directors Association office, in the middle of the compound. He was a powerful friend to have, and his deportment left no doubt about it. The way in which Shiplu's stars gathered around Chasi revealed the hierarchy that existed among the men. The male actors had all been intent on expressing their appreciation of the director and impressing on him their own expertise. Simultaneously, Shiplu and Litu had withdrawn to a far corner of their own set while the actresses had stayed where they were. Chasi's visit to Shiplu's shoot demonstrated he could walk on to any set at the FDC, knew everything that went on there, and was watching. He wielded institutional as well as symbolic power. Shiplu had neither.

The social hierarchy within the FDC was marked by the opposition between healthy and obscene cinema. Those in positions of substantial institutional power, such as Chasi Nuzrul Islam, considered themselves healthy filmmakers and in charge of a "movement" against the obscenity of others. They organized strikes and demonstrations against obscenity, drew up pledges against obscenity, and had spoken out in public. They were also called upon to adjudicate accusations against particular filmmakers. When Shiplu's membership of the Directors Association was cancelled, it had been because one of his films had been found by the Censor Board to contain obscene and uncensored material. The result was not merely to withdraw the certification of the film in question but also to share the findings with the Directors Association. Although the censorship legislation is not related to the functioning of the professional associations within the FDC, the elected board members of the Directors Association had nonetheless withdrawn Shiplu's membership.

Not long after Shiplu's membership was withdrawn, however, it was quietly reinstated. Directors such as Shiplu were always eventually readmitted. Until 2005 no single film director, actor, editor, or anyone else had been permanently banned (Khan 2006). While it was inconvenient and the confrontation with men such as Chasi Nuzrul Islam annoying, the campaign against obscenity was therefore never a real threat to Shiplu's work. The presence of Chasi Nuzrul Islam on the *Mintu the Murderer* set should not be interpreted, therefore, as a simple case of surveillance. Rather, the hierarchies among those who work at the FDC established

different regimes of visibility within the film industry. This was made clear to me after sequence 68 was completed.

The day after the conflict, shooting shifted to floor number seven, a small floor at the back of the compound. Compared to the heated excitement of the previous day, the soundstage was peaceful and quiet. The set had not been dressed with much: two wooden chairs and a stack of cardboard boxes. The godown set was almost empty. Adom sat on a stool, smoking a cigarette—an act that indicated he was the most senior person around. Smoking before one's seniors was unthinkable at the FDC, and this social rule was strictly observed, inscribing the social hierarchies in smoky visibility. Zainul had gone out while one of his assistants changed a reel.

"So quiet, Adom *bhai*," I said. He nodded but wasn't forthcoming with any information. I tried the adjoining makeup room. Here the chief makeup man sat combing a wig, his makeup cases arranged along the mirror. A junior artist sat sans makeup, enjoying the air-conditioning of the room. "It's so quiet," I tried again; "where is everyone?" "They went to Uttora," said the junior artist; "didn't you go?" She said she had gone to the shooting house in the northern suburb earlier in the week. As she spoke, the chief makeup artist tried to silence her. "Parallel cameras," he said, salvaging the situation. "Fight scene in Uttora; that's where they are." I asked where exactly in Uttora this shooting house was. Instead of giving me the details, he said that they would probably be coming back soon, I wouldn't catch them even if I left now. This seemed unlikely to me, knowing the tempo at Shiplu's sets. I went back out onto the set to ask Adom. He smiled at me and said they were working with parallel cameras. Zainul was working here; his chief assistant was using another camera in Uttora. "It's faster that way," said Adom. When I asked where they were and what they were shooting, however, Adom was not forthcoming. Outside it had started to rain lightly, and I knew there was no point in pushing the matter. Instead, I watched Adom smoke while Zainul worked with the fighters. Munna wasn't there, and the entire fight sequence came into being in collaboration between Zainul and one of the senior fighters.

When the small crew packed up at lunchtime, I sat with some of the crew members and asked about the parallel camera. Eventually, I found out that Zainul's senior assistant had been asked to shoot in Uttora. I asked what he was shooting. It was a "sensitive" sequence. The

euphemism indicated a sexually explicit scene. "That's why they are not here; it would be too visible." I was asked not to push it; they wouldn't show me in any case. "Shiplu could be banned again; then the entire investment would be lost!" I was told. Instead, Shiplu directed parts of the film away from the FDC, using another camera and the assistant cameraman. A few members of the lighting crew had been taken, as well as the assistant makeup man. The reels would not be brought back to the FDC. Instead, they would go to the only private film studio still in operation, Bari studio. They would be developed and printed from there, away from prying eyes and the Censor Board members that populated the FDC. It was through this shadow business that Bari studio had survived the expansion of the FDC.

Off-grounds shooting, known as "outdoor shooting," was a common practice for film crews. There were a number of shooting spots and private houses in Dhaka and around the country that they often used. The seaside resort of Cox's Bazar was especially popular, as were the special outdoor shooting locations, compounds such as Tepantor ("Never-never-land") and Shopnopuri ("Dreamtown"). In some sense shooting spots had taken over from the private studios in providing scenic backdrops. Such spots were heavily gated and only available to film personnel. Whole crews, from carpenters and cooks to cameramen, artists, and directors, would retire to these various spots for weeks at a time to shoot whole films in high tempo and away from the distractions and inconveniences of Dhaka city.[2] The gardens and swimming pools of these shooting spots were continuously reused in all genres of popular cinema and were recognizable to audiences.

What made shooting spots especially useful was their distance from the FDC. It was common knowledge that these spots were used to shoot "sensitive" sequences. The hooks written into scripts, such as scriptwriter Rony's sentences "bed scene" or "romance," would be shot at such locations. During the time I spent with a number of different crews making romantic action films with cut-pieces, I never saw Chasi Nuzrul Islam at any of these locations. Those who proclaimed themselves to be at the forefront of the movement against obscenity and vulgarity turned a blind eye to the shooting spots, the private studios, and the late-night activities at the FDC. This was comparable to the unwillingness to permanently ban Shiplu. The point was not that they didn't know that cut-pieces were being made; rather, they did not want them in their direct field of vision.

This can be explained through the conflicting requirements of appearance and finance. Through their movement against obscenity, filmmakers such as Chasi Nuzrul Islam appeared as healthy filmmakers. Only through the permanent indictment of other filmmakers as obscene could they maintain that their own, largely mediocre, films were "healthy" and thus claim a position of moral superiority on which they based their natural right to rule the professional associations. As a government institution, the FDC could also not be seen to condone the production of illegal pornographic or obscene visual material. However, the FDC was a public enterprise, and its only profit came from the rent of its equipment. Against the thirty healthy films made in 2005 stood seventy obscene films. The bulk of the FDC's income came from filmmakers such as Shiplu, not from the sporadic 1971 films made by Chasi Nuzrul Islam. It is this tightrope that resulted in parallel cameras, outdoor shooting, and the turning of a blind eye toward the production of cut-pieces in the FDC. In this sense the production process of *Mintu the Murderer* was marked by an oscillating visibility. Some parts of its production process were in full view, others bathed in the shadow of the public secret. Although ostensibly the FDC distanced itself from vulgar filmmakers and the professional associations proclaimed to be part of the movement against obscenity, everyone knew that "sensitive" scenes were shot in gated outdoor shooting locations and that the FDC relied on action filmmakers to hire cameras to shoot their cut-pieces. Action films kept the FDC in business.

The fragmentation of the production process of *Mintu the Murderer* to accommodate sensitive scenes finally also had an aesthetic impact on the film. Changes in camera work, lighting, color, and acting were visible because of the parallel cameras, different locations for developing and printing the reels, and a range of directors and actors working with Zainul and his chief assistant. "Won't you be able to tell the difference between your camera work and your assistant's?" I asked Zainul. "You can tell one hundred percent!" said Zainul. "Of course it is different from my work, my framing, my lighting." "Even though your assistant learned the work from you?" I asked. "He learned it from me, but the point is that it's about personality; he will work according to his own ideas," said Zainul. While the FDC is in many ways a machine that produces films through established formats and practices, this does not mean that personal preferences and work ethics are invisible. The way in which Zainul used the 2C and the wash light would imprint itself on *Mintu the Murderer* even if the final result could clearly be recognized as an FDC-produced film.

CONCLUSION

Why did Zainul lie on his back on the ground and twist the handheld camera rapidly? There are many answers to this question. One answer is related to the Arriflex 2C camera he used, which does not allow low angles to be taken unless the camera is handheld. Another answer would suggest that the lack of visual effects produced through montage was compensated by Zainul's cinematography. A further answer suggests Zainul's idea of a rural audience, hollering "*eh shala!*" at the unique special effect of a suspended lorry thus generated. Time was also a factor, Zainul's acrobatics quickly translating into a special effect that would require elaborate staging if it was to be achieved through the use of the trolley. What this discussion of Zainul's work for *Mintu the Murderer* has shown is that the particular form that the film took was related to the way the available technology was used, the institutional framework in which it was made available, and the social networks and hierarchies through which it became animated. Each of these elements endowed *Mintu the Murderer* with an aesthetic quality that is specific to its location of production, namely the Bangladesh Film Development Corporation. The FDC's technological, institutional, and social frameworks format the films made within them and make them recognizable. It is this form that becomes rejected as vulgar, unsophisticated, and unskilled.

But the aesthetic of *Mintu the Murderer* is not only the result of technological and institutional facilities. The form of *Mintu the Murderer* also came into being within the relations of power at play within the FDC. During the shoot of *Mintu the Murderer*, the crew relied in many ways on different regimes of visibility, sometimes hiding, sometimes operating in full view. The filmmaking process was at times opaque even to those who were its main protagonists. The disappearance of parts of the crew from the FDC was as formative for its aesthetics as the presence of Zainul at the compound. Those in control of the professional associations managed the social relations between filmmakers through the denouncing of obscenity on the one hand and turning a blind eye to the production of cut-pieces on the other. These different forms of visibility influenced *Mintu the Murderer* on many levels. From the opacities of the script and disappearing crews, the coming chapters will further elaborate such processes of increasing and receding visibility. The next chapter illustrates how these processes work, intimately, in the lives of the actresses of *Mintu the Murderer*.

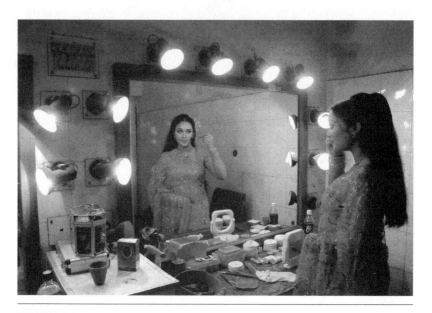

FIGURE 3.1

{3} ACTRESS/CHARACTER

THE HEROINES OF *MINTU THE MURDERER*

SHAVANA REFUSED to wear such a short dress. Nervously, an assistant director pleaded with her. Ignoring his entreaties, Shavana sat down in front of the big mirror dominating the small makeup room. A young makeup artist dabbed the sides of her cheeks with additional powder. The assistant director tried again. "It will look great on the screen," he said. "No it won't," she exclaimed. "It has less fabric than a miniskirt!" Through the mirror she could see the whole room, all eyes focused on her. At the back sat her mother. Shavana asked her what other dresses she had brought. But her mother had brought nothing appropriate for the song sequence Shavana was shooting today. Shavana sat back and let the makeup man do his work. Not until the director of the film, Shiplu, arrived did she resume the discussion. Her self-proclaimed cinematic father, Shiplu eventually agreed to find her another dress. The junior dress man was sent off to the production company's storage room to dig up another costume. He returned with a plain white sari. Shavana agreed to wear this. She rummaged through her jewelry cases and found a pair of matching silver earrings. Half an hour later the young actress was ready to shoot a romantic song-and-dance sequence. The white sari would be soaking wet and clinging to her narrow frame before long.

When Shavana demanded a different dress, one that she believed would expose less of her body, she tried to regulate the way her body became visible on set and onscreen. In this chapter I follow the actresses of *Mintu the Murderer* on set and off to demonstrate how they managed their visibility in the context of the production of cut-piece films. My ethnographic account of their lives and work will show that the actresses of *Mintu the Murderer* used different forms of becoming visible to work in the film industry.

I will argue that this can be understood as a form of *purdah*, or the conventions of female deportment. What the extensive literature on the veil and female seclusion in Bangladesh has most forcefully shown is that *purdah* does not consist in a straightforward injunction that can be read off scripture or patriarchal dictate. Instead, the conventions of female deportment in all communities in Bangladesh have been shown to be under continuous negotiation, and its forms are dependent on individuals and their class position, caste, and community affiliations, as well as their location, education, and age (Feldman and McCarthy 1983; Gardner 1995; Kabeer 2000; Rosario 1992; Shehabuddin 2008; White 1992). As a process that defines the deportment of women in various ways, it is a central element in the construction of gender in Bangladesh and evidently relevant to the actresses who lent their image to *Mintu the Murderer*. In this chapter I explore the ways in which the actresses used different regimes of visibility to position themselves within the filmmaking process. Both a concept expressing the ideal forms of the manifestation of women in the public realm and a process through which such ideals become negotiated, I understand *purdah* as the management of visibility rather than any simplistic form of veiling or seclusion. And as such, it is related to obscenity, which similarly indicates a preoccupation with managing visibility.

To understand this process of managing visibility, I rely on the notion of the screen. Kaja Silverman has elaborated the three positions that make up the visual field: the gaze, the screen, and the look (Silverman 1996). I will use her conceptualization of these three positions here because she reframes the Lacanian categories to make them applicable in sociological analysis. Briefly, Silverman argues that the gaze positions one in the field of vision, makes you aware that you are to be looked at. It precedes any individual act of looking, just like language precedes any individual speaker. The screen is the point at which something or someone becomes visible and through which one perceives (what Silverman dubs the "subject-as-spectacle" and "subject-as-look"). The screen is the manifestation of the gaze in a particular form, a sort of visible utterance. The screen is "that culturally generated image or repertoire of images through which subjects are not only constituted, but differentiated in relation to class, race, sexuality, age, and nationality. . . . The screen represents the site at which the gaze is defined for a particular society, and is consequently responsible . . . for much of the seeming particularity of that society's visual regime" (135). The look, belonging to an individual, apprehends this screen, this ideologically produced image, and is therefore not its

master. Rather "the look apprehends what is already given to be seen" (175). For my purpose the screen is the most important concept because it addresses the way in which someone becomes available to be seen. This is in no sense an effect of a natural capacity for vision. Rather, the look apprehends something that is already formatted "to be looked at," is already endowed with meaning. This is the screen, the socially and historically specific dimension of vision. What I will argue by way of the screen is that the actresses of *Mintu the Murderer* produced themselves in different ways to be looked at. They all managed their visibility skillfully, and their bodies thus acquired meaning in different ways as they played with the screen. It is in this way that I will use *purdah*. Meaning screen as much as curtain, I understand *purdah* to be the management of the becoming visible, the given-to-be-seen, of female bodies according to socially and historically produced repertoires of images.

By arguing that the actresses managed their visibility, producing themselves along a range of different images, I do not mean to suggest that these are masks, behind which lies an authentic subjectivity that is woman, which may appear in drag onscreen (and here screen means both the screen as the ideologically informed image of woman and the cinema screen on which *Mintu the Murderer* appears). This has been the long-standing concern within feminist film theory (de Lauretis 1984; Haskell 1987; Mulvey 1989, Smelik 1999), to question the terms of the relationship between the fictional construction of the idea of "woman" and "the real historical beings who cannot as yet be defined outside of those discursive formations" (de Lauretis 1984:5). When attending to the empirical relations between the image of "woman" that appears in *Mintu the Murderer* and the actual women who lend their bodies, minds, and work to make this representation appear, however, other questions emerge than how this gap works or how it may be bridged. Relying on more recent interventions into this feminist canon (Brail and Colebrook 1998; Mahmood 2001; Sobchack 2004), I will show how women who are intimately involved in a mechanical representational activity figure their bodily presence as so many different screens. As Vivian Sobchack argues, "relatively novel as materialities of human communication, photographic, cinematic, and electronic media have not only historically symbolized but also historically constituted a radical alterity of the forms of our bodily sense of existential 'presence' to the world, to ourselves, and to others" (2004:136). The institution of *purdah* as a form of figuring bodily presence in the world is similarly inscribed in this historical trajectory.

I will use my account of the ways in which the actresses of *Mintu the Murderer* figured themselves according to different screens, their *purdah*, to address related questions about gendered conflicts over labor and sexual violence, especially the trope of being despoiled (*noshto*). Describing each of the heroines of *Mintu the Murderer* sequentially will also allow me to set out the narrative of the film.

SHAVANA/RANI

"I got wet," lip-synched Shavana, "drenched in your love-rain." The song blasted from a small cassette recorder attached to big speakers. At the end of the chorus she turned and fell into the arms of the actor. "Cut!" cried Anwar Huque Noyon, choreographer extraordinaire, flamboyantly dressed in a short white coat and a colorful scarf thrown carelessly over his shoulder. "She just has no grace." He shook his head. A junior makeup man threw a towel over Shavana's bare shoulders. She shivered with cold. They had been shooting for two hours already, and the end was nowhere in sight. The assistant choreographer showed Shavana what her next few dance steps should be. "Step, cross, and down!" he encouraged her as she attempted to follow his moves on her high platform heels. "Take, take!" yelled Noyon. He had a whole song to finish before eleven at night, and at this rate they would never make it. Shavana threw off her towel and rearranged the white sari that lay messily along her shoulder. "Camera ready? Water!" shouted Noyon. On his command water started pouring from two big spouts held by set-men. Shavana braced herself for its icy impact. The gust of wind from the big fans on either side of the set caught the end of the wet sari, and it flapped against her bare back. "Action!" Shavana stepped, crossed, and dropped down. She tried to look up toward the camera, to keep her eyes open despite the impact of the water. The camera framed her close, as she struggled with the water. The prints would show her mouth slightly opened, the camera's gaze firmly focused on her breasts, dangling in the wet sari blouse as she bent down.

The wet sari is a stock image in South Asian cinema. Rachel Dwyer argues that directors of Indian films, "whether seeking sensual or pornographic effects, may well wish to maximise the eroticism of the female body, and they have found the most successful way to do this in the famous 'wet sari' sequence, where the semantics of the sari and the form of the female body come together in ways which can be constructed as 'tasteful' by the family audience . . . and the censors, while being simultaneously

erotic" (2000b:151). Dwyer uses the wet sari sequence to suggest that not all representations of women in cinema follow the logic of fragmentation and fetishization of the female body suggested by Mulvey (1989). Instead, "the erotic body here is fully clothed, but totally sensualised to the point of being orgasmic" (Dwyer 2000b:159). Mulvey suggested that the threat of sexual difference represented by the female body onscreen is tamed through the fragmentation of her body by the camera and an obsessive focus on the bits thus produced. Young actresses such as Shavana attempted to manage the way their body became available to the camera via clothes, chaperones, and forms of acting. In this section I will set out some of these ways and illustrate that as Shavana attempted to control the eroticization of her body, she preferred its fragmentation to full-body shots. I will argue that this preference is related more to the social environment on the set than to the idea of her body onscreen.

A little fearful of that much water around open electrical sockets, I waded through the ankle-deep water and sat down at the back of the set with Shavana's mother. I complimented her daughter's elegance. "You should see her older sister," her mother replied, "even more beautiful than Shavana." I asked whether she acted as well. "No, she was married when she was thirteen years old," said her mother. "At that same age, Shavana danced in her first movie." I suggested she must be happy with her daughter's success as a film actress. "I don't really like it," she replied quickly, "but Shavana has always wanted to be a star. When she was young, she was always dancing, always admiring film stars." She watched her daughter intently as she danced the next couple of steps to Noyon's directions.

Shavana had been dancing since she was a child. She had taken lessons in one of the dancing schools run by a choreographer who also worked in the film industry. When she was a teenager, she had been invited to perform with the troupe in a film. Dancing schools run by cinema choreographers were the source for dancers in the film industry. Unlike the dancing schools that focus on classical dance, schools like the one Shavana attended mainly taught modern dance and were closely linked to the film industry.[1] Noyon ran a similar institution. Besides furnishing him with additional income, it also supplied him with a body of students from which he could draw for cinema chorus lines. Noyon's assistants, three young men from his school, had many years of training. Together they would perform the steps and moves that the actors had to copy. Noyon would often sigh that the actresses were not nimble and supple enough and that his boys were so much more elegant. Despite many

female students in the dancing schools, the assistant choreographers, and the independent choreographers they subsequently became, were almost without exception male. There was an intense homosociality among the choreographers and their assistants in the film industry. As a somewhat liminal space, nonnormative forms of sexuality were in play at the FDC in different ways, its forms as Rao argues for India, "engendered under the auspices of normative patriarchal culture" (2000:299; see also Gopinath 2000).

It was during a performance at the FDC that Shavana was spotted by Shahadat Ali Shiplu. He offered her a role in his next film. "I didn't allow it," said Shavana's mother. "She was only thirteen years old, too young to work as an actress." Her mother had allowed her to dance with the troupe and had told Shiplu to wait until she was sixteen. "Since then she has acted in sixteen films," said Shavana's mother, who started to name the list of titles, "almost all with Shiplu bhai." I asked whether she had been there at each of the sixteen films. "Of course!" replied her mother. "I never let her go to any shoot without me." As happened with many young unmarried actresses, Shavana's mother chaperoned her everywhere. She wouldn't hear of letting her daughter go anywhere alone. I asked whether she ever got bored, sitting around all day at the FDC. Most shooting days lasted two shifts, the morning shift, running from nine to four in the afternoon, and the evening shift, from six to eleven. "I know many people here," said Shavana's mother, "Niha's mother and Nodi's mother." She made a list of the mothers of other young so-called first actresses with whom she spent her days at the FDC.

Most mainstream films have plots that include three actor-actress pairs, each of which fulfill a different generic narrative line: romance, action, and sex. Actresses are categorized according to the type of work they do. The first actress in a film enacts the romantic story line, considered the most prestigious part. Access to romantic parts is decided by producers and directors and based on ideas of physical beauty, defined mainly as fair skin, straight noses, and tall figures, all of which surpass the need for acting talent. These actresses are paid the most, typically receiving about 20,000 taka (US$320) signing money. When first actresses are newcomers and still young, they are almost always accompanied by a chaperone, often a family member. Scholars have pointed out the strictures of chaperoning women in Bangladesh (Feldman 2001; Kabeer 2000; Rosario 1992; Siddiqi 2000, 2002). Siddiqi suggests that "going 'out' to work carries with it the danger of sexual vulnerability—honour embodied in

[a] woman's reputation is at risk when a woman enters the public space of work" (Siddiqi 2000:L-16). As Siddiqi shows, this vulnerability is crucially mediated through class. Working-class women are more liable to be considered licentious when out without a chaperone (16). This is illustrated through the fate of first-tier actresses who become stars in the cinema industry in Bangladesh. Only when they reach star status do they have enough standing to appear alone on the set. Their rise through the cinematic hierarchy allows, financially and socially, for an increase in status that will allow women to work with no accompanying chaperone during all shifts without danger to their reputations or the threat of harassment.

While first-tier actresses rarely appeared in cut-pieces, the second- and third-tier actresses did. Second-tier actresses were coupled with an action hero and played roles involving more fighting. They were rarely chaperoned by anyone but a child assistant. As I showed in chapter 1, the second actress Jenny was hired for *Mintu the Murderer* on the basis of her reputation for sexually licentious acting. A second actress would receive about 10,000 taka (approx. US$160) signing money. The third pair of actors was considered least prestigious, and they acted in more and less sexually explicit sequences. Third-tier actresses typically received about 4,000 taka (approx. US$65) signing money. These actresses were once again firmly chaperoned, often by women who were addressed by familial terms but who were commonly understood to be madams rather than grandmothers. Although second-tier actresses may work themselves up to become first-tier, they remained somewhat tainted by their less respectful action work. Third-tier actresses rarely made it up the ladder. Downward movement was always a possibility among third-tier actresses and actors. Even further down the hierarchy were women who act as villains, as well as extra actresses, junior artists, and dancing girls. None of them typically received signing money and were mainly hired on a shift basis rather than on a contract.

Shavana's exceptional beauty had allowed her to move straight into the first tier of acting when Shiplu first cast her. Because she was a young artist, however, this did not entail a large salary. Shavana would receive about 40,000 taka (approx. US$635) per film. Her position as first-tier actress did place her in a clear slot within the division of dramatic labor. At fight scenes she merely stood back, and romantic dance sequences were her most important scenes. In an industry dominated by the idiom of *oshlilota*, this meant that Shavana, like other first actresses, did not consider herself part of vulgar filmmaking practices. Others were less

willing to indulge in this strict separation. Shavana's alliance with Shiplu, notorious for his cut-piece films, was taken by many to be a direct reflection on the sort of work she did. The film magazines would at times write about her dependency on a vulgar director. In the face of such speculation Shavana would often nervously reiterate how her acting had nothing to do with what Shiplu's other actors and actresses were up to. "The work I have done for *Mintu the Murderer*, my character, was good," she said to me. "And what others have done, that I don't know." She saw herself personally, as Shavana, as well as diegetically, as her character Rani, separated from the other actors and actresses in the film. She used her reputation as a first actress to resist obscenity accusations. In combination with her mother as chaperone, her romantic roles framed the way her image was made available and put up a barrier against any association with obscenity.

Night had fallen, and Noyon's work was still not finished. For the second part of the song sequence, Shavana and the romantic actor Salman would dance around burning fires, symbolizing their passion. With four sets of costumes for two first-tier actors and two different shooting locations within the FDC, as well as the special effects of water and fire, it was the most expensive song sequence in *Mintu the Murderer*. This song showed the romantic and physical union of two young lovers, Rani, played by Shavana, and Robi, played by Salman. The story of *Mintu the Murderer* was largely that of the obstacles put in the way of Rani and Robi's union. Their happiness was impeded by Rani's older brother, Mintu. A contract killer with political ambitions, Mintu decides to marry off his younger sister to the son of a powerful minister. When asked to go and meet her fiancé, Rani and some friends go to Wonderland, where they wait for his arrival. A young man passes by. "How handsome! How tall!" exclaims a friend, while Rani gazes at the handsome young man, dressed in jeans and wearing sunglasses. He, however, is not Rani's intended and moves swiftly on. In his stead arrives a short, fat man, sporting a small beard. He walks straight toward them. "I know that man," says one of Rani's friends. "He is the man that despoiled my friend Lopa [*noshto kore felechhe*], after which she killed herself!" Right there Rani decides not to marry her intended. On their way out Rani finds the college identity card of the beautiful young man, whose name is Robi.

Seeing his political ambitions crumble, Mintu insists on Rani's marriage. He sends his henchman to kill the owner of the identity card, whom he holds responsible for his sister's disobedience. Arriving at Mintu's house

after surviving the henchman, Robi falls in love with Rani at first sight. From then on the film's narrative becomes one long chase between Mintu's men and the renegade lovers. After Robi has rescued Rani from her brother's house, they consummate their relationship. Looking into each other's eyes, their stares dissolve into the refrain "I got wet, drenched in your love-rain" (*Bhije gechhi, tomar prem-er brishti-te*). The camera frames Shavana's body tightly, in close-ups of her face and chest. Such cinematography has been noted for the fragmentation of the female body and a fetishization of certain body parts. The soundtrack with its thinly disguised sexual content reattached these fragments to the experience of sexual climax. For Shavana, however, her body's fragmentation in Rani's close-ups was hardly noticeable. She danced with Salman to Noyon's instructions, at a distance of six to seven feet from the camera. Noyon hollered at her: "Play it child, show us your full figure!" Shavana danced with conviction. "It is all foam, you know," her mother told me laughingly; "we pad her bras and sometimes we put some foam on her hips as well."

Between shots Shavana would come to her mother and have a bite of the snacks that were passed around endlessly on the film set. She chatted with the cameramen and assistant directors. It was almost 10 p.m. when the set was rearranged for the final shots of the song sequence. Shavana took a short break and sat down on assistant director Nazmul's lap. "Do you like my hair this way, uncle?" asked Shavana. Shiplu intervened and said that this red wig didn't suit her but that it matched the fluorescent pink nylon miniskirt she was wearing. Shiplu considered Shavana his personal find and was at times jealously possessive of her. This was a perpetual source of jokes among Shiplu's assistants. Shiplu's cinematic paternity of the beautiful young Shavana led to a plethora of comments on illegitimate children and extramarital sexual activities. "If Shiplu is Shavana's father," the assistant directors would question my understanding of Bangladeshi familial terms, as well as poke licentious fun, "then what are we?" Shavana herself was well aware of this intricate game of family idioms and played along. On the set she would flirt with the assistants and address them in a number of familial terms, depending on their age and demeanor. It has been suggested that the adoption of kinship terms to address unrelated others allows for a negotiation of public space. Naila Kabeer argues that "in the context of the factory floor, the use of gender-related kinship terminology helped to desexualise encounters between men and women" (2000:97). But kinship terminology also carries a potentially raucous edge. Family relations are a common idiom through

which sexual relations are addressed, and Bangladeshi smut magazines are littered with them (see also Srivastava 2007:155). Although the use of such terms is considered polite, they always carry a potentially sexual edge. In her relationship with the men on the set Shavana's use of kinship terms expressed both connotations.

"Come, Shavana," called Shiplu; "over here, hero." Shiplu directed the two actors to a position behind a sheet held up before two spotlights. Shavana had taken off her skirt and was only wearing a pair of skin tight hot pants and top. Salman wore his jeans and a white vest. "Their shadows will look as if they are naked," laughed Noyon. "Music!" As the final chords of the song played from the cassette recorder, Noyon fired up Shavana and Salman. "Embrace!" he yelled. "And back again! We want to see the outline of your bodies!" The spectators looked on amused. "Sex, more sex!" Noyon cried. "Free-sex country!" Shavana had been comfortably dancing all day, but now she seemed nervous. "I think it is time to take away the sheet," said Noyon as he came up close to the sheet and put his hand in front of Salman's outline, creating the impression of a bizarre erection. "Let's play live!" "I won't do that!" cried Shavana in a panic; "I won't do it!" Her mother sat by dispassionately. Shiplu tried to calm down his leading lady while laughing about Noyon's irreverence. Rather than dropping the sheet, the final chords of the song showed Rani and Robi sinking into each other's arms. When fragmented by the camera's gaze, Shavana was perfectly comfortable dancing to Noyon's instructions. But the full-body shots behind the sheet disturbed Shavana immensely. Rani's affair had come too close to spilling over into Shavana's work on set.

SHADNAZ/SUFIA

"You're not married," said Shadnaz to me, sitting on the sofa in her parents' flat; "then you had better be careful with these cinema men!" She laughed. Shadnaz had been around the industry for many years and knew what she was talking about. Ten years earlier she had been the Shavana of her generation. A film director had spotted her when she was out on a company picnic with her colleagues. He had asked her to consider acting with him. "I wasn't really interested in acting," said Shadnaz. "I was happy with my job. But my older sister was really excited about it. She had always wanted to act or be a model. But not me." The film director didn't let up and even called at Shadnaz's house. "I let myself be persuaded," recalled Shadnaz. "We didn't tell my father; he wouldn't have agreed."

The director had cast her in a lead role. "My mother helped tell my father that I had already been cast, and he couldn't but agree," explained Shadnaz. Her acting career started this way. She was a successful first actress for a number of years in the 1990s. "I didn't like all these song sequences though," she laughed; "I preferred the fights!"

Neither of those roles was forthcoming any more. "I took a two-year break from acting, you know," she explained. "Only for the reason that the films became more and more vulgar. We would get offers to work at that time. But it would have created a particular impression." I asked her about the impression it would create. "Well, you had to wear 'open dress' and clothes without bra. It was only the dresses that bothered me; otherwise there were no problems. Many people demanded such dresses from me. But I couldn't adjust to this." I asked her what the problem had been with the dresses. "My son had grown up by that time. What if he saw his mother on a poster, only wearing a bra? How will that affect him? And then, my figure wasn't really beautiful, not really fit to be shown. It was no longer the sort of figure I had when I first started. I had gotten so fat." Shadnaz was always very concerned about her figure. "None of it was in my favor: the situation, my body construction, my son had grown up, and, if I am honest, I had to think of maintaining the relationship with my in-laws. It was all against me." Shadnaz didn't act for two years after that. "After those two years I got pregnant, had my daughter," said Shadnaz. "I became beautiful again, started working again." Since that time Shadnaz had been taking smaller parts, playing character roles such as a sister-in-law.

Shadnaz cursed the father of her daughter. "Before we got married, he was so interested in coming to the set, meeting the other actors," she said, "but once we got married, the story changed. He no longer wanted me to work long hours, would check up on me." She paused to pick up her two-year-old daughter. "In the industry, you know, you have to keep up relations with people," she said. "You have to chat with everyone; otherwise you won't get any work." She recounted how her husband would call her on set to tell her to come home. "But you can't just run away after your last shot. You have to stay and chat a bit, with the director, with the producer." She added: "That relationship amongst colleagues is a bonus for us, actually." Shadnaz often commented on how lucky she felt to work in a place where social interactions were less rigid than "outside," as she called it. Shadnaz played many small parts in different films and was at the FDC often. She relished its relaxed atmosphere and the joking

relationships that existed between most of the regulars there. She enjoyed sitting around in the makeup rooms and chatting with the directors and actors milling about. During long trips to outdoor locations she would at times take her young daughter and enjoy herself in between scenes with the actors and crew, playing at cards and joking around. Her social life revolved around the FDC, and during her children's birthday parties the rooftop of her apartment block was filled with FDC-related guests.

"I gave some advice to a new actress recently," Shadnaz continued. "I told her that she shouldn't get married whilst working. If you want to be a star, don't get married. And if you think that you want to get married, you should drop this work and marry. If not, there will be a clash." I asked her what sort of clash this would be. "If a girl has to stay at work all day," she asked me rhetorically, "how will she give any time to her husband when she gets home? She will be tired all day. If you are tired all day, how can you give any attention to your husband? There won't be any enjoyment. Everything will become irritating, a burden. You will feel mentally suffocated. You will keep thinking 'Allah, today it's gotten really late; I'll be home too late.' But in this line of work you have to make sure that those who are working with you like you. Only then will you be able to freely mix with them. If you don't, they'll mind. If you are working together all day, then having a couple of minutes of conversation, what's the problem with that?" Eventually, the situation with Shadnaz's husband became too much to bear. When she was pregnant with her daughter, she started to notice his affairs. As she told me the story, there was anger in her voice. "Eventually I divorced him," she said, "although I was worried about my children." The tabloid papers and cinema magazines all wrote about it (see chapter 5). "I thought I had to come clean about the whole thing," said Shadnaz; "otherwise everyone would be asking me about it."

Shadnaz had come to think of marriage and her work as mutually exclusive. When she divorced her husband, she started to work again to support her family. With the liberalization of the Bangladeshi economy from the early 1980s, women have become more prominent in the labor force. From the garment workers that supply the clothes shops in the West to the highly educated NGO executives and their micro-credited, entrepreneurial sisters that Bangladesh's aid dependency has spawned, women have become a more prominent part of the labor force. Of course, the work of female entertainers has always taken place within a public domain (Banerjee 2000; Oldenburg 1990). The shift has taken place in public arenas of work that used to belong almost exclusively to men, such as the factory

or the office. Discussing the impact of the presence of garment work-
ers in the public space of the city, Dina Siddiqi argues that these women
are "symbols of an inverted order, women workers signify through their
bodies male inadequacy and national failure" (Siddiqi 2000:L-16; see also
Kabeer 2000). Collapsing masculinity into the state, neither is able to take
care of what has been "entrusted" to them: their wives and the national
population. In this context "the aesthetic of family claims on daughters,
sisters and wives is articulated in a moral rather than material idiom"
(Siddiqi 2000:L-16). This means that the women transgressing into spaces
of former male domination are accused of moral laxity. Although Siddiqi
focuses on garment workers who bear the double brunt of classism and
sexism, the moral standing of middle-class women who work is similarly
questioned. These moral ambiguities echo the discussions of obscenity
surrounding the film industry: "the virulence of the disapproval, anxiety
and fear that underlie the various forms of harassment to which garment
workers are subjected must be read in the context of an overall disruption
of the social order" (ibid.).

The invocation of a moral idiom to denounce a reversed order is also
tainted with interest and desire. In popular cinema this disruption is the-
matized, and its plots often feature college girls, garment workers, and
businesswomen. Exploiting the interest and anxieties generated by the
increased visibility of working women, these films address such issues in
their own manner. State discourses, development narratives, academic
discussions, and Islamist injunctions constitute dominant idioms through
which women's labor is addressed in Bangladesh (White 1992). Relying
on each of these, the film industry also provides its own narratives about
female labor and education. Operating within patriarchal narratives and
suffused with symbolic violence against women, these action films are
simultaneously fascinated with women who escape patriarchal demands.

For Shadnaz, however, work in the film industry, combined with her
parents' support, allowed her an income to support her family. She attrib-
uted the opportunities she has to the FDC and its environment. Rather
than understanding these films only in terms of their completed narra-
tive and a clear statement about the moral order, the FDC, as a location
in the city, and the work of actresses within it should be investigated
to understand what possibilities cinema holds for addressing the social
transformations under way in Bangladesh. Actresses such as Shadnaz do
not only signify an inverse or disrupted social order through their bod-
ies onscreen. Rather, their appearances in the city, at the FDC, and on the

screen need to be seen together to understand the ways in which they come to embody the possibility for new roles for women.

To get to the sets for *Mintu the Murderer*, Shadnaz only had to traverse three big roads. Her family lived near the FDC. From her son's bedroom window on the fourteenth floor, one could look into the compound and see the floors lit up during the night shifts. It lay right beyond the slum and rail track that separated their neighborhood from Kawran Bazar, where the FDC was located. Without her own transport, and since they had closed the main roads for rickshaws, she would take a CNG (a rickshaw fueled by compressed natural gas) to work. The task of arranging a CNG to take her such a short distance was a perpetual hassle for her. Nonetheless, she would arrive for shoots immaculately attired in printed georgette saris. The type of roles she played required no other costume from her. Her own wardrobe doubled as a costume rack. Once at the FDC Shadnaz would sit down in the makeup room and rummage through her handbag to find a pair of appropriate earrings or bangles. She would only require some makeup before going on the set.

In *Mintu the Murderer* Shadnaz wore a printed pink sari with a bright blue edge. Her character, Sufia, was a middle-class, educated woman who had quit working when she got married. In the first sequence that features Sufia, we see her send her young sister-in-law, Rani, to college. When Sufia's husband, the contract killer and aspiring politician Mintu, asks his younger sister Rani what she is going to do in college, Sufia says Rani will study. Mintu forbids Rani to go to college, saying there is no point in schooling women. He turns to Sufia and tells her: "You were an educated girl when I married you. But since then all you have done is cook and keep the house." Rani, spurred on by Sufia, does not take her older brother seriously and runs off to college.

In *Mintu the Murderer* Shadnaz's role is only related to Rani. After Rani refuses to marry the man intended for her by Mintu, she becomes a prisoner in her own house. Sufia is the only one to support Rani, and Sufia escapes her husband's house by wearing a *borka*. Sufia goes directly to the slum dwelling of Robi's brother, the former mafia don Badsha. There Sufia warns Robi about the wedding that will be enforced. A few sequences later, Robi appears in Mintu's house to take away his beloved Rani. As they run to the door, Robi and Rani are stopped by Mintu, who holds a gun to Robi's head. In a reverse shot we see a gun being put against Mintu's temple. "Run Rani!" cries Sufia as she keeps a pistol to her husband's head. As Robi and Rani disappear, Mintu grabs Sufia's hand and twists it around. With

the gun now pointing to her own stomach, Mintu pulls the trigger. Sufia sinks to the ground and dies.

Shadnaz's sequences as Sufia are few, and her character's rebellion against her husband is punished by death. The symbolic violence in her sequences speaks volumes about how the patriarchal order must be restored in the diegetic universe. How might these enactments and Shadnaz's character be understood? While there is no doubt about the misogynist and patriarchal narratives of these action films, what more can be said about Shadnaz's part in *Mintu the Murderer*?

The screens by which Shadnaz allowed herself to become visible were at times difficult to distinguish. She came to the FDC on her own and appeared onscreen in her own saris and jewelry; her own mobile phone hung around her neck. The boundaries between Sufia and Shadnaz were porous. Rather than seeing the cinematic texts and her onscreen image as the signifier circulating in an abstracted symbolic order that stifles the everyday lives of real women, the "authentic" signified, I see the two as more intimately bound together. As Victor Turner argues about acting, "aspects of the actor's experience surface which tincture the script-role he or she has undertaken, while aspects of the . . . message embodied in the script and particularly as understood from the perspective of the 'character' being played penetrate the essence of the actor as a human being" (1982:121). Shadnaz becomes part Sufia, Sufia part Shadnaz, in a relay of images where the quest for the real woman becomes meaningless. Braidotti and Colebrook argue that "the body is not a prior fullness, anteriority, or plentitude that is subsequently identified and organised through restricting representations. Representations are not negations imposed on otherwise fluid bodies. . . . Images, representations, and significations (as well as bodies) are aspects of ongoing practices of negotiation, reformation, and encounter. Neither the body nor the feminine can be located as the innocent other of (patriarchal) representation" (1998:38–39). This is the process that I discussed above with reference to the screen. Similarly, Saba Mahmood has suggested that "outward behaviour of the body constitutes both the potentiality, as well as the means, through which an interiority is realised" (2001:214). Images, in the broadest sense, are constitutive in this process of producing subjectivity or interiority. Mahmood argues that it is through the repetition of certain bodily acts that subjectivity becomes constituted and foregrounds "the sedimented and cumulative character of reiterated performances" (216). Shadnaz's action parts had sedimented in her gestures and words, as she enacted the parts

of women in film after film and gave voice and body to their dialogue and movements. Neither purely text nor pure immanence, the characters that Shadnaz's body takes on lingered as visceral memory and sedimented presence. Brian Massumi writes that "simulation is a process that *produces* the real, or, more precisely, more real (a more-than-real) on the basis of the real" (1987:2, emphasis in original). Shadnaz the actress can therefore not be seen independently of Shadnaz's characters. In the perpetual relay of images that produces our everyday existence as real, there is not the unlimited fluidity that Dina Siddiqi has rightfully criticized (Siddiqi 2000:L-14). But this does not mean that the processes of becoming are chained to the Singer sewing machines or the camera gaze that produces garment workers and actresses as labor and then codes them as immoral. Shadnaz's life as a single working mother was directly related to Sufia. Not only did playing Sufia provide Shadnaz with much-needed income, but she also became an embodied memory of a life lived differently. Her account of her career, of motherhood, and of kinship relations echoed with the narratives and gestures of the FDC. These various screens had made Shadnaz who she was.

JENNY/TARA

During preproduction the most exciting and elaborate discussions were about Jenny's attire. The producer and the tailor of *Mintu the Murderer* argued about the best way to put what they called a "full gangster getup" under a sari. If the sari blouse was made out of a thicker fabric and matched the color of a pair of skintight stretchy trousers, then Jenny would be able to wear them instead of a petticoat. When the sari was ripped off she would immediately transform into a female gangster. A second-tier actress, Jenny's acting consisted mainly of fights and cut-pieces of all sorts. The disrobing sequence planned for her would combine in one stroke all the properties of a second-tier actress.

Jenny was one of the most important assets of *Mintu the Murderer*. She was what the producer called "the most commercial actress." She had shot to fame at the age of fifteen when she acted in the film *Heat* (2001). It was one of the first FDC films that had been shot largely abroad, in and around a number of tourist hotels in Thailand. The film has been considered a watershed, marking the point after which Bangladeshi cinema entered its current phase of vulgarity. The gossip that contributed to Jenny's reputation was that although she was very young, she went to Thailand

unaccompanied. The success of the film was directly related to Jenny's cut-pieces in the film. One of these continues to be in much circulation and shows Jenny in a see-through top by a swimming pool in a resort singing, "I'm a red rose, blossoming in Bangladesh." Although the film continues to be in and out of courts, Jenny became instantly famous on its release. Known ever since for licentious acting, Jenny has molded a career marked by controversy and censorship battles. Filmmakers and producers continued to cast her, as her titillating and infamous image on a poster could draw crowds, which the romantic Shavana or the minor Shadnaz could not guarantee. A star of the most prominent genre of Bangladeshi cinema, her name could be found in the tabloid papers and gossip magazines but not on awards lists. Her face could be seen across the country on posters and hoardings. However, her visibility was not unambiguous.

During my fieldwork in Dhaka I, too, had a chaperone. My companion Jewel would often accompany me to the Bangladesh FDC, always came with me if I was staying on late, and often traveled with me to outdoor locations and village cinema halls. One day in Dhaka, we went to see a film in a fancy new shopping mall. With its eleven stories and swimming pools, the shopping mall, Bashundhara City, was tons of undiluted modern fantasy. It is where one would come to indulge and exhibit one's modernity, sophistication, and worldliness. In synch with this idea the proprietors of the Bashundhara Star Cineplex, the only multiplex cinema hall in the entire country, were screening classic films from the golden history of Bangladeshi cinema. This week of Bangladeshi film classics opened with a press conference lamenting the state of the film industry, now in the hands of "uneducated thugs" who only produced "vulgarity." Against this onslaught the Cineplex was screening the highlights of 1970s cinema.

On one of the landings of the shopping mall, I was called over by Jenny. Dressed in a beige shalwar kameez, her hair in a bun at the back, she was carrying her young son on her arm while her husband browsed a CD shop. We chatted for a few minutes. Jewel stood a few feet behind me, politely waiting for the conversation to finish. Jenny turned, looked at him, and cried, "Eh Jewel! Don't you know me?! [*Amake chinte parteso na?!*]" Jewel stepped forward, confused. Although he had seen her on the set for months, here in Bashundhara he had looked right through her. Despite her visual prominence in the city's public space, at the very busy Bashundhara shopping mall, no one recognized her, not even Jewel. Without her makeup and colorful dresses, holding her little son and accompanied

by her husband, no one knew who this woman was. Unlike Shavana, who would often hide her identity by wearing a *borka* to go shopping, Jenny's physical transformation and drab clothes allowed her to shed her cinema persona and shop in peace.

As discussed in my introduction, the redefinition of *purdah* in the early twentieth century has translated female propriety to an "inner feeling," expressed through comportment and dress in the public life. This redefinition is related to marriage and privacy. "Shongshar means home, husband and children, these *are a woman's moral possessions, the cornerstone of modern Bengali Muslim femininity*" (Ahmed 1999:119, emphasis in original). From a working-class background, Jenny had used her acting career to acquire a certain amount of wealth and has climbed the social ladder. Married with children, shopping at Bashundhara City, she embodied this middle-class "modern Bengali Muslim femininity." Her "moral possessions" at hand, in public with all modesty, her cinematic other was effaced by her quotidian veneer. She was unrecognizable as the woman who reached out from the posters on the city walls. Like Shavana in her *borka*, the public part of Jenny was eclipsed, out of view and unrecognizable to the public. Rather than the deviant diva, she could be the respectable gentle-lady. Her *purdah* was a management of visibility that produced Jenny in different images or screens at different occasions. Embodying the cut-piece diva was crucial in her cementing relations with film producers, but in the shopping mall her *purdah* consisted of a small boy and no makeup.[2]

In *Mintu the Murderer* Jenny's character, Tara, became more and more marginal to the story line. The assistant director who explained the part to Jenny defined Tara as a "neighborhood girl" (*parar meye*). She is in love with underworld strongman Badsha, who lives next door to her. In the script and according to the rush cuts, Tara's character is introduced through a sequence in the neighborhood. She leaves Badsha's house and runs into a group of loitering men on the streets. They sexually harass her. One pulls at her sari and as the five men disrobe her, Tara's "full gangster get-up" appears. In the diegesis the screen shifts from sari-clad modesty to aggressive self-sufficiency. As her red stretch suit appears, Tara goes into action mode and single-handedly beats up the five men, who run away in fear. This is the end of the sequence, and no further mention is made of the men. The disrobing of Tara establishes her as an appropriate romantic match for the gangster Badsha and underscores that Jenny's function in the film is to disrobe.

During the editing process I saw Tara's disrobing again and again. Fight scenes are time-consuming because of the many short shots that need to be spliced together. Hence my amazement when this scene disappeared from the final cut of the film. Jenny's part in the film was reduced to a few scenes in which Tara is mainly a side character. There are no major dramatic sequences in which Tara plays any part, and her speaking lines are few. No one ever explained to me why exactly they had cancelled the disrobing of Tara. The editors merely said that they needed to shorten the film. The bits that were cut were those least relevant. After seeing the film a number of times, it occurred to me that Tara as a character was not as interesting as Jenny was as an actress. Jenny's reputation and public persona outweighed the character Tara. The dramatic sequences were irrelevant. The importance of Tara is that she allows the visibility of Jenny. The fact that one of the four posters that were designed for *Mintu the Murderer* featured only Jenny, seated on the floor, legs spread, in a small red dress, shows how Jenny was far more important than the character Tara, who was virtually invisible in the story.

Jenny performed in two song sequences with Sumit Hossain, the actor playing Badsha. Each of these songs was filmed at outdoor locations, away from the FDC premises. Shot largely within a single room, the actor and actress are shown lying on and across furniture, a bed, a sofa, a balustrade, their bodies moving closer and farther apart in a steady rhythm. Sitting astride Sumit, Jenny would move the top part of her body back and forth, down toward him. In a countershot Jenny lies stretched over two chairs and pushes her crotch up and down into Sumit's face. Neither of them wore any of the outfits that mark their characters Tara or Badsha. Sumit Hossain wore shirt and trousers in both songs, whereas Jenny wore lehengas, saris, and skirts. Both song sequences were diegetically completely disconnected from the rest of the narrative universe. There was no attempt to continue the narrative of the film within the song sequences, unlike Shavana's sequences. Where Shavana's song focused on choreography and the dancing of Shavana by herself, both of Jenny's songs focused on the interlocking of two bodies in a simulated sexual encounter. This was Jenny's unique selling point. Her body is recognized as the body through which lust, rather than the desire bound up with the romantic couple, becomes tangible in the film. Although the disrobing of Tara would have underscored the sexual independence of the character, casting Jenny, who was already intertextually marked as such, made the sequence dispensable.

Jenny was rather unwilling to talk to me about her career. She loudly claimed herself to be the top actress in the Bangladesh film industry but was never willing to discuss this success with me. Accompanied by her child assistant, she would at times be picked up by her husband. A mobile phone merchant in one of the shopping complexes in Dhaka, he maintained very good relations with the producer of the film. Jenny never talked to me about her personal life. She deflected questions about herself by giving me fashion advice. She would often urge me to change my drab single-colored cotton *kameezes* for more brightly colored ones she wore both on and off the set. "Just three hundred taka, and you can get a *kameez* like this," she'd say about the heavily beaded polyester dress she was wearing. "You can get these in all colors at Gausia market." Second-tier actresses were given costumes made out of extravagantly colored materials, such as animal prints and neon-colored polyester, paired with heavy costume jewelry and handmade wigs. Jenny was an expert on where to find such dresses. The tailors hired by production houses used the apparel dumped onto the Dhaka markets by the garment factories, such as Mintu's trademark shorts, and remodeled them to unique effect. The heavy black trench coat for Sumit Hossain, the fuchsia bicycling shorts for romantic heroine Shavana, and the sparkling red stretch suits for Jenny were remodeled versions of export-quality apparel.

The costumes for action films were a laughing stock for the cinema commentators of upmarket newspapers. The "Dhoom Dharaka" column of upmarket paper *New Age* would often devote lengthy parts of its review to ridiculing the costumes, such as in this review of the film *Ranga mastan* ("Colorful Gangster," 2005):

> A female journalist, wearing claustrophobic tight clothes and a top revealing a lot, goes to investigate a story but ends up in the hands of gundas led by a man wearing a long red overcoat (who's the tailor?). But, the fun of the red coat brigade is short-lived as Rubel, an army captain on leave (man this guy has taken some serious training because even on holidays he is in his battle tunic), comes to intervene. . . . On the other end of town is Ranga Mastaan (Dipjal) a very interesting character who is into gun trading, killing and extortion. And all this he does wearing a golden coloured chained robe (Versace?). (Feroze 2005a)

Such aesthetic judgment bespeaks a class distinction that does not translate to the FDC sets. There the dresses were considered modern,

fashionable, and appropriate for the characters represented. Those who wore the brightly colored georgette shalwar kameezes and sat down on the faded sofas of FDC sets expressed the modern aspirations of a class of new urbanites. For the *New Age* editors such imagery was rejected as the *mofo* aesthetic of the unsophisticated.[3] For Jenny, however, these were the badges of modernity and urbanity, of which she believed that I, too, should partake.

More than fashion advice I did not get from Jenny. What I know about her and the work of a second-tier actress came from her close friend and colleague Bokul. Bokul joined the industry a little later than Jenny, but their careers progressed roughly similarly. A significant part of my field-work was done in the bedroom of B-film heroine Bokul. Mistress to the chairman of the Producers' Association, Bokul had been in the industry for about three years when I met her in 2005. Her career had taken flight once she became linked to the chairman. Her producer-director-lover had cast her in all his action films and made her famous throughout Bangladesh. He had also set her up in a flat in the center of the city, in a middle-class neighborhood. Many of her family members used the flat. Her bedroom, however, was strictly private. Here she would receive personal guests. I became a frequent visitor and would sometimes find her lover there, often with a bottle of whisky, freshly picked up from the Dhaka Club.

Bokul identified herself as a second actress. Among the actresses she counted within her set, Jenny was her best friend. She had spent much of her time with Jenny and the other second-tier actresses, both at out-door shooting locations and by visiting each other's houses. Explaining the hierarchy to me, she drew a clear line between second-tier actresses, such as Jenny and herself, and third-tier actresses. The division was both in terms of roles played and lives lived. "You go to their houses," she said, "and you'll see that they are fully professional [implying sex work]. Not just the girl who works in the film, but also their younger sisters, their mothers." She warned me not to take any of the invitations of the third-tier actresses to visit their homes. The hierarchies of respectability cascaded, and similar anxieties and prejudices were expressed along various thresholds.

Talking about her career, she explained she'd arrived at a bad time. "I arrived in the industry at a time when besides vulgarity and commerce, there was nothing else," she said. "There is no scope for acting. Now there is only . . . commercial dance, commercial speech, commercial sequence. There is nothing else in film right now." At that time, though, she hadn't

understood this: "Of course, when I came, I didn't understand; I did it too. I didn't know which one was vulgar, which one was commercial, which one bad, which one good. . . . Those producers and directors would say 'Look, Bokul, you are new in film, you don't understand things. It won't look naked.' When they took the shot I didn't understand that they were taking it from here [pointing from a low angle at her crotch] or that the angle would 'grab' my breasts." She had not learned how the camera angles fragmented her body or how light filtered through the muslin cloth across her naked body. Through this experience she had learned to read the machinery that produced her image and could manage the fragmentation of her body. "If it is for the modern age, a modern character, I can wear a short dress," she said, "but I can't do the shoots naked. If . . . I take off all my clothes and the hero kisses me everywhere, that is dirtiness, not modern. . . . Those girls who engage in sexual acts on the screen, who give those shots, that is *nongrami* [dirtiness]. I don't like it."

Bokul made a very clear distinction between the sorts of films and shots she did. "I didn't do any dirty films," she reflected, "but I did do 'most commercial.'" Most commercial entailed a very different aesthetic than dirtiness for Bokul. "Commercial, modern I like, but dirtiness I don't like." She made the distinction clearly: "If it is for the modern age, a modern character, I can wear a short dress. I am following Bombay, and in Bombay, they are doing the most commercial shots: wearing only a panty and a bra. But when you see them, it looks very beautiful. Their figures, their styling is all very beautiful. The camera work is also very beautiful." I asked her to explain the difference between modernity and dirtiness. "Look, if you are doing a film, if with the main actor I have an 'open' kiss, that isn't dirtiness; that is modernity. If such a kiss comes up in a sequence, in a story, then that's fine. But if within a Bangladeshi film, in a shot, I take off all my clothes and the hero kisses me everywhere, that is *nongrami* [dirtiness], not modern; then it becomes a blue film. But Bangla film isn't blue film, is it?" I quickly said it wasn't. "So Bangladeshi cinema and blue film are two separate things. Because those girls who give those sort of shots . . . those girls who engage in sexual acts on the screen, who give those shots, that is dirtiness. I don't like it."

Like the journalists and antiobscenity crusaders, who talked about distastefulness and uneducated filmmakers, Bokul was concerned with questions of taste and style in relation to her work in a "most commercial" industry. Her work was in style, in synch with Bombay, that pinnacle of progress and modernity. She reproduced the narratives of obscenity

and propriety, and the rhetorics of civilization reverberated in her words and gestures. However, the clear moral boundary around dirtiness also allowed it to become erotically charged. In fact, the discourse on propriety could become part of personal erotic attachments to "dirty" representations. Bokul's personal enjoyment of the Bangladeshi porn clips is a case in point.

After Bokul had elaborately explained the difference between dirtiness and modernity, which I continued to find perplexing, she resorted to providing a visual illustration that even the dimmest anthropologist would comprehend. To illustrate the difference between modernity and dirtiness, Bokul showed me one of the VCDs she had been given by her lover. It contained song-and-dance sequences from different recent Bangladeshi films. The songs were familiar to Bokul, and she sang along with them. She said they often watched the VCDs together.[4] I pointed out actors I knew and asked her about them. We enjoyed ourselves with industry gossip and commentary on the outfits shown in the clips. Flipping through the different songs, Bokul categorized each according to the modernity/dirtiness distinction to explain it to me. Irrespective of the allusions to sex in the song lyrics, the close-ups of breasts, bums, and crotches or the movements of the actors' and actresses' bodies as they collided, Bokul's distinction had solely to do with the removal of clothes. The moment any female nipples or genitals became visible to the camera, it was dirtiness. Otherwise all the songs were modern.

Watching one particularly explicit sequence, clearly of the dirty category, Bokul jumped up and down, saying she couldn't see it anymore. "My sex has come up" [amar sex uthechhe], she laughed and reached for her mobile phone. She rang her lover and told him to come see her at once, that she needed him right now. To cool down, she changed the VCD for one containing romantic Bollywood song sequences. "You understand the difference now?" she asked me mischievously.

Although nude work was dirty to do, it was not reprehensible to watch. It was not her preferred mode of employment but she did appreciate the imagery. Her dichotomy was also more porous than it seemed. Under the label "most commercial" fell her own work in bathroom sequences, where she would wear only a pair of briefs, which she would pull down to reveal her bottom. Her "most commercial" consisted of an extra actor licking her body, including her nipples and buttocks.

Bangladeshi feminist scholars of cinema skirt the topic of cut-pieces by lumping all these activities together under the rubric of exploitation.

Sheikh Mahomuda Sultana argues that all women in mainstream Bangladeshi cinema are represented solely as sexual objects and that the actresses have no agency within the male-dominated production infrastructure (2002:191). However, Jenny's and Bokul's cases show the ambiguity of their work. Both their careers have blossomed, and their position in the class structure of Bangladeshi society has risen. The FDC has for them been a space for their production as modern women. In Jenny's case she has even outgrown the need for a character. This is characteristic only of stars, whose intertextual resonances allow them merely to appear onscreen to produce diegetic meaning: "the star phenomenon depends upon collapsing the distinction between the star-as-person and the star-as-performer" (Dyer 1992:79). Both Jenny and Bokul relied on different screens, according to which each became visible as a modern woman, as well as a good lover, wife, or mother, a young successful actress, a well-dressed urbanite, or a cut-piece queen. These emanations were produced serially in a continuous relay between the different screens of conventionalized images taken on by the actresses.

JOSNA/LOPA

Whereas Jenny's character, Tara, needed no narrative elaboration whatsoever, Tara's lover, Badsha, needed a protracted flashback of more than fifteen minutes to establish his character. To salvage the moral character of mafia boss Badsha, there were two rape sequences in *Mintu the Murderer*. Both established the character Badsha as a good guy through his long-standing feud with the corrupt politician with whom Mintu had made an alliance. The first rape is of Badsha's mother. As a young boy, Badsha protects his mother by killing her rapist. Gathering up her sari, she tells him to run away before the police come. The young Badsha runs away to a life on the streets. He quickly establishes himself as the head of a crime syndicate. It is as a gangster that he receives a phone call from a young girl who says she is a college student and that her name is Lopa. With terror in her voice she tells him that she is under attack, that someone wants to rape her. Badsha announces that he is on his way. Within the story line of the film this is the first act he undertakes as a gangster and follows within minutes of the mother's rape scene.

From Badsha's phone call, the film cuts to Lopa, who is running away from a man who chases her. She is framed in a medium long shot. Her ripped *kameez* reveals a black bra and parts of her breasts. Jump cuts

show her running for a number of blocks, until she is caught by her pursuer, who pushes her over into a stack of leaves. There he jumps on top of her and pulls at her *kameez*. The camera angle is from the top, and we see Lopa struggling. The man pulls at her bra, revealing her breasts up to her nipple. The camera lingers on the face of the rapist close to Lopa's breast. In a reverse shot we see Badsha jump from a roof onto the pile of leaves. He grabs the rapist, and Lopa gets away. As the rapist begs for his life, Badsha says that there can be only one punishment for destroying a girl's *ijjot* (honor). As the rapist begs for his life, Badsha shoots him in the head.

Rape scenes are very common in Bangladeshi films and are often enacted by junior artists or extras. Lopa was played by junior artist Josna. The rape sequence was the only sequence in which Josna acted for *Mintu the Murderer*. After her part of the sequence was over, she sat down beside the set with a towel wrapped around her shoulders, bare in the ripped *kameez*. She watched the other actors finish the scene. When the *azaan*, the call to prayer, resounded, the work temporarily stopped. I sat down with Josna. She was from Faridpur but had come to Dhaka for work three years ago. She was twenty-five years old, married, and had a six-year-old son. I asked her whether she had done a lot of movies. Without the enthusiasm that Shavana, Shadnaz, and Jenny expressed when describing the number of films they had been in, Josna said that she had worked in thirty different films. All of them offered small side parts such as this shift work. Since her husband left her, she had had to fend for herself. Her son lived in the countryside with her parents while she had stayed back in the city to earn some money. Working in the cinema industry supplied her with some income. I asked what a sequence such as this would pay. She said she was in the hands of the production team. She didn't know what they would give her at the end of the day. As the sound of the *azaan* faded, the work started again. The assistant director told Josna she was done. Apologizing to me, she got up to go and change out of the torn clothes.

Josna was one of the many "junior artists" or "extras" that worked at the FDC. Baring the true brunt of the vulgarity discourses, the women who play extra roles, as dancing girls or in rape sequences such as this, were doubly incriminated by being from working-class backgrounds and doing single-shift work. The regulations within the FDC for these actresses replicate some of the assumptions of the vulgarity discourses. The female junior artists were asked to spend their day in a waiting room near the compound gate. There was no such rule for male junior artists.

The waiting room could only be reached by going behind a fence that separated this room from the rest of the compound. The room was small and furnished with only two sets of plastic chairs. During the monsoon half of the room flooded. The women spent most of their day there, waiting for production managers or assistant directors to come when in need of extra actresses or particular sequences, specifically rape sequences, background college girls, or female friends of first or second actresses. Inside the room the women played a lot of Ludo but also sang, gossiped, quarreled, sold and bought bangles, and changed their clothes for costumes. They smoked in this room, out of the sight of men, both tobacco and marijuana. After 8 p.m., women who had not been hired for the night shift had to leave the FDC compound and the waiting room. For men there was no such rule. Although not generally conforming to these rules, the FDC could on occasion enforce them and ask the women to leave.

Many of the junior artists had worked elsewhere but preferred working in the cinema industry. Some liked acting; others preferred the camaraderie that Shadnaz also spoke of. Crucial to their employment was the maintaining of good relations with particular crews. While first- and second-tier actresses were patronized by directors and producers, some extra artists were patronized by cameramen or assistant directors. My closest friend among the junior artists, Taslima, would often lament that it was so much harder for her to maintain such relations because she believed she was too dark skinned. She complained that Josna and many of the other women were far fairer than she was. She felt she needed to compensate by wearing nice dresses in bright colors to attract work. It was, however, inconvenient when traveling home to a village right outside the city in the evenings. It would take her two hours to travel up and down to the FDC every day. She lived with her parents in Yatrabari. As her family did not know what sort of work she did in the city (she kept them under the impression that she worked as a seamstress), she wore a light blue, embroidered *borka* when she traveled between home and the city. She had come out of an abusive marriage and joined the cinema industry to take care of herself. Her arms attested to her violent past and were covered in scars. Recently she had remarried, and her new husband had no problems with her work. "My only sadness," she would repeat whenever I met her, "is that I don't have children." She yearned for a child, but she had never conceived. Her new husband juggled two jobs in the city and only visited her on his free Fridays. "How will I ever conceive?!" she would ask in despair.

Like Taslima and Josna, many women who worked as junior artists or in any number of working-class jobs lived separated from their husbands for all sorts of reasons. Their vulnerable position as working women without husbands close at hand, combined with their work in dance and rape sequences, had earned many junior artists the label of sex worker. They worked at the FDC unchaperoned but often kept an eye out for each other. Although sex work was part of the job for some junior artists, it wasn't for all and did not constitute the main labor for many.

The vulnerability but also transgressive independence of junior artists was narrativized in action films in many rape sequences, in which unchaperoned or independent women, such as Lopa and Badsha's mother in *Mintu the Murderer*, became victims of rape. Based on the many films in the genre I had already seen, I had assumed from the start of my project that those female characters that are raped in popular films or have sex out of wedlock do not survive until the end of the film. The raped character inevitably dies. But *Mintu the Murderer* and the character Lopa severely tested this supposition.

Gönül Dönmez-Colin argues that "violations of 'honour' are often exploited for erotic purposes by commercial cinema" (2004:76) and links this to notions about honor and shame in Muslim societies. I don't consider the prevalence of rape in Bangladeshi popular cinema an effect of religious discourse. Rather, there is another set of logics by which we can understand the particular emergence of rape in popular cinema, even if the availability of rape as a trope itself should be related to the patriarchal order that makes it available.

First, the Censor Code that regulates the representation of sexuality in Bangladeshi cinema does not condone "immorality" but does allow the display of crime if not glorified (Government of the People's Republic of Bangladesh, undated). A rape scene such as Josna's is therefore less likely to be cut by the Censor Board (as it is a "crime" that is punished by Badsha) than a scene showing her in a passionate embrace (which would be "immoral"). For producers of films exploiting the attraction of the naked female body, a rape scene is a much safer bet than a scene of passionate lovemaking (see Ghosh 1999 for an Indian comparative).

Second, the rape scenes in Bangladeshi cinema generally work as a narrative device to characterize the men involved in the scene and to comment on the political and governmental failures in the country. The rape sequence that Josna acted in constituted a complicated narrative move that revolved around her rescuer. The rapist that Badsha kills turns

out to be the brother of the corrupt politician. Thus the feud starts. The act of rescuing the girl from the rapist, just as he did his mother, establishes that Badsha is, in fact, a good character, despite his being a gangster. This sequence also illustrates the failure of law enforcement and the police in Bangladesh. The notion that local strongmen have to keep the order in society emphasizes the illegitimacy of the state, in terms of the police and the courts, as well as the self-proclaimed authority of specific local men. Rather than call the police, Lopa calls Badsha for protection, who takes it upon himself to capture as well as sentence the rapist. The rapist he kills emerges as the brother of a corrupt minister, thus indicting the political order in the country anew. In this way popular action film resonates with widely held ideas about the inadequacy of the police and government to maintain a situation of law and order and the corruption at the peak of government.

A similar symbolization of the failure of the state to provide protection has been noted in the case of revenge meted out by women in Indian cinema (Gopalan 2003; Virdi 2003). In the Indian films discussed by Gopalan, it is the raped women themselves who go out for revenge after the courts have failed to sentence their rapists (2002:43–44). Gopalan argues that eventually "this unfettered power [of the phallic female] is undercut by finally reeling in the authority of the state and revealing the avenging woman's own investment in the restoration for the social imaginary" (2002:49). Gopalan links the spate of avenging woman films to the tussles in the Indian public sphere over the legislation around rape in the 1980s. The character of the avenging woman is the cinematic solution to the disruption of the social consensus created by feminists protesting the legislations. But in the case of Bangladeshi cinema the raped woman inevitably dies, restoring the moral order and social imaginary disrupted by her revenge and contamination only through death. Even more frequently, the avenging women of Bangladeshi films act on behalf of others, such as parents or siblings, rather than on their own account.

Third, rape is a common trope in other forms of popular and literary genres. As Nayanika Mookherjee has shown, rape has become coded in relation to the Liberation War in Bangladesh (Mookherjee 2006). In a violation of the prime signifiers of Bengali nationhood, the Pakistani army and local collaborators raped many women, purportedly to "improve the race" of the Bengalis who were considered effeminate and inadequate Muslims (Kabeer 1991:122). In the 1990s, rearticulating the attempt by

Sheikh Mujibur Rahman to rehabilitate the women raped in 1971, the euphemistically termed *birongona* (war heroine) reappeared in the public realm as a contradictory subject of honor and dishonor (Mookherjee 2006:436.). Popular action films have rapidly picked up on this, and rape scenes are often set in a flashback to 1971. Action heroines in Bangladeshi cinema are often daughters or sisters of women raped in 1971 who died or committed suicide. In this way the films echo narrative conventions in other genres. As Siddiqi argues about such common narratives, the sacrifice on the part of raped women is lauded as a sacrifice for the nation: "Yet this sacrifice of her body can be redeemed only by the woman's subsequent exit from the plot, for her act signifies betrayal, shame as well as sacrifice. The choice of rejoining family and community is rarely exercised; ideally, she encounters death through suicide or accident, and is thus written out of the text of community" (1998:209). The focus on the raped woman drives divergent narratives, from highbrow plays to popular action flicks. But strategies used by middle-class playwrights to deal with the raped women of 1971, namely through depersonalizing and ensuring a quick exit for the raped woman, are equivalent to the strategies used in the popular cinema to deal with "defiled" women.

The national narratives about the *birongona* provided a generic form to deal with rape in popular media such as the cinema. As the constitutive outside of the moral order, and as a constant reminder of the state's failure to enforce law and order, and of men to protect "their" women's honor, the woman cannot but die once raped. *Mintu the Murderer* seemed to be a huge exception in this case. Never does a raped woman remain standing, I claimed. But what happened to Josna's character Lopa? Why was she spared? How was it possible that Lopa did not die in *Mintu the Murderer*?

INTERMISSION

After the shooting was packed up, I spent most of the next three months inside the editing rooms of the FDC. I had been aware that there were sequences shot for the film that I hadn't been allowed to attend. Gaining the trust of some editors, I saw whole new sequences rolling across the screen, such as Jenny's second song, a chase sequence, and various altercations between Mintu's men. What I hadn't realized, however, was that there was a whole extra story line, involving a pair of third-tier actors. They had been kept invisible to me quite effectively by the producer. Most of the sequences by the third pair had been shot away from the FDC, with

a different cameraman and different choreographer. Although not all was edited at the compound, I slowly started to piece together the story line. When I finally managed to get a copy of the script, I could read an entire additional story line, only tentatively related to the controversy over Rani and Robi or Mintu and his corrupt minister. There was a second Lopa.

ROSI/LOPA

The third pair of actors for *Mintu the Murderer* consisted of Shabazi and Rosi, playing the lovers Sohel and Lopa. In the script they enter at scene 2. The following excerpt from the script of *Mintu the Murderer* is their opening sequence:

SCENE 2

Hostel—Day
A peon stands at Lopa's door and knocks.
PEON: Money order—
Lopa, in wet clothes, turns towards the door.
LOPA: Coming.
Saying this Lopa quickly changes her dress and takes off her bra and again puts on all her clothes and goes towards the door.
PEON: Here take this money.
The peon gives her the money as the door opens. Lopa jumps up when she receives the money.
PEON: Get inside.
LOPA: Hey!
Saying this he pushes her inside—the peon goes inside and locks the door.
LOPA: How dare you—what did you think—why are you touching me?
PEON: I didn't touch you—I was examining you. You have to give two exams—one with pen and paper the other one for me.
Having said this, the peon takes off his costume and we see Sohel.
LOPA: You!
SOHEL: Yes—They didn't let me into the Girls' Hostel so I made this plan. I paid the peon 2000 taka and rented all this [referring to his costume].
Saying this he takes Lopa towards the bed.
LOPA: What happened?
SOHEL: Sit down.

LOPA: Why?

SOHEL: Just sit down. Look, I have brought fruits for you, today I will feed you with my own hands. But a different sort of feeding.

LOPA: What do you mean by a different sort?

SOHEL: Your eyes will be closed—and if you can tell the names of whatever I feed you, I will let you eat them.

LOPA: Alright, I'm closing my eyes.

Sohel blindfolds Lopa with a cloth. Then he sits her down in front of the fridge and brings out different food dishes one after the other. He puts a grape inside her mouth—Lopa eats it and says its name.

LOPA: Grape.

Sohel takes a piece of apple and runs it over her whole body and puts it in Lopa's mouth.

LOPA: Apple.—

He takes a big green chili and runs it over Lopa's body and puts it into her mouth. Lopa is surprised, bites it, jumps up and screams because of the burning sensation [the pun in Bengali refers to being "in heat"].

LOPA: Ah, ah, chili!

Lopa screams. Sohel laughs and puts honey into her mouth with a spoon. Lopa continuously licks the honey from the spoon.

LOPA: Give me a little more.

Sohel starts putting honey on her legs and then starts licking upwards. As he tries to put honey inside her mouth, some honey spills onto Lopa's feet. Her whole legs get covered with honey. Lopa feels ticklish. From here romance between the two—bed scene—from there to song.

This "bed scene" was not otherwise described and foreshadowed a cut-piece enacted by Rosi and Shabazi. The "bed scene" was not found in the script nor on the set.

The character Lopa is only tentatively linked to the main story line of *Mintu the Murderer*. This Lopa is Tara's younger sister, who studies in a college. References to colleges and hostels are always loaded with sexual connotations. The logic of the unchaperoned woman is similar to that described above. The moral outrage and devious pleasures associated with women's hostels are linked to the shifts that have taken place with an increase in female education and parallel move of women out of the home and into the streets and universities. Rosi's Lopa is therefore already set up to be sexually active by virtue of being characterized as a college girl.

The excerpt from the script shows that scenes which narrate and display sexual pleasure on the part of women are kept from public visibility more diligently than rape scenes. This may be related to the workings of the Censor Board hinted at above, but it may also relate to the greater taboo on the display of female sexual pleasure. Of the two common devices to display the female body engaged in sexual activity in popular cinema, rape is much more visible than scenes such as Rosi's. While rape has been a prominent discourse in Bangladesh's public realm, sexual pleasure on the part of women is far less common. Instead, it is pathologized and reduced to reproductive health and HIV/AIDS prevention. Research on sexuality in Bangladesh often reflects this.[5]

The script does not describe what the "romance" or "bed-scene" consists of. It clearly does begin what Bokul would term a most commercial or dirty sequence and is a typical cut-piece. Such sequences remain unaddressed by commentators of contemporary Bangladeshi cinema. Instead, journalists, academics, and state officials denounce a wide range of more or less explicitly sexual sequences as vulgar and obscene. This effectively leaves pornography unaddressed. Quoting Beverly Brown, Linda Williams has suggested that "pornography reveals current regimes of sexual relationships as 'a coincidence of sexual phantasy, genre and culture in an erotic organization of visibility'" (Williams 1989:30). The discussion of the sexual content of cut-pieces is part of an investigation of this erotic organization of visibility in Bangladesh. Having seen only parts of Rosi's sequence, I will supplement this discussion with the description of a generic cut-piece sequence based on viewing many of them, both inside cinema halls on celluloid and outside cinema halls on VCD. I will describe the generic qualities of such cut-pieces and suggest the contours of Bangladeshi pornography and their erotic organization of visibility. I will discuss the representation of sex acts in cut-pieces that are not rape scenes (for the latter see Hoek 2010b).

The scenes for cut-pieces are mostly shot within single rooms, bedrooms or a bathroom, and feature naked women and mostly dressed men. They are set to music, pop songs either composed for the film or background music. If the actress wears any clothes, she might wear bicycle shorts and a white *kameez* of thin fabric. The actress generally does not stimulate the male's body but enacts sexual pleasure through her facial expressions, such as rolling her eyes upward or closing them, opening her mouth slightly and moaning or pinching the whole face as in intense concentration. The camera will linger on her face. The (partly) dressed

actor undertakes most activities, including undressing the actress, kissing her, and licking her body. In bathroom sequences the woman may appear on her own, her body visible through a wet *kameez* or naked, rubbing her breasts and vagina.

In what Bokul would call dirty sequences, one step up from commercial sequences, the female genitals would also become visible. The penis is almost entirely kept out of view, except for penetration shots. This stands in some contrast to the ubiquitous external ejaculation of much Western pornography. In cut-pieces the camera and actor's activities are entirely directed toward the female body. This is the location of what Linda Williams has called "the frenzy of the visible," "the visual, hard-core knowledge-pleasure produced by the *scientia sexualis*" (1989:36). There are many close-ups of cunnilingus, clips of which are among the most regular cut-pieces in cinema halls. The narrative closure of the sexual act is here not dependent on the visible male orgasm but on the display of female genitals. The cut-pieces are concerned foremost with displaying the female body in sexual stimulation (for screen shots see Hoek 2010b).

Male sexuality remains unspoken, or "ex-nominated," in cut-pieces. In this they resemble the short pornographic features produced in the first six decades of the twentieth century. Thomas Waugh has argued for classical American stag films that the studied inattention to male bodies and organs should be understood as "the obsession of patriarchal culture with . . . the female sex" (2001:276–77). Like stag films, cut-pieces are made by men and consumed by men in cinema halls. The display of the female body in the cut-pieces narrativizes this masculinity as the disavowing of male embodiment, constituting the ex-nominated norm. Women, on the other hand, are exchanged publicly between families in reproductive institutions such as marriage. Red wedding saris, connoting fertility, state publicly female sexuality. Male sexuality is never made public in this way as "the self-identity and perpetuation of . . . domains of unmarked masculinity require that they be rigorously sealed off from the realms of privacy and sexuality" (Sánchez 2006:421). Cut-pieces disavow male sexuality. Staged for a male heterosexual gaze, they locate sexual pleasure entirely within the female body. In this representational logic, the cut-pieces resemble stag films, which focus on exposing the female body and whose visual characteristic is to "show that sexual activity is taking place" (Williams 1989:72) rather than to show satisfaction. This is the "forbidden spectacle" that exploitation films promise to display. The cut-pieces thus show that the erotic organization of visibility in popular

Bangladeshi cinema is framed by the display of the female body as the stage for sexual pleasure. This ultimately is the spectacle that the cut-piece promises and is directly related to the particular patriarchal order of ex-nominated masculinity in which they function.

Turning to the narrative context and mise-en-scène of cut-pieces, other aspects come into focus. The tiled floors, closed windows suggesting air-conditioning, and the omnipresent wrought-iron furniture of most cut-pieces indicate middle-class homes. Practically speaking, this is the result of the fact that only a few locations can be conveniently used to shoot cut-pieces. The bedrooms and bathrooms of much-used outdoor shooting locations return again and again in these scenes. When there is a clearer narrative integration with the main body of the film, such as Rosi's and Shabazi's encounter in the women's hostel, the cut-pieces mostly indicate the middle-class status of the female character. Like Rosi's college-student persona, the female characters are generally positioned as well-off urbanites. At times they are pictured as sex workers, but more often they are unmarried middle-class or elite girls. Sometimes a voyeuristic scenario is employed, in which an unmarried boy or girl spies on a married couple engaged in sexual activities. The latter scenario is often comic and can be set in a village or *bosti* (slum). Encounters are sketched between young and passionate unmarried men and women. They are depicted in modern venues, such as colleges, shopping malls, or hotels, which, in combination with sexual impropriety, codes them as "despoiled" (*noshto*). Young female characters are also presented in cut-pieces as extraordinarily wealthy, residing in the marble palaces of Dhaka. Sexual excess is the trademark of villainous males, from corrupt politicians and business-men who drink alcohol to exploitative rural landlords, village chairmen, and local religious authorities. In the mise-en-scène and characters of the cut-pieces a fascination with the New Woman is combined with a strong moral condemnation of corrupt public figures, thematizing extraordinary class inequalities.

Both Laura Kipnis (1996), in her account of *Hustler* magazine, and Thomas Waugh, in his analysis of stag films, discern class conflict and popular revolt in the narrative and visual form of the sexually explicit material they study. Extending this analysis to the Bangladeshi action film, the narratives and forms of the cut-pieces do seem to partake of an explicit antagonism toward society's powerbrokers, established institutions, and middle-class aesthetic values. The fervor and aggression with which the female body is explored, effacing its subjectivity before

positing the female characters as spoiled goods, similarly indexes an anxious masculinity. The representational strategies of the cut-pieces need to be understood in the context of the gendered conflicts over labor that Siddiqi so succinctly analyzed as well as the class controversies that I traced in my introduction.

The actress Rosi, who played this Lopa in *Mintu the Murderer*, was very familiar with these sequences. She had been working as a third actress for a few years, and I had come across her buxom figure in many editing rooms. Her mother had been an actress before her, and her older sister had acted as well. This sister had recently stopped working because her husband, a third-tier actor himself, no longer thought it appropriate for her to work now that she was married. Having missed Rosi during the shooting of *Mintu the Murderer*, I went to meet her at an outdoor shooting spot, Tepantor, after the film had already been released. I had hoped to talk to her about her part in *Mintu the Murderer*, but she kept deflecting. She talked about the saris she wore, as well as the beautiful locations she went to during the shoot. I asked her more specifically about her sequences, and she said that sequence number 2, where her character is seduced in her hostel room, was a beautiful romantic sequence she acted out with her friend Shabazi. Although Shabazi had been far more explicit about the sexual activity in the sequence when I spoke to him, Rosi referred to it as romance. For Shabazi it was easier to speak about his role in *Mintu the Murderer*. For men, work as third-tier actors does not inhibit upward movement in the industry. For women advancement was far more difficult. Rosi explained the story of *Mintu the Murderer* to me as a story revolving around her time in college. When I broached the topic of vulgarity, she immediately responded like Shavana, saying that all the work she did was "good" and that she doesn't know what other people are doing. Every time I spoke to Rosi, her mother was nearby. She would intervene and answer for Rosi. On her cue Rosi would come out with the statement that "we want good films. I want to become a star. Look at Shabnur madam [the respected actress]. We would never be able to become stars like that by doing dirtiness."

As I was about to leave Tepantor, Rosi asked me to wait, saying that she had something to show me. From her bedroom she retrieved a photograph, plasticized against the moist Bangladeshi weather. She handed the picture to me proudly. The photograph was a portrait of Rosi from a previous set. She was dressed in an embroidered red-and-gold wedding sari. She was wearing bridal makeup. "It was a wedding scene," said Rosi; "they

are my favorites." While the cut-pieces in which she acted had coded Rosi's character, Lopa, as middle class but despoiled, from Rosi's own perspective her characters provided a glimpse of the world that she intended to join, including an elaborate wedding sari. Like in her celluloid world, Rosi seemed to desire resolution that would normalize her in terms of the moral order. She was deeply invested in restoring that order. Again, the actress and character distinction seemed porous.

But in the universe of *Mintu the Murderer* equilibrium had still not been achieved. Rosi's unmarried Lopa had two intimate encounters according to the script. She danced off into the end of the film with her lover, Sohel. My theory on illicit sex and rape still seemed to be defeated by *Mintu the Murderer.*

LOPA/LOPA

It was almost a year after *Mintu the Murderer* had been conceived, written, shot, edited, and exhibited that it finally struck me. Coming back on the bus from a trip to North Bengal, where *Mintu the Murderer* had been showing, I finally realized that there were three characters named Lopa in the film. I hadn't known because the final Lopa had been kept hidden very effectively. As I watched *Mintu the Murderer* in a cinema hall in Joypurhat, a sequence started that I had never seen before (see chapter 6). After the sequence in which Rani rejects her intended husband, shot in Wonderland, there was a cut to a bedroom sequence. The cut-piece showed the corrupt minister's son with a young woman named Lopa dressed in bicycle shorts and a tight top tumbling over each other in bed, her bottom exposed. The scene ran for a while and was then suddenly over. If there was more footage to the scene, it was not shown that day.

The actress playing Lopa here used the name Lopa offscreen as well. Bokul could only tell me a little about her: that she did full nudity. Taslima was similarly curt about her work. I never met Lopa. She seemed to work mainly outside the FDC, and those who needed her knew where to find her. During the months in the editing room, I was privy to a number of conversations about actresses such as Lopa, and assistant director Faruk would provide producers and directors with the phone numbers of actresses that would do open, or *kholamela*, work. In the editing rooms bawdy conversations accompanied images taken from sexually explicit sequences such as Lopa's. I never met her. I barely even found her in the film I had followed for a year. Her performance in it was short, rarely screened, but diegetically

very important. In *Mintu the Murderer* it was this Lopa that carried the burden for the other Lopas. Right at the beginning of the film, Rani rejects her intended husband because her friends tell her in Wonderland that this is the man who had "'destroyed'" their friend Lopa's honor (*noshto kore felechhe*). It had been horrible. The man had despoiled her and left her. All she could do was commit suicide.

PURDAH AS SCREEN

From Taslima's baby-blue *borka* to Jenny's lack of makeup, Rosi's "wedding" photographs, Lopa's perfect disappearance, and Shadnaz's press conference, each of the women who acted in *Mintu the Murderer* negotiated their visibility. In this chapter I have shown how they mobilized different forms of visibility to navigate the different domains in which they worked. Presenting themselves for the gaze of others, inscribed in a patriarchal order, they appeared in different guises to-be-seen. Such different screens consisted of already available cultural images and were indicative of recent social transformations. Such transformations included the increased participation of women in the labor force and the anxieties of masculinity this created, as well as more established tropes, from the prevalence of rape as a symbol in the public realm to the explicitly sexual imagery associated with women in formerly male-dominated public spaces such as colleges and corporations. These tropes and images appeared especially crystallized in cut-pieces. Flickering in and out of visibility, these cut-pieces thematized exactly these transformations and anxieties through the illicit display of the female body. Working within this general domain, the actresses of *Mintu the Murderer* produced differently positioned visual signs as they played with *purdah*, adapting the screen to the occasion. In the next chapter I will show how montage joined these various screens into a single film in the FDC's editing rooms.

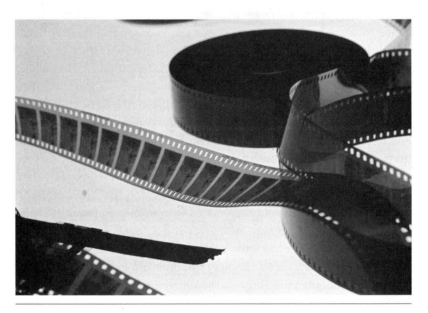

FIGURE 4.1 PHOTO BY PAUL JAMES GOMES.

{4} CUTTING AND SPLICING

THE EDITOR AND CENSOR OF *MINTU THE MURDERER*

ONTAGE IS the alchemy of cinema. It transforms separate shots into fluid, naturalized movements of time and space. The cutting and splicing of celluloid allows disconnected shots to be strung into narrative. The film editor wields the scissors to make meaningful cinema. *Mintu the Murderer* was graced by two sets of such cutting and splicing visionaries: its editing team, which operated under the regulatory powers of the Bangladesh Film Development Corporation, and the members of the Bangladesh Film Censor Board. Both organizations cut up the shots for *Mintu the Murderer* to make meaningful cinema. Montage here is a form of censorship while censorship is a form of montage. Each party separated out shots and produced appropriate scenes to make up the narrative of *Mintu the Murderer*. In this chapter I will investigate the cutting of *Mintu the Murderer* by these two parties and show how the editor and censor were locked into mutual practices of montage, making *Mintu the Murderer* meaningful through their excisions and insertions.

In *Excitable Speech* (1997) Judith Butler discusses the possibilities of censoring pornographic material in the United States. She suggests that "the circulation of the pornographic resists the possibility of being effectively patrolled, and if it could be, the mechanism of patrol would simply become incorporated into a pornographic thematic as one of its more savory plots concerning the law and its transgression" (95). Little could describe more effectively what cut-pieces are. Not mere narrative recourse, the cut-piece is the materialization of censorship as montage practice. The method by which the Bangladesh Film Censor Board aims to contain sexually explicit and suggestive material, by cutting it out of film reels during acts of censorship, has been appropriated to produce one

of the main forms of Bangladeshi illicit imagery: the cut-piece. The state regulations against pornography have, paradoxically, effected the main form of porn and are imbued with the fantasy and lure of the forbidden.

In pursuing ethnographically the actions of the Censor Board, and positioning this account within the anthropology of the state in South Asia on the one hand, and the study of censorship in South Asia on the other, a peculiar contradiction emerges. The recent expansion of the anthropology of the state in South Asia (Berenschot 2012; Fuller and Bénéï 2001; Gupta 1995; Hansen 2005; Parry 2000; Ruud 2011; Spencer 2007; Verkaaik 2004) has shown how official practices are shot through with unofficial alternatives and supplements; how the sovereignty of the state is not absolute or unchallenged, functioning as mythology instead; and how the letter of the law never spells the final word. The proliferation of ethnographic examples of the blurriness, challenged, and incomplete nature of the state's sovereign control stands in some contradiction to the ways in which censorship has been approached within the study of cinema in South Asia. Here, the idea that the functionaries of the state might not actually do as its laws say, or that official statements belie unofficial practices, has not been a central concern. Instead, the important scholarship on censorship in India has agitated against censoring, focusing on how censorship silences particular forms of dissent (Ghosh 1999), is used as a political tool (Kapur 1996), or enshrines certain notions of decency and taste (Bose 2006). Others have taken on Kuhn's (1988) Foucauldian suggestions about the productivity of censorship and self-regulation on the part of filmmakers (Ganti 2009; Mehta 2011). In this vein Prasad has shown how the famous song-and-dance sequence of Hindi cinema, the chases around trees and romps through gardens, kissing flowers on the way, as well as the use of fade outs, can be understood as generic devices to express sexuality in the context of tight censorship regulations (Prasad 1998:91), what Lalitha Gopalan describes as the moment "the camera withdraws just before we see a sexually explicit scene" (2002:37). In these accounts of the cinema, censorship does the work it says it does, even if in politically repressive or cinematically creative ways. In this chapter I will argue that the assumption that sexually explicit imagery is effectively controlled by censorship regulations or that it has produced some of the key narrative conventions of Bangladeshi cinema is only part of the story.

I position the case of *Mintu the Murderer*'s editing and censoring between these bodies of literature, presenting an ethnography of censorship that goes beyond the Censor Board offices to show how censorship does not

entail repression of illegitimate footage so much as it elicits a movement of such material to realms apart from the official spaces of censorship. I provide an ethnographic account of the cutting that the reels of *Mintu the Murderer* were subjected to by its editors and censors. I will follow the film's montage process and show how different sections were produced in different locations and under different circumstances. Uncertified scenes, illegal clips, and rogue frames did not disappear owing to censorship; rather, censors and editors worked together to push them into different realms, other moments. The editors and directors maintained clear divisions between the different sections of the film and produced different versions for different occasions and publics. In this, they followed the practices of the Censor Board, whose members similarly separated out certain scenes and shots to be made visible or invisible in the public realm. These two montage practices interlocked in the production of the film's so-called censor cut, the version of the film that was submitted to the Censor Board. I will describe how the censor cut of *Mintu the Murderer* was made by the editors and received by the Censor Board. While decoupage informed the editor's montage, the resulting continuity editing was undone by ideas about, and editing practices by, the Censor. Describing the process of editing and censoring *Mintu the Murderer* also shows how little either of these procedures draws on existing legislation, relying on generalized notions instead.

From this account it will be evident that the Bangladesh Film Censor Board functions somewhat ineffectively to control what visual material becomes available in Bangladesh's public realm. Instead, its activities are largely symbolic. Its main role is to produce ideas about "healthy" cinema, "our" culture, and "decent" women and to maintain these in a different realm of public access from material such as obscene cut-pieces. The board's policing does not consist in excising but in shifting sections of celluloid between different realms of visibility.

RUSH CUT

The lab had processed the first reels for *Mintu the Murderer* in the first week of March 2005. While the crew was working its way through the shooting script, the tins of processed negative from the first days arrived at the empty editing room. The small cubicle contained no more than a desk and a couple of chairs. An air conditioner kept the tiny room at a temperature that suited the delicate celluloid negative that twirled out of the small tins brought in from the lab.

Mohamad Abdul Karim searched the 35-millimeter frames for the image of the clapboard as the celluloid slid across the soft fabric of the white gloves he was wearing. Leaning in closely, the apprentice editor tried to find the frame that showed the clapboard on which the sequence, shot, and take numbers were written. Every film tin Karim opened contained four hundred feet of celluloid negative. It took him about fifteen minutes to sort the negative into individual shots. Beside him sat assistant director Faruk. As Karim cut take after take from the negative reel, Faruk decided which takes were to be kept and which were to be rejected. Faruk passed the accepted takes to Choyon, the junior assistant director sitting cross-legged on the floor. With the accepted takes rolled up tightly into small celluloid rolls, Choyon was building full sequences from the individual rolls. As if laying out the pieces on a chessboard, he placed the reddish brown rolls of celluloid onto the white sheet spread out on the floor. "That is why it is called lineup," he explained to me as he positioned the celluloid rolls into equally spaced rows making up the sequence. Every time Choyon had lined up a full sequence, he would hand the shots back to Karim one at a time. With a razor blade Karim scratched the top layer off the edge of the strips of celluloid. He then glued the separate shots back together into sequences and the sequences into scenes. Wound onto cores, the lined-up reels were sent back to the lab to be printed there.

Karim was waiting for his boss, Kamal, to hire a new junior assistant editor. Only then would he be able to get rid of the mind-numbing tasks like sorting and lining up. He had been an apprentice to Kamal for more than a year now, and he believed he was skilled enough to be allowed to do more complicated tasks. He had arrived in the city of Dhaka from the small southeastern town of Feni. After his school exams marking twelve years of education (HSC, Higher Secondary Certificate), Karim came to Dhaka and enrolled in a graduation college. After another two years of education, he started looking for a job. Curiosity drew him to the FDC. He quickly realized he preferred editing work to being an assistant director. "I get to sit in an air-conditioned room," Karim said laughingly. "Those guys have to be outside in the heat and on set all day." The job came through an acquaintance. "I had a friend who was working at the FDC," said Karim; "he introduced me to Kamal *bhai*." Chisthi Kamal had taught Karim all the editing techniques. Like most of the technical jobs at the FDC, editing skills were learned through an apprentice structure, where senior practitioners passed on their skills to junior protégés. "He put me forward to the Editors Guild," explained Karim; "in about a year I will have to take

an oral exam with them. If I pass, I will be able to become a member of the Guild myself."

To be eligible to work at the FDC, all editors had to belong to the Film Editors Guild. The Guild took on only those educated up to HSC and promoted apprentices to assistant level after two years of practice and exams.[1] Like the other professional associations, the Film Editors Guild mediates between its members and the Bangladesh Film Development Corporation. If rooms needed maintenance or equipment replacing, the Guild applied to the FDC. Similarly, the FDC set the rates for the rent of the rooms (350 to 1,400 taka per shift, depending on the room), and the FDC "editing-in-charge" collected the fees. Although at times the Guild members united on certain issues, including charges of being involved in obscene work, there was little security that the Guild as a union could provide.

Though the Guild attempted to mediate between the FDC and the editors working on its grounds, the editors were essentially freelance workers and, despite their unionization, depended largely on the whims of individual producers. The editors were paid according to the producers' standards, which generally amounted to 60,000 taka (approx. US$950) per completed film (about two hundred shifts), plus daily convenience money of about 100 taka (approx. US$1.50) and a packet of cigarettes each. The money was split among the whole editing team. Kamal's team consisted of senior assistant editor Insaan and the apprentice Karim when they were given the job of editing *Mintu the Murderer*. At any time they would work on about four to ten films simultaneously. Spread between the different filmmaking parties, the three were rarely at work together. Work was on every day of the week, 8 a.m. to 11 p.m., except for the two yearly Eid days.

Chief editor Kamal lit up yet another cigarette as he ran the rushes over the four-plate Steenbeck editing table. While the negative reels were treated with care and white gloves, the printed positive reels, or rushes, only functioned as a working copy and were disposed of when the film's final form had been put together. Leaning back in his chair, Kamal controlled the speed and direction of the reels with one hand. As the reel sped past, he stopped it only to mark the reels with circles and lines. It was then handed over to Karim, sitting at the back of the room. "The lines indicate where I should cut," explained Karim. "The circles show where I should stop." I turned to Kamal. "So if the editor can decide what gets cut out," I asked him, "the editor is really in control of the whole film?" Kamal shrugged and pointed to Faruk and Nazmul.

"The director decides," he said; "that's why his assistants are sitting here." In fact, the largest part of the editing of the film had been determined by the decoupage in the script. During the lineup, Karim had spliced the shots together according to this decoupage. What Kamal did was mark the dramatic sequences with lines and circles only to trim the shots of superfluous material. Any lingering of the camera was trimmed, pans excised, and, once dubbed, any superfluous dialogue expunged. "It needs to be tight," said Kamal; "only what is necessary stays in." Cutting the marked portions out, Karim spliced the trimmed shots back together with Sellotape. The effect of this montage practice was a series of actions and dialogue linked by jump cuts. "Effects and transitions are too expensive," director Shiplu had said. "Most editors don't even know what they are." The cinematic language of Bangladesh action cinema created by this montage practice produces meaning through an emphasis on action and dialogue joined by jump cuts.

The possibility for continuity editing was severely undercut by Kamal's rigorous excisions. Rather than smoothing out the movement across shots, Kamal's editing ensured jarring transitions from scene to scene in an attempt to shorten the film's length. These jarring transitions were exacerbated toward the end of the editing process. After the soundtrack for the film had been produced and had been synched to the images, Kamal would instruct his assistants to trim the scenes further. Cut by Kamal, the jarring jumps between scenes were exacerbated by the jump from one type of sound to the next. Often such jumps occurred midsound, cutting sentences and songs. In those cases, cutting within scenes also cut the sound transitions produced to smooth the visible effects of montage.

"Just cut the whole conversation," urged assistant director Nazmul. "We can go straight into the explosions!" Having been steadily cutting the rushes down to their bare minimum, Kamal now turned to Nazmul and gave him a piece of his mind. "It is a film!" he exploded. "It has to have a story." Impatiently Kamal started lecturing Nazmul on the definition of montage. "Tight editing doesn't mean you just cut out everything," he said, indicating the dramatic sequences Nazmul wanted axed. "Tight means cutting there where it gets too long or when the story gets boring." Unimpressed, Nazmul said that whatever "tight" might mean, the final film should be under 13,000 feet; otherwise, the Censor Board would take more money to examine the film.[2]

Kamal had every reason to mind the Censor Board's regulations. Regularly working with filmmakers notorious for making vulgar films, Kamal

had faced the courts more than once. While editing *Mintu the Murderer*, a case against him was under way in the district court of Comilla. A film edited by him had been seized from the halls and found to contain obscene and uncertified material. The producer of the film had sent a representative to witness the trial in Kamal's place. Every now and again he would receive phone calls to update him on the situation in Comilla. These would inevitably unnerve him, but he continued to accept work from the same producers that got him into trouble with such regularity. The dramatic sequences he was rapidly reducing to their bare minimums served largely to couch the sequences that Nazmul favored: cut-pieces. The narrative of *Mintu the Murderer* was a vehicle to present the fights and dances that were a film's main attractions. Its editing was made subservient to the possibilities of inserting cut-pieces. Not only scriptwriting and shooting, but also editing was geared to the production of the forbidden spectacle that was made available in oscillating visibility. One unfortunate afternoon's events illustrated how this worked and the extent to which Nazmul shared Kamal's anxiety about the visibility of cut-pieces and possible censorship.

That afternoon in May, about two months after editing had started, Nazmul had burst into the air-conditioned editing room. "They just walked in!" he cried, his eyes darting around the room in panic. "I really thought I had locked the door," he continued, "but they just walked in!" Seeing me sitting beside Karim, Nazmul turned to Adom, the senior assistant director smoking a cigarette next to the piles of rejected footage. "Relax," said Adom; "what happened?" The panic that spoke from Nazmul's fidgeting, his hand running back and forth over his newly shaven head, seemed to infect Adom. Nazmul started to speak fast and in low tones about the intrusion into his editing room. Karim continued cutting the reels with concentration, but like me, he was trying to follow Nazmul's account. I looked away, knowing this story was not intended for my ears. Nonetheless I listened in on Nazmul's panicked account.

"They just walked in!" Nazmul repeated. "There were about five of them; they were petitioning for some association." Adom asked what they wanted. "I don't know," replied Nazmul, increasingly disconcerted; "they wanted me to sign on or something." "Why wasn't the door locked?" asked Adom. "I don't know!" Nazmul went over the details again. He had gone out for a little bit, and when he came back in, he should have locked the door behind him, but somehow he forgot. And then they just walked in. "Did they see anything?" asked Adom. He too had lowered his voice. "I don't know, I don't know," repeated Nazmul. His eyes betrayed his panic.

With a knock on the door five men marched into our small editing room. Even Karim, stoically cutting the reels, now turned to see what was happening. "An association only for assistant directors," said the man leading the small party. He waved a piece of paper before Adom's eyes. "Everyone here has an association," he continued; "the directors, the producers, the editors, the choreographers, even the stuntmen have their own association!" The other men tried to find a place to stand in the now crowded room. "But we as assistant directors are totally dependent on producers and directors." The man seemed to speak solely to Adom, who listened impassively. Nazmul stood in the corner, looking away. "You know what it is like, Adom," the man argued; "for every bit of money we need to plead with the directors, with the producers. And when something happens in our family, if we get ill, then we hear nothing. No news from either director or producer." The man looked satisfied with his speech. He put the piece of paper on the table and asked Adom to sign. Adom declined and said that he would think about it. Gesturing to the vast quantities of uncut footage awaiting Karim, Adom ushered the men back out and shut the door behind them.

Locking the door with the heavy latch, Adom turned to Nazmul and told him he was an idiot. "Never leave that door unlocked again," he threatened. "But don't worry, they won't make any trouble, even if they had seen anything." Nazmul looked relieved but not convinced. "What if they go to the Directors Association?" asked Nazmul. "They won't," said Adom; "now get back to work." As Nazmul left the room, I asked Adom what had happened. Adom grumbled but did not divulge. The codes of secrecy surrounding the work in Nazmul's editing room had been restored.

I had tried to find out myself what Nazmul had been doing over the last couple of days. He and senior assistant editor Insaan, generally among the most forthcoming in the *Mintu the Murderer* team, had been sending me on errands and for cups of tea with increasing regularity. The film had been in its montage phase for about two months now, and more often than not, I had been refused entry into particular editing rooms or sent away to see other work in progress. The filmmakers were making sure that I saw only certain sections of the film, only those sequences that were deemed suitable for general consumption. Those parts of the film that they considered vulgar were not openly shown to me. What I did not realize until Nazmul's panic attack, was the extent to which these restrictions applied not only to the foreign anthropologist but also to their colleagues and the amount of anxiety that underlay this strict division.

This hierarchy was further clarified at the time of the run-through of the entire edited and dubbed film. Exactly three months after Karim had started sorting the negatives, the rushes were completely edited and dubbed. At this point music director Anwar Hossain Mithu was brought in to watch the complete film in one of the FDC sound studios, together with the directors and producers. He watched the film and made notes about the types of background music that would be needed for the various sequences. After the run-through he spent about an hour per reel over three days applying the music fragments to the individual sequences. He followed the montage logic of the film and cut the musical fragments to coincide with the jump cuts applied by Kamal between the sequences, underscoring rather than suturing the jumps from dialogue to dialogue, drama to action, action to romance. The musical fragments Mithu delved up from the memory of his laptop ranged from Bengali folk tunes to instrumental versions of Michael Jackson songs. The stock was limited, and the same sounds were used in many other films. Watching each reel before aligning his fragments, Mithu would ask Shiplu about the exact order of some of the sequences. "So there will be a song after this scene?" asked Mithu, watching the garlanding of Mintu after his engineered electoral victory. The reel ended with Mintu's henchmen asking Mintu whether they would celebrate that night. The dialogue was a clear indication that a song sequence involving alcohol and dancing girls, a stock sequence in Bangladeshi action cinema, would follow. "No, no," replied Shiplu hastily, "no song here. It will go straight on to reel three from here." A few reels down a similar confusion and suspicion marked Mithu's questioning of Shiplu's filmmaking logic. The side character of a drunken and lecherous villain played by assistant director Nazmul appeared in a few sequences throughout the film. Unclear what bearing Nazmul's character had on the narrative of the film, Mithu pointed out to Shiplu that he'd better cut Nazmul's character out. What I knew by then, but Mithu clearly didn't, was that Nazmul's character was linked to the third-tier actress Rosi and the hidden story line of her character, Lopa. That whole part of the narrative had not been included in the run-through. These songs and sequences were withheld from Mithu and processed in one of the private studios by other technicians.

"At the FDC we have everything," Insaan laughed, "all blue film, up to triple X." Insaan was synchronizing the sound and images of the song sequences and adding sound effects. Surrounded by dozens of small rolls of magnetic sound reels, Insaan searched the silent celluloid reels

of *Mintu the Murderer* for punches and mobile phones, doors slamming, and bombs exploding. For every whack and thump Insaan cut a couple of inches from the small reels and spliced them into the magnetic sound reels for *Mintu the Murderer*. Where the fighters swung their arms back, Insaan inserted a couple of frames worth of "white piece," or silent soundtrack, between the blows, separating out the sounds. I asked him how he knew how much to put in between. "Experience," said Insaan as he continued spinning the reels. Like Karim he had learned all the editing skills as an apprentice and had internalized the craft. The loose ends of the effect sound reels hung from his neck while he expertly spun the image reels back and forth with his right hand. He swiftly pulled the magnetic reel toward him, slid the small knife over it, grabbed a reel from around his neck, and taped the ends back together. His right hand rewound the reel tightly to incorporate the new sound effect. His body and the editing table were one in their steady and fluid movements, betraying Insaan's many years of editing work.

Insaan had been working as a film editor at the FDC for almost twelve years. Before that he had worked in a private video shop, mainly documenting weddings in VHS. In the hope of a more stable and profitable career, he had sought out possibilities of becoming an editor in the film industry. "Those who came much after me, when I had been working for years already," Insaan would often repeat, "they are already working as independent editors. I am a much better editor, with much more experience, and yet I am still working as an assistant." Highly skilled but lacking the right contacts, Insaan could not attract enough work on his own to be able to work independently.

The editing of *Mintu the Murderer* took more than three months. In the summer heat of May the editing rooms were a luxuriously cool hide-out. During one of the many long hours in one of the editing room, a befriended editor had taken his wallet out of his back pocket. "Look," he said while he shook a couple of frames of positive celluloid out of the wallet. I took a single frame between my thumb and index finger and held it to the light. And there she was, Rosi as Lopa, leaning forward, eyes closed, breasts hanging free from her open bra. The actor behind her held her to his body by her hips. "From this movie?" I asked. "It was being edited a couple of weeks ago for *Mintu the Murderer*," said the editor triumphantly; "you need to see more?" In single frames Rosi's full sequence came out of his wallet. Aligned, they fragmentarily showed the pornographic sequence that had been identified as "romance" in the

script for *Mintu the Murderer* (see chapters 1 and 3). The other editors smirked and pulled similar frames from back pockets and wallets. When editing, many of them took single frames from the various shots and kept them for private consumption. After spending three months in the editing rooms, the less conspicuous sides of editing Bangladeshi action cinema became visible to me. The wallets of the editing fraternity contained a veritable who's who of third-tier actresses caught in the buff. Apprentice editors emptied toolboxes to retrieve single frames of pornography while others boosted tins full of vulgar clips. A parallel world of rogue frames had become visible to me.

While waiting for a chance to work independently, assistant editors such as Insaan did most of the cut-piece work. Sitting with one of Shiplu's assistant directors, he synched the songs that did not bare the light of day while pornographic sequences were lined up. Here cut-pieces were made. They were cut out of the film during its run-through, and they would not be submitted to the Censor Board. But this didn't mean they didn't exist or that they were not intended to be screened. Kamal's assistants edited the reels that had been indicated in the script with terms such as "bed scene," shot away from the FDC with assistant cameramen and junior artists. The practices of montage and the cut-piece phenomenon show that in Dhaka, censorship in the film industry is a question of time and space rather than of metaphor, narrative resolution, or outright repression.

In the context of India, Lalitha Gopalan has insightfully argued that where censorship regulations have led to particular forms of substitution, these have become cinematic conventions in their own right (2003:367, 371). Gopalan dubs these conventions "*coitus interruptus* to exemplify the different ways in which the film industry negotiates the [censor] code to finally produce the female body on screen" (21). With this, she provides a concrete illustration of Annette Kuhn's argument that rather than prohibitive, cinema censorship is a productive activity, shaping rather than undermining film production, distribution, consumption, and even genre (1988:4). Clearly, filmmaking practices in Bangladesh are impacted by censorship regulations. I argue, however, that the productivity of censorship in Bangladesh isn't only about transformation and replacement; rather, it is about moving between different arenas of visibility. Regulation in Bangladeshi action cinema is not about expunging or substituting but about finding the right time and place to show different types of visual material, from romance to porn, from comedy to decapitation.

Despite underscoring the pleasure generated by genre conventions produced in conjunction with censorship in the Indian cinema industry, Gopalan repeatedly invokes a sense of loss when describing *coitus interruptus*. As the terms *interruptus* and *withdrawal* already indicate, she discerns "a cinephiliac mourning over lost footage" (21) and the replacing of "lost scenes" (27). Although the Indian state's capacity to police its film industry is not under discussion here, the ethnographies of other responsibilities of the Indian state cited above, as well as comparison with the situation in Bangladesh, suggest that such mourning might be premature. The productivity of Bangladeshi cinema censorship works not at the level of the film text but in the division of realms of visibility. What censorship in particular, and the law in general, calls into being is a parallel space for the appearance of the disavowed. The "lost footage" for *Mintu the Murderer* could be retrieved from locked editing rooms, editor's back pockets, and private studios. Rather than interrupting the film's narrative flow through genre-specific devices, ideas about film censorship produced a film in many forms. As the final negatives for the film were cut from the rushes by Karim and printed, it became clear that there could be any number of cuts of the same positive footage to suit any occasion.

This montage process should not be conceived as merely an illegal activity. The cut-piece phenomenon functions like a public secret, as analyzed by Michael Taussig, who suggests that "the public secret involves . . . the creation of social subjects who 'know what not to know,' thereby instituting a pervasive 'epistemic murk' whose core is an 'uncanny' dialectic of concealment and revelation, though the secret revealed in this case is, qua secret, not really a secret" (Taussig 1999; quoted in Surin 2001:206). The editing fraternity existed of such social subjects who knew what not to know and, crucially, what not to show. Taussig's public secret is maintained by the state, and the social subject is caught in the uncanny logic of concealment and revelation of this secret that is not really a secret. The montage of *Mintu the Murderer* was marked by this uncanny logic as cut-pieces appeared and disappeared. The editors were excellently versed in this logic. Their montage skills can be compared to the practice of giving bribes described by Akhil Gupta as a "competence" (1995:381). The editors of *Mintu the Murderer* had such performative competences. They were able to produce cut-pieces while maintaining them simultaneously in and out of view. Thus they produced cut-pieces according to the logic of the Censor Board: as a public secret. Their preparation of the so-called censor cut is its clearest example.

CENSOR CUT

When the date neared on which *Mintu the Murderer* would be examined by the Censor Board, Insaan and Kamal met with the producer and director behind closed doors. The meeting was held to prepare a copy of the film, known as the "censor cut," that would be appropriate for the Censor Board's consumption. The producer was unwilling to allow me any access to this cut of the film. I was not allowed to see what I knew very well already: the censor cut was intended to excise those sections of the film that would be deemed unacceptable by the board. It was one of the numerous moments in which I was forced into what I call "participant nonobservation," by which I mean that I participated through having to look away, which nonetheless allowed me to grasp the logic of the cut-piece in its oscillation between visibility and invisibility.

I will here describe the censor cut made for a similar action film, one that I call *Cruelty*, made with largely the same technical crew as *Mintu the Murderer*. While the final negatives for *Mintu the Murderer* were being cut by Karim in an "empty" room, Insaan and Kamal met with the young film director Masud, responsible for *Cruelty*. Insaan strung the first reel along the Steenbeck editing table and spun it to the opening frame. Flanked by editor Kamal, Masud, two of his assistant directors, and the two producers of *Cruelty*, Insaan ran the reels. The opening credits give way to a sequence in which a villain and his henchmen prepare bombs for a corrupt politician. Explaining the movie's story line to me, Masud said that the film's script was based on a Tamil or Telugu film (he wasn't sure which) that was inspired by the 9/11 events. "It is about a bomb attack," said Masud, "a romantic action film." Kamal immediately intervened. "Cut it," he said; "they won't allow it." "Why not?" asked Masud, inexperienced in matters of censor cutting. "It is not as if we are implying that the politician is in the government." "It is the bombs," said Kamal. "It's too sensitive right now; it needs to be cut."[3] Insaan stopped the reel, pulled up the celluloid, and cut around the dialogue of the politician. Masud looked on unhappily as Insaan reduced the sequence to a moth-eaten version in which it was no longer clear what the men were doing.

As the first song sequence rolled over the editing table, tension in the room began to rise. "But how can you make a film like this?" asked Masud angrily. Kamal had suggested taking out all close-ups of the leading lady as a spray of water hit her stomach and chest. "Look," said Kamal, "the Censor Board is in a bad situation; they are going to cut anything that

might be problematic." He was referring to the progressively hysterical demands from journalists of the quality press to reform the Censor Board and stop the cinema industry's move toward an exclusive focus on action cinema (see chapters 5 and 6). Kamal ordered Insaan to cut all close-ups of female breasts and crotches, all images of the actress in a state of wetness, and any suggestive sprays of water. "But this isn't right," said the choreographer, who was making his first venture into film production by partially financing *Cruelty*. "If those are really the rules, you can't make any sort of dance." He had been working as a choreographer within the FDC for many years and was astounded to see that his stock moves were reduced to cut-pieces by Kamal's unforgiving knife. When Kamal started to explain that an actor's hand is not supposed to touch the body of an actress in any dance sequence, Masud lost his temper. "Where does it say that?" he challenged Kamal. "Of course an actor can put his hand on her belly; it is shown all the time!" The argument that now erupted between Masud and Kamal quickly developed into a free-for-all. As everyone loudly proclaimed his opinion about the Censor Board, its regulation, and the state of the industry, it became clear that no one knew exactly what the Censor Code said. It was not the letter of the law that informed the production of the censor cut of *Cruelty*. Instead, the editors and producers relied on ideas about the Code, experience, and estimated guesses. Kamal worked on the basis of his experience with other films and his own misadventures with the board.

Young and adamant, Masud eventually managed to ward off Kamal's severest cuts. "He is trying to make a name for himself," explained Insaan to me later. "As a new director he has to bind his audience, make his name known. If his certified films are juicy, he can make a place for himself in the market." Kamal ordered Insaan to splice some shots back in. "It might get banned," said Kamal as he reviewed the song sequence in its new form, "but all the better. It will certainly be a hit then. The journalists will pick up on it. If you protest and get it re-released, you will have a massive audience." The biggest recent hits were films that had had serious brushes with the Censor Board, such as the banned films "Despoiled Girl" (*Noshta meye*, A. R. Rahman, 2005), *Model Girl* (M. A. Rohim, 2005), and *Fire* (Mohammad Hossain, 2002). Films were seized with some regularity from countryside cinema halls by police officers on the grounds of containing obscene material. Upon arrival of the reels in Dhaka, however, any trace of the offensive footage would have vanished. The board would be left with little choice but to dismiss the case. If a film did contain uncertified material and a court case ensued, films were rarely banned in the lower

courts. The notoriety that resulted from a film's seizure, court case, and eventual rerelease would ensure a large audience for the film. Often, the news of a film's banning was enough to generate massive interest in the film. It was the suggestion that a film contained vulgar material of such extremity that the board would want to ban it outright, rather than the actual material found, that would generate interest in the film. As Kuhn argues, "film censorship creates censorable film, and a censorable film, once it has entered the public domain, becomes a marketable property exactly because of the lure of forbiddenness conferred by known acts of censorship" (1988:96). A film containing footage explicitly kept from the Censor Board could also enhance the "marketable property" of *Cruelty*.

Masud seemed more than willing to take the chance of *Cruelty*'s getting banned and ordered Kamal to retain the shots of the actor's hand on the exposed midriff of the leading lady. His only worry was the inexperience of his choreographer-producer. "He doesn't know the ways," he complained to Kamal in the choreographer's absence. "How much, where and when," he continued in a matter-of-fact way. "This producer doesn't know which amounts should go where to ensure the proper censoring of the film." Kamal responded by giving his opinion on the amounts the Censor Board would "eat." "About 70,000 to 100,000 taka [approx. US$1,100 to $1,600] to the Censor Board," said Kamal, enumerating the different members of the board and staff that needed to be bribed.[4] When I asked Masud about the need to bribe, he responded that these days a film would not even be given a date for censorship without the right amounts distributed. An experienced producer would know exactly how to ensure a film's smooth sailing through the board. Both the ability to cut celluloid appropriately and to bribe efficiently were necessary competences for cultural production that functioned within a framework of state regulation.

A few weeks later, I spent an afternoon at the office of a producer whose newest venture was to appear before the Censor Board the next day. As I sat and enjoyed a number of cups of tea, three members of the board came by, one after the other. Out of earshot they would chat with the producer and leave again. When finally the board's projectionist came by and named a few numbers a little too loudly, the producer angrily nodded in my direction and took the projectionist off into the corridor. The next day the producer's film was censored, and only minor cuts were required. Despite his inexperience, the producer of *Cruelty* managed to replicate this success, and *Cruelty* was eventually certified after a few further cuts. The film became a success and established Masud as a director who brought *rosh* (juice) to the screen.

STATE CUT

"Censor duty is worse than the gas chamber," said the joint secretary of the Ministry of Information without a trace of irony as he bit into his *shingara*. He sat in the air-conditioned office of the director of the Bangladesh Film Archive, watching the director fiddle with the receiver of his new television. "I prefer art film," he continued. "I am a film activist. You know, I was with Alamgir Kabir before '71."[5] He recounted his many years abroad and his taste for what he described as "good" film. "The films that are produced in Bangladesh today lack any story, any sense," he explained, articulating his distaste for being a member of the Censor Board. He had come to the archive to watch some of the classics in the archive's possession. The newly built auditorium had not been officially opened yet, but for the joint secretary the director of the archive gladly made an exception. "The Lumière Brothers, *Rupban*, Nuzrul Islam's film, the original Bengali *Dev Das*," he instructed the projectionist. The projectionist set off to retrieve the classic films from the basement storage rooms. "Three, four times a week," the joint secretary continued, "watching hours of disgusting films, I don't want to be on the board ever again." But if I did want to put myself through it, of course he would ask the information secretary, the chairman of the Bangladesh Film Censor Board.

A few weeks after my meeting with the joint secretary, *Mintu the Murderer* was set to be examined by the Censor Board. Caught between the high rises that had shot up around it, the crumbling building that housed the Censor Board harked back to an older Dhaka. The two-story whitewashed house gently curved around a green courtyard. Each room opened to a wide veranda, allowing the air to circulate. The many windows of the vice chairman's office were closed tightly and curtained to accommodate the air conditioner. The portly man sat behind his imposing desk and called out for the files on *Mintu the Murderer*. On the couches lining the walls sat three members of the Censor Board, awaiting the start of the screening. They were Chasi Nuzrul Islam, film director, producer, and prominent member of various cinema-related associations; a senior government engineer; and the head of the Department of Film and Publications of the Ministry of Information, in her temporary function as managing director of the FDC. Together they would decide whether *Mintu the Murderer* would be certified for public exhibition or not.[6]

"Members of the government, of course, partake of the Censor Board," Mrs. Rahman had said to me about the composition of the board when

I interviewed her in her home. She had recently become a member of the board. "But the other half of the board is made up by civil society," she said, "people from the arts, intellectuals and writers." The elderly lady lived in a stately mansion in Gulshan with three anterooms where her politician husband received his guests. The walls of the rooms were decorated with pictures of him with fellow BNP bigwigs, including the head of his party and prime minister Khaleda Zia. "I am a Tagore dancer, you see," Mrs. Rahman had continued. "I was at Shantiniketan. As an artist and member of the civil society, I have been asked to be a member of the Censor Board."[7] Conceptualized as a sphere beyond or besides the state, the notion of civil society is a powerful one in contemporary Bangladesh. Considered the panacea for many social ills, the currency of the notion can be attributed both to the conceptualization of the popular protests against military dictatorship, which led to the reinstatement of democracy, and to NGO discourses that encourage a realm of nongovernmental actors and practices to be set up against the state. However, the composition of the Censor Board brings out starkly John and Jean Comaroff's observation that "the autonomy of civil society from the state, the very autonomy on which the Idea [of civil society] is predicated, is entirely chimerical" (1999:24). The Censor Board's very legitimacy derived from its being a government institution that harnessed the epitome of Bangladesh's cultural and intellectual life in the form of its civil society. Like the FDC, however, the Censor Board occupies a space that indicates the overlaps and intertwining of the state with the film industry. The managing director of the FDC was by default a member of the Bangladesh Film Censor Board, which was chaired by the information secretary. In 2005, during a leave of absence of the managing director of the FDC, the director of the Bangladesh government's Department of Film and Publications (DFP) also headed the FDC and was a member of the Censor Board by virtue of that position. As the Censor Board was made up of eminent members of civil society, the film industry, and the government, the managing director of the FDC could presumably partake of censor duties under any of these categories. Most important, the participation of the managing director of the FDC and influential film personalities in the tasks of the Censor Board bring censorship directly within the premises of the FDC. The peculiarly Janus-faced organization that the FDC is suggests that the state and the cultural industries are not at loggerheads over censorship but are, in fact, difficult to distinguish at all. The point is not to suggest, as Qader does, that the board is fully government controlled (1993:499).

What the relations among the members of the Censor Board suggest is, indeed, the impossibility of disentangling those representing the state from those members acting on behalf of civil society or the industry. The invocation of civil society grants artistic, intellectual, and moral legitimacy to the board more than anything else.

This invocation of civil society was largely symbolic. If the board's members did not appear for a particular screening, this was not problematic at all. As the scheduled time for examining *Mintu the Murderer* came and passed, no one else arrived. The vice chairman ushered the three members out into the courtyard and through to the screening hall. Notepads ready, the four sat down on the couches in the hall. At the front a VHS camera was set up to record the film about to be screened. Having been kept away from the censor cut for *Mintu the Murderer*, I was curious to see what this version would look like. Even before the credits rolled, it became clear that *Mintu the Murderer* had suffered much the same fate as *Cruelty*. Mintu's first act of terror, inaugurating the film and shown before the credits, is the decapitation of a political enemy of the corrupt politician who employs Mintu as his hit man. Setting the tone for the rest of the movie, the sequence as edited by Kamal showed the decapitation in Eisensteinian fashion, through a cut between a shot of Mintu brandishing his sword as the politico sticks his head out of the window, to a shot of blood squirting in a steady stream from the same window. At the Censor Board, however, all that was shown was the wielding of Mintu's sword, and the shot of him walking away, a sack on his shoulder. This "perfectly empty space filled with what was" (Taussig 1999:33) would have been entirely incomprehensible to a viewer without knowledge of the complete scene.

As in the case of *Cruelty*, there were major cuts in this version of *Mintu the Murderer*. Besides the decapitation scene, the visual evidence of two further murders (another decapitation and a severed hand) were both edited out. The majority of missing footage, however, related to sex. Although in places an embrace or kiss was cut out, in other places entire story lines were missing. The characters played by Shabazi and Rosi were virtually absent from this version of the movie, leaving only parts of their song sequences. Their appearance onscreen must have been puzzling for other viewers, as they seemed to have no bearing on the rest of the narrative. Elsewhere, gestures or dialogue were cut out. The shot in which Mintu's private aide picks a letter out of the sari blouse of a female servant in the house had disappeared, as had the question asked about

the need to "celebrate" Mintu's election victory. The song that ought to have come immediately after this suggestion was not part of the reels delivered to the Censor Board at all. In the song sequences that were present, close-ups of the actresses' breasts, buttocks, and crotches were excised. As the sound reels had been cut according to the images that required erasure, the soundtrack of the songs was erratic, skipping beats and lyrics according to the cuts made. Jump cuts broke up what little remained of Kamal's continuity editing in the songs. Of the three rape sequences in the film, one of which doubled as a pornographic sequence, little was left. Only Josna's chase remained largely intact. Although the latter had been shot in full view at the FDC during a busy morning shift, it was not present in its full form at the Censor Board screening. The second rape scene showed only the action hero's mother pinned to the bed and the subsequent stabbing of the assailant by her young son. Of the third rape scene not a trace was left.

As the two hours and twenty minutes of a ravaged *Mintu the Murderer* passed through the Censor Board's projector, four more members of the board, as well as the chairman, came in to watch parts of the film. While the secretary served tea and snacks intermittently, few were able to sit through the whole film with concentration. There was a steady amount of movement in and out of the stuffy auditorium, and mobile phones rang incessantly. If the film was fragmented, the viewing by the Censor Board was equally patchy. It resembled the workings of the Indian Central Board of Film Certification, which Monika Mehta observed "included notice-able informality in their everyday evaluation of films . . . [and] committee members examined films casually" (2011:67).

The final sequence of *Mintu the Murderer* was greeted with a rapid retreat to the Censor Board's conference room. Following the group, I encountered Litu in the courtyard. Clearly agitated, the producer gestured to me nervously. Angrily he waved his hands to indicate I should not follow the members into the meeting. He knew that I was aware of the film's full form and had seen the scenes that were now excised. Perhaps because I had rejected his indecent proposals on a number of occasions, he feared that I would now reveal his secret scenes to the Censor Board. This time, however, the producer could not send me away or bolt the door before me. Having been invited by the chairman of the board, I was no longer subject to the producer's control of what I saw or heard. Like the appearance and disappearance of the cut-pieces, access to vision was predicated on relations of power.

Inside the conference room the seven members sat around the table and signed the list presented to them by the secretary of the board. They each went over their notes and scribbled down some further comments. Khaleda Mahbooba, acting managing director of the FDC and head of the Department of Film and Publications (DFP) of the Ministry of Information, was new to the censoring job. She had made a long list of comments and chatted to her neighbor about how "Western" the song sequences were. "And a child committing murder like that!" she said enthusiastically; "that really isn't acceptable!" "Well, this is how these stories are made these days," was the perfunctory response of Chasi Nuzrul Islam. "But the story is so common," she replied, "all brothers and sisters and their gangster connections." She then turned to me and asked me where I was from. The chairman called the meeting to attention and asked each member for his or her opinion. "Those red shorts of that girl, what's her name," opened Mahbooba. "Lopa?" asked the engineer. "Rosi's shorts and the way she shows her body," continued Mahbooba, "did you see that?" Another member raised the disgust he felt when watching someone lick spit from a shoe. Four out of seven members raised objections, each of which was written down by the secretary of the board. Although a small booklet containing the Censorship of Film Act, Rules and Code, with various amendments, had been prepared by the Ministry of Information "for official use," it was nowhere in sight during this meeting. Even if the cuts to *Mintu the Murderer* suggested by the members of the board were based mainly on their previous experience and their own opinion of the songs as "Western" or "how these stories are made these days," their position allowed these notions to be active formulations of national ideology. The ethnography of censorship (Ganti 2009; Mehta 2011) illustrates "the ambiguity and indeterminacy of legal processes" (Kelly 2012:46), producing idiosyncratic outcomes.

As a ritual, censorship puts on show the state's moral worth and its position as the bearer of the nation's morality, culture, and religion. The act of censorship combines the three symbolic languages that Hansen and Stepputat suggest produce the state as the center of authoritative power, namely "the institutionalization of law and legal discourses . . . the materialization of the state in series of permanent signs and rituals . . . and the nationalization of the territory and the institutions of the state through the inscription of a history and a shared community of landscapes and cultural practices" (2001:8). The certificate appended to every film screened in Bangladesh is followed by the national anthem and the

image of the Bangladeshi flag flying in the wind. These speak the symbolic languages of the state loudest. The deliberations of the board work toward formulating and instantiating this language. The ritual of censorship produces a dramatic articulation of its sovereign power to decide what should remain visible to the national public. The members of the board require no recourse to the letter of the law as they are well aware that they fill the shoes of "the Master, in this case the Heideggerian protagonist of the state-machine . . . who . . . names the Event and reconfigures the symbolic field accordingly" (Surin 2001:214).

After ten minutes of roundtable discussion, the secretary of the Censor Board had compiled a list of nine objections, which he read out to the board. This is the list as it was sent in a letter to the producers of *Mintu the Murderer*:

First, at the end of the song "When He Feeds Me Soft Drinks," when [Rosi][8] is wearing the red shorts, the close shots of her chest and navel and all obscene [oshlil] shots must be removed.

Second, in the song "I Got Wet in Your Love-Rain," the close-shots of [Shavana's] wet navel and chest and all obscene shots must be removed.

Third, in the song "There Are Small and Big Locks, Those Which Are Open," the embracing, as well as close-shots of [Jenny's] wet navel and chest and all obscene shots must be removed.

Fourth, in the song "This Warm and Soft Body," [Rosi's] embracing and holding the actor's head to her chest and all improper [oshalin] shots must be cut.

Fifth, the open murder with a sword on the highway as well as the murder of the commissioner must be made more suggestive.

Sixth, the shot of [Jishu] licking the spit of [Sumit Hossain's] boot must be cut out.

Seventh, when [Sumit Hossain's] mother is being raped, the image of her breast must be cut out.

Eighth, the number of fighting sequences must be reduced.

Ninth, the invasion of the polling centre by [Jishu's] men must be made suggestive.

The vice chairman asked whether this list was comprehensive. With no further comments to be made, the meeting was suspended fifteen minutes after it began. With these suggested cuts the members had spoken out against violence and obscenity in the cinema. The list was a statement

about the board's moral position. It expressed a desire to cut all obscene and improper imagery and encouraged the production of "suggestive" violence. Everything that was visceral (spit, wetness, breasts, or bloody violence) had to be excised or made suggestive, its resonant, visceral qualities the major concern for the Censor Board, which targeted, as Kaur and Mazzarella have suggested, "the affective intensity of images" (2009:8). It distanced itself from the blood and sweat in favor of suggestive violence and "proper" displays of sexuality. Thus, members of the board inscribed themselves as cultured, sophisticated, civil, in a word *bhodro*.

Yet the actual suggestions sent to the producer of *Mintu the Murderer* were variously interpretable, and the symbolic language they spoke had a less easily containable surplus, because acts of censorship "rely, for their political efficacy, on harnessing and mobilizing the public energy of the very artifacts that they appear to be trying to suppress" (Kaur and Mazzarella 2009:7). Although a number of shots were specified for removal, most of the Censor Board's requirements were of a rather vague nature. The removal of "all vulgar shots" and the transformation of explicit violence into a more "suggestive" form left plenty of room for interpretation. Like the Code's wording itself, the recommendations of the board could not pinpoint exactly what obscenity looks like. The Code speaks of "immorality or obscenity" when a film "condones or extenuates acts of immorality; overemphasizes, glamorizes or glorifies immoral life; enlists sympathy or admiration for vicious or immoral character; justifies achievement of a noble end through vile means; tends to lower the sanctity of institution of marriage; depicts actual acts of sex, rape or passionate love schemes of immoral nature; contains dialogue, songs or speeches of indecent interpretation; exhibits the human form, actually or in shadowgraphs in a state of nudity, indecorously or suggestively clothed, indecorous or sensuous posture" (Government of the People's Republic of Bangladesh, undated). These forms of immorality are then hinged to the nation by appending the final clause, which states that a film is of immoral or obscene nature when it "indecently portrays national institutions, traditions, custom or culture. (This covers kissing, hugging and embracing which should not be allowed in films of sub-continental origin. This violates accepted canons of culture of these countries. Kissing may, however, be allowed in case of foreign films only. Hagging [*sic*] and embracing may be allowed in sub-continental films subject to the requirements of the story, provided that the same do not appear to be suggestive or of suggestive nature)" (ibid.).

Clearly, such a Code is polysemous and difficult to enforce. But enforcement of the Code was not the main aim of the censoring of *Mintu the Murderer*. Just as the censor cutting of an action movie made little recourse to the text of the Code, so the cuts made by the Censor Board were not specifically linked to the legislation. The song "I Got Wet in Your Love-Rain" ends with the romantic hero and heroine sinking into each other's arms behind a white sheet. It "exhibits the human form in shadowgraphs in a state of nudity." None of the members objected to this sequence. Instead, there were more abstruse demands for a removal of all vulgar shots, such as from the song "There Are Small and Big Locks, Those Which Are Open," the title referring to the body's orifices. The song "When He Feeds Me Soft Drinks" relied on a rhyming slang in Bangla, substituting *danda* (stick or, lasciviously, penis) for *thanda* (cold), the word used for soft drinks. The Censor Board was incapable of controlling such rhyming slang and its resonant surplus.

In its demand for the removal of "all obscene scenes," the members of the Censor Board actively dissociated themselves with the production of obscene films. As most members were intimately involved with the FDC and film production, they were clearly aware what the fate of these scenes would be. Similarly, the cut-piece phenomenon was not unknown to them. The vice chairman sent out inspectors to village cinema halls with some regularity. The board was involved in numerous court cases in attempts to ban films that had been seen to contain cut-pieces. This required many board members to watch cut-pieces brought in on a weekly basis. But with four inspectors for a thousand cinema halls scattered across the country, this could be little more than a gesture. In fact, I would argue that the entire performance of censorship was more a symbolic gesture toward the separation of realms of legitimacy and illegitimacy than a concerted effort to actually excise sexually explicit or violent materials from *Mintu the Murderer* and the public realm. Through this gesture they instated the board as the bearer of "values" and "culture" while simultaneously allowing the possibility for the production of cut-pieces in a realm not so sanctioned. The point was not to disallow the public circulation of sexually explicit material. Rather, it was to make sure that this type of material could only become visible as cut-pieces and apparently outside the purview of the state. This can be compared to Mazzarella's analysis of a dynamic of hiding and showing in Indian politics (2006) and coincides with other ethnographic accounts of the state (Hansen and Stepputat 2001).

Through the moral high ground, the Censor Board's activities produced ideas about the cultural nation and its upholder, the moral state. "If you really want to see a good film," said a member of the board as they got up to leave, "you should come next week, when we will review *Momotaj*." The chairman nodded and insisted I should come. "A folk story," added Mahbooba, "it is a good film, about the life of the singer Momotaj!" As I have shown, the flip side of the vulgarity coin is the production of "good" or "healthy" films. The film *Momotaj*, recounting with elaborate flourishes of imagination the true story of the rise to fame of a village girl by singing folk and mystical songs, would pass through the board without a single cut required, despite the disturbing rape sequences to which the original Momotaj had objected herself. Its success at the Censor Board was predictable. The film eventually flopped.

Healthy films rely largely on the display of the shorthand indicators of state ideologies and values. The category of "folk" is crucial among these. In literature as in cinema the category of folk narratives "has shown the ancient roots of identity, [and] it has also proven the existence of the virtues of syncretism that serve the purpose of sanitising the middle class mind" (Samaddar 2002:116–17). Films that extol the peace and virtues of a rural Bangladesh, the mystical quest of its protagonists, and Bangladesh's folk themes inevitably carry the stamp of approval of the board. Folklore, adaptations of novels by Rabindranath Tagore, as well as the Liberation War provide indicators of all that is healthy, "educated," and cultured in Bangladesh.

The members of the board who also worked in the film industry doubled their moral position through an almost singular engagement with these themes. The most glaring example of this was the career of Chasi Nuzrul Islam. Taking up powerful positions within the FDC and the Censor Board and part of important committees, institutions, and associations related to the cinema industry, he represented the overlap between the state and the cultural industry and its reproduction of categories of healthy and obscene films. Islam made *Ora egarojon* ("Those Eleven Men," 1972), one of the first fiction films about the Liberation War, which allowed him to take up a position of (moral) authority in reproducing the narrative of the state. He perpetuated this by producing a steady stream of films related to the shorthand indicators of state ideologies and values. He specialized in nondescript films relating to those things synonymous with culture, religion, and nation: a stream of Tagore adaptations, his Liberation War oeuvre, and historical dramas about folk heroes such as Hason Raja. His

films were generally set in an abstracted Bengali village full of rice fields and cotton saris. This imagination of the Bangladeshi countryside as rural idyll links all the synonyms of *culture*: the golden Bengal of Rabindranath and Jibanananda, the wandering Baul mystics, and the land for which an organic uprising of villagers demanded freedom. Coded as "our culture," this Bangladesh has little to do with the corporatization of the country-side into a shrimp farming, cash cropping, and coal mining hinterland (Hussain, 2013). As with the representation of Dhaka city described in chapter 1, a monster city eaten up by the rawest forms of capitalism, driven by laundered NGO money, disrupted by political instability, and fed by the crime it spawns, such imagery could be incorporated into the cultural nation only as "depraved culture" (*oposhongshkriti*), uneducated (*oshikkhitho*) and obscene (*oshlil*).

Describing such a Bangladesh, *Mintu the Murderer* could never have survived the Censor Board without the requirements of further cuts. But for every bit that was cut, other bits would be spliced into other forms and emanations of the film. The cutting and splicing by the editors and censors was a continuous process, where both were locked into mutual montage to produce different forms of the same film, thought to address different publics in different places. Nothing was cut out of *Mintu the Murderer* permanently or absolutely. But where a shot would appear and when was ultimately in the hands of projectionists, not censors, or editors, as chapter 6 will show.

CUT IT OUT

I have recounted the various ways in which *Mintu the Murderer* was cut to illustrate that in this case censorship regulations produced a mobile film form. The different "cuts" of the film that were in circulation show how the productivity of censorship in the context of the Bangladesh film industry was largely one of moving among different arenas of visibility. Ideas about censorship called into being a film in many forms and thus reduced the possibility of continuity editing. The reliance on jump cuts came forth from this mobile means of editing but has become a genre convention in its own right. These conventions depend in part on censor-ship regulations, which disperse editing practices into different physical locations, as well as different forms of the same film. Film censorship thus did not repress the production of sexually explicit material but called it into being as "cut-pieces."

This ethnographic account also indicates that any sort of engagement with the Censor Board in the hope of producing more equitable, progressive, or diversified representations of women and sexuality is likely to be in vain. Women's rights and issues are gladly taken up by members of the Censor Board for conservative, moralist, or progressive reasons in the legal and symbolic realm of the board. But this leaves cut-pieces, a key location for the representation of female bodies in Bangladesh, completely untouched in the shady realm of illegality.

While the members of the Censor Board disassociated themselves from the cut-pieces, the cut-pieces remained in existence, moving in and out of public vision. In this move the board enshrined itself as the moral guardian of culture, religion, and society while at the same time condoning cut-pieces in a separate realm. But by bringing the notion of obscenity to the forefront of cinema production in Bangladesh, they also foregrounded a discursive formation that they could hardly control. What is more, the notion of obscenity and the elaborate use of it made by film producers and directors relied on the categories set out by the Censor Code. The regulation produced its own contradictions, allowing what it repressed to surface in forms of its own making. The Censor Board became the site of obscenity's public expression. The overpowering obscenity idiom bound filmmakers, editors, and censors together. Each relied on notions of obscenity to cut the film into different forms. Although none referred to the exact wording of the Code, all relied on the circulation of notions of obscenity that were difficult to define. The next chapter will show how the board's insistence on the excision of obscene materials from Bangladeshi cinema, echoed in the print media. There the notion of obscenity took on forms and associations that could not be contained by the Censor Code and the board's members alone.

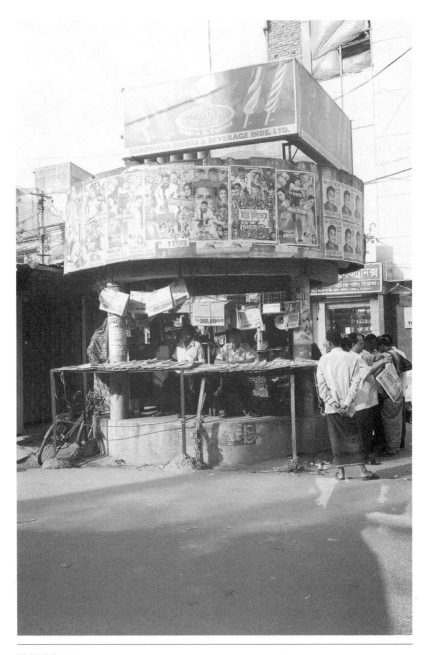

FIGURE 5.1 PHOTO BY PAUL JAMES GOMES.

{5} NOISE

"SHADNAZ DIVORCED!" screamed the headline (*Tarokalok* 2005:15). The article divulged the details of the actress's divorce, offering up an elaborate description of her courtship and her husband's subsequent misconduct and infidelities. It was one among many articles in the print media to indulge in extravagant accounts of the moral depravity in the film industry and its immeasurable obscenities. Moral panics lend themselves particularly well to the orchestration of such dissonant voices and noises, each rebounding from another, echoing and twisting outrage, distaste, or exhilaration. In Bangladeshi newspapers and magazines the contours of cinematic obscenity were lamented, exaggerated, and offered up for greedy consumption by the amorphous public. "Cut-pieces rule supreme!" (Feroze 2005b), yelled the headlines in the quality papers; "Women presented as sexual object in Bangla films" (*New Age* 2005a), cried the feminists; "Rid film industry of vulgarity" (*New Age* 2004), urged the prime minister; "Where is the end of the depravity of cinema's man-eating actress Shabnur?" (*Agomon* 2005a), wondered the pulp writers; "all vulgar films must be banned" (*Prothom Alo* 2005a), demanded the Film Directors' Society; and "a sensible man cannot allow such things," (Shahriar 2005) wrote one concerned citizen. It was onto such boisterous turf, rife with accusations of vulgarity and resonant with enticing gossip, that *Mintu the Murderer* was to be released. From its very beginning the film and its crew were enveloped by the din of printed discussions about obscenity.

In May 2005 a number of magazines carried the news of *Mintu the Murderer* actress Shadnaz's divorce. Both cinema magazines *Tarokalok* and *Chhayachhondo* brought her news next to interviews and reports on

the stars of cinema and television. Filled with advertisements for home appliances, fashion, cooking oils and spices, jewelry, and housing agencies, these magazines address a middle-class audience. *Tarokalok* devoted a full page to the story behind Shadnaz's divorce, accompanied by two color photographs of Shadnaz, while the slightly more up-market *Chhay-achhondo* allocated one paragraph within its "Exclusive" section (2005). In a single paragraph *Chhayachhondo* gave the details of the case filed at the Ramna police station, the date of the divorce, Shadnaz's home situation, and the reasons for the divorce. *Tarokalok* divulged the details of Shadnaz's love affair and marriage to her second husband, as well as his misconduct during the marriage, including his infidelities.

The same story of Shadnaz's divorce was covered by the magazine *Shornali*. In "*Shornali*'s interview with [Shadnaz][1] about Romel and [Shadnaz's] separation" (Khoshru undated:15), the news about the divorce was printed as an interview between reporter Parvez Khoshru and Shadnaz. Like the *Tarokalok* article, Parvez Khoshru provided the details of Shadnaz's divorce and her career. He mentioned blackmail, alcoholism, and physical and mental abuse as Shadnaz's reasons for divorce. An inset in bold lettering quoted Shadnaz as saying that she had never acted in obscene films. The piece was accompanied by a black-and-white image of Shadnaz in a dance pose. The text and wording of the interview did not differ much from the *Tarokalok* and *Chhayachhondo* reports. If anything, the *Shornali* interview was slightly less licentious because it did not mention Shadnaz's and Rumel's love affair before marriage nor Rumel's later extramarital affairs. *Shornali* was a cheaply produced Bangladeshi porn magazine. The one-page interview was set amid pornographic stories and pictures of naked men and women engaged in sexual intercourse. These images served as illustrations for stories that carried titles such as "If You Stroke Me Like That, I Will Die" and "How to Excite Your Wife." What was Shadnaz's divorce doing amid these pornographic stories? How was it possible for this story to appear in two completely different contexts and apparently serve two different functions: on the one hand gossipy information about the stars and on the other arousal in a porn magazine?

In this chapter I will explain the surprising inclusion of Shadnaz's divorce news among the pages of a cheap pornographic magazine. I will do this through an analysis of the appearance of the notion of obscenity in the Bangladeshi print media. Having traced the production process of *Mintu the Murderer*, this chapter and the next will follow the film as it

enters the public realm and finds its audience. While the next chapter will focus on the actual audiences that *Mintu the Murderer* encountered in cinema halls, this chapter focuses on the less clearly defined "public" addressed by the printed discussions about vulgarity in the cinema (see Warner 2002). I will use a loose definition of the public sphere as a "theater of talk" in which this public stirs, marked by inequalities of access, where texts circulate among strangers who constitute an "imagined community" of fellow readers (Anderson 1991; Fraser 1992). This amorphous whole of addressees constitutes the public. In her analysis of cinema spectatorship, Miriam Hansen has distinguished three analytic categories for spectatorship, namely, "the textually inscribed viewer and the empirical viewer," as well as "the public dimension of cinematic reception" (Hansen 1991:6–7). Whereas chapters 1 and 4 investigated the textually inscribed spectators for *Mintu the Murderer* and chapter 6 will look at the empirical viewers, this chapter looks at the public dimension of cinema consumption in Bangladesh.

In the previous chapter I outlined how censorship regulations in Bangladesh have produced a space and shape for obscenity in the form of cut-pieces that appear and disappear from view. In this chapter I will show how, once set in motion, the concept of obscenity becomes difficult to contain. As Butler suggests, "prohibition . . . occasions a reversal in which the sexuality prohibited becomes the sexuality produced. . . . That discourse itself proliferates . . . [and] its recirculation is not within the control of any given subject" (1997:94). The public discussions about vulgarity and obscenity can be understood as such a proliferation. The elaborate discussion of obscenity in the Bangladeshi print media shows how the idea of *oshlilota* (obscenity) circulates among the most diverse type of publications. Rather than a debate about a clearly defined concept, the circulation of the notion of obscenity in print is largely given shape by echoes and resonance, each articulation necessarily invoking and reproducing other discussions of obscenity.

Returning to a stable idiom through which to discuss obscenity, very different sorts of texts, written by authors with wildly different intentions, resonate with each other. The affective excess that accompanies the discussion of obscenity in the public realm ensured a blending together of the different texts into a resonant vulgarity debate, where the boundaries between ideological and class positions become less and less distinguishable, traversing the "split public" (Rajagopal 2001). Bengali and English-language newspapers, the tabloids, journals, magazines, and cheaply

produced pornographic magazines all drowned together in the noise of obscenity, taking the crew, cast, and film with them. This noisy public realm, filled with resonance, echoes, and amplifications, was the destination of *Mintu the Murderer*. Even before its release, the film was already firmly embedded in the controversies over obscenity.

"OBSCENE FILMS EVERYWHERE"

"Obscene films and posters exhibited in Joypurhat" (Parvez 2005). On July 21, 2005, this headline appeared in the national daily newspaper *Prothom Alo*. Beneath the headline was a picture of a wall covered in film posters. It carried the caption: "These sort of obscene posters are pasted onto the city's walls." The local correspondent for *Prothom Alo* introduced its readers to the vice of cinema in Joypurhat as follows: "In the cinema halls rampantly obscene cinema is exhibited; because of the display of eroticism on indecent posters of obscene films, obscenity has now become full-blown in the district town of Joypurhat and neighbouring municipality Kalai. It was learnt that in the halls of these two towns, local hall owners exhibit unbridled uncensored cut-pieces, distasteful porn images and songs containing naked scenes to draw an audience in the name of Bengali cinema" (Parvez 2005).

In an attempt to understand this dire situation, the journalist had traveled around the local cinema halls to discover its causes. Speaking to local film viewers, he had found that the audience for what he termed healthy (*shushthodhara*) films had decreased significantly. The "audience of a good class" (*bhodroshreni*) had become adverse to visiting the cinema halls because of the deficient environment, the undignified sitting arrangements, the lack of ventilation and good toilet facilities, the "unrestrained smoking of *biri*, cigarettes and *ganja*," the "monstrous smell," as well as the rise of obscenity in Bangla cinema (Parvez 2005). Among the films featured in the article was one by Shahadat Ali Shiplu. While his *Mintu the Murderer* was awaiting censor certification, local authorities in Joypurhat had found obscene scenes spliced into one of the songs from his earlier film "Naked Traitor" (*Nogno gaddar*, Shahadat Ali Shiplu, 2004).

Throughout the production process of *Mintu the Murderer* the newspapers reported with great regularity on the apparent decay of Bangladeshi cinema. Reports came in from all around the country discussing the dilapidation of the cinema halls and the depravity that flooded them. With the exposé titled "Lights Out!" (Khandker 2007) the English daily

New Age devoted an entire page to understanding the crisis in the cinema halls. Its author noted that "the sad demise of halls as well as an interest in local films are due to lack of technological advancement and professionalism, unabated piracy coupled with vulgarism, retrograde policies and the spread of satellite TV channels" (Khandker 2007). Family viewers were reported to be discouraged by "unclean toilets and the movement of unruly youth" (Khandker 2007) and scared off by a series of bomb attacks on cinema halls. The author deplored "entertainment from bawdy elements, vulgar storylines and irrational dialogue" (Khandker 2007). The same paper reported that a Parliamentary Standing Committee had come to similar conclusions: "Bangla movies top satellite channels in obscenity" (*New Age* 2005b). The committee recommended an "update" of censorship legislations to waylay obscenity. Many concerned newspaper readers linked the depravity to the influx of foreign media into Bangladesh. "The modern form of the Indian entertainment industry has led nowhere but to increased crime, sexual harassment and AIDS which have become major problems in the country [India]" (Mowla 2005).

Both the *New Age* and the Bangla daily *Prothom Alo* often discussed such a threat to nation and society in terms of vulnerable audiences of Bengali cinema. Under the heading "High Tide for Obscene Films in Demra" (M. Rahman 2005), a reporter for *Prothom Alo* sketched the departure of a young boy to school. He recounted how the young boy, dressed in his school uniform, abandoned his classes in favor of watching pornography in the cinema hall. "When I tried to discipline him, he curses me in that vulgar language," his aged father was reported to have said, "breaking the furniture in the house" (M. Rahman 2005). During the afternoon show the journalist reported a huge line of schoolboys and college boys, books in hand, waiting outside the local cinema hall. Besides schoolboys, the rural public was at risk. In an editorial entitled "Dealing with Movie Obscenity," the *New Age* noted that "despite the visible hullabaloo over the screening and production of films containing obscene material, local films are still not free from the clutches of profanity and gratuitous display of the female anatomy" (*New Age* 2005c). The editor celebrated the recent banning of a controversial film but deemed it insufficient. "Of course we do have reason to worry because we are left wondering about the kind of social education villagers, both young and old, are getting through these movies" (*New Age* 2005c).

The written complaints about obscenity and vulgarity pick up a number of familiar topics. Obscene images, smelly toilets, and unruly youth can

be understood as part of a common litany of objections against popular culture, fear of the undisciplined crowd, and the proximity of the working class to the bourgeois drawing room (Mazzarella 2010; Srinivas 2000; Vasudevan 2004b). The newspaper articles construct a vulnerable public, located in the countryside, that needs protection from corrupting influences to which the authors themselves are immune. Cinematic obscenity endangers the social and moral education of the youth and villagers, both of whom are idealized as "flowers of the nation." The disruption of this rural idyll and the soiling of school uniforms are presented as threats to the nation, Bengali culture, and the integrity of the family and domestic life. Addressed by the shorthand "sky culture" (*akash shongshkriti*), referring to the satellite channels bringing foreign audiovisual media into Bangladesh, the international media not only form detrimental competition for the local industry; they are also held responsible for the circulation of material inappropriate for women, children, and villagers. The backlash is constructed as unfortunate yet inevitable. The attacks on cinema halls and other forms of entertainment by what are vaguely termed "Islamist outfits" find agreement in the paternalistic government, which is urged to adopt tougher censorship laws and bans on folk entertainment.

Each of these proposed measures is aimed at pushing back popular or less-than-sophisticated *mofo* cultural forms and the prominence of the working class in public places. The much-lamented defeat of the "good classes" within cinema production and consumption states this class anxiety unabashedly. The appellation "rickshawwallah cinema" expresses middle-class discontent with action genres that it presumes draw working-class men to the cinema halls. Class anxieties are translated into moral anxieties that cast those who speak out against vulgarity in terms of moral worth and cultural authenticity. In cinema these are the healthy filmmakers who produce films for family audiences that are screened in air-conditioned cinema halls. These are the people who are imagined to be able to take on Indian and Western cultural influences responsibly, in their march of progress and modernity, while the working class and peasant population cannot but be corrupted by such foreign inspirations. The tussle over cinema imagery forms part of a double crisis of public imagination. On the one hand it expresses fears about the inability of the Bangladeshi middle classes to maintain center stage in public narratives about the nation and society such as can be found in the cinema. On the other hand it dramatizes the uncomfortable proximity of the "masses" to the *bhodrolok* drawing room, both in physical and imaginary terms.

This very condensed summary of the public discussions of obscenity and vulgarity in the Bangladeshi papers resonates with those found in similar moral panics (Critcher 2003) and resembles closely debates about the cinema halls in Andhra Pradesh of the 1940s and 1950s analyzed by S. V. Srinivas (2000). Srinivas notes that these debates point to a larger struggle taking place over the control of public space: "there is the assertion that 'we' are a public, but 'they' are just masses and are incapable of constituting a public" (2000:n.p.). Thus, the public consisting of citizens is separated out from the masses. This resonates with Rajagopal's analysis of the "split public" in contemporary India (2001). The discussions of Bangladeshi cinema in the broadsheets that self-consciously cater to a highly educated and elite readership, such as *Prothom Alo*, the *Daily Star*, and *New Age*, make many similar moves, presenting an ideal public of critical citizens with a clear vision of their role in the public sphere. Against this public it poses a mass populace, dwelling within and threatening a pure Bengali culture, based on a rural idyll with ideally restrained and domesticated women and children, sovereign and God-fearing men, the sacred backbone of the nation, who are under a permanent threat of profanation by unrestrained and uncultivated single men, obscene cultural remnants, foreign invasions, and the life of the senses.

This basic equation is captured by a set of common adjectives found throughout the newspapers that discuss the vulgarity issue. Appended to particular films or genres, as well as to those individuals involved in their making and consumption, the main opposition is expressed in terms of "healthy" (*shushthodhara*) versus "obscene" (*oshlil*). Rather than using *shlil* (proper) as the opposite of *oshlil* (although used at times) the preferred term was *shushthodhara* (healthy), which expresses the anxiety over the health and cleanliness of the public space and the moral fiber of the nation. Other prominent adjectives for those films and people patronized by the antiobscenity crusaders are important (*guruttopurno*), clean/neat (*poricchhonno*), tasteful (*ruchipurno*), healthy (*shashtoshommotto*), and responsible (*daittoshil*). The list of adjectives to describe vulgar filmmaking is far longer. Here the adjectives are objectionable (*apottikor*), distasteful (*kuruchipurno*), perverted (*bikrito*), loathsome (*bibhotsho*), immoral (*onoitik*), improper (*oshalin*), corrupted (*oshadhu*), vile (*mondo*), stigmatized/stained (*chinnito*), antisocial (*somajbirodhi*), deformed (*bedhop*), loose (*shithil*), erotic (*rogroge*), explicit or open (*kholamela*), sought-after (*romroma*), distasteful (*oruchikor*), and negative (*netibachok*). To the general description of obscene (*oshlil*), dirtiness (*nongrami*), and nudity (*nognota*)

are added superlatives such as beyond (*bohirbhuto*), extreme (*chorom*), and deadly (*marattok*). Combined, they set up the opposition between pure and healthy Bengali entertainment made by responsible individuals for the ideal family audience against the perverted cinema of immoral individuals given over to dirt and deprivation. The terms indicate distinction in taste, education, and sophistication but never index a religiously defined morality or use the term *haram*. All the newspapers and magazines favor the same stock of terms, irrespective of their political leanings. All in all, these terms provide a predictable set of discursive opposites generated during a moral panic. But leaving the analysis of the newspaper exclamations here would fall short of understanding what more this standardized discourse achieved in the public sphere of Bangladesh.

"PEOPLE SAY HOT SPICE!"

"You know what the slogan of our paper is?" entertainment journalist Kamruzzaman Babu asked me rhetorically, "With All Things Good, *Prothom Alo* [*Ya kichhu bhalo, tar shonghe Prothom Alo*]!" The newspaper's name, *Prothom Alo*, or "First Light," rhymes with *bhalo* (good). "We are in the movement against drugs, the drive against piracy, and in the antivulgarity movement," he added; "we do this from a sense of social responsibility." As in an ideal version of the public sphere, the journalists of *Prothom Alo* strive for the creation of a perfect polity, free of pirates, addicts, and perverts. Babu had been working for *Prothom Alo* since its inception in 1998. *Prothom Alo* aims to be the paper of the intellectuals and the elite; it is centrist and focuses on high culture. Like its sibling English-language paper, the *Daily Star*, it was financed by the Transcom group of companies, of which Phillips and Nestlé Bangladesh were also a part. The four main entertainment correspondents of *Prothom Alo* produced half a page of entertainment news daily and a four-page entertainment supplement called *Anondo* (happiness) every Monday. The reports on the cinema industry for *Prothom Alo* were the responsibility of Kamruzzaman Babu.

Babu's greatest notoriety came from his *Boycott Obscenity* (*Oshlilota Borjon Korun*) series, which ran regularly in the pages of *Prothom Alo*. The articles were framed by bright red borders and headed by the recognizable logo of a Bangladeshi movie CD with the text *Boycott Obscenity* written across it. It was in these reports that the greatest battle against obscenity and vulgarity was fought. Through these contributions, Babu indicted particular films that he had seen in cinema halls near and far, highlighted

sinister dealings by suspect Censor Board members, and recounted the brazen attempts by film producers to bribe him. With pride he told me the story of the time when producers whom he had written against tried to get him fired through accusations of slander and corruption. "There arrived a list with the signatures of about 170 producers who were campaigning against me," said Babu. "The text stated that 'the reporter from this paper, Kamruzzaman Babu, has for long been cheating us and we want to keep a good relationship with *Prothom Alo*, so please take measures against him.'" He never feared because, as he said, "If you aren't guilty, then they can't say anything against you." Indulging in the anecdotes, Kamruzzaman Babu narrated his battles against vulgarity to me like a war reporter returning from the front lines.

Babu's editors joined him in the superlative terms that framed their reporting as part of an epic battle between the forces of light and darkness. On July 21, 2005, Babu's article "The New Censor Board: Much Hope" carried an inset by the editor of the weekly *Anondo* supplement. Entitled "Congratulations and Hope," the *Anondo* editor, Kabir Bokul, opened his short piece by stating that "during the last four years, *Prothom Alo* has been campaigning against obscenity" (Babu 2005a). Recounting the ways in which *Prothom Alo* had been pursuing corrupted producers and others involved in making vulgar and obscene films, Kabir Bokul noted that "for this reason *Prothom Alo*'s editors and related reports have been falsely accused and harassed on different occasions. Nevertheless, *Prothom Alo* never took a single step back" (Bokul 2005). Expressing their continued collaboration with healthy filmmakers, the editor concluded by saying that "we all have but one dream: to retrieve our lost film glory" (ibid.). Kamruzzaman Babu's job at *Prothom Alo* was dedicated to this very cause. However, whether his reports actually served that end was a different question.

In an edition of the *Boycott Obscenity* series printed on February 3, 2005, Babu related a trip to a rural cinema hall. During the Eid days he had gone to Shirajgunj to watch three of the released films, and he reported what he found. In the film "The Boatman's Son Becomes a Barrister" (*Majhir chhele barrister*, Enayet Karim, 2005) Babu found uncensored scenes contained in the song "There's Honey in the Beehive." "The song 'People Say Hot Spice!' from the same film featured a naked girl who could be seen to act distastefully in the song" (Babu 2005b). He continued to report that in the film *Gutibaj*, among the 359 feet cut by the Censor Board were Rani and Alek's vulgar scene, and in the scene of Megha's sister's rape,

cut-pieces showing a girl's naked breasts were seen, added to the song "Why Don't You Come and Taste the Honey?" The detailed references in the article to reel numbers and amount of feet of uncensored and vulgar material revealed that Babu had seen the Censor Board reports. Kamruz-zaman Babu expressed his hope that the authorities would soon take up their responsibilities.

"People Say Hot Spice!" The song title quoted by Kamruzzaman Babu could not put the meaning of noise (*awaaz*) more precisely. "It is all about creating *awaaz*," explained assistant director Nazmul. "When people hear about the spice in a film, they'll come running!" Much of the advertise-ment for action movies relied on the reverberation of noise. The idea is that word-of-mouth advertisement of a film is far superior to any other means of drawing a crowd. "Why don't you come and taste the honey?" the producers invited their prospective patrons; you know that "there's honey in the beehive!" Kamruzzaman's detailed description of the nudity and rape scenes, down to the amount of feet a ticket buyer might expect to find for 12 taka, would inevitably raise the appropriate amount of noisy advertisement. "People Say Hot Spice!" would create the hoped-for buzz in the bazaar. The newspaper articles by Babu and his colleagues made an important contribution to the production of such noise. The derogatory adjectives they used to describe the films, their crews, and stars would initiate a ripple of attention surrounding a film. In addressing the topic, the antivulgarity campaigners drew the concerned public's attention to the dastardly acts of the producers and directors involved in the produc-tion of such footage and incited the tremor of excitement that accom-panied it. Linda Williams has discussed the paradox of moral crusading against obscenity as a gesture of "bringing *on* the obscenity in order to keep it *off*" (Williams 2004:3, emphasis in original). Effectively, the reports by Kamruzzaman Babu achieved just this. They brought on the obscenity to then accuse it. Film producers harnessed this paradox to amplify the *awaaz* surrounding their films.

The written reports about vulgarity generated not only noise but also a frisson of excitement and outrage. The "bringing on" of this material generated a certain amount of affect, pleasurable or irritating, within the public sphere of Bangladesh. An embodied response, stirring the body "affect is . . . in part . . . something that *assails* us" (Colebrook 2006:65, emphasis mine). Comparing affect to a "vibratory or felt movement" (Colebrook 2006:54), cinema can separate out this assailing quality, beset-ting or overcoming the spectator. Action films and pornography "move"

their viewers, arousing them to passion, lust, disgust, contempt or even boredom (Williams 1991). In the case of cut-piece films, their frisson and *awaaz* extended beyond the films themselves into the public sphere through articles such as the *Boycott Obscenity* series. These held a surplus of meaning that was not reducible to its written words or purported aims. As Christopher Pinney has argued, a significant element of the pleasure and efficacy of public cultural forms is located exactly in the physical resonances generated by them, the affective side of form (2004). The passion of the antiobscenity writing and other attempts to cleanse and purify the public sphere in Bangladesh was brimming with moral indignation. The frisson generated by action films in the first place, beckoning with "honey," was the spring to much of the excited printed discussions about vulgarity.

The antiobscenity texts indicting the obscene cut-piece films were wildly resonant, enticing the senses, providing pleasure or disgust. The obscenity debates were brought to a boiling point where the texts buzzed with the alluring words on paper. Whether this excitement was pleasurable or disturbing was of little consequence to the effect and contagiousness of these texts. The frisson of excitement generated by the *Boycott Obscenity* pieces is the affectivity of moral crusading. The gut reactions that such writing conjures do, indeed, undermine any separation of text and discourse on the one hand, and of sensation and affect on the other (Mazzarella 2005:14). The distinctions that Babu tried to maintain between healthy and vulgar cinema and between the discerning public and the mass audience similarly faltered. His quotes and rhetorical strategies were enticing and became an important instrument for producers to generate interest in their films. When raising the issue of vulgarity, he could not but raise the excitement that went along with it.

RESONANCE

Generated around particular films and people, the vulgarity vibe would resonate across the public realm, taking on a capacity to excite. The idiom that highlighted the division between healthy and vulgar films could take on a whole new set of meanings in different contexts and in the hands of different people. Although the language was relatively stable, returning again and again to the main set of adjectives outlined above, the uses to which it was put were diverse and seemingly incompatible. Returning to common themes, such as the depravity of producers, the sexual nature

of actresses' activities, or the lusty desires of the audience, the written petitions against obscenity were extremely similar despite their different ends. Many articles addressed the sexual activities of Bangladeshi cinema actresses in the face of depraved film producers. Tracing this common theme across different articles will illustrate how the contamination of meaning worked. Despite the different uses to which the articles were put, the stories were all the same.

On January 20, 2005, Kamruzzaman Babu wrote a *Boycott Obscenity* piece with the subheading: "Government Effort Stepped Up After Eid: Obscene Films Produced Nonetheless" (Babu 2005c). He showed how despite increased government efforts, "some producers are filming dirty scenes with unwitting directors and second- and third-tier actresses" (ibid.). He quoted a junior editor who confessed he had edited the "dirty and obscene scenes," as well as a rape scene. A couple of months later an unnamed "entertainment correspondent" for *Prothom Alo* broke the news of the acting career of a local producer. "Producer acts in obscene scenes himself," said the headline and named the producer who had "acted in a scene in which a girl is raped" (*Prothom Alo* 2005b). When he was called for further information, the producer was quoted to have said laughingly, "My honor and dignity are destroyed in any case; there's no point in discussing it any further." The *New Age* reported on the same incident by noting that "the producer of the film took part in an overtly sexual scene that involved an actress named Swapna" (Feroze 2005b). In the same paragraph the author introduced "Shilpa, an actress known for her enthusiasm and willingness to act in such scenes [who] is now a must for many movie producers."

A few days later a similarly unnamed entertainment correspondent wrote in from Gazipur with an excited report from the industrial town of Tongi, about an hour away from Dhaka. Discussing the release of the new film "Depraved Girl" (*Noshta meye*, A. R. Rahman, 2005), the correspondent noted that "tickets were like a golden deer, impossible to find" (*Prothom Alo* 2005c). Reporting from among the enthusiastic crowds, the writer asked a *rickshawwallah* why the film was such a big hit. The driver's reply was only partially reported. " 'I heard that three men . . . a girl' (impossible to print)" (*Prothom Alo* 2005c). The author leaves the readers in suspense and free to imagine what would be impossible to print that three men and a girl could do. The omission functioned like the textual equivalent of a cut-piece. When the author finally managed a ticket and took place in the overcrowded hall, he described part of the treasures

that *Noshta meye* held. "In the story a girl is willing to spend the night with the sons of the wealthy. The actress gets naked willingly" (*Prothom Alo* 2005c).

The concerns expressed in *Prothom Alo* were not unique to the paper that imagined itself wrapped up in a battle against vulgarity. Pornographic magazines would print similar stories. An unnamed author for the monthly porn magazine *Agomon* wrote in an article entitled "They are Despoiled, They are Depraved, They are Actresses" that "the story of how fearful the screen life of the actresses of Dhaka's cinema . . . is, has been concealed from those outside of the cinema" (*Agomon* 2005b). He adds that "it is an unknown history how, when any beautiful lady arrives in the Dhaka film industry with the dream of becoming an actress, her life is, from that moment on, in the hands of the 'Dhallywood mafia ring.'" This "mafia ring" consists of the directors and producers in the industry who take advantage of the young women's vulnerability and ambition. "Amongst those beautiful young girls who dream of becom[ing] a silver screen actress and have a foothold in the industry, there is not a single one who, to become an actress, has not distributed her full sexuality in the beds of the members of the film mafia" (*Agomon* 2005b).

An article by Sheikh Mahmuda Sultana in an edited volume on mass media in Bangladesh similarly discusses the position of women in the Dhaka film industry. The feminist critic concludes that "all those women who are called 'extras' in Bangla cinema are fundamentally used as prostitutes" (Sultana 2002). The author elaborates by noting that "within that short introduction [of an extra character], during the 5/6 minutes of a dance sequence, the clothes chosen for them and their presence bring out their full sexuality" (ibid.).

The daily tabloid *Manobjomin* had a regular column called *Gunjon*, referring to the humming sound that a bee makes. It was narrated by the fictional *moumachhi* (honey bee), who buzzed around the film industry and picked up on all hummings of gossip. Of all newspapers, this paper was closest to the industry, devoting two full pages daily to entertainment, most of which dealt with cinema. The main cinema reporter for *Manobjomin* had transferred to the paper after more than a decade with a famous cinema magazine. He could be seen at the FDC and the producers' offices with great regularity. Discussing the relative properties of two specific actresses within the industry, the "honey bee" suggested that "compared to Moyuri, Jenny acts in very revealing clothes and instantaneously gives pleasure to obscene makers and audiences" (Moumachhi 2005a).

A slightly lengthier analysis by Fawzia Khan finally arrives at the same conclusion and uses very similar imagery. Printed in the visual arts journal *Drishyorup*, the filmmaker wrote that "today our society is completely in the grasp of terror and vulgarity. . . . But by only showing terror you [the producers] won't get back the invested finances. Therefore inevitably all actors want a woman to satisfy their lust. Now female characters are not shown on the screen for any other reason than this sexuality. To get back the invested money businessmen depend upon perverted sexuality. Therefore inevitably they wanted to get the security of retrieving their investment by introducing women's bodies to produce lust" (Khan 2005–6:98). With this analysis Khan comes to a very similar conclusion as Babu and the other authors quoted here. Ultimately, the conclusion of all these articles was that depraved producers cater to the perverted taste of an undiscerning audience by using the sexuality of unwitting actresses, who were either poor, stupid, perverted, coerced, or all of the above.

While the articles quoted above arrived at roughly the same conclusions, their ideological underpinnings could not be further removed from each other. The first article was taken from *Agomon*, the cheaply produced black-and-white monthly with pornographic stories illustrated with pictures of actresses and international models in their underwear. The cover carried color pictures of three Bangladeshi actresses, including Jenny from *Mintu the Murderer*. Among the headlines across the cover were: "The Appreciation of Youth on the Bed of the Neighbour's Sister-in-Law" and "The Sexual Heat of the Naked Bodies of Mumbai's Actresses." The second article, likening extras to prostitutes, was written by the feminist critic Sheikh Mahmuda Sultana and published in a scholarly volume. Third, the discussion of Jenny's attractiveness to vulgar producers and audiences was part of the gossip column in *Manobjomin*. The final analysis was by Fawzia Khan, a documentary filmmaker from an NGO, passionately engaged in the promotion of women in film. Her article traced women in world cinema and was published in the visual culture journal *Drishyorup*, which collects essays by intellectuals and practitioners in the fields of cinema, photography, and fine arts. *Prothom Alo*, the quality newspaper engaged in the battle against vulgarity, and *New Age*, the newest English-language newspaper, whose young staff reported on Bangladeshi cinema in playful registers that approach the films as slightly absurd and camp cultural expressions,[2] invoked similar repertoires of vulgarity and illicit sexual transactions to discuss the position of women in the industry. The point is not to suggest that these texts and their authors are not differently

positioned, have genuinely different intentions, and pursue entirely different routes of circulation and imagined audiences. These important differences notwithstanding, each of these articles relies on a similar set of metaphors and turns of phrase to make roughly the same point.

What functioned as pornographic writing in *Agomon* was a feminist critique in an arts journal. This was possible because in each of the articles quoted, there remained a trace, a resonance, of the other meanings attributed to *oshlilota*. The term *oshlilota* pulled these different texts together and produced meaning and sensation across a range of genres. The cinema in general, and action films in particular, have become a crucial location for the articulation of *oshlilota*. Relying on the image of illicit sexuality by exploited women for the benefit of depraved and impressionable men, each of the articles here drew on the same category of *oshlilota*. While originating in censorship regulations that attempted to circumscribe, among other things, the place of sexuality in the public realm, these injunctions have produced the form that sexuality could take in this realm. This is why it is available for both pornographers and radical feminists to address gender difference, pleasure, and sexuality.[3]

The pornographic stories rely on the rejection of obscenity as exploitative and transgressive for its full effect. Describing the horrors in the lives of the actresses guarantees the titillating effect. Similarly, the dismissive reports from the *New Age* and *Prothom Alo* cannot resist the excitement forbidden sexuality affords. Even if the authors could be blissfully unaware of the shared idiom they tap into, on individual readers the multivalence of such texts can hardly be lost.[4] The discursive rejection of obscenity cannot be divorced from the corpothetic qualities inhering in the discussion of sexuality in the public realm. This is the buzz that cannot be dispelled when addressing obscenity. The figure of the garrulous bee of the *Manobjomin* gossip columns captures neatly how the vulgarity discussions generate a vibratory hum within the public realm, stirring not only the minds but also the bodies of its public. A buzzing of excitement emanates from the busy bees of the written press, some warning for the sting in its tail, others celebrating the honey in its hives.

The journalists at *Prothom Alo* were self-conscious about the fulfillment of a public role in the moral uplift of society. This is in line with notions about the ideal functioning of the public sphere as expressed by Habermas and taken up so enthusiastically by those who promote the efficacy of "civil society" in the development of accountable and good governance (Comaroff and Comaroff 1999). From such perspectives the public realm

is a space of rational debate between different parties to the social contract. Authors and journalists have been considered especially significant in the formation of public opinion and checking government. This model of the public sphere and the role it holds for civil society, however, imagines clearly distinguishable discursive positions for each party to the debate, as well as a frigid isolation from popular cultural expression and representations. Those who have interrogated this ideal of Habermas's public sphere have postulated counter publics and alternative public spheres (Fraser 1992; Warner 2002). What the articles quoted above show, however, is that a shared idiom and a resonant subject matter make for a contamination of meaning among very differently positioned authors, such as journalists, filmmakers, critics, pornographers, state officials at the Ministry of Information, and members of the Censor Board, who have very different positions and agendas. In contemporary Bangladesh, filmmakers and editors, censor board members and government employees, pulp writers and broadsheet journalists, film activists and feminists all make off with the same expressions, framing their discussion of sexuality, pleasure, exploitation, or depravity in the register of *oshlilota*.

HEADLINING THE CREW OF *MINTU THE MURDERER*

"What will happen now, Nazmul?" I asked Shiplu's assistant director nervously. That morning a staff reporter from *Manobjomin* had reported: "Membership of two film directors to the Directors Association permanently cancelled" (*Manobjomin* 2005b). After watching two films, "Illegal Attack" (*Oboidho hamla*) and "Forbidden Society" (*Nishiddho shomaj*) on CD, the leaders of the Directors Association had found "dreadful obscenity" added to the films. Subsequently, they had cancelled the membership of the two offending directors, Raju Chowdhury and Shahadat Ali Shiplu. "What will happen now?" I asked. "Shiplu won't be able to make any more films?!" The requirement for any film director working at the FDC was that he or she was a member of the Directors Association. I feared the worst for Shiplu's career and my project. "What will happen now?!" Nazmul shook his head and said: "Nothing will happen, nothing whatsoever." Leaving me completely astounded, Nazmul returned to the editing room where work was in full swing for the latest Shiplu venture. It was June, and the work on *Mintu the Murderer* was all but complete. Despite the repeated association of Shiplu and his colleagues with vulgarity, they all continued to work. *Mintu the Murderer*, its cast, and crew

were continually implicated in and impacted by the vulgarity vibe sur-
rounding the industry.

Unknown to me at that time, this was not the first instance in which
Shiplu had faced the wrath of the Directors Association and had his mem-
bership taken away. Most of Shiplu's films bore the brunt of the asso-
ciation's dismay. Not only the Directors Association but also the Censor
Board and the law courts had seen Shiplu's films repeatedly offend their
rules and guidelines. Throughout the months that *Mintu the Murderer* was
being made, Shiplu's films were frequently discussed in the papers, when
vulgar images were found, prints were ceased, or court cases scheduled.
And it was not only Shiplu who was incriminated in print. The crew and
artists of *Mintu the Murderer* were similarly headlined on more than one
occasion. Nonetheless, the work continued. The *awaaz* generated around
those involved in making *Mintu the Murderer* guaranteed the film a posi-
tion in the public realm. Gossip, slander, and insinuation made *Mintu the
Murderer* into more than its composite parts. The film had a public life
before it was even completed.

A few days before the report of Shiplu's membership cancellation,
Manobjomin had indicated the likelihood, if futility, of such an event.
Under the heading "Nine film directors served with show-cause notices
on the accusation of making obscene films," Shiplu and others were
indicted for making obscene films (*Manobjomin* 2005a). Of one of the films,
the reporter wrote that "the leaders of the Society sat in the Directors
Association office to watch the film." What the gentlemen saw there was
"the end of all custom and close to criminal." Discussing the peculiar posi-
tion of Shiplu and his colleagues, the reporter explained that they were
"bringing the making of cut-piece filled films to the highest level. They've
shown themselves to be very skilled at making cut-piece filled films and
therefore the number of films coming out of their hands is highest" (ibid.).
Just as Nazmul had indicated, however, even the outrage of the dignitar-
ies of the Directors Association was unlikely to alter this state of affairs.
"It became known that of the nine directors who have been served with
a notice, some have meanwhile lost their membership of the Directors
Association on the charge of making vulgar films in the past. A number
of directors received their membership back after signing pledges to the
Directors Association" (ibid.). Shiplu was one of them.[5]

The *Manobjomin* article also reported that the crew and artists of the
nine films would all be charged under criminal law. Given the huge over-
lap in artists and crew that participated in the making of romantic action

movies, this implied almost everyone who was involved in making *Mintu the Murderer*. The editors, cameramen, choreographers, and makeup men, as well as the artists, were all drawn from a relatively small pool of craftspeople. Working through the professional associations, each of them relied on the producers to provide them with work. When a film was charged on grounds of obscenity, they, too, were liable. As we saw in chapter 4, Kamal, the editor of *Mintu the Murderer*, stood accused in a number of local courts, and a representative attended his hearings far away from Dhaka. The film *Attack,* directed by M. A. Rohim, mentioned in the *Manobjomin* article, was edited by Kamal as well. The cameraman for that film had been Zainul, *Mintu the Murderer*'s untiring cameraman, and Jenny was one of its prominent actresses. When adding up the crew and artists for the accused films, few of the *Mintu the Murderer* crew and artists would remain without charges. The entire crew was thus caught up in the newspaper discussions of obscenity. Some, such as the editor, Kamal, and artists Jenny and Jishu Jadughor, would be accused on multiple accounts. Like Shiplu, however, they all continued to work.

In fact, they continued work because of rather than in spite of the vulgarity din growing increasingly loud around them. The repeated public display of the obscenity of the works produced by Shiplu and his colleagues, accompanied by pronouncements of the need to take them out of public circulation and the elaborate rituals of pledges by actors and directors to the Directors Association to affirm that they would better their lives, were intrinsic to the continuation of this mutually beneficial scheme of obscenity. The leaders of the Directors Association and the Censor Board members would regularly watch material that they then publicly announced to be obscene or "the end of all custom." They required exposure to the obscene material to then indict the obscene directors. They had to consume the vulgarity to set themselves up as moral guardians. Their often lucrative service as members of the Censor Board depended on this image, and their own movies were sold on the basis of their self-proclaimed cultural health and artistic reference. A yearly venture dealing with the Liberation War to be released around December 16 and a Tagore adaptation to follow at the time of the Bengali New Year were de rigueur for such gentlemen. Without setting these films off against the depraved features of men like Shiplu, however, such films would be unlikely to find an audience. As argued by Abdullah Al Mamun, the value of good films was derived only from their opposition to obscene films (2005). Shiplu's reputation, however, as well as that of

much of his crew and the producers he worked with, was based on the fact that he could produce the desired forms of vulgarity and that he could do it fast. Amid the continuous cycle of accusations, proof, and confessions, Shiplu and his colleagues were the most productive directors working at the FDC. They out-produced many of the association's leaders ten to one. If the newspapers announced the cancellation of Shiplu's membership this could only benefit his career.

STARS AND FANS

Whereas the crew of *Mintu the Murderer* could be encountered mainly in newspaper articles, the movie's stars were also discussed in film and smut magazines, as well as gossip columns. *Manobjomin*'s buzzing honey bee focused specifically on the stars. *Mintu the Murderer*'s villain, Jishu Jadughor, appeared with some frequency in the tabloid's columns. One of these asked whether Jishu's wife, a schoolteacher, kept track of what her villain husband did to junior artists in the name of rape scenes (Moumachhi 2005b). "Hot actress" Jenny's supposed quarrels with scantily clad stars were also repeatedly reported (Moumachhi 2005a, 2005c).

The focus on Jishu and Jenny in the printed press made them stars. "The basic definition of a star is that of a performer in a particular medium whose figure enters into subsidiary forms of circulation, and then feeds back into future performances" (Ellis 2004:598). John Ellis describes how classic Hollywood stars such as Bette Davis and Audrey Hepburn became publicly available beyond the screen: "the star image functions in two ways. First it is the invitation to cinema, posing cinema as synthesising all the disparate and scattered elements of the star image. Second, it repeats the cinematic experience by presenting an impossible paradox: people who are both ordinary and extraordinary" (ibid., 601). The first function of the star's image is most relevant to the circulation of the names and faces of the stars of action films in Bangladesh. The promise of Jenny's image on a poster, or the account of her involvement in a controversial film, did not arouse the desire to "know" the private person behind the star facade. Whereas the stars that are addressed by Ellis are the A-list international stars whose loves and lives are of interest to their fans, the image of B stars or porn stars functions differently in the "subsidiary" media. The image of romantic action stars in Bangladesh, such as *Mintu the Murderer*'s Jenny, Rosy, and Lopa, generated a different sort of promise that the viewing of their films would fulfill. The promise

they exuded in the subsidiary press was that the disparate still images and fantasies attached to them would be synthesized onscreen into the full picture of their naked bodies, engaged in sexual acts. This was the promise made through the circulation of the stars in the print media and their association with the obscenity buzz.

The circulation of the star image and the contamination with the suggestion of obscenity in the public realm had a self-referential logic that went beyond the writings of professional authors. Not only journalists, critics, and academics invoked the idea of obscenity to address the state of the film industry, but also fans wrote to the stars in this idiom. Film enthusiasts and fans would often write to the stars via magazines or directly to the FDC's Artists Society. Many of the letters written to magazines such as *Tarokalok* and *Chhayachhondo* expressed concerns by readers about a particular star being caught in an obscene film. Often, readers would write in to narrate their experience in a particular cinema hall, where they had been surprised to see their icon involved in what they termed obscene cinema. A concerned viewer wrote in to *Tarokalok*: "Nowadays, in all the movies in which Popy has acted that I have seen, in all of them there are some obscene scenes of hers. . . . I'm starting to think, has a top actress like Popy joined the ranks of actresses such as [Jenny] and Moyuri?" (A. Rahman 2005). Similarly, in a letter published in *Chhayachhondo* a Dhaka-based reader confesses that when he went to see a recent film by Shahadat Ali Shiplu, he had much liked the actress Shavana, but "in the opinion of two of my friends, [Shavana] had acted in explicit [*kholamela*] scenes. Against their view, it should be said that, compared to [Shavana], [Jenny] acted more openly. Then again, seeing [Jenny] doesn't look bad. Because we have seen this sort of acting from [Jenny] before. But to see [Shavana]'s explicit acting for the first time, I was a little surprised" (Akhondo 2004).

In letters directly addressed to the stars, sent to the FDC, fans would sometimes express similar surprise and warning. I read many of these letters in the Artists Society offices. Letter writers would suggest to particular actresses that they ought to leave the industry and escape its vulgarity by extending their "friendship" to, or marrying, the author. A fan from a village in Sylhet wrote to Shavana by way of the FDC in August 2005: "Believe me *apu* [elder sister], I don't see you with other eyes, I see you as a younger brother sees his elder sister. I love you like a sister. . . . The other day I saw your film in Kakoli cinema hall in Sylhet. Coming out from the

hall my friend asked me which actress I liked. I said [Shavana]. He asked whether I fancied you. Believe me *apu*, I really, really see you as a sister." Other letter writers would send lewd stories or suggestions to the stars, some illustrating their epistles with doctored pornographic images with the heads of the stars attached. The discussion of obscenity was thus not limited to professional authors or those directly involved in the industry. Among fans and film viewers obscenity was similarly a dominant form to address the industry.

Jenny, one of the most notorious and recognizable of actresses, received a lot of media coverage, none of which dealt with her private life, family life, outfits, or interior design (cf. Dwyer 2000a:168–201). Jenny inevitably appeared in the printed press in relation to vulgar films and her dealings with vulgar producers and competitors. Her image was completely entwined with the obscenity issue, and she required little introduction. As shown in chapters 1 and 3, this made her a particularly useful investment for producers, and she maintained the image carefully. Her image connoted a particular type of movie and promised what was commonly called *gorom moshla* (hot spice). Her name or photograph condensed within itself a whole range of connotations and promises related to obscenity. Through circulation in subsidiary media this image had become detached from specific films. The edition of *Agomon* quoted above carried a picture of Jenny on the front cover. The article illustrated by her image was entitled "The Storm of Hira's Sexual Desire" and told the story of a man named Hira, who accidentally comes across two lovers having sex and who then wants to practice his acquired knowledge on his new wife (*Agomon* 2005c). The story had nothing to do with Jenny, nor was her name mentioned anywhere in any of the stories in the magazine. Nonetheless, the magazine evidently relied on her image to generate interest among its public, as well as illustrate the nonrelated story about male heterosexual desire.

Producers treated Jenny's persona similarly, as the relative lack of importance of her character in *Mintu the Murderer* testified. While her character in *Mintu the Murderer* was minimal, the producer featured her prominently on one of the four posters that was designed to promote the film. On this poster she is pictured in a short red dress, sitting on the floor with her legs open and drawn in, suggesting the possibility for the viewer to look under her skirt. The noises generated around Jenny's name and image had become more important than the actual films she was in or the

characters she portrayed. Jenny's image as a vulgar actress could allow printed text, as well as the films she was in, to be about sex without necessarily providing the images of nudity or sexual intercourse, the promise of which her name and image would generate.

The news of the divorce in combination with the star image of Shadnaz was similarly sufficient to qualify her interview for inclusion in a pornographic magazine that was mainly sold unseen on ferries and bus stands and carried only advertisements for solutions to sexual problems. Despite her loss of the limelight and her marginalization into side-character roles, Shadnaz's name and image could be encountered in the pages of magazines such as *Shornali*, side-by-side with white porn stars, Indian superstars, and Bangladeshi college girls. What appeared as a sober interview, therefore, was more than its constitutive parts. The sober text resonated with the vulgarity vibe that echoes from the names and images of those associated with the industry, irrespective of their actual position or activities within it. Shadnaz had not been able to control the buzz of obscenity that she was also part of. "I just wanted people to get the story straight," she had explained to me about a meeting she had called to explain the details of her divorce to assembled journalists. "I wanted to stop the gossiping and questions." She had not been able to do so because obscenity had a contagious quality in the public realm. Her image could attach itself to pornographic stories, and her name in press was in itself a cause for excitement. Her efforts to stop the gossiping around her divorce by calling a small press conference in her home only led to the proliferation of possibilities to use her persona. The most exalted stars of the Bangladeshi firmament, the actresses from the 1960s and their directors, were no less implicated than Jenny and Bokul. Similarly, contemporary "healthy" stars such as Shabnur and Riaz, could be found in the pages of pulp magazines that discussed their supposed debauchery.

No one was immune to the association of vulgarity. Not even Kamruzzaman Babu. At the newsroom of *Prothom Alo*'s English sister paper, the *Daily Star*, the story of the disappointment of action star Moyuri was told to a bawdy audience of male journalists whenever an opportunity arose. "But why do you write these things about me?" the actress Moyuri had asked Kamruzzaman Babu according to this story. "After all those nights we spent together?!" Playing with the fire of vulgarity, the gossip and slander about moral crusader Kamruzzaman Babu would often turn into ribald laughter and frame Babu as the ultimate public for obscenity rather than its foremost foe.

CONCLUSION

While the theaters of talk heated up faster than the average Bangladeshi action movie, the production of *Mintu the Murderer* continued unabated. Within this public realm the journalists and reporters of national newspapers drew the attention of the concerned public to the issue of obscenity and called on the authorities to undertake action against those involved in the production of vulgar cinema. Self-consciously expressing the concerns and opinions of the "respectable class" (*bhodroshreni*) of Bangladesh, the journalists seemed to embody the ideal Habermasian realm of critical and rational dialogue. As this chapter has shown, however, their writings were part of a wider field of antiobscenity writings, some of which were used by producers and actors to profile their own decency and artistry, others to arouse the sexual desire of magazine readers. Talk of obscenity constituted a space of resonance, in which each story echoed another, and each piece of information could be put to use in a wide variety of different contexts. Ultimately, the different accounts of obscenity in cinema accomplished the same tasks. On the one hand they set apart good cinema, that which is morally pure and socially healthy, bestowing on the journalists moral worth, aligning them with tradition and value. On the other hand they allowed those very same journalists to discuss sexuality, the body, and titillation in public. But the register of *oshlilota* was sticky and its resonance attached to all those who came in contact with it. This is why the articulation of a position of moral worth was perpetually in danger of becoming a transgression, such as when journalists were libeled, antivulgarity writings were used as pornography, Censor Board members were accused of evil dealings, uniform-clad college boys were led astray, and the Liberation War was used as an excuse for rape narratives.

The contagious and affective nature of the obscenity buzz does not indicate the repression of civil society, the disintegration or refeudalization of the public sphere, or the institutional failure of the press and democratic accountability. It shows that public cultural forms produce a resonance that cannot be contained by individual authors. The film industry and newspapers walk a tightrope in which obscenity is always the flip side of any assertion of moral value. This does not mean, however, that the debate is innocuous or mere pretense. It could ruin the careers of any party in the debate, as well as ground films, stars, and directors in the industry. It could make mediocre directors into moral guardians and action heroes into porn stars. On the whole, however, it functioned to keep

the industry afloat in complicated times of rapid media transformation and increased competition.

It was these murky waters that *Mintu the Murderer* would have to navigate after its release, generating enough *awaaz* to draw a crowd, keeping the journalists happy enough not to get nasty, relying on the names and images of its cast and crew for attention, but not drawing so much attention to itself that the film would get sucked too deeply into the controversies. It would be a complicated balancing act, as *Mintu the Murderer* was already heavily inscribed in the obscenity buzz surrounding the film industry. Its crew had been indicted and its stars displayed in pornographic magazines. Given all of these elements, it is perhaps not surprising that the film would be seen as an obscene cut-piece film on its release during Eid-ul-Fitr in 2005.

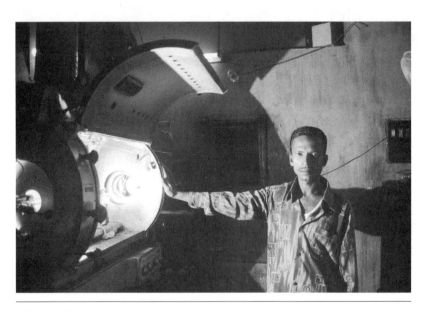

FIGURE 6.1 PHOTO BY PAUL JAMES GOMES.

{6} UNSTABLE CELLULOID

THE EXHIBITION OF *MINTU THE MURDERER*

W E ARRIVED in Feni in the fading light of day. The *azaan* signaled the breaking of what would be the last fast of that Ramadan. I had decided to await the opening morning of *Mintu the Murderer* in this small southeastern town. The film was not to be released in Dhaka, only in provincial capitals. In the quiet *iftar* hour my companion, Jewel, and I explored the small town by rickshaw. We traveled along the two crosscutting roads that defined the Feni urban grid. Along one of them, Station Road, the town's three cinema halls were clustered. At the top of the road stood the city jail, its illuminated cells shining out into the dark evening. The inmates communicated with their friends and relatives underneath the wall by gesturing and screaming through the bars in front of their windows. Right beside the jail, seemingly tucked under its wing, stood the Kanon Cinema Hall. The tea and snack shops set around the hall's entrance left only a narrow strip of road to the jail's outer wall. Posters on the jail wall advertised Kanon's Eid release: the film "Protection" (*Nirapotta*, Bodiul Alam Khokon, 2005), advertised by the English slogan "Stop the Crime" and promising its patrons "100 percent protection." Following the Station Road further down, a power cut darkened the increasingly desolate road. Passing over the rail tracks that gave it its name, the street led away from the center of Feni, imperceptibly transforming into a rural thoroughfare, connecting the outlying villages with the town.

Along Station Road two boys were busily at work pasting cinema posters to a wall. The youngest, Manik, held a bunch of rolled-up posters under his arm and used a flashlight to illuminate the work of his partner. Anowar balanced on a small ledge, attempting to put up a single-sheet

poster high onto the facing wall. Once he had two multicolor posters up, he reached down to take a few red-and-white, text-only posters from Manik. All around the colorful posters he pasted the smaller announcements. The red-and-white posters read: "On the occasion of Holy Eid-ul-Fitr, Running at the Badol Cinema Hall, Feni, Shahadat Ali Shiplu's *Mintu the Murderer*, featuring: Sumit Hossain, Jenny, Salman Khan, Rosi, Shabazi Khan, Kabilla and Jishu."

We chatted with the boys. "I started in the morning," said Anowar; "the cinema hall people pay me 100 taka per day to do things like this." He often did jobs for the management of the Badol cinema hall. "After Eid I will organize the 'miking' for this film," he said, referring to the circulation of rickshaws or scooters equipped with sound systems to announce the films. He turned back to the wall, putting up one poster after the other. As we returned to the jail, the previously quiet center of town was now bustling with energy. "Eid Moborak! Eid Moborak!" announced the speakers attached to a municipality van. "Tomorrow will be Eid! Eid prayers will commence at 8:45." The van drove up and down through the crowds of celebrants busily completing their holiday shopping. Somewhere the moon had been spotted. Tomorrow would be Eid. And *Mintu the Murderer* would be released.

In this chapter I will describe the exhibition and reception of *Mintu the Murderer* in the cinema halls of different provincial towns. Rather than the public that was produced through the discourses of Censor Board members or journalists, or the textually embedded spectator produced by filmmakers, here I focus on the actual audiences that *Mintu the Murderer* encountered as it made its way around the country. My reception study was structured by the circulation of the film that I had been following all along, and my perspective is formed by the experience of this single film as it passed through different towns, projected on different types of equipment, at different hours, amid different competitors, and for different people. What became clear as I followed *Mintu the Murderer* from cinema hall to cinema hall was that the form of the film changed dramatically from one venue to the next. The film was transformed under the pressure of audience demands, censorship regulations, cinema hall management, journalists' interventions, and producers' interests. I therefore argue for understanding film exhibition in terms of "unstable celluloid," that is, films capable of changing while being screened. Film projection does not guarantee the replicability of a film from one screening to the next but can actively undermine its physical integrity and narrative coherence.

In studies of film audiences and their responses to cinema in South Asia the material and narrative integrity of cinema is assumed. Belied by empirical engagement with projection practices, the persistence of this assumption is attributable to the fact that "film exhibition is without doubt one of the most under-studied, under-theorized and unappreci- ated areas in the study of cinema in India" (Hughes 2003) and elsewhere in South Asia. I will argue for a rethinking of audience studies on the basis of *Mintu the Murderer*'s unstable celluloid. If the object of viewing is not the same for every spectator, there is little that can be said authorita- tively about how audiences receive a particular film. While the common emphasis in audience studies on the intersectional identities of individual film spectators can illuminate reading strategies of audience members, the assumptions about the replicability of films in exhibition underlying this approach are empirically unjustified. Paying attention to exhibition practices opens up a range of new questions about the nature of audience reception and methodologies for audience research and illustrates the effects of unstable celluloid.

EXHIBITING *MINTU THE MURDERER* IN FENI

On Eid morning one could finish one's prayers and still make it to the first show of *Mintu the Murderer* at Badol cinema hall. The opening show was scheduled for 10:30 a.m. The oldest of the three Feni halls, only the arcs over the entrances to the bright green building and a smoothly curved balcony along its side betrayed the time of its construction. Dating from 1952, the building is now jammed into a narrow alley off Station Road. Inside, the equally green lobby showed signs of decay. Its peeling walls were decorated with the large four- and two-sheet posters for *Mintu the Murderer*. The wooden frames displayed the photoset for the film, as well as a number of other pictures of Bangladeshi actresses unrelated to *Mintu the Murderer*.

Despite the early hour of the festive day, many had gathered at Badol. Before long, tickets to all 380 seats were sold out. While most patrons were trying to make their way up the narrow stairs into the auditorium, the film had already started. Consisting of only a single floor, the auditorium filled up fast. The women's cabin, consisting of nine chairs behind a narrow wooden railing, was packed. I was the only woman in the cinema hall.

Poised to finally see *Mintu the Murderer* in the cinema hall, I strained to see and hear what appeared on the screen. Over the excited laughter and

chatter of the spectators, the film's dialogue was barely audible. The first twenty minutes of the film, introducing Mintu and his evil scheme, were drowned out by the combination of a struggling sound installation and the general murmur in the theater. The gruesome murders committed by Mintu at the beginning of the movie seemed lost in the din. Preemptively cut by editor Mukul, the censor cut of the movie had not included the images of decapitation that accompanied Mintu's rapid rise to the top. But here in the Badol cinema hall, heads and hands were severed by bloody blades. Scriptwriter and director both considered such scenes of gore specifically appealing to the audience of romantic action movies. Keeping these scenes away from the Censor Board, they were put back in the moment the film was certified. This audience, however, seemed little interested in decapitations or dismemberment.

It was not until the entrance of the young hero Salman Khan that the audience let out a cheer of collective recognition and appreciation. In all the screenings I attended, Salman Khan drew the most applause. Whenever Salman's character, Robi, defied unjust authority, the audience responded with clapping. Caught in the web of Mintu's intrigue and violence, the thwarted lover Robi had a number of characteristic scenes in which he confronted Mintu and his henchmen with grand gestures. Cameraman Zainul had frequently shot Robi's entrances in slow motion and from a low angel. Whether Robi spun around to sit down on a chair, walked in with his trench coat aflutter around his tight jeans, flexed his muscles in confrontation with Mintu's henchmen, or snapped his fingers to order a Diet Coke, the audience responded to each of these stylized gestures with applause and calls of encouragement. The largest collective cheer, however, followed on Robi's first encounter with his lover, Rani. In that scene Robi sees the beautiful Rani in Mintu's house. Angry at Mintu, he struts across the living room and kisses Rani in front of her seething brother. He then points a finger at Mintu and says in English: "Mind it!" Whistling, clapping, and shouting in the hall accompanied Robi's bold actions. The only other characters to find such public endorsement were the two comic figures, their slapstick stumbling and fumbling drawing much laughter.

Other sequences received far less attention than had been expected by the director and producer. The romantic song sequence between Robi and Rani ("I Got Wet in Your Love-Rain") had been the most expensive of all six songs. Unlike the other songs in the film, this romantic encounter had been directed by Noyon, one of the few top-end choreographers working

within the FDC. The big production number failed to draw any attention from the Eid crowd at Badol. Many used the opportunity to get out of the hall for a break while others talked with one another. Similarly, the death of Robi's mother at the hands of rival gangs elicited no particular response. During the scripting of this sequence, assistant director Nazmul had said that the killing of one's mother would be specifically unpalatable to the audiences. When the scene was shot, there was general jubilation on the part of the technicians over the powerful acting and speculation about the impact the scene would make. In Badol this scene did not elicit any such enthusiasm among its morning audience.

The rape sequence that preceded the mother's murder, however, was greeted with rapt attention. For the few minutes of the rape sequence, the audience was almost completely quiet, following the action onscreen. Members of the Censor Board had objected to the partial exposure of the actress's breasts and had demanded cuts. The version in the Badol cinema hall, however, had retained the images. Another objectionable sequence, in which Mintu is forced to lick the spit off Badsha's boots during the final climactic fighting sequence, was retained by the producer despite the Censor Board's demand to cut it. As described in chapter 2, during the shooting of this sequence the senior actors—Jishu Jadughor, playing Mintu, and Sumit Hossain, playing Badsha—had attempted to upstage one another in front of a number of important directors. The ensuing argument over the necessity of the shot, the angle at which it was to be taken, and the diegetic logic of such an encounter in the first place had held up the shoot for more than an hour. At the Badol cinema hall most of the members of the audience were already on their way out of the cinema hall, recognizing climactic sequence number 68 as the end of the movie. While the battle was in full swing, many started to make their way out of the cinema hall. By the time Badsha arrived at the hospital to reunite with his brother and lover, the main lights in the cinema hall had been turned on. Few remained for the final two sequences, in which the Bangladeshi state is reinstated in its monopoly over violence by the arrest of the fighting heroes Robi and Badsha, and the final sequence, in which justice and love reign supreme as the men are released from jail and their lovers await them. By that time the Badol cinema hall was almost completely empty. Clearly, there was some disjuncture between the director's expectations and the responses of *Mintu the Murderer*'s actual audience.

After the film's screening Jewel and I talked to Badol's manager, Raju. "The Eid holidays are always good for the cinema halls," he said; "we can

oversell up to six hundred tickets per show. But the rest of the year, business is very slow." While Raju explained the competition posed by the satellite dishes, another man entered the office from behind us. "Jewel *bhai*," the man said, vaguely ominously, "I knew it was you." Introducing himself as Mukul, he sat down next to Raju. "I knew I recognized them," Mukul said to Raju. "I had seen them at the FDC, at a shooting." Turning to us he explained: "They were very worried, you see. But I vouched for you, told them I had seen you two before." Confused, Jewel asked who exactly he was, as we had never met him before. "Mukul, representative," he answered; "I work for Litu. Did you inform him of your visit to Feni?" I responded that we talked to an assistant of Litu's, the producer of *Mintu the Murderer*. "They were very worried," Mukul continued. "The hall staff spotted you yesterday night. You traveled along the Station Road by rickshaw, right?" We concurred. "They weren't sure who you were exactly. And then you appeared for the morning show." Raju corroborated this story. "We immediately noticed you," Raju said. "We thought something was up." I said that I was interested in the film business and wanted to see whether people in Feni liked *Mintu the Murderer*.

Mukul leaned back and let Raju talk about the exhibition business. "Well, the Feni audience likes these sorts of movies," Raju said. "You see, Feni is one of the important places for cinema, besides Mymensingh, Rangpur, and Gazipur. In Feni there are one hundred thousand rickshawwallahs, especially from Rangpur and Borishal. They like to watch these sorts of films. Action films are for the working class." He elaborated on Feni's strategic position: "It is a communication point for five *zelas* [districts], many people travel through. So action films like *Mintu the Murderer* have an audience here." Mukul added that Feni was quite unlike Mymensingh. Although that was also a good area for cinema, *Mintu the Murderer* would not be released there any time soon. "Up towards Mymensingh it is all folk stories that do well," he explained about the distribution business; "that's where all the village stories come from. This Eid you can watch *Momotaj* [a biopic about folksinger Momtaj], *Bilashi* [Shiplu's attempt at period drama], *Chhoto ektu bhalobasha* ["A Little Bit of Love," a remake of Mani Ratnam's *Bombay* set in rural Bangladesh] and *Molla barir bou* ["Wife of the Mullah's House," a high-end village drama] in Mymensingh, while in Feni you can see *Nirapotta* ["Protection"], *Seven Killers*, and *Mintu the Murderer*." I asked Mukul why this was. "It has a history, doesn't it?" he replied cryptically. Implicit in Mukul's statement was the idea that Feni was a violent town. From the perspective of Dhaka-based bookers and

representatives, the rest of the country was framed in terms of regional stereotypes. This impacted the way films were subsequently distributed. While Mymensingh was associated with sweets and fairy tales, in the public imagination Feni was associated with organized crime and poor northern labor migrants. These combined to provide a regionalist and classist explanation of the attraction of *Mintu the Murderer* on the Feni population.

During the second afternoon show, this popularity was hard to deny. This probably had to do with the Eid holidays, though. Eid is one of the few moments in the year that cinema halls all over the country sell out. For the 4:30 p.m. show of *Mintu the Murderer* in Feni, black market ticket prices for the film had shot up to 40 taka (approx. US$0.60). An enthusiastic all-male crowd ruffled its Eid finery in the crush to acquire tickets. The second afternoon show could easily be taken in after Eid lunches and family obligations. The theater was packed. Trying to hold my own in the dense crowd, I held tightly to the railing along the stairwell, fearing I would otherwise fall. In front of me a boy told me to stay behind him, instructing Jewel to follow closely. This way we pushed through and found a way to the women's cabin. It was already full, but the boy directed two men out of their seats, letting us pass. He sat down on an armrest in front of us, having found his friend. As Raju had predicted, tickets had been much oversold. The armrests of every chair were used as seats, and everywhere people sat on the floor. The fragile railing around the women's cabin barely held the weight of the people who clambered on top of it. All along the narrow ridge around the projectionist's booth viewers tried to find their balance.

The screening proceeded as in the morning. During a dance sequence performed by Shabazi and Rosi, the man in the seat next to Jewel whispered to him, "Here it comes, here it comes." When the apparently truncated sequences ended midsong, jeering and shouting ensued. As shown in the previous chapter, *Mintu the Murderer* was embedded within an obscenity buzz. The photosets supplied to the exhibiting cinema halls by the producer enhanced this perception by foregrounding images of sparsely clad actresses. It fed into the air of the licentiousness that surrounded the film. Rumors and suspicions about a high dose of sexually explicit cut-pieces had spread rapidly, creating the noise that producers try to induce around their films. The combination of the photosets with this noise resulted in extraordinary expectations for the movie.

The audience members who booed the projectionist did so at specific moments within the narrative of the film. In all the halls in which I saw

Mintu the Murderer this happened not only when the film suddenly cut to black but also after particular dialogue exchanges or close-ups. Familiar with the generic qualities of the romantic action movie, spectators knew that a sudden cut-to-black could denote the absence of a cut-piece. Similarly, scenes ending in dialogue such as "Tonight we will celebrate," as uttered by the corrupt minister to his rapacious son, or a close-up of an embrace, as performed by Salman Khan and Shavana, were moments within the narrative that could be used to lead into cut-pieces. Such moments were recognized as hooks, onto which an additional scene could conveniently be hung but without which the movie could precede as well. Spectators recognized such hooks and knew that they could lead to hidden story lines within the movie or unrelated footage that one could always expect to be incorporated into romantic action films. The exhibition of cinema on celluloid made the insertion of cut-pieces possible. The celluloid could easily be cut with scissors and a new piece of footage attached with Sellotape. Those cinema halls that used two projectors to screen their films could load one of them with a cut-piece and switch projectors at the moment of a hook, thus showing the cut-piece.

During the screening of *Mintu the Murderer*, the boy who had so graciously helped me up the stairs averted his eyes a number of times. When any of the numerous rape scenes appeared on the screen, the boy looked toward his feet rather than at the screen. When other spectators yelled at the projectionist and next to him a middle-aged man attempted to take pictures of the screen with his mobile phone, the boy looked down rather than ahead. "I was told not to look at such sexy images," he told us after the movie had ended. His name was Shahid, and he was fifteen years old. He and his friend were sharply turned out, their Eid wear consisting of skinny trousers and tailored shirts. Shahid was wearing a white-checked shirt, the top buttons undone to reveal a black string tied around his neck tightly, a *tabij* suspended from it. On his right ring finger was a simple metal band embossed with the Nike logo. Educated, middle-class boys, neither conformed to the suggestions made by the cinema hall staff, journalists, or even film directors and producers about film audiences consisting entirely of working-class men or labor migrants.

I asked the boys what they had thought of the film. "From the posters it seemed that this would be the best of the three films," Shahid said, explaining his choice of *Mintu the Murderer* over *Seven Killers* and

Nirapotta, "but in the end it was just the same as the other films." The film had contained many "sexy" images rather than a good story, he felt. "You are not supposed to look directly at unknown women," he stated, explaining why he averted his eyes. "My grandmother told me not to do so, and I was also taught by the Tablighis." Shahid's father and brother worked in the United States, and he lived with his grandmother, mother, and younger sister. Turning toward Jewel he said: "But it's impossible! How can you not look at women when you are on the street?" Shahid tried to follow some of the rules he had learned when he spent four weeks with the Tablighi Jamaat in Dhaka. His father had sent him to Dhaka after Shahid had misbehaved and skipped school. Shahid laughed and said he had tricked his dad into paying him for his spiritual education. Back in Feni it was impossible, however, to stick to the Tablighi rules. "But at least I do my school work properly now," he continued. "Our SSC exams are next week, after the Eid holidays." Shahid planned to go to Dhaka to continue his studies there. He had spent some time in Dhaka with his cousin. "Often he would give me money and say, 'Go, take your sister-in-law and see a movie.'" Shahid exhibited his knowledge of the Dhaka cinema halls. He wouldn't mind being a hero himself and asked us to let him know when the FDC would have a round of "New Faces," the yearly open auditions held at the Dhaka studios. Shahid felt that many of the films screened during Eid were bad and uninteresting. But he had an interest in cinema, and the idea of becoming a star appealed to him. He had gone to see *Mintu the Murderer* because going to the cinema was a fun thing to do on Eid day.

The opening day of *Mintu the Murderer* in Feni had brought out a diverse audience, filling Badol cinema hall to the brim. Viewers had responded most vocally to the action hero, Salman, and hollered at the projectionist at particular places during the screening. Expectations on the part of producer Litu, director Shiplu, and scriptwriter Rony of audience response to their film did not entirely match the actual responses I witnessed by the audience in Feni. While their wisdom of releasing the film at Eid had drawn *Mintu the Murderer* a substantial crowd, the dicey inclusion of uncertified scenes, such as those of decapitation, went seemingly unnoticed by the audience. Meanwhile my presence at the cinema hall had not gone unnoticed by the film's representative, Mukul, and the cinema hall's manager, Badol. They had their eyes firmly trained on all *Mintu the Murderer*'s patrons.

JOURNALISTS, CUT-PIECES, AND FILM EXHIBITION

The day after Eid, we were invited to have lunch with the representative of *Mintu the Murderer*, Mukul. "You need to know where to eat in these little towns," he had told us; "otherwise you will never find any good food." He had spent many weeks in Feni over the years, traveling with different movies. In a small roadside restaurant he ordered curried hilsa and complained about the food in Feni. When I asked him about the other representatives, he said that during Eid there were twenty representatives traveling with *Mintu the Murderer*, one for each copy of the film. "Basically we take care of the prints and the money," he said. He explained the business of distribution and his role as the producer's representative. "During the first months, the film is distributed on the basis of percentages. During the first Eid week, 60 percent of the income from ticket sales goes to the producer and 40 percent to the hall owner. The second week it is 55 versus 45 percent. I need to make sure that the money is distributed properly."

As Mukul told us about film contracts, his colleague Mizan from Bilashi cinema hall arrived. He was holding what seemed to be a small film tin, wrapped in newspaper and bound together with elastic bands. "I managed it," he told Mukul. "That bastard, I recognized him immediately!" Mukul and his colleague talked animatedly. "I spotted him yesterday morning," continued Mukul, "but he caught me looking at him and disappeared." Mukul ordered Mizan a plate of rice, and they sat at the table behind ours, continuing to talk out of earshot.

After Mizan left, Mukul rejoined us. "Kamruzzaman Babu," he said. "He and five other journalists came to Feni to inspect the films." Cursing the *Prothom Alo* journalist of the *Boycott Obscenity* columns, Mukul said he had immediately warned Raju, the manager of Badol cinema hall. Babu had finally showed up at Bilashi. "Somehow they slipped through," explained Mukul. "Mizan didn't spot them until the film had already started. But he managed the situation." I asked him what he meant by "managed the situation," but Mukul seemed unwilling to divulge. "Listen, you know that we do bad films [*amra kharap chhobi kori*]," he offered by way of explanation. "I just have to mind the audience, make sure there are no journalists, no Censor Board people. That's a lot harder than dealing with the crowds." Jewel asked him how he knew who they were. "It's obvious," he said. "Sometimes we're warned; mostly they just stand out. Like you two."

"You didn't see it yet?!" cried apprentice editor Karim when he saw us in the afternoon. He laughed and said that the producer clearly didn't trust us. Karim's family lived on the outskirts of Feni. He had returned home to celebrate Eid and was catching up with friends in the center of town. "There is a song sequence with Marjuk and Lopa," he informed us about the cut-pieces in *Mintu the Murderer*, "and of course a hot sequence featuring Rosi and Shabazi." All the rushes and every piece of negative had gone through Karim's hands as he performed the dreariest editing jobs befitting his position as apprentice editor. "We made a trailer for *Mintu the Murderer*," continued Karim. "We had put in all the hot action and fighting, but Litu didn't like it. So he gave us stuff from his private collection to splice into it."

The sun had set over Feni, and the fairy lights decorating the snack shops around the pond illuminated the holiday crowds. Karim's friends sat around and listened to his tall tales from the belly of the Dhaka film industry. He displayed his intimate acquaintance with popular heroines and reinforced the rumors about their immoral lifestyles. Karim's FDC tales awarded him an effortless cool among his Feni-based business-school friends in faded jeans, *Panjabi* shirtsleeves carefully rolled up to reveal trained arm muscles. Karim bought a round of Sprite and told his stories about the FDC. Quizzing Karim about *Mintu the Murderer*, it was clear that his friends, too, constituted part of the audience for romantic action cinema. Again, the actual audiences for *Mintu the Murderer* were more varied than the stereotyped *lungi*-clad rickshawwallahs and cheeky schoolboys Babu sketched in his *Boycott Obscenity* writings.

Leaving to catch the night show of *Mintu the Murderer*, Jewel and I discussed the possibilities of seeing Karim's elusive scenes at the 9 p.m. show. Although I was hopeful, Jewel doubted it. "Late-night show, the day after Eid," I attempted; "it would be the logical show for some extra juice." But Jewel could not be swayed. When we arrived at the Badol cinema hall, most of the late-night patrons had already found their seats. The house was almost full, but the holiday excitement of the previous day had completely dissipated. Instead, most viewers sat in their seats unperturbed, smoking a cigarette or calling to the boys selling nuts. Unlike the day before, the projectionist now showed the slides with the house rules and uplifting messages concerning care for the environment, respect for one's elders, and the need for education. As the flag and anthem appeared onscreen, no one felt the need to stand up. From our now familiar seats in the women's compartment, we watched *Mintu the Murderer*, identical

to the version we had seen the day before. Behind us two policemen in uniform followed the battle of two gangsters on the screen attentively. "Maybe they won't show us anything until those cops are gone," I whispered to Jewel. He laughed. "I doubt it," he replied; "just now one of them instructed the ushers to get rid of that white woman and show some cut-pieces!" As one of the few women, and white at that, to attend the screenings of *Mintu the Murderer*, I impacted the screening of the film. As Raju and Mukul had said, they had spotted me immediately, and they were cautious, calibrating the screenings by watching who was in the audience. It seemed the police believed that I was inhibiting the display of cut-pieces. The veracity of this statement became clear after the interval.

As Rosi and Shabazi appeared on the screen, they danced their censor-cut dance in a paddy field. "If anywhere, it will be here," I tried to persuade Jewel. "Enough," he said. "It won't come; let's go." Mukul had appeared twice during the show, asking us to come and have dinner with him, before the restaurants closed. As he appeared for a third time, Jewel agreed we would come and eat with him and his colleagues. "It will be more interesting than sitting through the end of *Mintu the Murderer* again," he reasoned with me. I gave in. As we descended down the narrow stone steps to the street, the sound of Rosi and Shabazi's paddy song followed us into the Feni night. It was 11:30 and the streets were completely still. Only the cinema hall's sound system disturbed the dark night. The gatemen sat together on a low bench outside the only gate that had remained open. We squeezed through the narrow opening to join them. As we moved out, Mukul suddenly remembered a forgotten task. "One minute," he said as he turned and dashed up the stairs. Behind us the gate closed. Suddenly the paddy song stopped, midway. A new, unrecognizable sound could be heard from inside the hall. "They are playing something else!" I cried in astonishment. "I can't believe it!" The gate behind us was closed, and there was no way to get back in. The audience was completely silent and whatever was being shown did not have a very loud soundtrack. Agitated, I paced around the gates, trying to listen to what was happening inside. After no more than three minutes the paddy song came back on, and the audience cheered loudly. "Let's go," said Mukul, as he appeared again through the gate. I gritted my teeth, knowing I had been had.

Before returning to Dhaka the next day, we had lunch with Badol's manager, Raju. As we sat down to rice and fish, he laughed at my frustrations over the unreachable cut-pieces. "Of course we didn't show them as long as you were there," he said. "The producer didn't want it, too risky."

Eid was the only profitable time of the year for the film industry. *Mintu the Murderer* was likely to reclaim its entire investment in ticket sales during the week of Eid. If the film was seized now, the possibility of recovering the investment would be much slimmer. Jewel asked Raju about the lightning-speed operation of the night before. "We use two projectors," explained Raju; "that way you can switch and run a cut-piece anywhere during the movie and quickly switch back if necessary." Discussing the cut-piece culture in Feni, Raju confirmed what we had heard earlier. "Films won't run without cut-pieces," he said; "only with vulgar films containing cut-pieces do you get a repeat audience. That's where the money is made."

TECHNOLOGY, FILM FORM, AND THE CINEMATIC AUDIENCE

Mintu the Murderer was different whenever it was screened. Embedded in censorship regulations that make certain footage illegal, the action film had the potential to shape-shift according to context. Possessing reams of illegal footage, the film grew and shrank according to need and possibility. The hall management, the producer's representative, the projectionist, and the audience combined with the technology to produce a specific form of *Mintu the Murderer*. Each recombination resulted in a different version of the film. It is truly an assemblage, "a nonsubjectified machine assemblage with no intrinsic properties, only situational ones" (Deleuze and Guattari 2005:389). It draws attention to the immanence of particular film constellations, and the various alliances that produce different enunciations of *Mintu the Murderer*, rather than to a single significance of *the* film. The repeated screening of *Mintu the Murderer* was less about reproducing and representing than it was about reassembling, depending on the context. The title *Mintu the Murderer* referred to a range of such different recombinations, each unique in its constellation.

A film's replicability is one of its defining features. The public presentation of a ream of celluloid and the narrative embedded in it can be repeated in numerous locations. But as Rick Altman has noted, "rather than recognize the legitimate existence of multiple versions of a film, based on diverse social and industrial needs . . . critics have regularly made a fetish of locating the 'original' version" (Altman 1992:6). The stability of the film form, based on this idea of an "original," is perhaps more illusory than real. Censorship regulations necessitate the excision of certain parts as a film moves between countries; foreign-language dubbing

transforms the dialogue exchanges, and airplane versions take the edge off overly exciting sequences. The shape-shifting operation of Bangladeshi film exhibition may be no more than an extreme example of a more general feature of films: that their forms are never stable and that screenings are rarely the same from one exhibition to another. This is the case not simply because each audience is composed differently or each exhibition space has its own characteristics; rather, at the level of the technology and materiality of cinematic exhibition, difference creeps into films. The burning out of a scene, a broken reel, the willful neglect of a scene before the interval, a disk that skips—all these kinks in the faultless display of a film are perhaps more the rule than the exception. Brian Larkin has argued that one must pay attention to "the small, ubiquitous experience of breakdown as a condition of technological existence" (Larkin 2004:304). Setting himself off from theorists of technology who assume technologies to be either perfectly oiled or nonexistent altogether, Larkin sketches technological conditions in Nigeria to be in need of continuous attention and intervention. He sees technological breakdown and piracy as the norm rather than the exception. Of film prints arriving from abroad to be shown in Nigeria he writes: "they are often shown until they literally fall apart. All are scratched and heavily damaged, full of surprising and lengthy jump-cuts where film had stuck in the projector and burned" (2004:307). No film print is the same, and each showing may exhibit a film slightly changed from the day before.

Tim Ingold's objection to work in the study of material culture in which "materials appear to vanish, swallowed up by the very objects to which they have given birth" (2011:26), is also evident in the study of cinema, where an analysis of the completed film almost always takes precedence over its materials but also its "failed" forms, such as Larkin's Nigerian examples or disrupted cut-piece flicks. It is celluloid and its technologies that allow breakdowns and assemblages to emerge that produce film as a meaningful form. The plasticity of celluloid, which can be cut and spliced with scissors and tape, generates the very possibility of the *cut*-piece. Like the peculiarities of the chemical processes that produce colors on celluloid (especially the blue hues of the FDC washes in combination with HMI lamps and T-type film), the malleability of celluloid makes cut-piece films meaningful, beyond any particular diegetic cohesion.

Such "failing" technology may produce pleasure rather than irritation. The pleasure of failing technological systems such as the old projection

equipment and the progressively shabby print of *Mintu the Murderer* lay in the possibilities it allowed for the audience to voice its opinion on the state of the theater, the shape of the movie, and their collective presence in the hall. Rather than dismissing ragged film prints as inadequate and unacceptable to audiences, Larkin relies on Yuri Tsivian's suggestion that such technological breakdowns might create meanings of their own (Larkin 2004:308). Whereas for Larkin's Nigerian audiences, such distortions seem to fuel fantasies of foreign lands of technological bliss and an acute awareness of a Nigerian lack, in Bangladeshi cinema halls, the faltering equipment and jagged visual edges suggest a possible submerged story line and an ideal location for some sexual diversion. When *Mintu the Murderer*'s audience protested the failure of the equipment in one of the Feni shows, this did not necessarily express real discontent. The voluble commentary seemed to be an agreeable exercise of a mass dialogue among the spectators and the hall staff, part of the pleasure of being in the cinema hall together. Responding to such glitches, viewers encouraged the projectionist to show what may lie behind. What is projected onscreen is not necessarily all that is on offer, and audiences actively engage with the projectionist to run other reels and show different footage, producing different cinematic assemblages. It is not only in Bangladesh that "the film must pass through the hands of a projectionist, whose performance is constantly open to criticism" (Altman 1992:9).

Like the neglect of the material qualities of cinema, the film as narrative or text takes precedence. This impacts the ways in which cinema audiences are studied in South Asia. Here, insights from the "active audience" debates in media studies (Brooker and Jermyn 2003; During 1993; Fiske 1986; Hall 1999; Hebdige 1979) have been corroborated by ethnographic research among cinema audiences. This research suggests that viewers respond to the experience of the cinema in a manner shaped by their "culture" (L. Srinivas 2002) or that they negotiate textually inscribed messages according to their own intersectional position, marked by class, gender, ethnicity, and religion (Derné 2000; Dickey 2001). The experience of the cinema and the nature of "active" audiences can be read off other cultural or social factors already known. There is a circularity to the argument that audience members of a particular gender, caste, or class will read a film according to that gender, caste, or class. There is more that can be said about the role of the audience as it participates in the articulation of particular cinematic assemblages, such as inhibiting or facilitating the insertion of particular scenes.

S. V. Srinivas suggests that illegal practices and interventions into the screening of films in the B circuit in Andhra Pradesh lead to "the de-standardization of a film's status as an industrial product" (2003:49). In the case of the cut-pieces, such destandardization allows audience participation within the cinema halls in a manner reminiscent of the early film audiences described by Miriam Hansen. She emphasizes the contingent nature of film exhibition, which "lent the show the immediacy and singularity of a one-time performance" (1991:94) and impacted the ways in which audiences received films (93). With such a destandardized product and contingent exhibition, the dialogic possibilities of cinema are reinstated as nonfilmic events, such as projection itself, become a focus for audience activities. In this segment of the film industry the audiences of *Mintu the Murderer* were not merely walking, talking, and singing, interpreting movies according to class, caste, or gender. Instead, the unstable celluloid, or destandardized film product, allowed different constellations to arise. The audience made its mark on film form as viewers entered into a dialogue with the projectionist. Projectionists and managers surveyed the audience to see what would be retained or excluded from a given film. The confrontation with physically and culturally degraded cut-piece films urges a rethinking of cinema audiences in Bangladesh. The nature of the active audience is related to the possibilities offered by technology, the material qualities of celluloid, and the circumstance of exhibition. These combine to form a contingent and singular emanation of a filmic experience that is hidden under the name *Mintu the Murderer*.

BREAKING NEWS! READ ALL ABOUT IT!

"Obscene films everywhere on Eid" (Babu 2005d). In the days after Eid the Bangladeshi newspapers ran a number of articles and reports about the vulgarity of the films released during the holidays. They not only reported on the cut-pieces screened in cinema halls around the country but also elaborately discussed the efforts by officials from the Censor Board and local police officers to seize films rumored to contain cut-pieces. In this section I discuss the reporting on the Eid films and the type of audience they present for the cut-piece films. I contrast this with my own experience of the audience for *Mintu the Murderer* in cinema halls in Joypurhat, Jessore, and Feni in the weeks after Eid.

Kamruzzaman Babu's article was unrelenting. *Prothom Alo* ran his report on Eid in Feni: "In Feni's Badol cinema hall [*Mintu the Murderer*] was

exhibited. The film's vulgar photoset was displayed inside and around the hall" (Babu 2005a). He noted how, once again, Eid had been an occasion for the release of films with vulgar scenes added to them. He sketched a scene of crowds of college students and schoolboys forming long lines to enter the cinema halls: "Once inside the hall, two vulgar songs acted out by [Jenny and Sumit Hossain] were seen. The lyrics were so vulgar, that it is inappropriate to print. Besides that, an unknown extra's acting in two such songs was shown, it was more than a porno film. At that time there were two police constables watching the movie. Afterwards they said: 'our work is to provide security to the cinema hall, not to judge vulgarity'" (Babu 2005d). Babu's observations did not match those of the Censor Board, whose vice chairman suggested that his inspectors in Gazipur and Norsindighi had found no vulgar materials in *Mintu the Murderer, Nirapotta*, or *Seven Killers*. But during the coming weeks his inspectors would travel the country and would seize any vulgar films (Babu 2005d).

Two days later Kamruzzaman Babu was vindicated. "Exhibition of Obscene Scenes in Three Films: Three Producers Served with Show-Cause" (*Prothom Alo* 2005d). The producers of *Mintu the Murderer, Nirapotta*, and *Seven Killers* had been asked to provide reasons why the Censor Board should not withdraw certification, but "healthy filmmakers said that unless the films were seized, asking for a 'show cause' would only inspire the makers of vulgar films" (*Prothom Alo* 2005d). Elsewhere in that morning's *Prothom Alo* the truth of this statement was brought out. The small article on the margin of the morning paper was titled "After Cutting Scenes." The Potiya (Chittagong) reporter had the following to report: "When electricity failure cut into a vulgar scene, an excited audience started to break down a cinema hall. This happened last Monday evening at seven, in the Shobuj cinema hall of Sodor, Potiya sub-district. The audience complaint was that the film [*Mintu the Murderer*] was shown without vulgar scenes. Besides that, they also got angry because of the electricity failure. Almost 400 members of the audience smashed the place, including breaking chairs and furniture. They caused almost 2 *lakh* Taka [approx. US$3,000] in damages, said the cinema hall management" (*Prothom Alo* 2005e).

Such reports of the aggressive audience recuperate standardized notions about the rowdy nature of cinema audiences. The darkened spaces for the mass copresence of excitable and impressionable spectators and potentially inflammatory imagery endangered the maintenance of peace, property, and propriety. In the study of South Asian cinema scholars have

discerned the energetic public and the apparent threat emanating from young working-class men in the cinema halls as a common theme (see Dickey 1993; Hughes 2000; S. V. Srinivas 2000). Babu's analysis of *Mintu the Murderer* and the report from Potiya invoked similar images. As the previous chapters have shown, it was not just Babu who imagined such a threatening mass of spectators. Members of the Censor Board, authors for film magazines and journals, as well as the scriptwriter for *Mintu the Murderer*, its director, producer, bookers, and representatives rehashed many of these images in their analysis of the audience for action films.

Everywhere I saw *Mintu the Murderer*, the audience was much more diverse than presented in the predictions by the crew or reports from journalists. The film was screened in Bangladesh during six weeks of the winter months of 2005. During this time I saw the film in a number of different locations. The film was never screened in Dhaka, only in its outlying areas, such as Gazipur, and further afield in the different districts of Bangladesh. There are four observations to be made about the audience for *Mintu the Murderer*.

First, the halls outside of the big cities were not much fuller than those in Khulna, Rangpur, and Jessore, where I saw the film. The audience attendance was very similar to other romantic action films I saw, both in Dhaka and Chittagong, the biggest cities, and in the smaller towns. In an interview the chairman of the association representing cinema hall owners suggested that "there are no perfect statistics about the attendance but at the moment it is not more than 35 percent in the cities and 40 percent in the villages." There are little statistics available about cinema attendance. The associations keep no records, nor do the hall owners. In all cinema halls I attended, managers recounted the heavy competition from satellite channels and VCDs. While healthy films could do well in the big cities for a couple of days, the only really full houses I witnessed were during the Eid days, Friday morning shows of cut-piece films such as *Mintu the Murderer*, and screenings of English films, old prints of full-length pornographic features from abroad. The first thing to note, therefore, is that cinema attendance in Bangladesh is not overwhelming, and full houses are very rare, even outside the big cities.

In Joypurhat the manager of the cinema hall that screened Mintu had explained the financial difficulties for the halls. His Prithibi cinema hall was built on the top floor of a shopping complex. "Only with the revenue from the shop rent can the cinema hall survive," explained the hall's manager. "It costs 30,000 taka [approx. US$470] per month just to pay the

seventeen members of staff. All the other costs amount to another 20,000 taka [approx. US$320], just to keep the hall going. Without the market we would never survive. Soon all cinema halls in Bangladesh will be like this." The Prithibi Complex was only two years old. The owner's father had another cinema hall in Joypurhat that was constructed out of tin. He had convinced his son to convert the top floors of the market into a cinema hall. "With benches and VIP boxes we can house twelve hundred people," the manager continued, "but we rarely fill all the seats." I asked how *Mintu the Murderer* was doing. "We had some trouble. The first three days we had a magistrate here every day. They didn't find anything because we didn't show everything. So the magistrate had to admit it was a 'fresh' film." We had been introduced to the manager through a befriended film director from Joypurhat. His introduction seemed to have taken away any suspicion that our presence might cause. "Now we show some things," continued the manager, indicating cut-pieces, "but not all. If we showed all, there wouldn't be any seats available in the house!" I asked whether they were making a profit on Mintu. "This is only the fourth day, but it is going all right," said the manager. "This is a farming area. Right now, the farmers have just started to cut their paddy, so they have some money. They are coming into town to watch a movie. And after the trouble the film had in Comilla, everyone wants to see *Mintu the Murderer!*"

Second, the general impression of the class background of the audience was not brought out by my visits to the cinema halls. Like in Joypurhat, the halls generally drew viewers from the surrounding areas. While the attendance of film shows was clearly age inflected, different class positions were represented in the cinema halls. Very few elderly or even middle-aged viewers watched action films in the cinema halls. The ages of the people that I talked to in-depth about their film-watching experience ranged from ten to early forties. I did not manage to speak to anyone above this age, and it was my impression that few in those age groups attended action films. Of the younger viewers, however, class positions varied. Although the youngest boy I spoke to was ten years old, had never been to school, and helped out in the cinema halls sometimes in exchange for a ticket, other viewers were highly educated or described themselves as businessmen.

What was striking to me was that without fail and irrespective of age or class background, those I talked to about action film in the cinema halls all expressed their distaste for vulgar films and their preference for the top stars of the healthy genres. There seemed to be no other critical

idiom available by which to discuss the nature of contemporary action movies. The resonance of this rhetoric was another reason why audience interviews about cut-piece films did not make for a very effective methodological tool in audience research. Instead, it suggested that the public discourse around film quickly becomes part of personal accounts of individual films as the contours of this thoroughly conventionalized form of addressing cinema become part of individual accounts. Again, this means that asking questions about the viewing of a certain film may produce responses about the social space of the cinema in general, through conventionalized idioms of response rather than giving any evidence of the experience of a specific film.

Third, men were the overwhelming majority of action film viewers. Whereas more women attended screenings of romance or folk films, they made up a tiny proportion of the action film audience. Only the air-conditioned Dhaka cinema halls screening healthy film and telefilms, such as Modhumita and the Star Cineplex, drew a substantial female audience. Women were very rare among *Mintu the Murderer*'s audiences but not absent. Especially in North Bengal a few women came to see the film, chaperoned by male relatives. Single women did appear in the cinema halls, often heavily veiled. During a number of screenings, we witnessed the eruption of a fracas when veiled women were thrown out of the hall on accusation of being prostitutes. Some of the cinema halls did function as a working place for sex workers. "We have to be careful outside," explained a female sex worker who worked regularly in a cinema hall in Jessore; "the police put cases against us under the women and children's law." Referring to the 2000 Suppression of Violence Against Women and Children Act, she said that when she worked in the cinema hall, she would at times be threatened by the police with this law.

Although in the cinema hall women were rare, the VCDs of action films, as well as cut-piece CDs, reached a much broader audience. *Mintu the Murderer*, too, made it to VCD. Long after I completed my fieldwork, I was sent a copy. With two of its cut-pieces burned to the disk, but without some of the dramatic sequences, this copy of *Mintu the Murderer* was once again a different formulation of the film I had seen in the cinema halls. In this form it would have reached a much larger audience of women. While I have done no systematic research into the production and circulation of VCDs, some anecdotal evidence may be brought to bear on the question of women's viewing. In Khulna I was told brazenly by a husband that he watched cut-piece VCDs with his wife while my friend the actress

Bokul was a fervent viewer. Small VCD shops throughout the country sold such disks. Similarly, the young girls living in the alley alongside my flat in Dhaka would dip into my VCD collection for entertainment, making their way through the action film archive I was slowly putting together. Anecdotally, colleagues have suggested Bangladeshi cut-piece VCDs make it to the markets in Kolkata. I have no systematic data on these other movements of the cut-piece, but it does suggest that in disk form *Mintu the Murderer* had other audiences, including women.

Finally, most of the conversations about *Mintu the Murderer* were quite similar. Rarely did anyone suggest that this was a particularly good or exceptionally entertaining film or that its stars were especially appealing. Inevitably, the subject of obscenity was raised in relation to *Mintu the Murderer*, which was commonly understood to contain cut-pieces. The following conversation is typical of these discussions. In Jessore, where *Mintu the Murderer* was released on Eid and ran for two weeks (see Hoek 2010b for an elaborate account of the screening and reception of the film in Jessore), we discussed the film with Kalam, a twenty-two-year-old laborer in a metal yard, and his friend and coworker Salim, sixteen years old. Kalam said that although most films nowadays have no real story line, *Mintu the Murderer* did, and he enjoyed watching it. The friends watched movies together about twice a month. Salim first came to a cinema hall when he was about sixteen years old. These days they went less because Kalam's family owned a VCD player. They would watch movies with Kalam's family sometimes. Salim felt that *Mintu the Murderer* was better than most action films, not very obscene. Because the films were often obscene, he explained that he watched some films with his friend in the cinema hall, others at home with the family. "Films used to be better," said Salim. "Jenny was pretty good in this film," added Kalam. "She acted in *Heat*, did lots of open [*kholamela*] shots. She really captured the audience!" Kalam looked meaningfully at Jewel. "Nowadays she is doing less, though," he continued, "not like when she was young." Kalam and Salim showered appreciation on Shadnaz's character. "She did what a sister-in-law should do," said Salim. In the film Shadnaz's character points a gun at her treacherous husband, Mintu, to allow Rani and Robi to escape his evil reign. Unlike their discussion of Jenny, the description of Shadnaz's participation in the film was based on her character's actions. Kalam quickly dismissed Rosi's part in the movie. "The third pair is just put in to pass the time," he said. In this he read the producer's intentions very accurately. The third pair had no bearing on the narrative and was only put in for its cut-pieces.

Although in Jessore that night the projectionist had not shown Rosi's cut-pieces, Salim and Kalam had hardly broken the place down. The Potiya incident, as reported in the newspapers, was miles removed from the screenings of *Mintu the Murderer* that I saw. Nonetheless, journalists such as Kamruzzaman Babu were hot on its heels. A week after the Potiya incident, the newspapers reported that a print of *Mintu the Murderer* had been seized in the Kakoli theater in Sylhet. Six days after the film had been released, local authorities had held the film on the grounds of finding uncensored scenes added to it. *Manobjomin* reported that the print in question had not reached the Censor Board yet (*Manobjomin* 2005c). The report continued to state that Shahadat Ali Shiplu was "heavily criticized before as a director of obscene films" (*Manobjomin* 2005c). The rapid capture could mean an early demise for the film. However, once the fated print reached Dhaka to be inspected by the Censor Board, no uncensored materials could be found. Somewhere between Sylhet and Dhaka, the cut-pieces had disappeared. "Most likely at Sylhet," said someone close to the board when I phoned to inquire after Mintu's fate. "The local police can make good money off a panicked producer. It's a common ploy, especially at Eid." The webs of intrigue surrounding *Mintu the Murderer* seemed to be thickening. But for now, the film was safe.

Not a fortnight later, however, another print of *Mintu the Murderer* was seized. Both *Prothom Alo* and *Manobjomin* reported on the film's capture from Comilla's Rupali cinema hall. *Prothom Alo*'s Comilla reporter suggested the film had been seized because vulgar scenes had been added. A letter from the Censor Board had tipped off the local authorities (*Prothom Alo* 2005f). *Manobjomin* suggested that pending the investigation and case against the producer, director, and crew of *Mintu the Murderer*, the film was already declared forbidden (*Manobjomin* 2005d). Another phone call to our source revealed a battle around *Mintu the Murderer*. Although the film had been seized, the producer had not been charged as yet. A court case seemed inevitable, but for the time being the film was circulating and could continue to be screened.

MINTU THE MURDERER IN BHURUNGAMARI

The bridge curved along its three-mile stretch across the Jamuna. The powerful river bisected the North of Bangladesh, joining the river Padma downstream to further separate the Northwest from the rest of the country. Before the bridge was opened in 1998, the journey to North Bengal

from Dhaka was lengthy and laborious, with travelers dependent on ferries to get across. Built by a Korean company and supported by Japanese funds, the bridge unlocked the poor agricultural region haunted by famines, the yearly *monga*. Households in the North suffered from a lack of food and jobs in October and November, before the crops could be harvested. We crossed the bridge as the *monga* waned. As we traveled into North Bengal, the late November light touched the golden fields where farmers were tying up bunches of newly harvested paddy. We traveled north to the provincial capital, Rangpur, from which to explore the northern cinema halls screening *Mintu the Murderer*. A rural and impoverished region, North Bengal is nonetheless a key region for cinema exhibition. In its fourth week *Mintu the Murderer* had moved out of the regional capitals of North Bengal, such as Thakurgoan and Rangpur, to be screened in the smaller towns around these capitals.

The roads leading away from Rangpur had not been kept up for years. The final twelve miles took more than two hours as we struggled through potholes to reach the northern town of Bhurungamari in Kurigram district, where *Mintu the Murderer* was being screened. The road had been last restored in the 1980s, when General Ershad was still the head of the country's military regime. Kurigram was Ershad's home district, and he had lavished attention on the remote area. Until today the area remained in the hands of Ershad's Jatiyo Party. Sidelined from power since the democratic overhaul in 1990, the decay of the party could be read from the state of the roads in Kurigram.

The road bisected the district, traveling from the district border all the way up to Bhurungamari. The road led through the center of all larger settlements of Kurigram. Pasted to the edge of the sandy road were the cinema halls of the *zela*. Some had been shut and stood abandoned in green fields. Others sat amid the roadside market and rickshaw stands, the villages' main activities all clustered together at the roadside. At the town of Nageswari two cinema halls faced each other from either side of the road, challenging their competition with posters and music. On the posters announcing the film "New Gangster" (*Noya mastan*, Opurbo-Rana, 2005), the English words "He Is Killer But Not Terrorist" were written along a bloody blade. Elsewhere the same film was advertised as *Kopa shamsu* on cheap two-color posters. The Censor Board had objected strenuously to the latter title. "Kopa shamsu" was a proverbial encouragement supposedly used by rickshawwallahs when they slammed into a rickshaw in front of them. *Kopa* means "to chop" or "to strike" but was more lasciviously used as "to poke."

The young directors of the film had been convinced that with this slang title the film would be a definite hit. The Censor Board, however, judged the name inappropriate. Unable to object to the faint suggestiveness of the title, they reasoned that the title was inappropriate because one of the former members of the Censor Board had been called Shamsul, and the title was therefore disrespectful. In Kurigram, as elsewhere in North Bengal, both titles were used to encourage people to come and see the film. The Censor Board could be bypassed up north.

Leaving Nageswari for the final stretch to Bhurungamari, I received a call. Our friend at the Censor Board asked where we were and whether we had heard the news. Without waiting for a reply he said that *Mintu the Murderer* had been banned. "We watched the Comilla reels yesterday evening, and the censor certificate was cancelled today." I asked him what they had found. "Jenny's solo song. They'd never submitted it." We had seen the song in a cinema hall in Jessore, where our excitement at seeing the previously hidden song had not matched the general disinterest of the audience. "There was also a rape sequence and vulgar shots in another song sequence. And they hadn't taken out the vulgar and violent shots we had requested." It seemed the Censor Board had gotten its hands on a version of *Mintu the Murderer* that was more elaborate than the censor cut but not as explicit as the version we had heard in Feni. Nonetheless, it seemed the end of the road for *Mintu the Murderer*. I asked what would happen next. "They'll appeal," said our friend. "They'll try to get a stay order from the lower courts. If they get that, they'll be able to screen the film again." Hoping that the news had not reached Bhurungamari yet, we traveled on, hoping to see *Mintu the Murderer* one more time.

The Modhuchhondo cinema hall was set amid the golden fields. The winter sun filtered through a gentle haze. The sandy track leading up to the cinema hall traveled on for another kilometer and there ended in barbed wire. Through the fields behind the cinema hall stretched the invisible Indian border. The main town had a border crossing point. "They'll shoot you if they see you try anywhere else," said a man waiting outside the cinema hall, "but it isn't too difficult to avoid the Indian border guards." The crossing was mainly used by Indian trucks filled with onions to be dumped onto the Bangladeshi market.

In the cinema hall at the edge of the country we were invited as guests. There appeared to be no suspicion, merely interest in our straying into such distant lands. "Sometimes white people come to watch a film," said the hall manager as he sat us down for a chat before the start of *Mintu the Murderer*.

He fed us spicy puffed rice and told stories about the foreigners who worked with an international Christian NGO. The NGO had offices and guest-houses dotted all over North Bengal. We sat in his office until the speakers attached to the outside of the hall announced the start of the afternoon feature. Those who did not buy tickets could enjoy the dialogue and songs of *Mintu the Murderer* sitting in the tea stall just outside the cinema hall. The soundtrack was played over the speakers and resounded across the fields. We climbed the wooden ladder to the projectionist shed and the entry to the balcony seats. The usher led us to the front row benches at the edge of the balcony as *Mintu the Murderer* started.

The film opened once again with the decertified decapitations. The form of the film was roughly similar to the one in Feni and the other cities in which we had now seen it. Small differences made themselves felt, though. A scene consisting of a dialogue between two gangsters of the opposing factions started midsentence, halving the dialogue. Another scene had been reassembled in a rather creative way. It was Josna's chase scene, in which she played one of the Lopa's running away from her rapist. Eventually, he captures her and throws her into a pile of leaves. At this screening, however, the shots making up this sequences seemed oddly placed, with a shot of Josna being pushed to the ground spliced amid two shots of her running away from her captor. A little later the attempted rape suddenly jumped to her running again. Most likely, this scene had been used to add in cut-pieces of a more explicit rape scene or unrelated sexually explicit footage. The rape scene was clearly a hook, one of the points in the film that a sexually explicit scene could be expected and easily spliced in. The fact that the shots were now reassembled rather oddly suggested that once the cut-pieces had been taken out, the shots making up the sequence were not put back into a logical sequence. The splicing practices had left their marks on the print that was screened today, in the form of a topsy-turvy chase sequence.

About ten minutes into the film, the usher returned and whispered something to Jewel. As he left, Jewel could not contain his amusement. "Perhaps *memsaab* would prefer to step outside for a few minutes," he chuckled; "there will be some naked images appearing onscreen shortly. The management thought you might feel uncomfortable." Jewel laughed. "I told them that you are very fond of nude images and for them not to worry." A little later the imagery appeared. A new sequence had been spliced between Salman's departure from his dormitory and his arrival at his brother's house. The film suddenly cut to an apparently unrelated

bedroom sequence involving the third pair of actors, Rosi and Shabazi. The scene started middialogue and showed Rosi on a bed in tight cycle shorts and a top, her legs raised to Shabazi standing beside the bed. He rubbed her legs with oil. Although the introduction to the scene was missing, it was clear that this was part of the hostel scene quoted in chapter 3. In the script the scene depicted the clandestine encounter between Shabazi and Rosi in a college hostel, in which the actor strokes the actress's body with suggestive foodstuffs. As editing apprentice Karim had said in Feni, the scene had been shot and edited and should be part of the film. Here in Bhurungamari it was.

Minutes later, the entrance of glamorous hero Salman Khan followed. Wearing sunglasses, he strode through the lanes of the amusement park where he was meeting up with friends. The entry consisted of a number of low-angle medium long shots showing Salman's full height. The sequence was shown in slow motion. Behind his head a Ferris wheel framed his face like a crown or a halo. Unlike every previous time I had seen the film, there was not a single response from the audience in Bhurungamari. The hero entered and exited, without so much as a clap or a whistle. Like in the Feni night when I had paced the gates of Badol cinema hall, the audience was silent.

A little later on in the film, Lopa and Marjuk appeared onscreen. The sequence was not where I had thought it would be. I had imagined this scene after the election victory sequence. Instead it was right before the introduction of the heroine Rani to Marjuk, her intended spouse and lecherous son of a villainous politician. At Bhurungamari Rani's encounter with Marjuk was preceded by a sequence involving him and Lopa. Both junior artists, Lopa and Marjuk had retained their own names for their characters. The scene was set to a song, but neither of the actors lip-synched the words. The sequence was shot in a single room, resembling closely the room used for Rosi's and Shabazi's oil sequence. Marjuk was wearing the red coat and pants he wore throughout the film. Lopa sported bicycle shorts and a tight top that just reached over her breasts. The sequence was made up of close-ups of Lopa's breasts, crotch, and bum and of Marjuk licking the naked parts of Lopa's body, specifically her stomach and her breasts. Medium long shots were devoted to the two rolling over each other, Marjuk burying his face in Lopa's crotch and between her breasts. Lopa brought her mouth to Marjuk's crotch and undoes his zipper. This shot was cut to her sitting on top of him, suggesting intercourse. There were also a number of long shots in which Marjuk pulls

down Lopa's bicycle shorts to reveal her buttocks and licks them. The entire song sequence lasted for about three minutes, and it was not clear to me whether there was more footage that was not screened.

Immediately following Marjuk and Lopa's number Salman's character, Robi, turned into a villain-slaying hero, taking on Mintu's henchmen single-handedly. Once again there was no response. What had the cut-pieces done to Salman's charisma?

My overwhelming recollection of each time I saw a cut-piece or pornographic reel in a cinema hall is of the total silence that would envelop even the fullest auditorium. Especially hard-core imagery elicited a silent tension that enveloped all spectators; we would collectively hold our breath as the physical impact of the sexual imagery hit home. Such imagery illustrated the "palpable, sensuous, connection between the very body of the perceiver and the perceived" (Taussig 1993:21) that Taussig discerns in mimesis. In the cinema hall the spectator stands in such a visceral, "palpable" connection to the figure onscreen, the collective hush and tense concentration its manifest result. Vivian Sobchack (2004) describes a "cinesthetic subject," who "touches and is touched by the screen . . . able to experience the movie as both here and there rather than clearly locating the site of cinematic experience as onscreen or off-screen" (2004:71). She suggests a kinetic energy that emanates from the screen and rebounds in the body of the spectator. Linda Williams's work on sex in movies has taken Sobchack's suggestions of the cinesthetic subject's experience of film to argue that "as a 'porous interface between the organism and the world,' my body before the screen . . . becomes habituated to diverse qualities and kinds of sexual experiences" (2008:19). In the Bangladeshi cinema halls where I caught glimpses of sexually explicit reels and cut-pieces, such a relay of energy produced an intense relation not only to the screen but also to others, to fellow viewers, especially in crowded cinema halls.

Empirical research with viewers, such as in the cinema halls where cut-pieces are screened, allows me to raise the question of what this visceral relation then *does*, what the awareness of the body accomplishes beyond the acute perception of one's own flesh and the new forms of knowledge and experience gained through it. What strikes me from the experience of watching porn in groups, in public, in an awareness of transgression, is the *duration* of the tense collectivity generated through the visceral relation urged by the images onscreen. Seeing pornography in groups in Bangladeshi cinema halls is marked first by the hushed tension that builds up

in the room, an intense awareness of bodies, collectively. But this intensity, the energy rebounding across bodies and screen, lingers on beyond the imagery that generated it. As it persists beyond the specific cut-pieces that produced it, this tension contaminates other forms of affect emanating from the screen. Subsequent scenes generating a different sort of response, such as Salman's defiant action scenes, were undermined by the impact of the cut-piece, which persisted beyond its actual screening. The affective dispositions generated by the cut-piece do not end with the jump cut that spells its end. The lingering impact of the cut-pieces temporarily destabilizes the generic properties of the action film.

In Bhurungamari the scenes continued to roll through the projector. The encounter between Rani and Marjuk now took place. This was scene 17, shot by Zainul in Wonderland. The encounter between Rani and Marjuk thematized female education, changing sexual mores and gender norms, political corruption, as well as struggles around forms of arranged marriage. These themes befit a cut-piece. In the scene one of the extras leaned in and warned Rani. Onscreen the dialogue now resounded: "I know that man. He is the man that despoiled my friend Lopa [*noshto kore felechhe*], after which she killed herself!" As shown in chapter 3, this was when it started to make sense to me. My theory had been that all girls that are raped or have sex without the promise of wedlock in Bangladeshi action cinema would die before the end of the movie. *Mintu the Murderer* did not seem to fit the pattern. What struck me only at Bhurungamari was that all the girls who were raped in the film were called Lopa. The characters played by the actresses Rosi, Josna, and Lopa were all called Lopa in the film. The suicide announced right at the beginning of the film would suffice for all three Lopas. They died before their rape scenes were even shown. But this standard narrative device was seen by only a handful of members of the audience. I had been following the film for months and had only now put the disparate and rarely screened bits together.

After the show we sat down to tea with some of the staff from the hall. The little tea stall was bathed in the afternoon light and from the speakers came old Hindi film songs. We talked about the state of the industry and the changes taking place. Although business wasn't excellent at Bhurungamari, the hall was not threatened with closure. Viewers still came to Modhuchhondo for entertainment. As Jewel disappeared to get his camera, the projectionist descended from his office. As he sat down, the manager asked him, "Did you give them all?" "I ran two," he replied. I knew they were talking about the cut-pieces in the film. It seemed they had a stock,

and the projectionist had decided that two would suffice for that afternoon. The projectionist decided what he would show his audience on any particular occasion. *Mintu the Murderer* had been taken on contract, rather than on percentage. The managers of the hall had paid for the film in full and now could screen it at their discretion. There was therefore no representative that had traveled with the reels up to Bhurungamari. The otherwise prevalent fear of journalists was similarly absent. Here in the border hall of Bhurungamari the administrative center of Dhaka seemed very far away. The controversy over *Mintu the Murderer* had apparently not reached. The rules of projection clearly depended on context and location. In Bhurungamari journalists and film inspectors were far away, as were the nervous representatives and demanding producers. Here the projectionist decided. And his decision shaped the sequences of celluloid that ran through the projector. This arrangement, in turn, determined how the film was received and in which register the audience read the film. It was the last time I saw *Mintu the Murderer* in a cinema hall.

CONCLUSION

Mintu the Murderer was a success. The producer reclaimed his investment within the first two weeks of the film's release. The Eid crowds made the return on the meager investment almost inevitable. Any circulation after the first two weeks provided solid profit. The half-empty halls were a greater threat to the profits made by the cinema hall management than to the investment by the production company. To boost their returns, the halls relied on the associations of obscenity that romantic action movies such as *Mintu the Murderer* evoked. The posters and photosets for the film ensured such associations and guaranteed an audience for the film. Simultaneously, however, such displays invited commentary by journalists and the increased vigilance by the Censor Board and its inspectors.

This constellation of needs and interests ensured a flexible form for *Mintu the Murderer*. Screened from celluloid, the movie was adaptable to the context in which it was being shown. Depending on the demands from the audience, the needs of the cinema hall management, the leeway provided by local authorities, the interests of the producer, the judgment of the projectionist, and the location of the cinema hall itself, changes could be made to the narrative order of the film. Sexually explicit material could be spliced in and out within seconds, and violent encounters could be reinserted after censorship had taken place. When thinking about

active audiences and their appropriation and intervention into mass media, the possibility must be considered that dialogic opportunities do not arise only with new digital technologies and interfaces but are present in cinema halls screening films on celluloid. This is not an instance of technological determinism; rather, it shows how people and technology interlock. In rural Bangladesh the action genre provided a possibility for a changing film form resulting from the interlocking of exhibition and viewing practices.

As the film shifted its shape in the course of circulation and exhibition, the responses garnered from the audience were transformed. With the inclusion or exclusion of certain scenes the ways in which the gathered spectators reacted to the screened imagery and the narrative flow changed. Especially the inclusion of cut-pieces would transform public reactions to the film into a shared visceral tension, which outlasted the actual screening of the images of sex. Without cut-pieces the viewers responded vocally to the iconic action sequences featuring action hero Salman Khan. With their inclusion Salman no longer garnered any response, silence and tension marking the space of the auditorium instead. The duration of the affective response to pornography among viewers gathered together in public spaces of film projection undermines the affective responses encouraged by other genres.

Action films like *Mintu the Murderer* are reassembled to produce new emanations. Such transformations are not just accidental events in rural cinema halls. Rather, the instability of the film form is intrinsic to cinema in Bangladesh. This malleability must inform the way in which audiences and film reception are studied, urge a focus on exhibition practices, and temper the inclination to reduce films to coherent and logical texts. "Unstable celluloid" means that approaches to cinema that either see films as unambiguous ideological cages or film spectators as nimble readers are inadequate because of their overdetermined reliance on "knowable" cinema. The ethnography of exhibition and projection brings out the ways in which film form is less stable than textual analysis might assume and urges a rethinking of spectatorship and media reception in the context of those projection and exhibition practices.

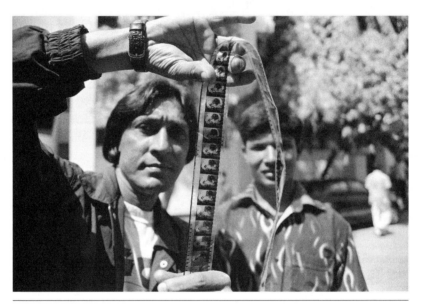

FIGURE C.1 PHOTO BY PAUL JAMES GOMES.

CONCLUSION

AFTER *MINTU THE MURDERER*

MINTU THE Murderer was banned on December 11, 2005, six weeks after its initial release. Upon inspection, the members of the Bangladesh Film Censor Board found uncertified material among its reels. The producer of the film appealed the Censor Board's decision in court. He eventually managed to obtain a stay order for the film. In the spring of 2006 *Mintu the Murderer* was rereleased for a second run. Playing to packed houses in small-town cinema halls, the film realized a solid profit. A VCD copy of *Mintu the Murderer* sold in Dhaka reached me in Amsterdam months later and revealed new cut-pieces, a bondage scene and the "celebration" song sequence that I had expected all along. When its reels were seized once more, the Censor Board found obscene material spliced into its reels and took it out of circulation once again.

In the summer of 2012, researching VCD production in Dhaka, I once again came across a VCD of *Mintu the Murderer*. This version was even more explicit, with all decapitations restored and more cut-pieces added. It followed a broader trend of sexually explicit material increasingly circulating in digital formats, from VCDs to mobile phones. The suspension of democracy and the Emergency Power Rules enforced by the 2007–8 Caretaker Government had increased pressures on the FDC to take action against directors and crews associated with cut-pieces. By 2012 the industry had not recovered from this hiatus. Tentative steps toward digitalization, the discontinuation of P-type film arrangements, the rise of private television producers and former ad-men as film directors, as well as the stranglehold on producers by *Mintu the Murderer*'s own Salman Khan, all aided the transformations under way at the FDC. Alongside a slump in filmmaking, more and more "culture-oriented" (Ahsan 2005) people could be seen at the FDC.

As cinema halls were closing down because of a dearth of marketable films, the cut-pieces and other forms of locally produced sexually explicit audio-visual material progressively found new formats and carriers.

Nonetheless, bits and pieces of *Mintu the Murderer*'s reels might still be running through celluloid projectors somewhere, in small-town cinema halls in Bangladesh, perhaps even in West Bengal or further afield. The reels of a cut-piece film like *Mintu the Murderer* have little integrity, and scenes and shots could easily be removed and find their way into other films, other projectors, other audiences, other carriers. The entire process of the production and consumption of *Mintu the Murderer* was marked by the instability of its form. From the gaps in its script and the moth-eaten censor cut, to the prominent presence of Jenny on its posters and the topsy-turvy chase scene in Bhurungamari, *Mintu the Murderer* was never a singular object with clear boundaries, content, and shapes. Its story suggests there is some merit in thinking about cinema less in terms of cohesive narratives and finite shapes than as a compilation of unstable practices and forms that can be pulled together in particular constellations or assemblages for particular occasions or moments.

The instability of *Mintu the Murderer* emerged out of censorship regulations and editing techniques. Prohibitions, aesthetic conventions, and production logics produce stray sequences and "previously unseen footage!" that disappears from official spaces of censorship and social surveillance. They reemerge under certain conditions: when the editor splices them back in after censorship, when the members of the Censor Board look away, when the producer deems it profitable, or when the repeat audience demands it. Then cut-pieces may emerge in action films, tangentially woven into the narrative or entirely haphazardly, disrupting continuities in sound, image, and storytelling. These are not radical gestures of defiance in the face of a repressive state system but the everyday practices of less than ideal citizens acting within the indeterminacy of the law and opaque legal injunctions, such as not to depict "passionate love schemes of an immoral nature." In this context cut-pieces emerge and oscillate between presence and absence.

The movement of the cut-piece between visibility and invisibility generates its own forms of cinematic pleasure. Easily spliced, cut-pieces can appear and disappear rapidly, even from reels already rolling through the projector. Their mercurial movement between presence and absence produces an anticipation in viewers that is rarely satisfied. It is a clever device because there may always be more to see, given that a single film

may exist in endlessly different forms. The logic of the appearance and disappearance of the cut-pieces keeps the viewer enthralled. Encouraging repeat viewing, these films entice spectators through wild stories and "noise" to come back again and again to the elusive object of desire that is the cut-piece. It can keep a cinema hall alive. While celluloid is facing obsolescence in many places, in Bangladesh its peculiar plasticity keeps cinema halls in business.

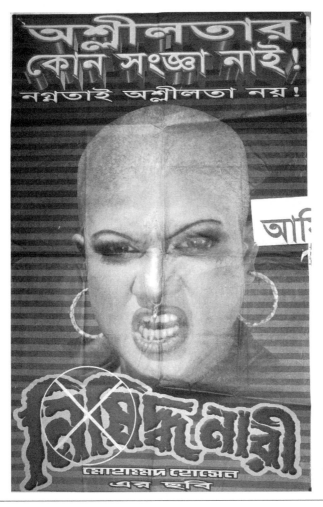

FIGURE C.2 Poster for *Nishiddho nari* ("Forbidden Woman," Mohammad Hossain, 2003).

PHOTO BY PAUL JAMES GOMES.

The poster for the film "Forbidden Woman" (*Nishiddho nari*, Moham-mad Hossain, 2003) illustrates the way in which cut-piece films can pull in spectators by making present the absence of the cut-piece. At the time *Mintu the Murderer* was seized in 2005, the poster of this film could be admired on the walls of Dhaka city. Like *Mintu the Murderer*, the film had been through a number of conflicts with the Censor Board. The film depicts the rape of a woman and the murder of her husband by village powerbrokers: a landlord, a *mullah*, a Hindu priest, and a chairman. She is subsequently ostracized as "forbidden" in the village. As a sign, her head is forcibly shaven. She avenges herself through attacks on the men and eventually dies. The Censor Board had objected to obscene scenes in the film as well as the word *forbidden* in its title. When the producer man-aged to receive a stay order, the film's posters were reprinted. On the new poster, the word *forbidden* had been retained but crossed out. Above the face of the bold woman, two lines of text had been added: "Obscenity has no definition" (*Oshlilotar kono shonggha nai*) and "Nudity is not obscenity" (*Nognotai oshlilota noy*). The posters were pasted onto the walls of the city and prominently displayed in central Dhaka outside the rundown cin-ema hall that screened the second run of the film. In full visibility, the posters announced the presence of cut-pieces through three negations: the cross, the suggestion that obscenity has no definition, and the state-ment that nudity is not obscenity. Such a poster makes no positive claims, only negative ones, behind which the viewer of the poster can assume the presence of cut-pieces, nudity, and forbidden themes. The "Forbidden Woman" poster also illustrates how a cut-piece film survives in the con-text of an increasingly competitive media landscape. Promising to reveal a forbidden spectacle, playing on gendered forms of violence and expec-tation, enticing in its lack of definition, the absences on the poster hint at and produce the pleasure of anticipation that fills cinema halls in the context of stiff competition from other forms of mediated entertainment. The cut-pieces are audiovisual gestures not fully precipitated, bordering on a breakthrough into public life. Such a break never states its presence unequivocally; it is always attenuated, partially hidden, disappearing.

The "Forbidden Woman" poster intervenes in the debates about obscen-ity that have wrapped themselves around the institutions, practices, and venues of film culture in Bangladesh. It "queries the Master's naming of the Event . . . and therefore asks the Master: 'Why is *that* the Name of the Event?'" (Surin 2001:214). The poster asks why is *that* obscenity, and why are *these* films obscene? But as it takes up the term *oshlilota* to expose

the arbitrary nature of the Censor Board legislation or moral norms, it immediately becomes caught up in the distractions of this term. The term *oshlilota* provides a reference point for an entire field of filmmaking, contaminating what comes in contact with it. Inflected by its position on the walls of the cinema hall, the statement "Nudity is not obscenity" becomes a lascivious gesture, enticing potential customers and antiobscenity crusaders to insist on the depravity of this sort of film. All the better to sell tickets. Whether denounced by the moral guardians of Bengali culture at the Censor Board, satirized for its *mofo* ways in the pages of the *New Age* newspaper, reviled as sexism in scholarly papers, or when selling tickets for struggling cinema halls, obscenity produces interest and fortifies the contours of "good" culture and cinema and those who speak in its name.

The oscillating presence of the cut-piece lures spectators and draws boundaries between good and bad culture. But when the cut-piece does emerge into full visibility, becoming present on the screens of rural cinema halls, it generates another form of pleasure. The collective viewing of illicit spectacles of sex, appearing suddenly within a film, can quiet a crowded cinema hall. Intense focus and awareness wraps itself around the spectators. The visceral impact of the cut-piece generates intense concentration and an awareness of one's surroundings and fellow viewers. The affective response to viewing a cut-piece is not merely individual but radiates out into the collectivity of the audience and the space of the cinema. The impact of the cut-piece can thus linger well beyond its actual screening. Interrupting the narrative logic of the scenes following it, the cut-piece interrupts genre as its impact on the audience persists. The affective response to the cut-pieces lingering in the cinema hall pushes back any other enticements emerging on the screen. It shows the complex relays that exist between the screen, the viewers, and the space of the cinema hall.

Cut-pieces also emerge sporadically, tangentially, in the literature on South Asian cinemas. Footnotes and asides suggest practices of cutting reels, stashes of illicit frames, and irregularities in cinema halls elsewhere across the region. This literature suggests that comparable conditions of censorship, production, exhibition, and competition have produced unstable celluloid elsewhere, especially in the realms of cinema marked by low investment and small margins. The striking aesthetic similarities between a film such as *Mintu the Murderer* and Pashto films made in Lahore or the echo of *Mintu the Murderer*'s practices of exhibition in Indian C circuits suggest consonance across the region. My account of the

production, distribution, and exhibition of *Mintu the Murderer* has been a gesture toward comparative research asking about the ways in which cinematic pleasure is produced in *mofussil* cinema halls, how production logics may create surprising gaps and opacities, and, most important, how unstable the form of film can really be.

Opening out even further, the question arises whether the logic of the cut-piece that marks *Mintu the Murderer* radiates outward from the space of the cinema? The logic of the cut-piece is one of suspense, collective forms of disavowed awareness, and noisy speculation combined with unpredictable moments of emergence commanding complete concentration. Does it apply only to action films and their contemporary principles of production? Or could this form of collective attention to something that may or may not emerge, the temporary availability of something to behold, furtively made present to then be withdrawn again, generating a hushed concentration and elation, be found elsewhere in the public sites of collective life in South Asia? The cut-pieces illuminate forms of effervescence and affectivity emerging out of the oscillation between absence and presence that may be found to energize processions, devotion, elections, or communal violence.

The cut-piece asks the researcher to be on the lookout for those degraded materials or disavowed cultural forms that tenaciously appear, disappear, and reappear. It claims attention for what is being cut out—out of films, out of public narratives, out of scholarly accounts, and out of personal conversations. It asks what the maneuvers are that allow such forms to emerge and be disavowed, kept out of view yet making present new or different forms of social life, cultural forms, and secret pleasures. Appearing at the brink of visibility, temporarily, it throws a momentary light on anxieties, fantasies, and possible tomorrows. As *Mintu the Murderer*'s brash hero Robi would say: "Mind it!"

NOTES

INTRODUCTION: BEFORE *MINTU THE MURDERER*

1. In this book, I use the pseudonym *Mintu the Murderer* for the film I studied. I have also used pseudonyms for all the members of its crew, cast, and exhibitors. I do the same for other action films whose crews were involved in the production and distribution of cut-pieces. When their names or titles are quoted in newspapers or magazine articles, I use square brackets to indicate the substitution of the actual name with a pseudonym.

2. From here I will drop the quotation marks around the terms *vulgarity* and *obscenity*. I do not analyze the category of the obscene as an unsymbolized surplus, as could be suggested with reference to the work of Julia Kristeva on the abject or Jacques Lacan's notion of the Real (Kristeva 1982; Lacan 1977). Kristeva's notion of the abject refers to phenomena in which object and subject are not clearly separated, producing an in-between where meaning collapses. The Lacanian Real marks that which is beyond symbolization and to which no meaning can be attributed. In my understanding the obscene is a social category, and thus integral to the symbolic order, and conveys meaning eloquently, even though its forms and imagery may generate moments of abjection or encounters with the Real.

3. The term *cut-piece* is used in Bangladesh for different sorts of off-cuts, including the strips of cloth left over by tailors. The term, redolent of disappearance, fragmentation, and violence, appears in Yoko Ono's 1964 work of performance art called "Cut Piece," in which she allowed members of the audience to cut her clothes away with a pair of scissors.

4. The noun *oshlilota* is derived from the adjective *shril* through a consonant shift from *r* to *l* (Bandhyopadhyay 1978:199; Das 1931:149). *Shril* means the same as *shriyukto*: not only prosperous, well-shaped, and illustrious but also "an epithet of respect prefixed to names of living men, usually of those who are elders or superiors" (Mitra 1911:97). Beauty, respectability, and social distinction define *shril* and

shriyukto. William Carey's dictionary, first published in 1825, suggests that *oshril* meant "unfortunate, unlucky, not glorious, not beautiful, not illustrious," whereas *oshlil* meant "vulgar, low, rustic, coarse (applied to language)" (Carey 1981:255–56). Mitra suggests by 1911 that *oshlil* means "inelegant, vulgar, coarse, rude, gross, filthy, indecent, obscene, shameful," while *oshril* is defined as "unprosperous, unfortunate, unhappy; unbeauteous, unhandsome, ugly" (Mitra 1911:97).

5. In Žižek's Lacanian terms, "it constructs the scene in which the *jouissance* we are deprived of is concentrated in the Other who stole it from us" (1997:32).

6. My use of the "ideology of form" as derived from Žižek here is quite different from the use M. Madhava Prasad (1998:221–22) makes of Žižek's text to analyze the Indian 1990s films *Roja* (Mani Ratnam, 1992) and *Damini* (Rajkumar Santoshi, 1993). In his analysis *form* refers to the narrative structure of the films, whereas in my analysis *form* refers less to the diegesis than to the exhibition, montage, and formal aesthetic conventions. It is in this sense that I want to take up Žižek's challenge to find "the secret of this form itself."

7. Sharmistha Gooptu (2011) accounts for similar transformations under way in the West-Bengal film industry.

8. In Kabir's own words: "I had felt that my foremost task would be to try and usher in a simple cinematic language and make it acceptable to an audience who have been thoroughly brainwashed for decades by what may be termed *camera-theatre*. I had to work on two planes to counteract some of the deep-rooted concepts. I had to establish that visuals have the principal role in true cinema" (1979:70). His text resonates with Satyajit Ray's suggestion that the main formulas of Bengali film "have evolved out of the producers' deliberate and sustained playing down to a vast body of unsophisticated audience brought up on the simple tradition of the *Jatra*, a form of rural drama whose broad patterns have been retained in the films to a degree unimaginable to those not familiar with this unique form of filmmaking" (Ray 1993:40).

1. WRITING GAPS: THE SCRIPT

1. Of about twenty scriptwriters active in the industry in 2005, only two used laptops; the others wrote scripts by hand.

2. Because of fiscal policy changes, the BDT-USD exchange rate fluctuated heavily in 2005. All amounts used in *Cut-Pieces* are from 2005, so I use that year's exchange rate throughout: US$1 = 63 BDT.

3. Art films include "Slowly Flows the Meghna" (*Dhire bohe meghna*, Alamgir Kabir, 1973); "The Ominous House" (*Surjo dighol bari*, Moshiuddin Shaker and Shaikh Niamat Ali, 1979); "The Wheel" (*Chakka*, Morshedul Islam, 1993); "A Tree Without Roots" (*Lal shalu*, Tanvir Mokammel, 2001); "The Clay Bird" (*Matir moina*, Tareque Masud, 2002). Healthy films include "Cloudy Monsoon Days" (*Shrabon megher din*, Humayun Ahmed, 2001); *Kirtonkhola* ("The River Kirtonkhola," Abu Sayeed, 2002); and "Cloud After Cloud" (*Megher por megh*, Chashi Nuzrul Islam, 2004).

4. *Beder meye Josna* deserves a lot more critical attention than I can give it here. One of the few "folk films" to come out of the 1980s, it was a massive success and continued to be screened throughout the country in 2005. For discussions of *Beder meye Josna* see Mazhar (undated) and Roberge (2004).

5. There are no father characters in *Mintu the Murderer*, only siblings and mothers. This allows the disintegration of the moral order that propels the action plot. Through this lack of paternal figures in the film, transgressions become possible without overstepping the patriarchal order. While romantic action films often show young people rebelling against authority and social norms, made possible by incapacitated, unreliable or absent paternal figures, toward the end of these films the legal and patriarchal order is generally restored. For a comparison see Thomas 1996.

2. A HANDHELD CAMERA TWISTED RAPIDLY: THE TECHNOLOGY

1. This practice could be found among many of the crew, and gestures of respect were made to diverse tools, such as the script, the camera, and the celluloid negative. For an account of comparable engagements between person and machine see Chakrabarty (1996b:90) and Ramaswami (2006). The respect with which the reels and equipment were treated at the FDC was part of a much more widespread practice in Bangladesh of treating with vigilance that which maintains one's livelihood, including uncooked rice and business ledgers.

2. The building of "Zia Film City," an FDC initiative undertaken under the 2001–5 Bangladesh Nationalist Party (BNP) government, was an attempt to provide such a scenic backdrop within the FDC structures. It was set up "to integrate natural facilities in favor of outdoor shootings that will enhance the standard and appeal of Bangladeshi films." Among its main development activities were listed "construction of a Pagoda, Swing, Sleeper etc. in the Picnic Spot" (Bangladesh Film Development Corporation, Undated b).

3. ACTRESS/CHARACTER: THE HEROINES

1. Classical dance academies such as Bulbul Academy, Chayanaut, and Shishu Academy are important markers for Bengali culture and middle-class sophistication, performing during key national celebrations such as the Bengali New Year. The dance classes attended by Shavana focused mostly on modern dance, which was modeled on music videos from around the world and stood in lesser esteem.

2. For an account of the auditory elements of Jenny's *purdah* see Hoek 2009.

3. Naila Kabeer notes a very similar aesthetic rejection of new urban groups in the mid-1980s in her book about garment workers. She quotes a report from the *New Nation* describing the "garment girls": "A group of girls . . . with faces in cheap makeup, gaudy ribbons adorning their oily braids and draped in psychedelic coloured sarees with tiffin carriers in hands" (*New Nation*, 1986; quoted in Kabeer 2000:82).

4. DVDs, VCDs, and mobile phones are the most important noncelluloid means through which cut-pieces and other pornography can be seen in Bangladesh. These carriers are the main devices by which women can watch cut-pieces, but I only studied this anecdotally, such as with Bokul.

5. Scholarly research on sexuality in Bangladesh, whether heterosexual or homosexual, is mostly undertaken in the context of discussions of sex work and sexually transmitted diseases and the discourse is embedded in NGO and medical discourses that pathologize most if not all sexual practices. See, e.g., Khan et al. (2002); and Johnston et al. (2007).

4. CUTTING AND SPLICING:
THE EDITOR AND THE CENSOR

1. In 2005 members paid 3,000 taka (approx. US$45) in membership fees and a 20 taka (approx. US$0.30) monthly contribution. Once a member of the Editing Guild and established enough to attract clients, editors may start working for themselves and obtain their own apprentices.

2. For 35mm films of fewer than three thousand feet the cost was 200 taka per one thousand feet to examine; 35mm films between three thousand and thirteen thousand feet cost 600 taka, plus 300 taka per one thousand feet, or part of that, which exceeds three thousand feet; penalized are films that are more than thirteen thousand feet, which cost 4,500 taka to examine, plus 1,000 taka per one hundred feet exceeding the thirteen thousand feet limit. See the 1983 amendment of the Bangladesh Censorship of Films Rules 1977, in Government of the People's Republic of Bangladesh (undated).

3. The summer months of 2005 saw a rash of bomb attacks all over Bangladesh, stepping up the political unrest.

4. On bribes and the Censor Board see Qader (1993:494–98).

5. A major figurehead of the Short Film movement in Bangladesh, a filmmaker, and a prolific writer on cinema, the late Alamgir Kabir is considered the driving force behind the development of art cinema in Bangladesh and is generally revered by those who consider themselves connoisseurs.

6. The Bangladesh Film Censor Board has only one form of certification. A film either is or isn't suitable for public exhibition and has no other category such as "parental guidance" or "suitable only for adults."

7. Shantiniketan, the university set up by Rabindranath Tagore, is considered by many in Bangladesh to be the epitome of high culture.

8. In this citation I have substituted the names of the actors with their pseudonyms, marked by square brackets. Note that the Censor Board refers to the actors' names, not their characters.

5. NOISE: THE PUBLIC SPHERE

1. Square brackets indicate the substitution of a name with a pseudonym when citing newspapers and magazines.

2. The mainstream film reviews that were printed in the *New Age* column "Dhoom Dharaka: Camera Lights Attraction!" used a blend of English and Bengali in their generally derisive assessments. Speaking the language of upper-middle-class English-medium educated urban Bangladeshi youth, these reviews generally indulge in the extravagance of the concept of Bangladeshi action movies rather than expressing an actual interest or enjoyment in any specific movie. The pleasure in such reviews comes from the reproduction of cinematic catchphrases in Dhakaiya Bangla, discussing the "'absurdity" of outfits and props and describing the proportions of the women in the films. Some examples of the review style are: "Tell me, where do they get such obese women and why do they have to wear mini-skirts?" (Feroze 2005c); "Arey, this is Bangla film: dum maro, script lekho, jay baba Bholanath bolo" (Khan 2005); "On the other side of the plot (is there one?) we get [actress] Moushumi. . . . We are in la la land and again Moushumi is seen wearing jeans with pockets (what's with the pockets?) and chains dancing in the garden and on derelict buildings. . . . A huge house [is] guarded by men openly carrying weapons that are made of card-board, but then you are not supposed to understand that. . . . The plot is lost under a whirlwind of irrationality and somehow I am okay" (Feroze 2005d).

3. Another crucial location for the discussion of sexuality is NGO activities relating to women's reproductive health and family planning (White 1992). Such initiatives are similarly a fount of lewd jokes and invite violent attacks.

4. This text, too, cannot avoid this multivalence.

5. In October 2006 the ban imposed on ten filmmakers, including Shiplu, was withdrawn. In an interview with a *New Age* reporter (Khan 2006) the secretary of the Directors Association was quoted as saying that banning such directors made no difference because "powerful quarters" were engaged in making vulgar films. Nonetheless, other experts were hesitant to grant all rights to the returning filmmakers. To Shiplu it would make little difference. In the intervening eighteen months he had made more than a dozen films.

BIBLIOGRAPHY

Abdullah, Abu. 2002 [2000]. "Social Change and 'Modernization.'" In Jahan 2002, 129–47.

Abu-Lughod, Lila. 2005. *Dramas of Nationhood: The Politics of Television in Egypt.* Chicago: University of Chicago Press.

Adamu, Abdalla Uba, Yusuf M. Adamu, and Umar Faruk Jibril, eds. 2004. *Hausa Home Videos: Technology, Economy, and Society.* Proceedings of the First International Conference on Hausa Films. Kano: Center for Hausa Cultural Studies.

Agomon. 2005a. "Cholochitrer purush kheko nayika Shabnurer noshtamir shesh kothay?" [Where is the end of the depravity of man-eating actress Shabnur?]. May 25.

——. 2005b. "Ora noshto, ora bhroshto, ora nayika" [They are despoiled, they are depraved, they are actresses]. May 25.

——. 2005c. "Hirar youbone kamonar jhor" [The storm of Hira's sexual desire]. May 25.

Ahmed, Rahnuma. 1999. "'Women's Awakening': The Construction of Modern Gender Differences in Bengali Muslim Society." In *Shamprotik nribigyan* [Contemporary anthropology], edited by S. M. Nurul Alam, Ainoon Naher, and Manas Chowdhury, 109–30. Dhaka: Department of Anthropology, Jahangirnagar University.

Ahmed, Rumi. 2008. "The Manna Factor." *Daily Star*, Dec. 23.

Ahsan, Syed Badrul. 2005. "Of Movies, of Old Story Lines." *New Age*, Oct. 6.

Akhondo, Makchudullah. 2004. "Kholamela drishye obhinoy chhadun" [Stop acting in open scenes]. *Chhayachhondo*, Feb. 2.

Ali, Tariq. 2010. "The Hinterland and the Metropole: Jute, Economic Life and Political Discourse in Eastern Bengal, 1853–1947." Paper presented at Bangladesh Studies Group Workshop, London School of Economics, June 18.

Allison, Anne. 1996. *Permitted and Prohibited Desires: Mothers, Comics, and Censorship in Japan.* Boulder, CO: Westview Press.

Altman, Rick, ed. 1992. *Sound Theory, Sound Practice.* New York: Routledge.

Amin, Sonia Nishat. 1995. "The Orthodox Discourse and the Emergence of the Muslim Bhadromohila in Early Twentieth Century Bengal." In *Mind, Body, and Society: Life and Mentality in Colonial Bengal*, edited by Rajat Kanta Ray, 391–422. Delhi: Oxford University Press.

Anderson, Benedict. 1991 [1983]. *Imagined Communities: Reflections on the Origin and Spread of Nationalism*. London: Verso.

Ang, Ien. 2005 [1982]. *Watching Dallas: Soap Opera and the Melodramatic Imagination*. New York: Routledge.

Appadurai, Arjun. 1997. *Modernity at Large: Cultural Dimensions of Globalization*. Minneapolis: University of Minnesota Press.

Armbrust, Walter. 2002. "Islamists in Egyptian Cinema." *American Anthropologist* 104(3): 922–31.

Arondekar, Anjali. 2009. *For the Record: On Sexuality and the Colonial Archive in India*. Durham, NC: Duke University Press.

Ashraf, Kazi K. 1989. "Muzharul Islam, Kahn and Architecture in Bangladesh." *Worldview: Perspectives on Architecture and Urbanism from Around the Globe*. http://worldviewcities. org/dhaka/islam.html (accessed Oct. 15, 2007).

Askew, Kelly, and Richard R. Wilk, eds. 2002. *The Anthropology of Media: A Reader*. London: Blackwell.

Axel, Brian Keith. 2005. "Diasporic Sublime: Sikh Martyrs, Internet Mediations and the Question of the Unimaginable." *Sikh Formations* 1(1):127–54.

Babu, Kamruzzaman. 2005a. "Notun Censor Board: Protyasha onek" [The new Censor Board: Much hope]. *Prothom Alo*, June 21.

——. 2005b. "Censor Board o FDC kortripokkho dayitto palone bertho?" [Do the Censor Board and FDC fail to foster responsibility?] *Prothom Alo*, Feb. 3.

——. 2005c. "Tobu-o nirmito hocchhe oshlil chhobi" [Obscene films produced nonetheless]. *Prothom Alo*, Jan. 20.

——. 2005d. "Obscene films everywhere on Eid" [Eide oshlil chhobir chorachori]. *Prothom Alo*, Nov. 7.

Bal, Ellen. 2007. *They Ask If We Eat Frogs: Garo Ethnicity in Bangladesh*. Singapore: ISEAS.

Banaji, Shakuntala, ed. 2010. *South Asian Media Cultures: Representations, Audiences and Contexts*. London: Anthem.

Bandhyopadhyay, Haricaraṇa. 1978 [1933]. *Bangiyo shobdokosh* [Bengali dictionary]. Vol. 1. New Delhi: Shahitya Academy.

Banerjee, Sumanta. 1987. "Bogey of the Bawdy: Changing Concept of 'Obscenity' in Nineteenth Century Bengali Culture." *Economic and Political Weekly*, July 18:1197–1206.

——. 2000. *Dangerous Outcast: The Prostitute in Nineteenth Century Bengal*. Calcutta: Seagull.

Bangladesh Film Development Corporation. Undated a. "Policies Regarding Films." www. fdc.gov.bd/fdc/facilitatingpolicies.asp (accessed Dec. 12, 2007 [page no longer available]).

——. Undated b. "Exclusive Projects." www.fdc.gov.bd/projectsexclusive (accessed June 24, 2007).

Bannerjee, Himani. 1995. "Attired in Virtue: The Discourse of Shame (*lajja*) and the Clothing of the *Bhadramahila* in Colonial Bengal." In *From the Seams of History: Essays on Indian Women*, edited by Bharati Ray, 67–106. New Delhi: Oxford University Press.

Banu, U. A. B. Razia Akter. 1992. *Islam in Bangladesh*. Leiden: Brill.

Barber, Karin. 2007. *The Anthropology of Texts, Persons and Publics*. Cambridge: Cambridge University Press.

Bazin, André. 2004. "The Evolution of the Language of Cinema." In Braudy and Cohen 2004, 41–53.

Belton, John. 2004. "Technology and Aesthetics of Film Sound." In Braudy and Cohen 2004, 386–394.

Berenschot, Ward. 2012. *Riot Politics: Hindu-Muslim Violence and the Indian State*. London: Hurst.

Bhattacharya, Tithi. 2005. *The Sentinels of Culture: Class, Education, and the Colonial Intellectual in Bengal (1848–85)*. New York: Oxford University Press.

Bokul, Kabir. 2005. "Obhinondon ebong protyasha" [Congratulations and hope]. *Prothom Alo*, June 21.

Booth, Gregory D. 1995. "Traditional Content and Narrative Structure in the Hindi Commercial Cinema." *Asian Folklore Studies* 54(2):169–90.

Bordwell, David. 2008. "The Hook: Scene Transitions in Classical Cinema." *David Bordwell's Website on Cinema*. www.davidbordwell.net/essays/hook.php (accessed April 18, 2012).

Bordwell, David, Janet Staiger, and Kristin Thompson. 1988 [1985]. *The Classical Hollywood Cinema: Film Style and Mode of Production to 1960*. London: Routledge.

Bose, Brinda, ed. 2006. *Gender and Censorship*. New Delhi: Women Unlimited.

Brail, Abigail, and Claire Colebrook. 1998. "The Haunted Flesh: Corporeal Feminism and the Politics of (Dis)embodiment." *Signs* 24(1):35–67.

Braudy, Leo, and Marshall Cohen, eds. 2004. *Film Theory and Criticism*. 6th ed. New York: Oxford University Press.

Brooker, Will, and Deborah Jermyn, eds. 2003. *The Audience Studies Reader*. London: Routledge.

Buck-Morss, Susan. 2004. "Visual Studies and Global Imagination." *Papers of Surrealism* 2:1–29.

Butler, Judith. 1997. *Excitable Speech: A Politics of the Performative*. London: Routledge.

Carey, W. 1981 [1825]. *A Dictionary of the Bengali Language, in Which Words Are Traced to Their Origin and Their Various Meanings Given*. New Delhi: Asian Educational Services.

Chhayachhondo. 2005. *Shami-ke divorce dilen nayika [Shadnaz]* [Actress (Shadnaz) gave her husband a divorce]. May 5.

Chakrabarty, Dipesh. 1996a. "Remembered Villages: Representation of Hindu-Bengali Memories in the Aftermath of the Partition." *Economic and Political Weekly* 31(32):2143–51.

——. 1996b. *Rethinking Working-Class History, Bengal 1890-1940*. Delhi: Oxford University Press.

——. 1999. "Nation and Imagination: The Training of the Eye in Bengali Modernity." *Topoi* 18(1):29–47.

Chatterjee, Partha. 1993. *The Nation and Its Fragments: Colonial and Postcolonial Histories*. Princeton, NJ: Princeton University Press.

Chatterji, Joya. 1996. "The Bengali Muslim: A Contradiction in Terms? An Overview of the Debate on Bengali Muslim Identity." *Comparative Studies of South Asia, Africa, and the Middle East* 16(2):16–24.

Chowdhury, Afsan. 2007. "The Anger of Bangladesh's Non-elite." *Himal*, June: http://himalmag.com/component/content/article/1233-.html (accessed Oct. 8, 2012).

Chowdhury, Manosh. 2006. "Politics of Secularism in Bangladesh: On the Success of Reducing Political Vocabularies into 'Evil' Islamism." *Journal of Social Studies* 109:1–14.

Chowdhury, Nusrat. 2012. "Energy Emergency: Phulbari and Democratic Politics in Bangladesh." PhD diss., University of Chicago.

Cleland, John. 1985 [1749]. *Fanny Hill, or Memoirs of a Woman of Pleasure*. London: Penguin.

Cohen, Lawrence. 2007. "Song for Pushkin." *Daedalus* 136(2):103–15.

Cohen, Stanley. 1980 [1972]. *Folk Devils and Moral Panics: The Creation of the Mods and Rockers*. Oxford: Martin Roberson.

Colebrook, Claire. 2006. *Deleuze: A Guide for the Perplexed*. London: Continuum.

Collingham, E. M. 2001. *Imperial Bodies: The Physical Experience of the Raj, c. 1800-1947*. Oxford: Blackwell.

Comaroff, John L., and Jean Comaroff, eds. 1999. *Civil Society and the Political Imagination in Africa: Critical Perspectives*. Chicago: University of Chicago Press.

Critcher, Chas. 2003. *Moral Panics and the Media*. Buckingham: Open University Press.

Daily Star. 2005. "Signs of a Deeper Malaise." May 17.

Das, Jinendra Mohan. 1931. *Dictionary of the Bengali Language*. Vol. 1. Calcutta: Indian Publishing House.

de Certeau, Michel. 1988 [1984]. *The Practice of Everyday Life*. Berkeley: University of California Press.

de Lauretis, Teresa. 1984. *Alice Doesn't: Feminism, Semiotics, Cinema*. Bloomington: Indiana University Press.

Deleuze, Gilles, and Félix Guattari. 2005 [1987]. *A Thousand Plateaus: Capitalism and Schizophrenia*. London: Continuum.

Derné, Steve. 2000. *Movies, Masculinity, Modernity: An Ethnography of Men's Filmgoing in India*. Westport, CT: Greenwood Press.

Derné, Steve, and Lisa Jadwin. 2000. "Male Hindi Filmgoers' Gaze: An Ethnographic Interpretation." *Contributions to Indian Sociology* 34(2):243–69.

Dickey, Sara. 1993. *Cinema and the Urban Poor in South India*. Cambridge: Cambridge University Press.

——. 2001. "Opposing Faces: Film Star Fan Clubs and the Construction of Class Identities in South India." In Dwyer and Pinney 2001, 212–46.

Dickey, Sara, and Rajinder Dudrah. 2010. "South Asian Cinemas: Widening the Lens." *South Asian Popular Culture* 8(3):207–12.

Dönmez-Colin, Gönül. 2004. *Women, Islam and Cinema*. London: Reaktion.

Douglas, Mary. 2002 [1966]. *Purity and Danger: An Analysis of Concepts of Pollution and Taboo*. London: Routledge.

Dudrah, Rajinder, and Amit Rai. 2005. "The Haptic Codes of Bollywood Cinema in New York City." *New Cinemas: Journal of Contemporary Film* 3(3):149–58.

During, Simon. 1993. *The Cultural Studies Reader*. London: Routledge.

Dwivedi, R. C. 1981. "Concept of Obscenity (aślīlatā) in Sanskrit Poetics." *Annals of the Bhandarkar O.R. Institute* 62:67–76.

Dwyer, Rachel. 2000a. *All You Want Is Money, All You Need Is Love: Sexuality and Romance in Modern India*. London: Cassell.

——. 2000b. "The Erotics of the Wet Sari in Hindi Films." *South Asia* 23(1):143–59.

Dwyer, Rachel, and Christopher Pinney, eds. 2001. *Pleasure and the Nation: The History, Politics and Consumption of Public Culture in India.* New Delhi: Oxford University Press.

Dyer, Richard. 1992. *Only Entertainment.* London: Routledge.

Eidsvik, Charles. 1988. "Machines of the Invisible: Changes in Film Technology in the Age of Video." *Film Quarterly* 42(2):18–23.

Ellis, John. 2004 [1974]. "Stars as Cinematic Phenomenon." In Braudy and Cohen 2004, 598–605.

Feldman, Shelley. 1991. "Rural Industrialisation: The Shaping of 'Class' Relations in Bangladesh." In *Bringing Class Back In: Contemporary and Historical Perspectives*, edited by Scott G. McNall, Rhonda F. Levine, and Rick Fantasia, 119–37. Boulder, CO: Westview Press.

——. 1993. "Contradictions of Gender Inequality: Urban Class Formation in Contemporary Bangladesh." In *Gender and Political Economy: Explorations of South Asian Systems*, edited by Alice W. Clark, 215–45. Delhi: Oxford University Press.

——. 2001. "Exploring Theories of Patriarchy: A Perspective from Contemporary Bangladesh." *Signs* 26(4):1097–1127.

——. 2002 [2000]. "NGOs and Civil Society: (Un)stated Contradictions." In Jahan 2002, 219–43.

Feldman, Shelley, and Florence E. McCarthy. 1983. "Purdah and Changing Patterns of Social Control Among Rural Women in Bangladesh." *Journal of Marriage and Family* 45(4):949–59.

Feroze, Towheed. 2005a. "Ranga mastaan: Oi rangare rangais na." *New Age*, March 24.

——. 2005b. "Cut Pieces Rule Supreme!" *New Age*, April 18.

——. 2005c. "Koyla: Or Heart of Burning Coal." *New Age,* April 28.

——. 2005d. "Rokte Amar Agun: Bloodied Imagination." *New Age.* May 12.

Fiske, John. 1986. *Reading the Popular.* New York: Unwin Hyman.

Foucault, Michel. 1990 [1978]. *The History of Sexuality.* Vol. 1. *An Introduction.* New York: Vintage.

——. 1991 [1984]. "Preface to 'The History of Sexuality,' Vol. 2." In *The Foucault Reader*, edited by Paul Rabinow, 333–39. London: Penguin.

Fraser, Nancy. 1992. "Rethinking the Public Sphere: A Contribution to the Critique of Actually Existing Democracy." In *Habermas and the Public Sphere*, edited by Craig Calhoun, 109–28. Cambridge: MIT Press.

Fuller, Christopher, John Bénéï, and Véronique Bénéï, eds. 2001. *The Everyday State and Society in Modern India.* London: Hurst.

Ganti, Tejaswini. 2002. "'And Yet My Heart Is Still Indian': The Bombay Film Industry and the (H)indianisation of Hollywood. In Ginsburg, Abu-Lughod, and Larkin, 281–300.

——. 2004. *Bollywood: A Guidebook to Popular Hindi Cinema.* London: Routledge.

——. 2009. "The Limits of Decency and the Decency of Limits: Censorship in the Bombay Film Industry." In Kaur and Mazzarella 2009, 87–122.

——. 2012. *Producing Bollywood: Inside the Contemporary Hindi Film Industry.* Durham, NC: Duke University Press.

Gardner, Katie. 1995. *Global Migrants, Local Lives: Travel and Transformation in Rural Bangladesh.* Oxford: Clarendon.

Gazdar, Mushtaq. 1997. *Pakistan Cinema 1947–1997.* Oxford: Oxford University Press.

Geertz, Clifford. 1973. *The Interpretation of Cultures.* New York: Basic Books.

Ghosh, Anindita. 2000. "Valorising the 'Vulgar': Nationalist Appropriations of Colloquial Bengali Traditions, c. 1870–1905." *Indian Economic and Social History Review* 37(2):151–83.

———. 2002. "Revisiting the 'Bengal Renaissance': Literary Bengali and Low-Life Print in Colonial Calcutta." *Economic and Political Weekly*, Oct. 19:4329–38.

———. 2006. *Power in Print: Popular Publishing and the Politics of Language and Culture in a Colonial Society.* Delhi: Oxford University Press.

Ghosh, Avijit. 2010. *Cinema Bhojpuri.* New Delhi: Penguin .

———. 2012. "Bhojpuri Cinema: Between Yesterday and Tomorrow." *South Asian History and Culture* 3(1):70–80.

Ghosh, Shohini. 1999. "The Troubled Existence of Sex and Sexuality: Feminists Engage with Censorship." In *Image Journeys: Audio-Visual Media and Cultural Change in India*, edited by Christiane Brosius and Melissa Butcher, 234–59. New Delhi: Sage.

———. 2011. "The Prohibition and Production of 'Bad' Images: Film Censorship and Post-Liberalization India." Paper presented at the conference "Media and Power in Contemporary South Asia," Minpaku, National Museum of Ethnology, Japan, Dec. 18, 2011.

Gillespie, Marie. 1995. *Television, Ethnicity, and Cultural Change.* New York: Routledge.

Ginsburg, Faye. 1993. "Culture/Media: A (Mild) Polemic." *Anthropology Today* 10(2):5–15.

———. 2002. "Screen Memories: Resignifying the Traditional in Indigenous Media." In Ginsburg, Abu-Lughod, and Larkin 2002, 39–57.

Ginsburg, Faye, Lila Abu-Lughod, and Brian Larkin, eds. 2002. *Media Worlds: Anthropology on New Terrain.* Berkeley: University of California Press.

Gooptu, Sharmistha. 2003. "The Glory That Was: An Exploration of the Iconicity of New Theatres." *Comparative Studies of South Asia, Africa, and the Middle East* 23(1 & 2):286–300.

———. 2011. *Bengali Cinema: "An Other Nation."* London: Routledge.

Gopal, Sangita. 2011. *Conjugations: Marriage and Form in New Bollywood Cinema.* Chicago: University of Chicago Press.

Gopalan, Lalitha. 2002. *Cinema of Interruptions: Action Genres in Contemporary Indian Cinema.* New Delhi: Oxford University Press.

———. 2003 [1996]. "Indian Cinema." In *An Introduction to Film Studies*, edited by Jill Nelmes, 359–88. 3rd ed. London: Routledge.

Gopinath, Gayatri. 2000. "Queering Bollywood: Alternative Sexualities in Popular Indian Cinema." *Journal of Homosexuality* 39(3–4):283–97.

Government of the People's Republic of Bangladesh. Undated. *A Manual on Censorship of Films Act, Rules and Code with Amendments; Cinematograph Act and Rules, with Amendments; Films Clubs Registration & Regulation Act & Rules and Various Notifications, Orders etc.* Dhaka: Ministry of Information.

Grazia, Edward de. 1992. *Girls Lean Back Everywhere: The Law of Obscenity and the Assault on Genius.* New York: Random House.

Grosrichard, Alain. 1998 [1979]. *The Sultan's Court: European Fantasies of the East.* London: Verso.

Guha-Thakurta, Tapati. 2004. *Monuments, Objects, Histories: Institutions of Art in Colonial and Postcolonial India*. New York: Columbia University Press.

Gupta, Akhil. 1995. "Blurred Boundaries: The Discourse of Corruption, the Culture of Politics, and the Imagined State." *American Ethnologist* 22(2):375–402.

Gupta, Akhil, and James Ferguson. 1992. "Beyond Culture: Space, Identity and the Politics of Difference." *Cultural Anthropology* 7(1):6–23.

Gupta, Charu. 2001. *Sexuality, Obscenity, Community: Women, Muslims, and the Hindu Public in Colonial India*. Delhi: Permanent Black.

Gupta, Sarmistha Dutta. 2009. "Saogat and the Reformed Bengali Muslim Woman." *Indian Journal of Gender Studies* 16(3):329–58.

Hall, Stuart. 1999 [1993]. "Encoding, Decoding." In During 1993b, 90–103.

Hall, Stuart, Chas Critcher, Tony Jefferson, John Clarke, and Brian Roberts. 1979 [1978]. *Policing the Crisis: Mugging, the State and Law and Order*. London: Macmillan.

Hamera, Judith. 2006. "Performance, Performativity, and Cultural Poiesis in Practices of Everyday Life." In *The Sage Handbook of Performance Studies*, edited by D. Soyini Madison and Judith Hamera, 46–64. Thousand Oaks, CA: Sage.

Hansen, Kathryn. 2001. "The Indar Sabha Phenomenon: Public Theatre and Consumption in Greater India (1853–1956)." In Dwyer and Pinney 2001, 76–114.

Hansen, Miriam. 1991. *Babel and Babylon: Spectatorship in American Silent Film*. Cambridge, MA: Harvard University Press.

Hansen, Thomas Blom. 2005. "Sovereigns Beyond the State: Authority and Legality in Urban India." In *Sovereign Bodies: Citizens, Migrants and States in the Postcolonial World*, edited by Thomas Blom Hansen and Finn Stepputat, 169–91. Princeton, NJ: Princeton University Press.

Hansen, Thomas Blom, and Finn Stepputat, eds. 2001. *States of Imagination: Ethnographic Explorations of the Postcolonial State*. Durham, NC: Duke University Press.

Haskell, Molly. 1987. *From Reverence to Rape: The Treatment of Women in the Movies*. Chicago: University of Chicago Press.

Hayat, Anupam. 1987. *Bangladesher chalachitro itihash* [The history of Bangladeshi cinema]. Dhaka: Bangladesh Film Development Corporation.

Hebdige, Dick. 1979. *Subculture: The Meaning of Style*. London: Methuen.

Heeren, Katinka van. 2007. "Return of the Kyai: Representations of Horror, Commerce, and Censorship in Post-Suharto Indonesian Film and Television." *Inter-Asia Cultural Studies* 8(2):211–26.

Hewamanne, Sandya. 2006. "Pornographic Voice: Critical Feminist Practices Among Sri Lanka's Female Garment Workers." *Feminist Studies* 32(1):125–54.

Hirschkind, Charles. 2006. *The Ethical Soundscape: Cassette Sermons and Islamic Counterpublics*. New York: Columbia University Press.

Hoek, Lotte. 2009. "'More Sexpression Please!' Screening the Female Voice and Body in the Bangladesh Film Industry." In Meyer 2009, 71–90.

——. 2010a. "Cut-Pieces as Stag Film: Bangladeshi Pornography in Action Cinema." *Third Text* 24(1):133–46.

——. 2010b. "Urdu for Image: Understanding Bangladeshi Cinema Through Its Theatres." In Banaji 2010, 73–89.

——. 2012. "Mofussil Metropolis: Civil Sites, Uncivil Cinema and Provinciality in Dhaka City." *Ethnography* 13(1):28–42.

Hughes, Stephen. 2000. "Policing Silent Film Exhibition in Colonial South India." In *Making Meaning in Indian Cinema*, edited by Ravi S. Vasudevan, 39–64. New Delhi: Oxford University Press.

——. 2003. "Pride of Place." *Seminar* 525. www.india-seminar.com/2003/525/525%20 stephen%20p.%20hughes.htm (accessed April 24, 2012).

——. 2010. "What Is Tamil About Tamil Cinema?" *South Asian Popular Culture* 8(3): 213–29.

——. 2011. "Anthropology and the Problem of Audience Reception." In *Made to Be Seen: Perspectives on the History of Visual Anthropology*, edited by Marcus Banks and Jay Ruby, 288–312. Chicago: University of Chicago Press.

Hulsing, Milan. 2004. "Pashto Horror Films in Pakistan." *Wasafiri* 19(43):53–57.

Hunt, Lynn. 1993. *The Invention of Pornography: Obscenity and the Origins of Modernity, 1500–1800*. New York: Zone.

Huq, Maimuna. 1999. "From Piety to Romance: Islam-Oriented Texts in Bangladesh." In *New Media in the Muslim World: The Emerging Public Sphere*, edited by Dale F. Eickelman and Jon W. Anderson, 133–61. Bloomington: Indiana University Press.

Hussain, Delwar. 2013. *Boundaries Undermined: The Ruin of Progress on the Bangladesh/India Border*. London: Hurst.

Ingold, Tim. 2011. *Being Alive: Essays on Movement, Knowledge and Description*. London: Routledge.

Jahan, Rounaq. 2001 [1972]. *Pakistan: Failure in National Integration*. Dhaka: University Press.

——, ed. 2002 [2000]. *Bangladesh: Promise and Performance*. Dhaka: University Press.

Johnston, Lisa Grazina, Rasheda Khanam, Masud Reza, Sharful Islam Khan, Sarah Banu, Md. Shah Alam, Mahmudur Rahman, and Tasnim Azim. 2007. "The Effectiveness of Respondent Driven Sampling for Recruiting Males Who Have Sex with Males in Dhaka, Bangladesh." *AIDS and Behavior* 12(2):294–304.

Kabeer, Naila. 1991. "The Quest for National Identity: Women, Islam and the State in Bangladesh." *Feminist Review* 37:38–58.

——. 2000. *The Power to Choose: Bangladeshi Women and Labour Market Decisions in London and Dhaka*. London: Verso.

Kabeer, Naila, and Simeen Mahmud. 2004. "Globalization, Gender and Poverty: Bangladeshi Women Workers in Export and Local Markets." *Journal of International Development* 16(1):93–109.

Kabir, Alamgir. 1969. *The Cinema in Pakistan*. Dhaka: Sandhani.

——. 1979. *Film in Bangladesh*. Dhaka: Bangla Academy.

Kapur, Ratna. 1996. "Who Draws the Line? Feminist Reflections on Speech and Censorship." *Economic and Political Weekly* 20(16–17):WS15–30.

Kaur, Raminder, and William Mazzarella, eds. 2009. *Censorship in South Asia: Cultural Regulation from Sedition to Seduction*. Bloomington: Indiana University Press.

Kaur, Raminder, and Ajay J. Sinha, eds. 2005. *Bollyworld: Popular Indian Cinema Through a Transnational Lens*. New Delhi: Sage.

Kaviraj, Sudipta. 2004. "Reading a Song of the City—Images of the City in Literature and Films." In *City Flicks: Indian Cinema and the Urban Experience*, edited by Preben Kaarsholm, 60–82. New Delhi: Seagull.

Kelly, Tobias. 2012. *This Side of Silence: Human Rights, Torture, and the Recognition of Cruelty*. Philadelphia: University of Pennsylvania Press.

Khan, Ali, and Ali Nobil Ahmad. 2010. "From *Zinda Laash* to *Zibahkhana*: Violence and Horror in Pakistani Cinema." *Third Text* 24(1):149–61.

Khan, Fawzia. 2005–6. "Cholochitre naribad" [Feminism in cinema]. *Drishorup* 2 & 3:65–100.

Khan, Marcel. 2005. "Bhalobasar juddha: Prem mane bhejal!" [War of love: Love means trouble!]. *New Age*, May 5.

——. 2006. "Obscene Filmmakers Back." *New Age*, Oct. 21.

Khan, M. E., John W. Townsend, and Shampa D'Costa. 2002. "Behind Closed Doors: A Qualitative Study of Sexual Behaviour of Married Women in Bangladesh." *Culture, Health and Society* 4(2):237–56.

Khandker, Adnan. 2007. "Lights Out!" *New Age*, May 13.

Khoshru, Parves. Undated. "[Shyam Shadnaz]-er bicchhed—Shornalir mukhomukhi [Shadnaz] [The divorce of (Shyam and Shadnaz)—Shornali's interview with (Shadnaz)]." *Shornali*.

Kipnis, Laura. 1996. *Bound and Gagged: Pornography and the Politics of Fantasy in America*. Durham, NC: Duke University Press.

Kittler, Friedrich A. 1999. *Gramophone, Film, Typewriter*. Translated by Geoffrey Winthrop-Young and Michael Wutz. Stanford: Stanford University Press.

Kochanek, Stanley A. 2000. "Governance, Patronage, Politics, and Democratic Transition in Bangladesh." *Asian Survey* 40(3):530–50.

——. 2002 [2000]. "The Growing Commercialization of Power." In Jahan 2002, 149–80. Dhaka: University Press.

Krings, Matthias. 2005. "Muslim Martyrs and Pagan Vampires: Popular Video Films and the Propagation of Religion in Northern Nigeria." *Postscripts: The Journal of Sacred Texts and Contemporary Worlds* 1(2 & 3):183–205.

——. 2009. "Turning Rice into *Pilau*: The Art of Video-Narration in Tanzania." *Intermédialités* 4 (Re-dire). http://cri.histart.umontreal.ca/cri/fr/INTERMEDIALITES/redire/pdfs/e4_krings_e4.pdf (accessed April 29, 2012).

Kristeva, Julia. 1982. *Powers of Horror: An Essay on Abjection*. New York: Columbia University Press.

Kuhn, Annette. 1988. *Cinema, Censorship and Sexuality, 1909–1925*. London: Routledge.

Lacan, Jacques. 1977. *The Four Fundamental Concepts of Psychoanalysis*. London: Hogarth Press.

Laclau, Ernesto. 2006. "On the Names of God." In *Political Theologies: Public Religions in a Post-secular World*, edited by Hent de Vries and Lawrence E. Sullivan, 137–47. New York: Fordham University Press.

Larkin, Brian. 2004. "Degraded Images, Distorted Sounds: Nigerian Video and the Infrastructure of Piracy." *Public Culture* 16(4):289–314.

——. 2008. *Signal and Noise: Media, Infrastructure, and Urban Culture in Nigeria.* Durham, NC: Duke University Press.

Lastra, James. 2000. *Sound Technology and the American Cinema: Perception, Representation, Modernity.* New York: Columbia University Press.

Lee, Tong Soon. 2003. "Technology and the Production of Islamic Space: The Call to Prayer in Singapore." In *Music and Technoculture*, edited by René T. A. Lysloff and Leslie C. Gay, 86–100. Middletown, CT: Wesleyan Press.

Lewis, David. 2011. *Bangladesh: Politics, Economy and Civil Society.* Cambridge: Cambridge University Press.

Liang, Lawrence. 2011. "Media's Law: From Representation to Affect." *Bioscope* 2(1):23–40.

Liechty, Mark. 2001. "Women and Pornography in Kathmandu: Negotiating the 'Modern Woman' in a New Consumer Society." In *Images of the "Modern Woman" in Asia: Global Media/Local Meanings*, edited by Shoma Munshi, 34–54. London: Curzon.

Lintner, Bertil. 2002. "Bangladesh: A Cocoon of Terror." *Far Eastern Economic Review*, April 4:14–17.

Madianou, Mirca, and Daniel Miller. 2011. *Migration and New Media: Transnational Families and Polymedia.* London: Routledge.

Mahadevan, Sudhir. 2010. "Traveling Showmen, Makeshift Cinemas: The Bioscopewallah and Early Cinema History in India." *BioScope: South Asian Screen Studies* 1(1):27–47.

Mahmood, Saba. 2001. "Feminist Theory, Embodiment, and the Docile Agent: Some Reflections on the Egyptian Islamic Revival." *Cultural Anthropology* 16(3):202–36.

Mahmud, Selim. 1991. "Film Society Movement in Bangladesh." *View from Bangladesh.* Festival pamphlet. Dhaka: Bangladesh Federation of Film Societies.

Majumdar, Boria. 2002. "The Politics of Soccer in Colonial India, 1930–37: The Years of Turmoil." *Soccer and Society* 3(1):22–36.

Mamoon, Muntassir. 2001. "A Search for Dhaka's Grub Street or Colportage-Mart." *Journal of Social Studies* 93:13–47.

Maniruzzaman, Talukder. 2003 [1980]. *The Bangladesh Revolution and Its Aftermath.* Dhaka: University Press.

Mankekar, Purnima. 1999. *Screening Culture, Viewing Politics: An Ethnography of Television, Womanhood, and Nation in Postcolonial India.* Durham, NC: Duke University Press.

Manobjomin. 2005a. "Oshlil chhobi nirmaner obhiyoge 9 chitroporichalok-ke show-cause" [Nine film directors served with show-cause notices on the accusation of making obscene films]. June 1.

——. 2005b. ""Dui porichaloker cholocchitro porichalok shomitir shodoshopod shtayibhabe batil" [Two directors' membership of the Film Directors Association permanently cancelled]. June 3.

——. 2005c. "Sylhete [Khuni Mintu]-r print ebong Natore Ekrokha o Nogno Hamla reel jobdo." [In Sylhet the print of (*Mintu The Murderer*) and in Natore the reels of Ekrokha and Naked Attack reels seized]. Nov. 11.

——. 2005d. "Kumilla-y [Khuni Mintu] chhobir film jobdo." [Film of the movie (*Mintu the Murderer*) seized in Comilla]. Nov. 23.

Marcus, George E. 1998. *Ethnography Through Thick and Thin.* Princeton, NJ: Princeton University Press.

Marks, Laura. 2000. *The Skin of the Film: Intercultural Cinema, Embodiment, and the Senses.* Durham, NC: Duke University Press.

Massumi, Brian. 1987. "Realer Than Real: The Simulacrum According to Deleuze and Guattari." *Copyright* 1. www.anu.edu.au/HRC/first_and_last/works/realer.htm (accessed Dec. 14, 2007).

Mat, Joke. 2006. "Pedophilia Party onto the Streets" [Pedopartij gaat de straat op]. *NRC Handelsblad,* July 29.

Mazhar, Farhad. Undated. "Beder meye Josna: Chhobiti keno eto dorshok tenechhe?" [Gipsy Girl Josna: Why did the film draw such a large audience?]. Unpublished.

Mazumdar, Ranjani. 2003. The Bombay Film Poster. *Seminar* 525. www.india-seminar.com/2003/525/525%20ranjani%20mazumdar.htm (accessed October 8, 2012).

——. 2007. *Bombay Cinema: An Archive of the City.* Minneapolis: University of Minnesota Press.

Mazzarella, William. 2005. "Public Culture, Still." *Biblio: A Review of Books* 10 (Sept.-Oct.):9–10.

——. 2006. "Internet X-ray: E-governance, Transparency, and the Politics of Immediation in India." *Public Culture* 18(3):472–505.

——. 2010. "The Myth of the Multitude, or, Who's Afraid of the Crowd?" *Critical Inquiry* 36:697–727.

McGuire, John. 1983. *The Making of a Colonial Mind: A Quantitative Study of the Bhadralok in Calcutta, 1875-1885.* Canberra: Australian National University.

Mehta, Monika. 2011. *Censorship and Sexuality in Bombay Cinema.* Austin: University of Texas Press.

Meyer, Birgit. 2004. "'Praise the Lord . . .': Popular Cinema and Pentecostalite Style in Ghana's New Public Sphere." *American Ethnologist* 31(1):92–110.

——. 2005. "Religious Remediations: Pentecostal Views in Ghanaian Video-Movies." *Postscript* 1(2/3):155–81.

——. 2006. *Religious Sensations: Why Media, Aesthetics and Power Matter in the Study of Contemporary Religion.* Inaugural Lecture, Vrije Universiteit, Oct. 6. Amsterdam: Vrije Universiteit.

——, ed. 2009. *Aesthetic Formations: Media, Religion, and the Senses.* New York: Palgrave Macmillan.

Mir-Hossaeini, Ziba. 2007. "Negotiating the Forbidden: On Women and Sexual Love in Iranian Cinema." *Comparative Studies of South Asia, Africa, and the Middle East* 27(3): 673–79.

Mitra, Subal Chandra. 1911. *The Student's Bengali-English Dictionary.* Calcutta: Published by the author.

Mamun, Abdullah Al. 2005. "Bangla cinema uddharprokolpo: *Chondrokotha, Bachelor*-der poyabaro" [Saving hypothesis of Bengali cinema: *Chondrokotha* and *Bachelor*'s run of luck]. Paper presented at the conference "Jonoshongshkritir Rajniti: Bangladesh Cholochitro Shilpo" [The politics of popular culture: Bangladesh cinema]. Dhaka University. August 13.

Mohaiemen, Naeem. 2006. "'Kothai aj shei Shiraj Sikder (Where today is that Shiraj Sikder)?' Terrorists or Guerrillas in the Mist." In *Sarai Reader 2006: Turbulence,* 296–311. Delhi: Centre for the Study of Developing Societies.

Mokkil Maruthur, Navaneetha. 2011. "Re-viewing Her Nights: Modes of Excess in Indian Cinema." *South Asian Popular Culture* 9(3):273–85.

Mookherjee, Nayanika. 2006. "'Remembering to Forget': Public Secrecy and Memory of Sexual Violence in the Bangladesh War of 1971." *Journal of the Royal Anthropological Institute* (n.s.) 12(2):433–50.

——. 2007. "The 'Dead and Their Double Duties': Mourning, Melancholia, and the Martyred Intellectual Memorials in Bangladesh." *Space and Culture* 10(2):271–91.

——. 2008. "Gendered Embodiments: Mapping the Body-Politic of the Raped Woman and the Nation in Bangladesh." *Feminist Review* 88(1):36–53.

Moore, Lindsey. 2005. "Women in a Widening Frame: (Cross-)Cultural Projection, Spectatorship, and Iranian Cinema." *Camera Obscura* 20(2):1–33.

Morris, Meaghan. 2004. "Transnational Imagination in Action Cinema: Hong Kong and the Making of a Global Popular Culture." *Inter-Asia Cultural Studies* 5(2):181–99.

Moumachhi. 2005a. "Birodher rohoshyo ki?" [What's the secret of the quarrel?]. *Manobjomin*, June 18.

——. 2005b. "[Jishu Jadughor's] upodeshbani" [(Jishu Jadughor's) advice]. *Manobjomin*, June 4.

——. 2005c. "[Jenny]-Shayla-r dondo barchhe" [(Jenny) and Shayla's competition increases]. *Manobjomin*, August 29.

Mowla, Sabiha. 2005. "On the Indian Entertainment Industry." *Star Weekly Magazine*, June 3.

Mukherjee, Madhuja. 2007. "Early Indian Talkies: Voice, Performance and Aura." *Journal of the Moving Image* 6: http://jmionline.org/film_journal/jmi_06/article_03.php# (accessed April 24, 2012).

——. 2011. "Cinemas Outside Texts: The Mise-en-scene in Publicity Images and Theaters of Spectacle." *South Asian Popular Culture* 9(3): 327–34.

Mukherjee, S. N. 1970. "Class, Caste and Politics in Calcutta, 1815–38." In *Elites in South Asia*, edited by Edmund Leach and S. N. Mukherjee, 33–78. Cambridge: Cambridge University Press.

Mulvey, Laura. 1989. *Visual and Other Pleasures*. Basingstoke: Macmillan.

Naficy, Hamid. 1995. "Iranian Cinema Under the Islamic Republic." *American Anthropologist* 97(3):548–58.

Nasreen, Gitiara, and Fahmidul Haq. 2008. *Bangladesher chalochchitra shilpo: Sangkote janosangskriti* [The film industry of Bangladesh: Popular culture in crisis]. Dhaka: Shrabon Prokashoni.

Nead, Lynda. 1992. *The Female Nude: Art, Obscenity and Sexuality*. London: Routledge.

Neale, Steve. 2000. *Genre and Hollywood*. London: Routledge.

New Age. 2004. "Rid Film Industry of Vulgarity, PM Tells Filmmakers." Dec. 2.

——. 2005a. "Women Presented as Sexual Object in Bangla Films." Jan. 29.

——. 2005b. "Bangla Movies Top Satellite Channels in Obscenity." March 29.

——. 2005c. "Dealing with Movie Obscenity." July 18.

Niles, John D. 1999. *Homo Narrans: The Poetics and Anthropology of Oral Literature*. Philadelphia: University of Pennsylvania Press.

Nochlin, Linda. 1986. "Courbet's *L'origine du monde*: The Origin Without an Original." *October* 37(summer):76–86.

Oldenburg, Veena Talwar. 1990. "Lifestyle as Resistance: The Case of the Courtesans of Lucknow, India." *Feminist Studies* 16(2):259–87.

Ortner, Sherry. 2010. "Access: Reflections on Studying Up in Hollywood." *Ethnography* 11(2):211–33.

Padmanabhan, R. 1998. "Assault on Art." *Frontline* 15(10): www.frontlineonnet.com/fl1510/15100210.htm (accessed Oct. 8, 2012).

Painter, Andrew A. 1994. "On the Anthropology of Television: A Perspective from Japan." *Visual Anthropology Review* 10(1):70–84.

Pandian, Anand. 2008. "Cinema in the Countryside: Popular Tamil Film and the Remaking of Rural Life." In Velayutham, 124–38.

Parry, Jonathan. 2000. "The 'Crisis of Corruption' and 'The Idea of India': A Worm's Eye View." In *Morals of Legitimacy: Between Agency and System*, edited by Italo Pardo, 27–55. New York: Berghahn.

Parvez, Anwar. 2005. "Joypurhate oshlil cholochitro o poster prodorshoni" [Obscene films and posters on display in Joypurhat]. *Prothom Alo*, June 21.

Pease, Allison. 2000. *Modernism, Mass Culture and the Aesthetic of Obscenity*. Cambridge: Cambridge University Press.

Pinney, Christopher. 1997. *Camera Indica: The Social Life of Indian Photographs*. London: Reaktion.

——. 2001. "Piercing the Skin of the Idol." In *Beyond Aesthetics: Art and the Technologies of Enchantment*, edited by Christopher Pinney and Nicholas Thomas, 157–80. Oxford: Berg.

——. 2004. *Photos of the Gods: The Printed Image and Political Struggle in India*. London: Reaktion.

——. 2005. "Things Happen: Or, From Which Moment Does That Object Come?" In *Materiality*, edited by Daniel Miller, 256–72. Durham, NC: Duke University Press.

Powdermaker, Hortense. 1950. *Hollywood, the Dream Factory: An Anthropologist Looks at the Movie-Makers*. Boston: Little, Brown.

Prasad, M. Madhava. 1998. *The Ideology of the Hindi Film: A Historical Construction*. New Delhi: Oxford University Press.

Prothom Alo. 2005a. "*Noshta meye* soho shob oshlil chhobi nishiddho korar dabi" [Demand to forbid all obscene films, including "Despoiled Girl"]. April 28.

——. 2005b. "Oshlil drishye obhinoy korechhen proyojok nije-i" [Producer himself acted in obscene scene]. April 24.

——. 2005c. "Oshlil chhobir poster chheye gechhe Gazipur" [Obscene posters captured in Gazipur]. April 28.

——. 2005d. "Tinti chhobite oshlil drishyo prodorshon chholchhei: Tin proyojok ke show-cause" [Exhibition of obscene scenes in three films: Three producers served with show-cause]. Nov. 9.

——. 2005e. "After Cutting Scenes" [Drisho katar por]. Nov. 9.

——. 2005f. "Kumillay [Khuni Mintu] chhobir print jobdo" [Film (*Mintu the Murderer*)'s print seized in Comilla]. Nov. 23.

Qader, Mirza Tarequl. 1993. *Bangladesher chalachitra shilpa* [The cinema of Bangladesh]. Dhaka: Bangla Academy.

Qureshi, Irna. 2010. "Destigmatising Star Texts—Honour and Shame Among Muslim Women in Pakistani Cinema." In Banaji 2010, 181–98.

Radway, Janice. 1995. "The Institutional Matrix of Romance." In During 1993b, 438–54.

Rahman, Ashish. 2005. "Obhiyukto" [Accused]. *Tarokalok*, June 1.

Rahman, Mofizur. 1999. "Short Film Movement: Search for Alternative Cinema in Bangladesh." *Journal of Social Studies* 83:96–113.

Rahman, Mokolechur. 2005. "Dhamrai-ye oshlil chhobir joyar" [High tide for obscene films in Dhemrai]. *Prothom Alo*, May 5.

Rai, Amit S. 2010 [2009]. *Untimely Bollywood: Globalization and India's New Media Assemblage.* New Delhi: Oxford University Press.

Rajadhyaksha, Ashish. 2003. "The 'Bollywoodization' of the Indian Cinema: Cultural Nationalism in a Global Arena." *Inter-Asia Cultural Studies* 4(1):25–39.

Rajadhyaksha, Ashish, and Paul Willemen. 2004 [1999]. *Encyclopaedia of Indian Cinema.* Delhi: Oxford University Press.

Rajagopal, Arvind. 2001. *Politics After Television: Hindu Nationalism and the Reshaping of the Public in India.* Cambridge: Cambridge University Press.

Raju, Zakir Hossain. 2000. "National Cinema and the Beginning of Film History in/of Bangladesh." *Screening the Past* 11: www.latrobe.edu.au/screeningthepast/firstrelease/fr1100/rzfr11d.htm (accessed July 26, 2007).

——. 2002. "Bangladesh: A Defiant Survivor." In *Being and Becoming: The Cinemas of Asia*, edited by Aruna Vasudev, Latika Padgaonkar, and Rashmi Doraiswamy, 1–25. Delhi: Macmillan.

——. 2006. "Bangladesh: Native and Nationalist." In *Contemporary Asian Cinema: Popular Culture in a Global Frame*, edited by Anne Tereska Ciecko, 120–32. Oxford: Berg.

Ramaswami, Shankar. 2006. "Masculinity, Respect, and the Tragic: Themes of Proletarian Humor in Contemporary Industrial Delhi." *International Review of Social History* 51(Supplement S14):203–27.

Ramaswamy, Sumathi. 2010. *The Goddess and the Nation: Mapping Mother India.* Durham, NC: Duke University Press.

Rao, R. Raj. 2000. "Memories Pierce the Heart: Homoeroticism, Bollywood-Style." *Journal of Homosexuality* 39(3–4):299–306.

Rashiduzzaman, M. 1994. "The Liberals and the Religious Right in Bangladesh." *Asian Survey* 34(11):974–90.

Ray, Satyajit. 1993 [1976]. *Our Films, Their Films.* New Delhi: Orient Longman.

Riaz, Ali. 2005. "Traditional Institutions as Tools of Political Islam in Bangladesh." *Journal of Asian and African Studies* 40(3):171–96.

Roberge, Gaston. 2004. *Shongyog cinema unnoyon* [Communication, cinema, development]. Kolkata: Obonindornath Bera.

Rosario, Santi. 1992. *Purity and Communal Boundaries: Women and Social Change in a Bangladeshi Village.* London: Zed.

Ruud, Arild Engelsen. 2011. "Democracy in Bangladesh: A Village View." In *Trysts with Democracy: Political Practice in South Asia*, edited by Stig Toft Madsen, Kenneth Bo Nielsen, and Uwe Skoda, 45–70. London: Anthem.

Samaddar, Ranabir. 2002. *Paradoxes of the Nationalist Time: Political Essays on Bangladesh.* Dhaka: University Press.

Sánchez, Rafael. 2006. "Intimate Publicities: Retreating the Theologico-Political in the Chávez Regime?" In *Political Theologies: Public Religions in a Post-secular World,* edited by Hent de Vries and Lawrence E. Sullivan, 401–26. New York: Fordham University Press.

Sarkar, Mahua. 2008. *Visible Histories, Disappearing Women: Producing Muslim Womanhood in Late Colonial Bengal.* Durham, NC: Duke University Press.

Schaefer, Eric. 1999. *"Bold! Daring! Shocking! True!" A History of Exploitation Films, 1919-1959.* Durham, NC: Duke University Press.

Schwartz, Susan L. 2004. *Rasa: Performing the Divine in India.* New York: Columbia University Press.

Sengupta, Shuddhabrata. 2005. "Reflected Readings in Available Light: Cameramen in the Shadows of Hindi Cinema." In Kaur and Sinha 2005, 118–40.

Shah, Panna. 1981 [1950]. *The Indian Film.* Westport, CT: Greenwood Press.

Shahriar, Sadat. 2005. "Bangla Movies." *Daily Star,* May 16.

Shehabuddin, Elora. 1999. "Contesting the Illicit: Gender and the Politics of Fatwas in Bangladesh." *Signs* 24(4):1011–44.

——. 2008. *Reshaping the Holy: Democracy, Development, and Muslim Women in Bangladesh.* New York: Columbia University Press.

Shohat, Ella. 1997. "Post-Third-Worldist Culture: Gender, Nation, and the Cinema." In *Feminist Genealogies, Colonial Legacies, Democratic Futures,* edited by M. Jacqui Alexander and Chandra Talpade Mohanty, 183–209. New York: Routledge.

Siddiqi, Dina M. 1998. "Taslima Nasreen and Others: The Contest over Gender in Bangladesh." In *Women in Muslim Societies: Diversity Within Unity,* edited by Herbert L. Bodman and Nayereh Tohidi, 205–27. Boulder, CO: Lynne Rienner.

——. 2000. "Miracle Worker or Womanmachine? Tracking (Trans)national Realities in Bangladeshi Factories." *Economic and Political Weekly,* May 27:L-11–L-17.

——. 2002. "Bangladesh: Sexual Harassment and the Public Woman." *Himal Southasian,* May 21.

Silverman, Kaja. 1996. *The Threshold of the Visible World.* London: Routledge.

Silverstein, Michael, and Greg Urban, eds. 1996. *Natural Histories of Discourse.* Chicago: University of Chicago Press.

Singh, Bhrigupati. 2008. "Aadamkhor haseena (the man-eating beauty) and the Anthropology of a Moment." *Contributions to Indian Sociology* 42(2):249–79.

Sinha, Mrinalini. 1995. *Colonial Masculinity: The "Manly Englishman" and the "Effeminate Bengali" in the Late Nineteenth Century.* New Delhi: Kali for Women.

Smelik, Anneke. 1999. "Feminist Film Theory." In *The Cinema Book,* edited by Pam Cook and Mieke Bernink, 353–62. 2nd ed. London: BFI.

Sobchack, Vivian. 2004. *Carnal Thoughts: Embodiment and Moving Image Culture.* Berkeley: University of California Press.

Souza, Eunice de. 2004. *Purdah: An Anthology.* New Delhi: Oxford University Press.

Spencer, Jonathan. 2007. *Anthropology, Politics and the State: Democracy and Violence in South Asia.* Cambridge: Cambridge University Press.

Spitulnik, Debra. 1993. "Anthropology and Mass Media." *Annual Review of Anthropology* 22:293–315.

Sreberny-Mohammadi, Annabelle. 1994. *Small Media, Big Revolution: Communication, Culture and the Iranian Revolution.* Minneapolis: University of Minnesota Press.

Srinivas, Lakshmi. 2002. "The Active Audience: Spectatorship, Social Relations and the Experience of Cinema in India." *Media, Culture and Society* 24(2):155–73.

Srinivas, S. V. 2000. "Is There a Public in the Cinema Hall?" *Framework* 42: www.frameworkonline.com/Issue42/42svs.html (accessed Dec. 14, 2010).

——. 2003. "Hong Kong Action Film in the Indian B Circuit." *Inter-Asia Cultural Studies* 4(1):40–62.

——. 2009. *Megastar: Chiranjeevi and Telugu Cinema After N.T. Rama Rao.* New Delhi: Oxford University Press.

Srivastava, Sanjay. 2007. *Passionate Modernity: Sexuality, Class and Consumption in India.* New Delhi: Routledge.

Sultana, Sheikh Mahmuda. 2002. "Dhakar cholochitre nari: Danob, debota o potir rajyo—noshto, extra o shoti" [Women in Dhaka cinema: The kingdom of monsters, goddesses and husbands—despoiled, extra and chaste]. In *Gonomaddhom o jonosamaj* [Mass media and society], edited by Gitiara Nasreen, Mofizur Rahman, and Sitara Parvin, 191–224. Dhaka: Shrabon Prokashoni.

Surin, Kenneth. 2001. "The Sovereign Individual and Michael Taussig's Politics of Defacement." *Neplanta: Views from the South* 2(1):205–20.

Swaminathan, Roopa. 2004. *Stardust: Vignettes from the Fringes of the Film Industry.* New Delhi: Penguin India.

Tait, Robert. 2005. "Iranian Morals Police Arrest 230 in Raid on 'Satanist' Rave." *Guardian,* August 6.

Tarokalok. 2005. "Divorce dilen [Shadnaz]." [(Shadnaz) divorced]. 23(19) May.

Taussig, Michael. 1999. *Defacement: Public Secrecy and the Labor of the Negative.* Stanford: Stanford University Press.

——. 2003. "Viscerality, Faith, and Skepticism: Another Theory of Magic." In *Magic and Modernity: Interfaces of Revelation and Concealment,* edited by Birgit Meyer and Peter Pels, 272–306. Stanford: Stanford University Press.

Thomas, Rosie. 1996. "Melodrama and the Negotiation of Morality in Mainstream Hindi Film." In *Consuming Modernity: Public Culture in a South Asian World,* edited by Carol Breckenridge, 157–82. Delhi: Oxford University Press.

Tripathy, Ratnakar. 2007. "Bhojpuri Cinema: Regional Resonances in the Hindi Heartland." *South Asian Popular Culture* 5(2):145–65.

Turner, Victor. 1982. *From Ritual to Theatre: The Human Seriousness of Play.* New York: PAJ.

Uberoi, Patricia. 2001. "Imagining the Family: An Ethnography of Viewing Hum Aapke Hai Koun . . . !" In Dwyer and Pinney 2001, 309–51.

Van Schendel, Willem. 2002a. "A Politics of Nudity: Photographs of the 'Naked Mru' of Bangladesh." *Modern Asian Studies* 36(2):341–74.

——. 2002b [2000]. "Bengalis, Bangladeshis and Others: Chakma Visions of a Pluralist Bangladesh." In Jahan 2002, 65–105.

——. 2009. *A History of Bangladesh*. Cambridge: Cambridge University Press.

Varzi, Roxanne. 2006. *Warring Souls: Youth, Media and Martyrdom in Post-Revolution Iran*. Durham, NC: Duke University Press.

Vasudevan, Ravi. 1995. "Addressing the Spectator of a 'Third World' National Cinema: The Bombay 'Social' Film of the 1940s and 1950s." *Screen* 36(4):305–24.

——. 2000. "Shifting Codes, Dissolving Identities: The Hindi Social Film of the 1950s as Popular Culture." In *Making Meaning in Indian Cinema*, edited by Ravi Vasudevan, 99–121. New Delhi: Oxford University Press.

——. 2004a. The Exhilaration of Dread: Genre, Narrative Form and Film Style in Contemporary Urban Action Films." In *City Flicks: Indian Cinema and the Urban Experience*, edited by Preben Kaarsholm, 223–36. New Delhi: Seagull.

——. 2004b. "Disreputable and Illegal Publics: Cinematic Allegories in Times of Crisis." In *Sarai Reader 2004: Crisis/Media*, 71–79. New Delhi: The Sarai Programme.

——. 2010a. "In the Centrifuge of History." *Cinema Journal* 50(1):135–40.

——. 2010b. *The Melodramatic Public: Film Form and Spectatorship in Indian Cinema*. Delhi: Permanent Black.

Velayutham, Selvaraj, ed. 2008. *Tamil Cinema: The Cultural Politics of India's Other Film Industry*. London: Routledge.

Verevis, Constantine. 2005. "Remaking Film." *Film Studies* 4:87–103.

Verkaaik, Oskar. 2004. *Migrants and Militants: Fun and Urban Violence in Pakistan*. Princeton, NJ: Princeton University Press.

Virdi, Jyotika. 2003. *The Cinematic ImagiNation: Indian Popular Films as Social History*. Delhi: Permanent Black.

Vitali, Valentina. 2009. *Hindi Action Cinema: Industries, Narratives, Bodies*. Delhi: Oxford University Press.

Wahid, Zeenat Huda. 2007. "Emergence of Satellite Television and Enigmatic Geopolitical Strategy of Bangladesh Government." *Bangladesh e-Journal of Sociology* 4(1): 73–88. www.bangladeshsociology.org/BEJS%204.1%20Final%20(draft).pdf (accessed Nov. 14, 2007).

Warner, Michael. 2002. "Publics and Counterpublics." *Public Culture* 14(1):49–90.

Waugh, Thomas. 2001. "Homosociality in the Classical American Stag Film: Off-Screen, On-Screen." *Sexualities* 4(3):275–91.

Weber, Samuel. 1996. *Mass Mediauras: Form, Technics, Media*. Stanford: Stanford University Press.

White, Sarah. 1992. *Arguing with the Crocodile: Gender and Class in Bangladesh*. Dhaka: University Press.

Wilkinson-Weber, Clare M. 2010. "A Need for Redress: Costume in Some Recent Hindi Film Remakes." *Bioscope* 1(2):125–45.

Willemen, Paul. 2004. "For a Pornoscape." In *More Dirty Looks: Gender, Pornography and Power*, edited by Pamela Church Gibson, 9–26. London: British Film Institute.

Williams, Linda. 1989. *Hard Core: Power, Pleasure, and the "Frenzy of the Visible."* Berkeley: University of California Press.

——. 1991. "Film Bodies: Gender, Genre, and Excess." *Film Quarterly* 44(4):2–13.

——. 2004. *Porn Studies*. Durham, NC: Duke University Press.

——. 2008. *Screening Sex*. Durham, NC: Duke University Press.

Williams, Raymond. 1977. *Marxism and Literature*. Oxford: Oxford University Press.

Wilson, Anton. 1983. *Anton Wilson's Cinema Workshop*. 4th ed. Hollywood: A. S. C. Holding.

Worth, Sol. 1981. *Studying Visual Communication*. Philadelphia: University of Pennsylvania Press.

Ziring, Lawrence. 1994 [1992]. *Bangladesh: From Mujib to Ershad, An Interpretive Study*. Dhaka: University Press.

Žižek, Slavoj. 1989. *The Sublime Object of Ideology*. London: Verso.

——. 1997. *The Plague of Fantasies*. London: Verso.

INDEX

South Asia Across the Disciplines is a series devoted to publishing first books across a wide range of South Asian studies, including art, history, philology or textual studies, philosophy, religion, and the interpretive social sciences. Series authors all share the goal of opening up new archives and suggesting new methods and approaches, while demonstrating that South Asian scholarship can be at once deep in expertise and broad in appeal.